A Cottage for
EVERY SEASON

A Cottage for
EVERY SEASON

CINDY SMITH COOPER

PRESS

Hoffman Media
1900 International Park Drive, Suite 50
Birmingham, Alabama 35243
hoffmanmedia.com

83
PRESS®

ISBN #978-1-940772-88-2
Printed in China

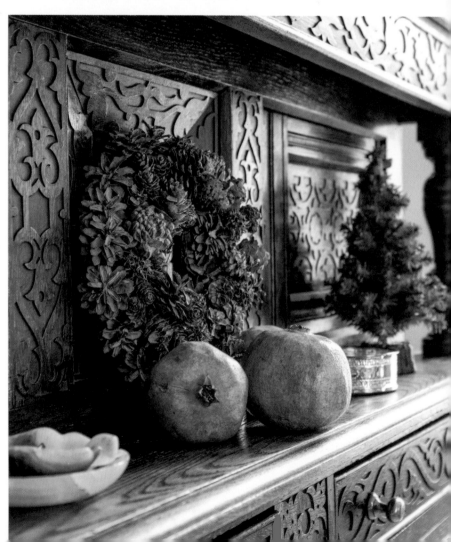

TABLE OF CONTENTS

INTRODUCTION

Cottage style today remains inviting and welcoming and always captures the heart of the home. Every room in your cottage has its own identity—from the entry and the family room to the bedrooms and the back porch. A home's flow and sense of history wrapped in a feeling of perfect harmony allow for a simple lifestyle. Each room has its own purpose, with details as comforting as fresh bedding crisp from the wash or a lovely toile fabric with trimmed edges for interest, resulting in the ideal ambience for holiday celebrations and entertaining. Meaningful objects, personal collections, and family treasures all gathered in the home add charm to every occasion. A little history is always welcome, making a home seem well-loved, combining layers of various styles and curated items. Character shines from one-of-a-kind furniture pieces, combining the new and the antique and giving a unique feel to interiors.

Seventeen classic cottages, whether on the coast or within the city, are filled with the spirit of each season of the year. In this book, we present the four seasons—spring, summer, autumn, and winter—and each cottage brings seasonal flair and highlights its place in the country. Whether influenced by the colors of the season or its surroundings, each dwelling reflects the style and essence of its location. And each personal story carries the characteristics of those who live inside, opening up a lifestyle that is truly home sweet home to those within.

SPRING

COTTAGES BURST WITH NEW APPROACHES TO COLOR AND FRESH
STYLE, AND SEASONAL NODS TO FLORALS ABOUND. FROM
SUN-DRENCHED ENTRYWAYS TO GARDENS OVERFLOWING WITH
BLOOMS, EACH SPACE SETS THE STAGE FOR A NEW SEASON OF LIFE.

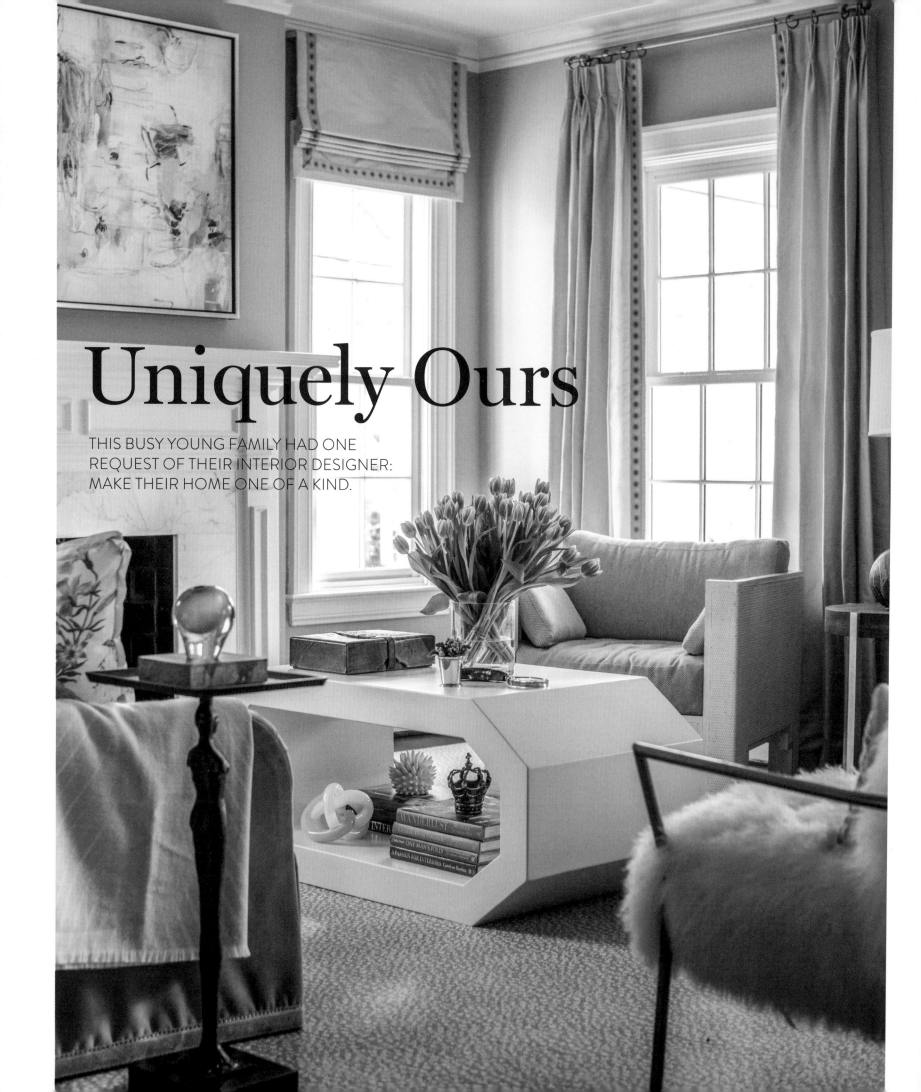

Uniquely Ours

THIS BUSY YOUNG FAMILY HAD ONE
REQUEST OF THEIR INTERIOR DESIGNER:
MAKE THEIR HOME ONE OF A KIND.

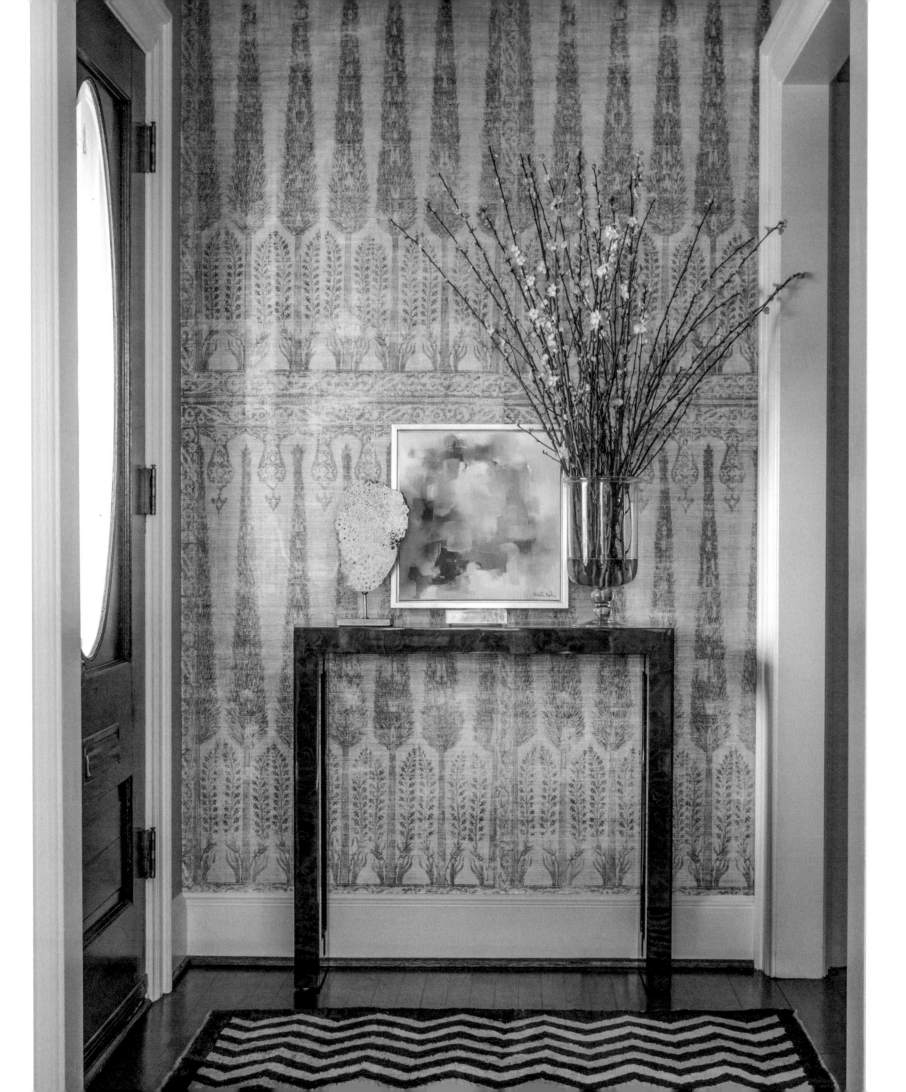

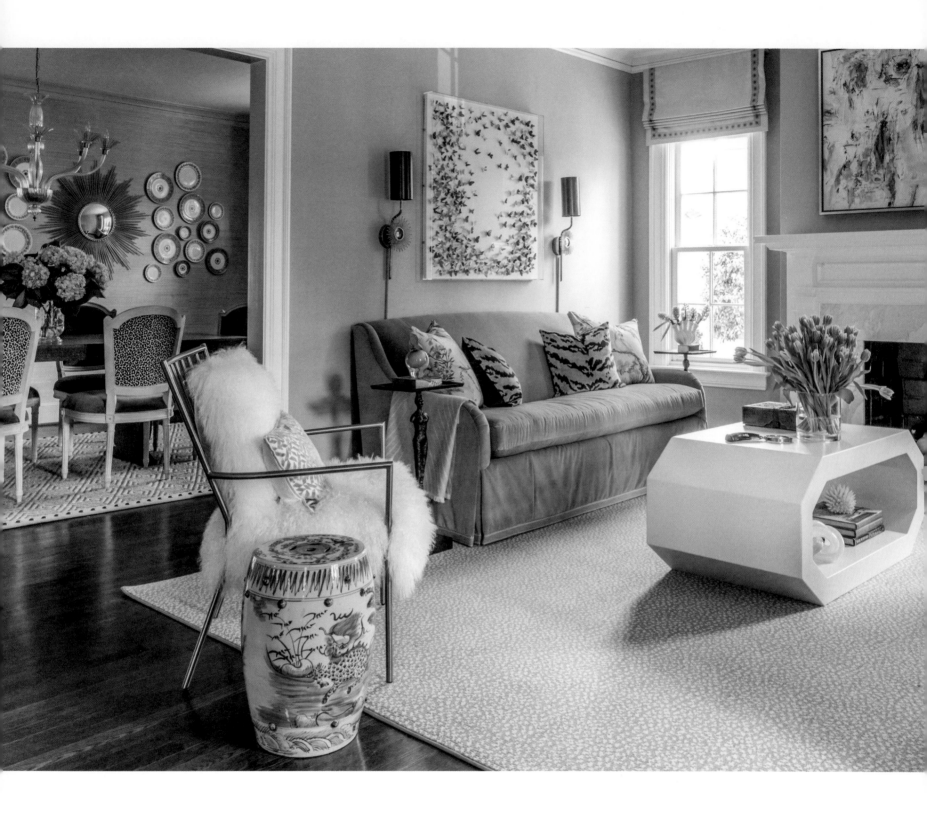

A s an event planner, mother, and wife, Katrina Hutchins has a full plate. So, when it came time to redesign her 1936 home in Charlotte, North Carolina, the decision to source it to designer Ashley Shaw was an easy one. She just had one specific request: that her family's home be unique to them. With paint, wallpaper, and new light fixtures, Ashley gave the historic home new life and a breath of fresh air with a new color story. "The Hutchinses are an active family—so happy and energetic," Ashley says. "I wanted the house to reflect the owners." Starting with what she describes as her "launch point," Ashley picked a fabric and played off that. For the living room, she started with the pillows, which feature a floral-and-cockatoo print with coral, green, blue, and hints of yellow.

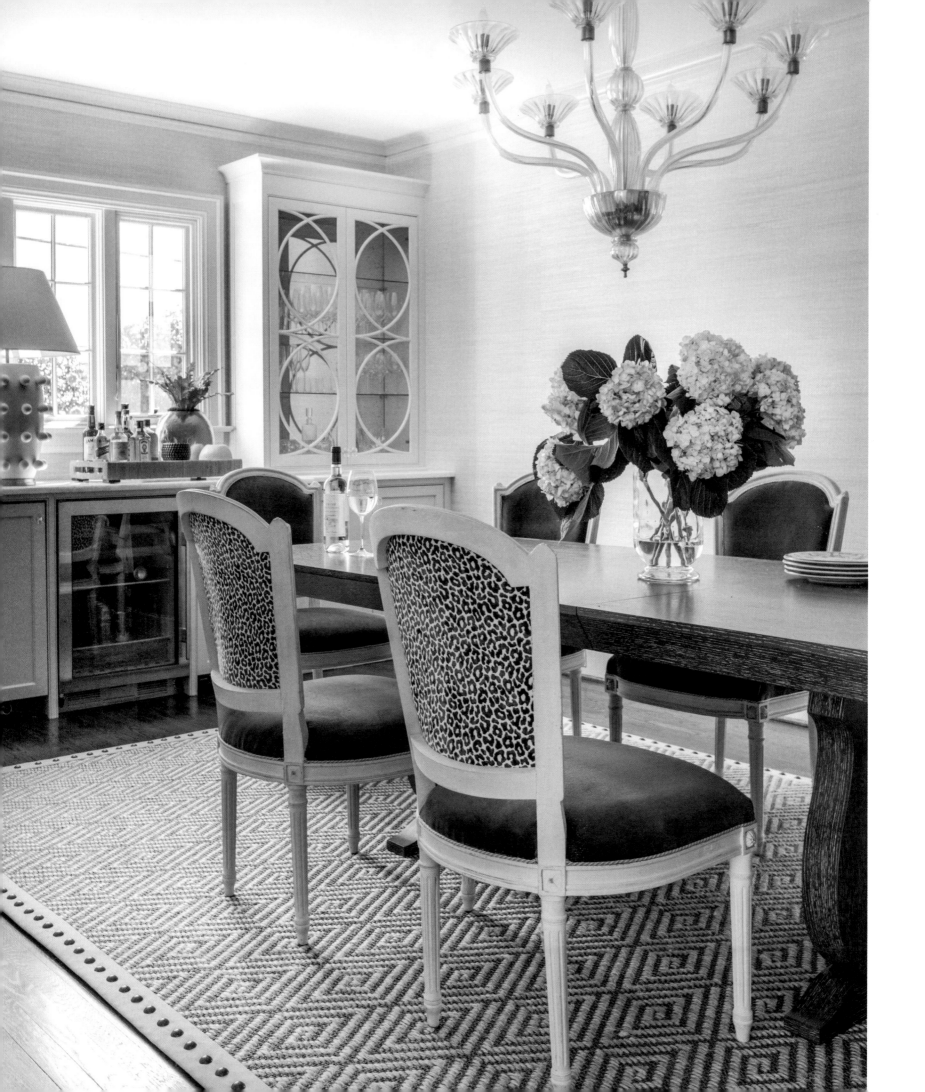

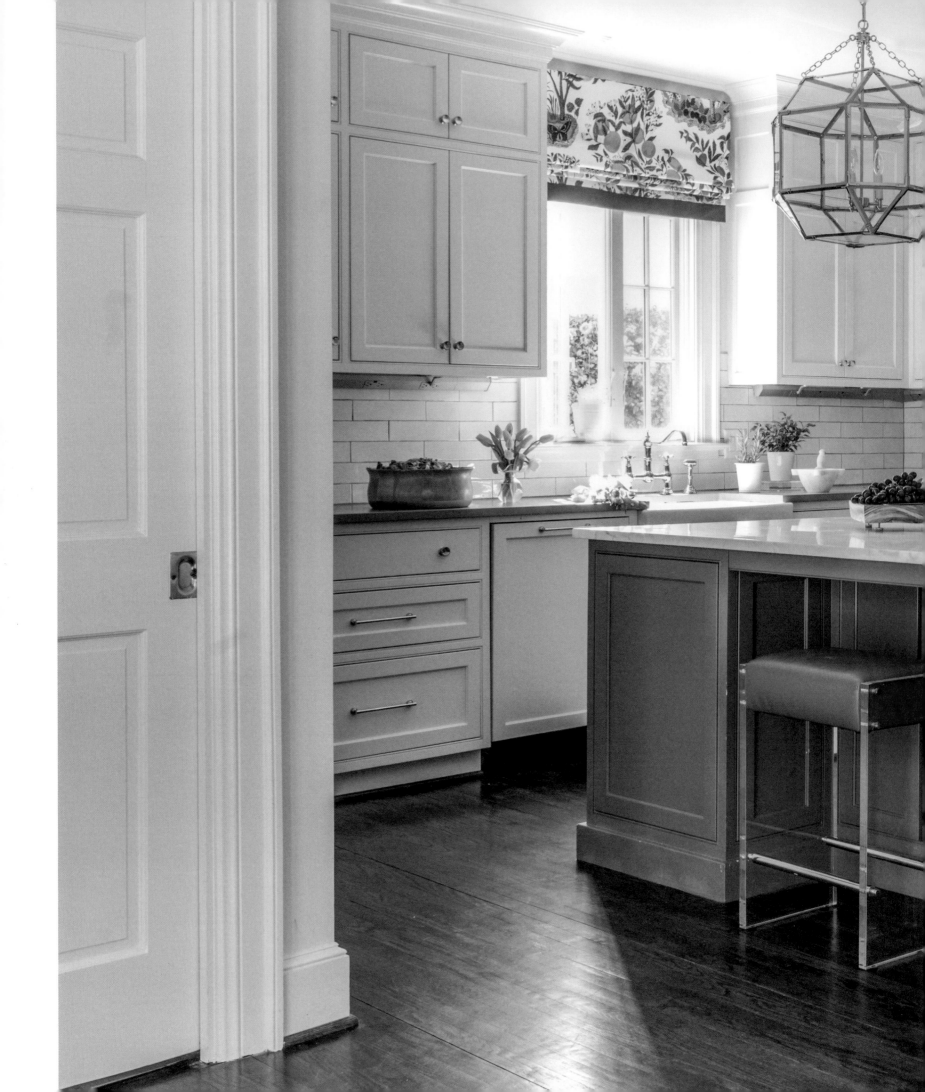

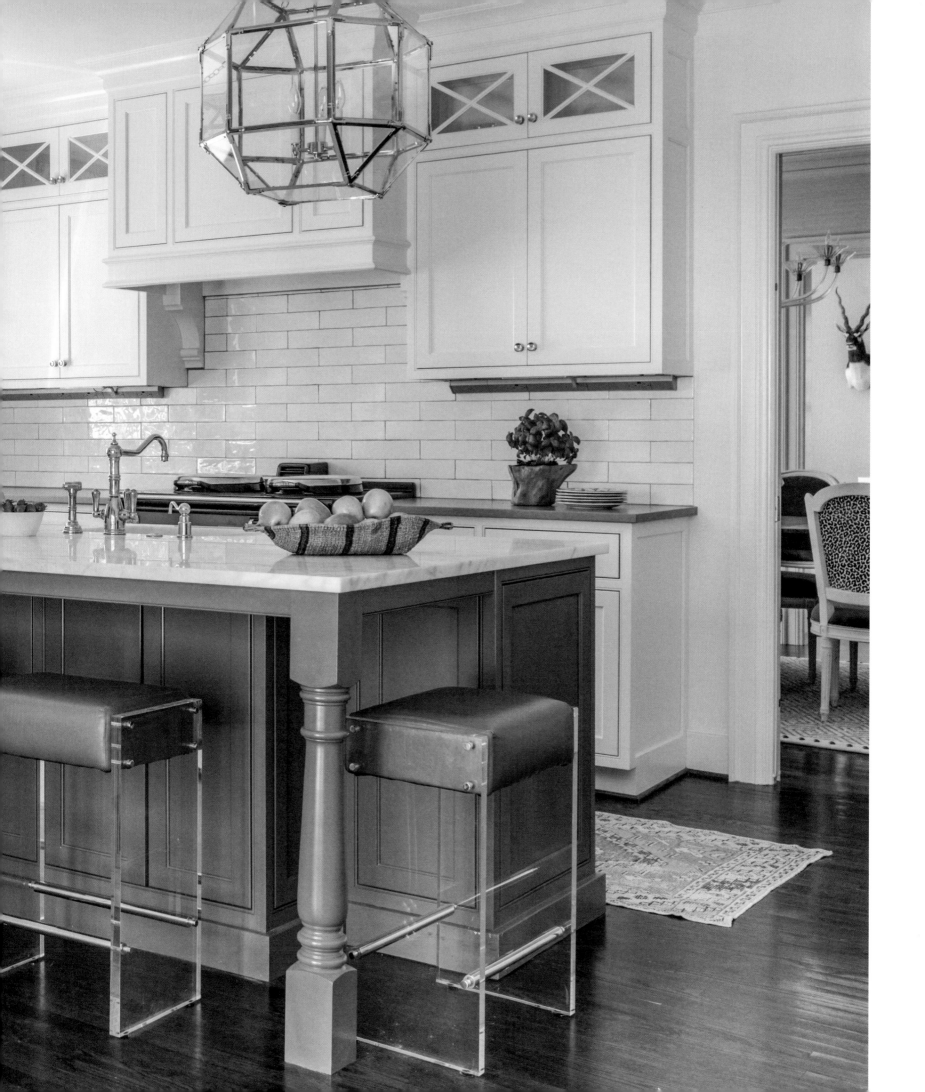

With the open floor plan of the home, the color palette needed a thread to tie each room together, so Ashley used plenty of green and blue hues throughout the space. "We had to skillfully weave color throughout the house because of the shotgun layout," Ashley says. "If done improperly, it will feel choppy, but if done correctly, color, pattern, and texture will pull your eye from one room to the next in a cohesive manner." Luckily for Ashley, the Hutchinses' tastes reflect their fun personalities. "I'm an event planner, so lighting and color are two things I am incredibly drawn to," Katrina says. "We've always had colorful homes—we've never been neutral people!"

Also of utmost importance to Katrina was a home that could withstand her two boys. Knowing this, Ashley used outdoor fabrics for different rooms. "Outdoor fabrics have come such a long way," she says. "We use them all the time now in formal dining and living rooms."

Another way the two created a unique look was through mixing vintage and new pieces throughout the home. "I told Ashley I wanted something she hasn't done before and that I haven't seen before," Katrina says. "That led to a lot of the pieces being custom or vintage—one of a kind!"

From room to room, you'll find an array of styles all intricately woven together through color, pattern, and pieces. The dining room features bold emerald-green chairs and a contemporary lamp and sunburst mirror surrounded by antique dinnerware and a traditional chandelier. The living room is centered around a modern coffee table and accented with traditional Southern chinoiserie side tables. Everything melds together beautifully, though, to create a home that is totally unique to the Hutchins family.

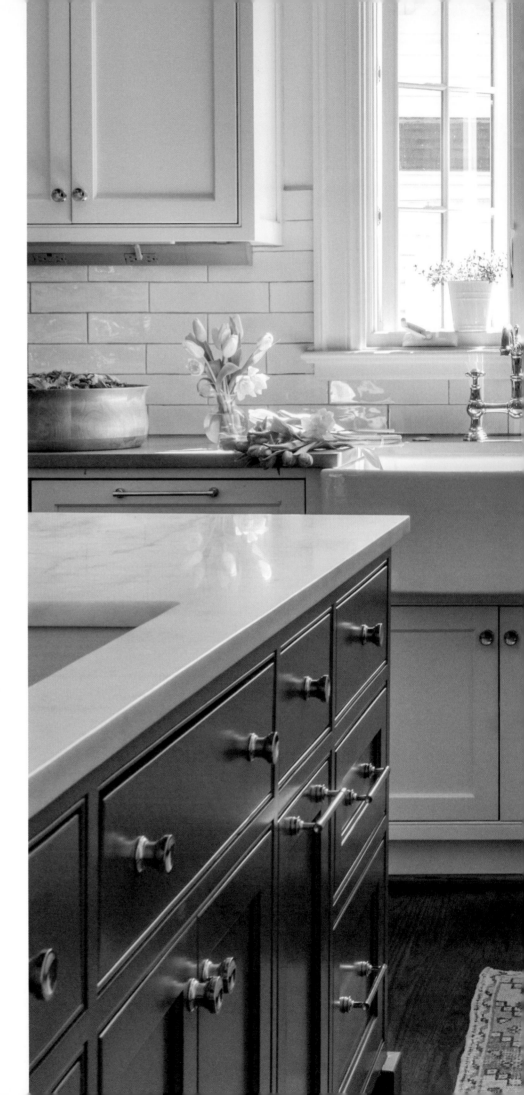

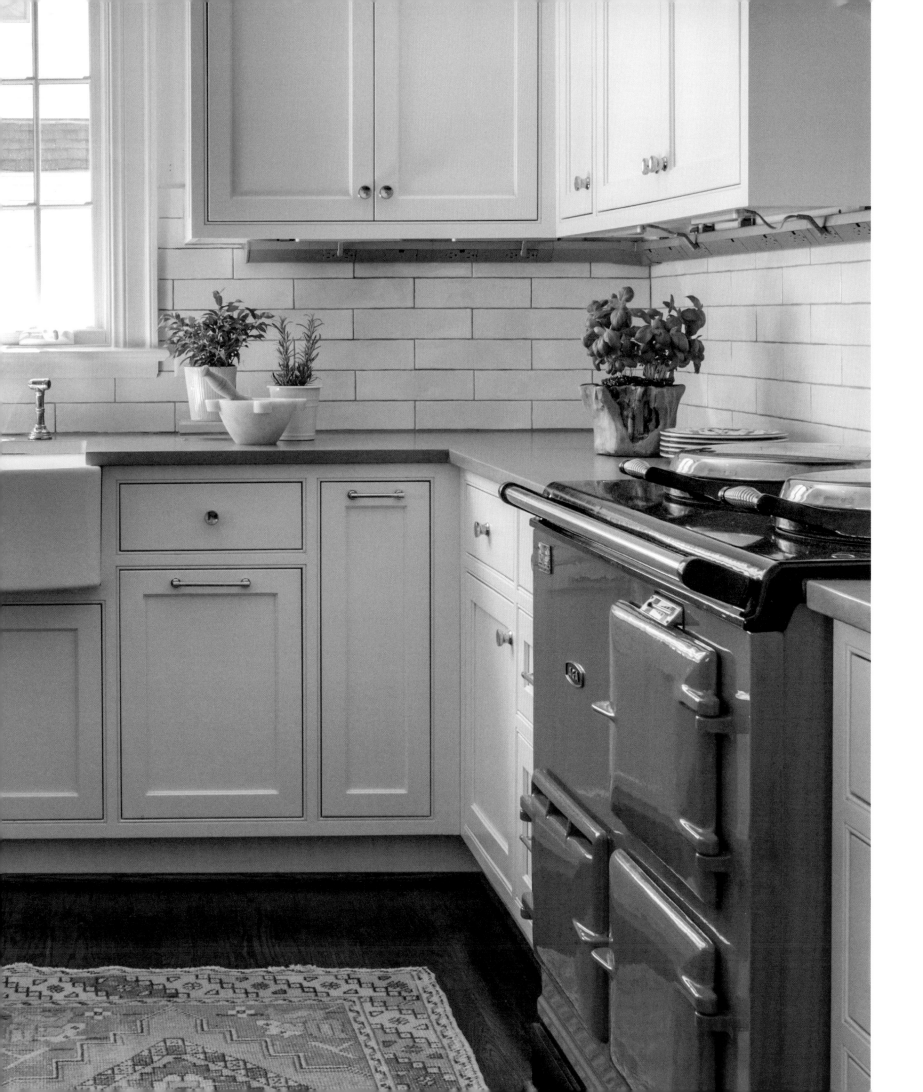

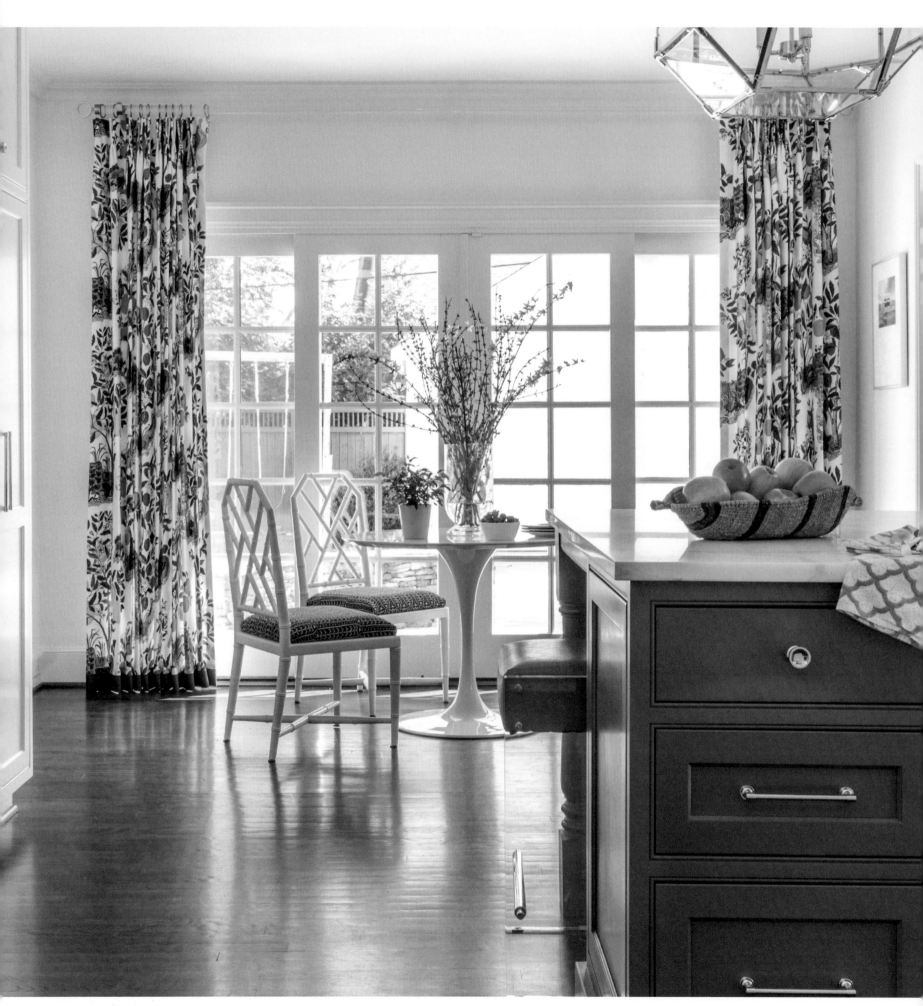

Though the home went through a dramatic transformation, Ashley is quick to note that no major renovations were done. "We only did cosmetic updates—paint, wallpaper, and changing light fixtures," she says. "It's amazing how much of your own spin you can put on a home with paint, paper, and proper lighting!"

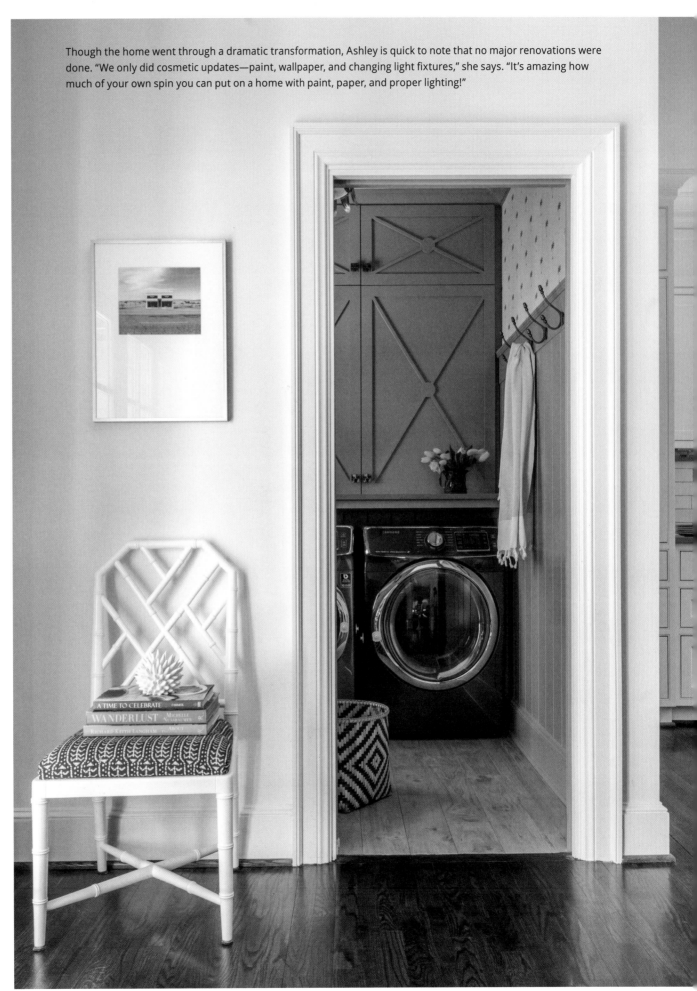

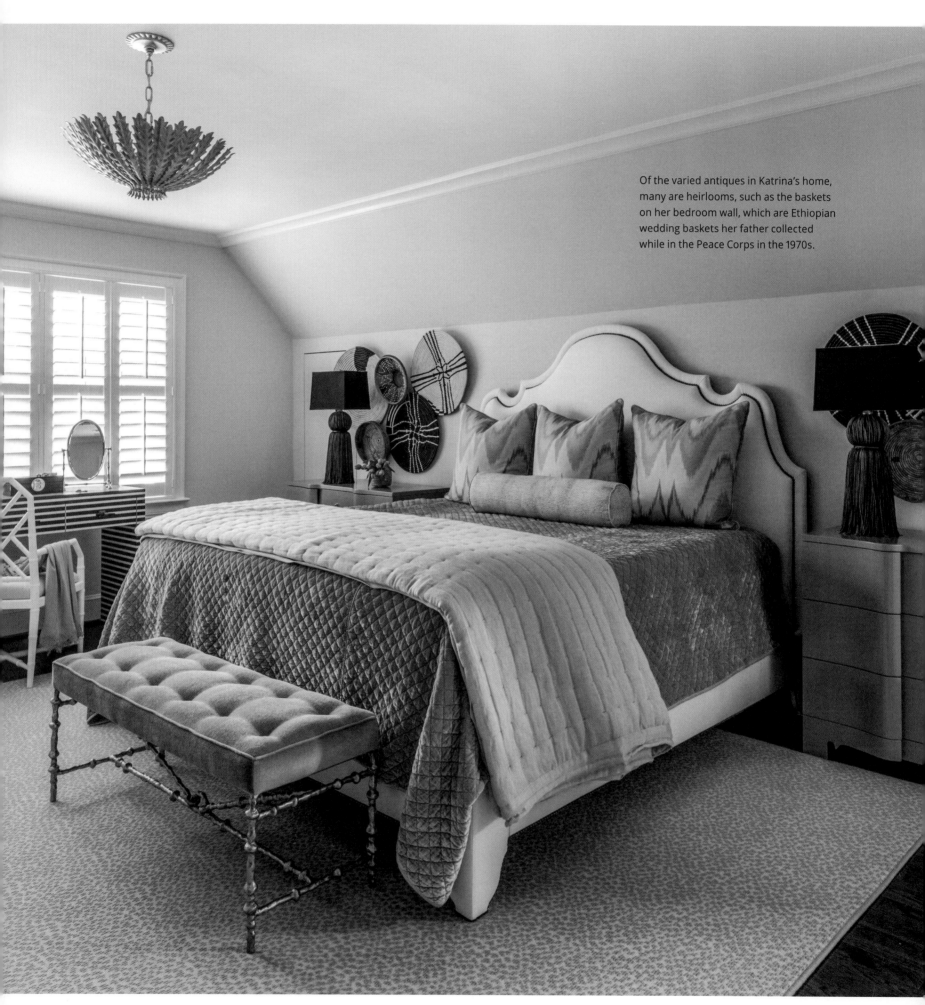

Of the varied antiques in Katrina's home, many are heirlooms, such as the baskets on her bedroom wall, which are Ethiopian wedding baskets her father collected while in the Peace Corps in the 1970s.

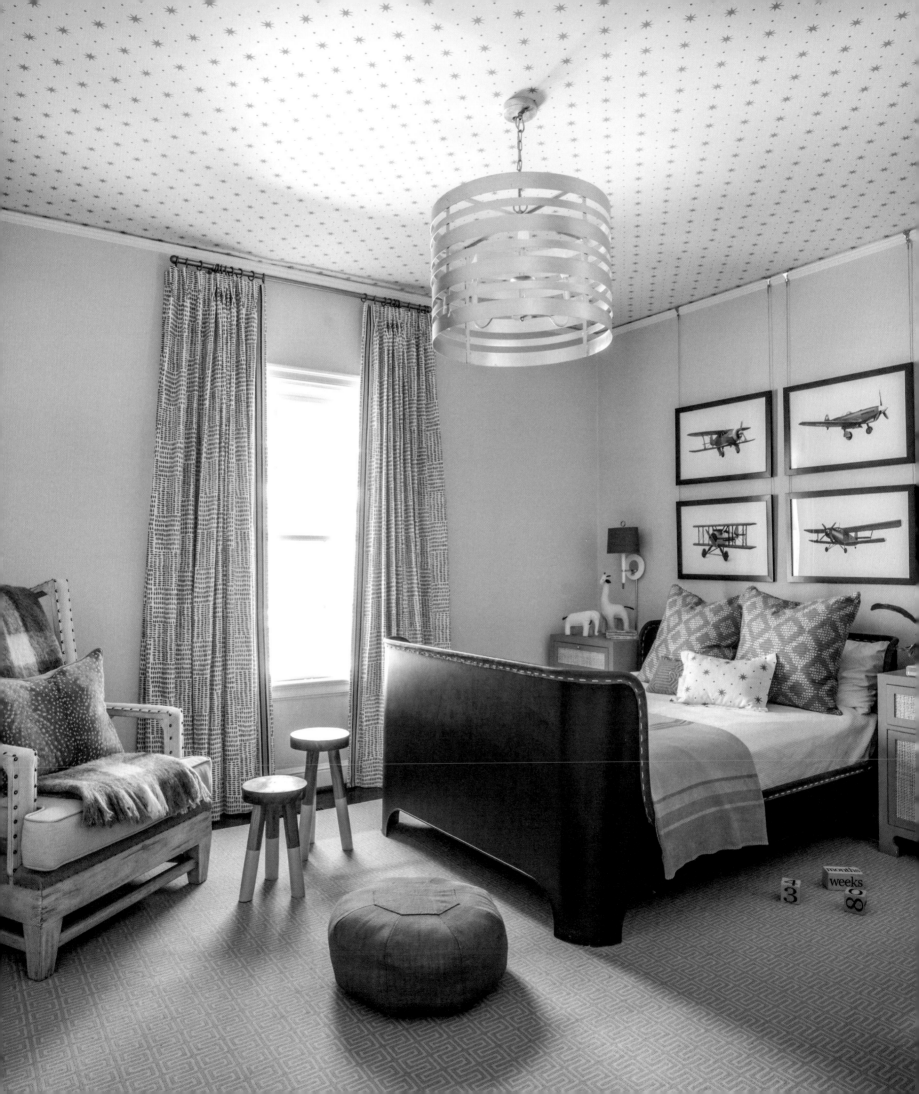

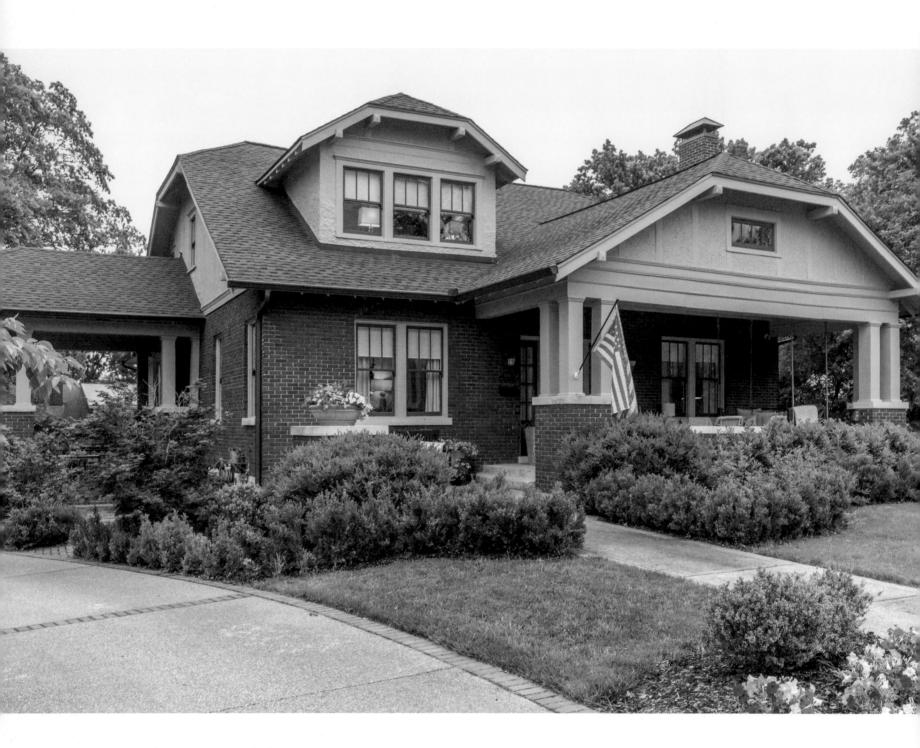

Craftsman in the City

AFTER LIVING IN THE COUNTRY FOR NEARLY TWO DECADES, THIS
COUPLE FOUND THEMSELVES NESTLED IN THE HEART OF TOWN.

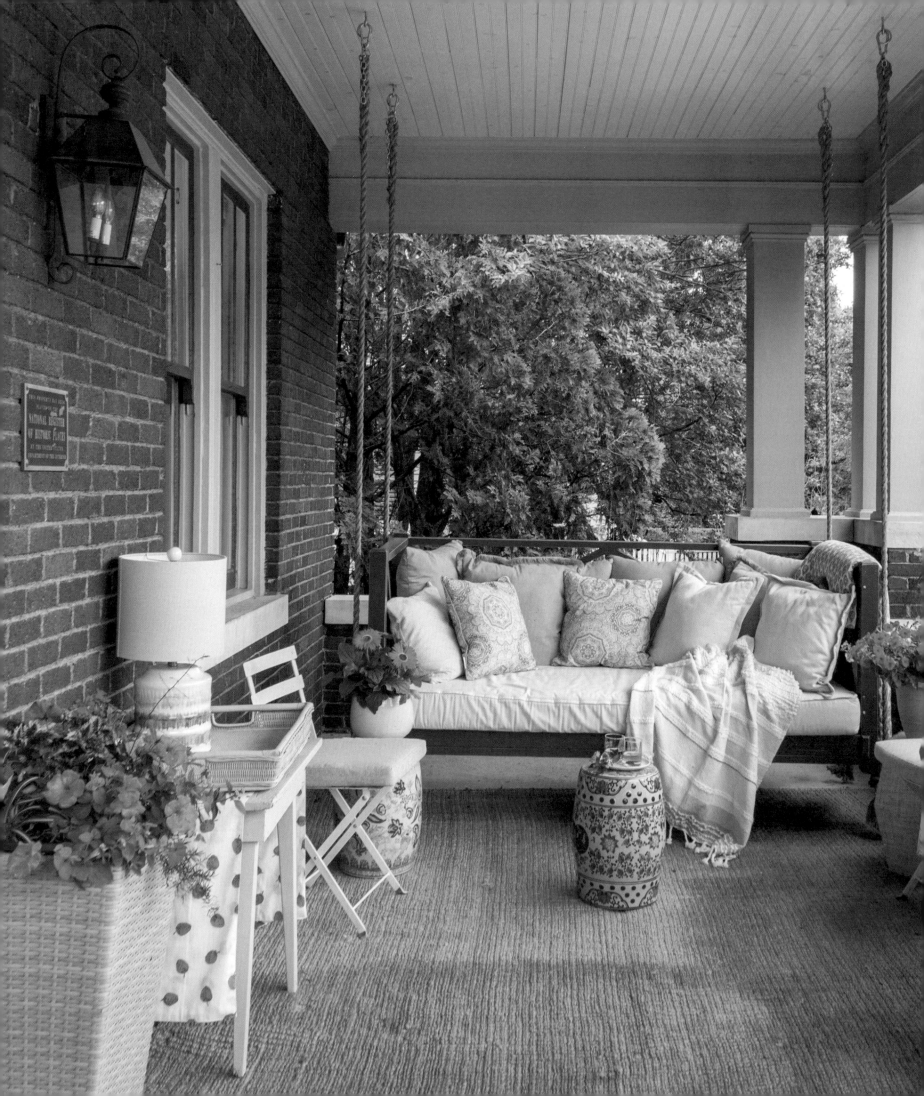

Juli and Robert Clendenin spent a majority of their married lives in the country and are now completely immersed in their quaint but bustling town of Franklin, Tennessee. The couple is always involved with something in their neighborhood—be it races, festivals, or parades. "We moved here from our home of 19 years, the home where we raised our four children," Juli explains. "We lived on 20 acres with no neighbors close by."

While the pastoral solitude was perfect for their family then, once the couple became empty nesters, they decided to move closer into town, and the choice of location was an easy one. "We've always loved downtown Franklin," Juli says. "For years, we would drive around downtown and dream of owning a house here." Their nearly 100-year-old Craftsman bungalow is a dream come true, with touches of that past country life mixed in.

From the exterior, the Clendenin home sings for spring, with vibrant flowers edging the sidewalks and overflowing bushes in front of the porch. Juli humbly attests to being only a beginner gardener, drawing inspiration from her neighbors. "I love beautiful flowers, and the colors make me so happy," she says. "Many of my neighbors have beautiful yards and work hard to make everything so lovely."

The Clendenin home was first built and owned by Dr. B.T. and Mrs. Margaret Nolen. To pay homage to the family, the Clendenins have a wedding photo from 1931 of one of the Nolens' daughters.

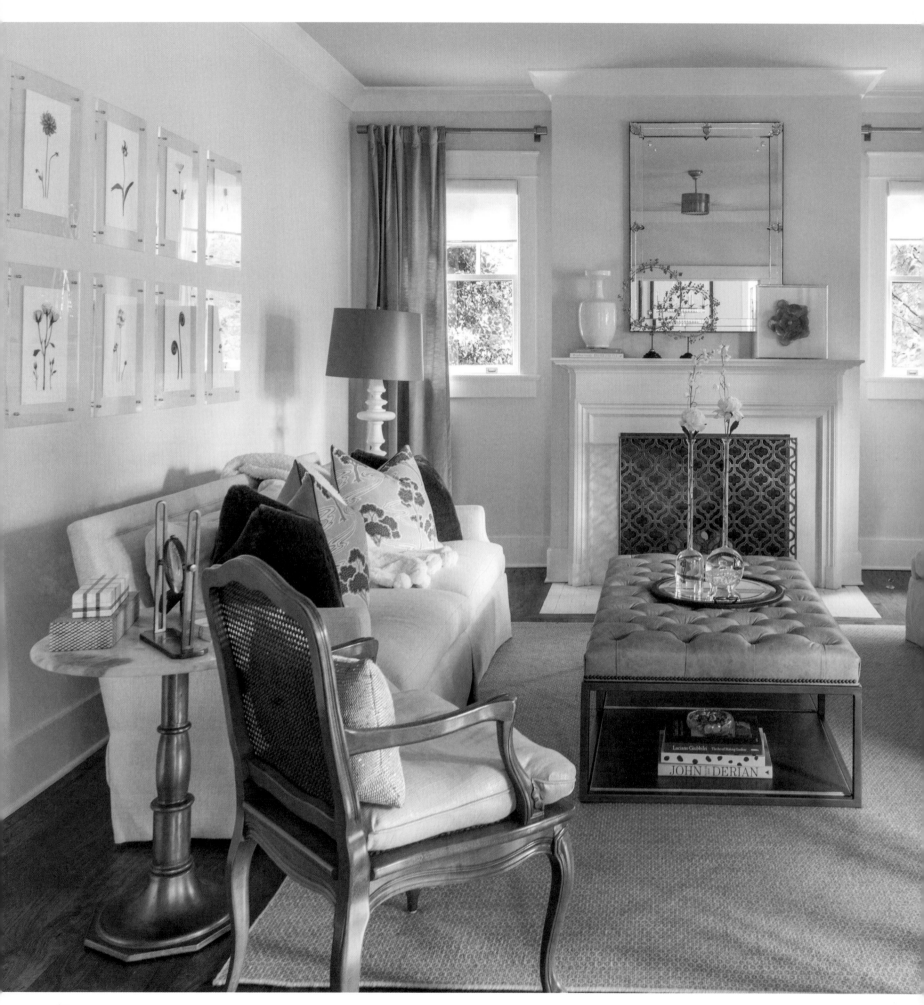

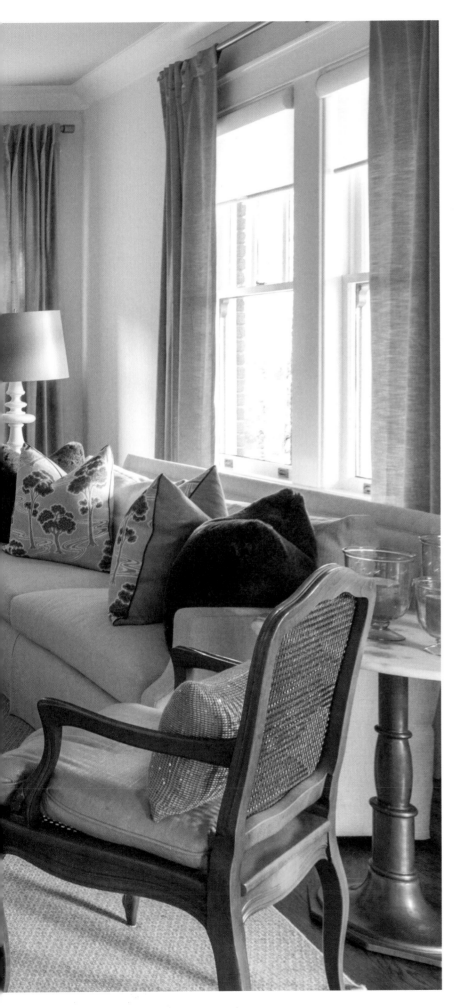

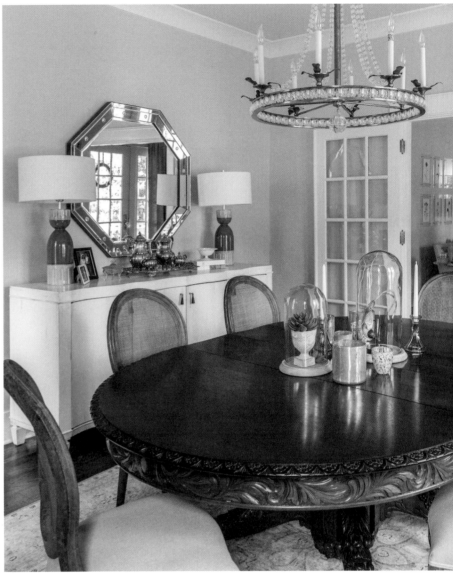

Juli isn't afraid to use color and pattern throughout her home. Switching trim hues and adding wallpaper in small spaces helps the house charm with bright spring aesthetic.

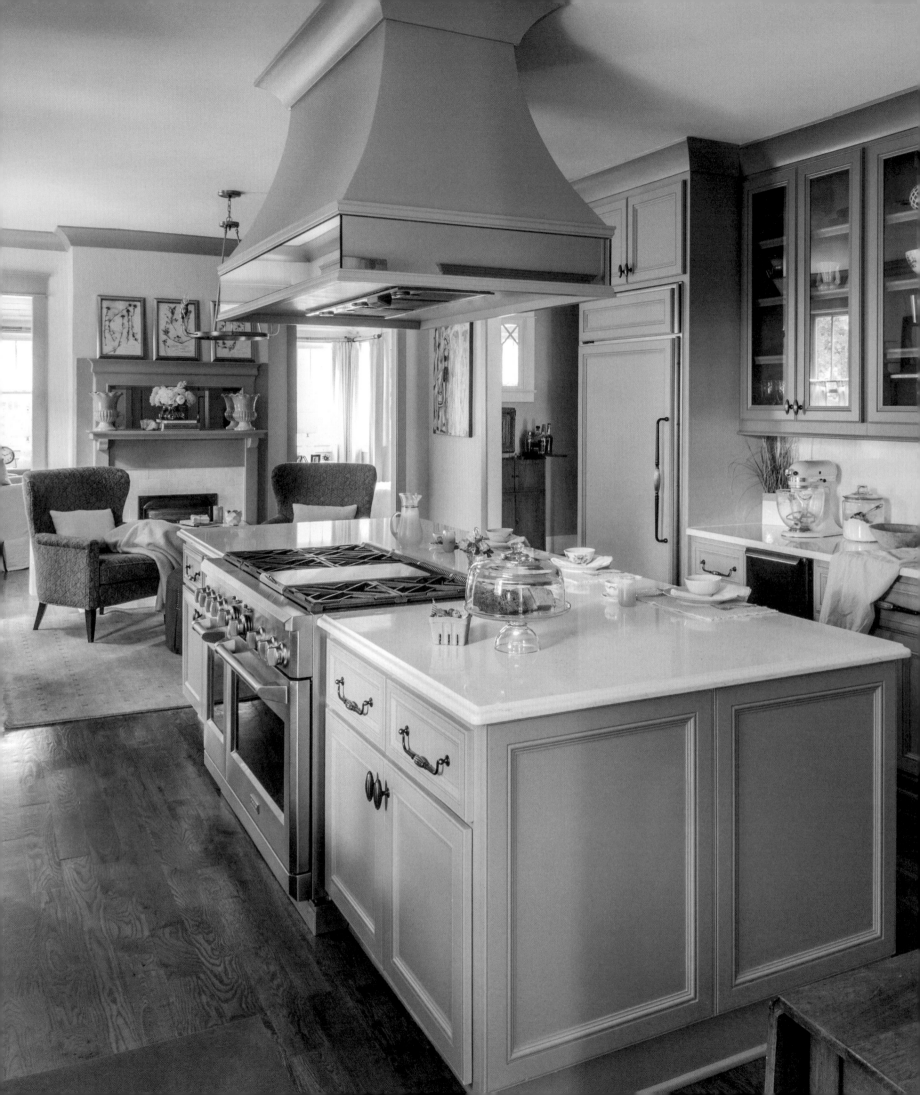

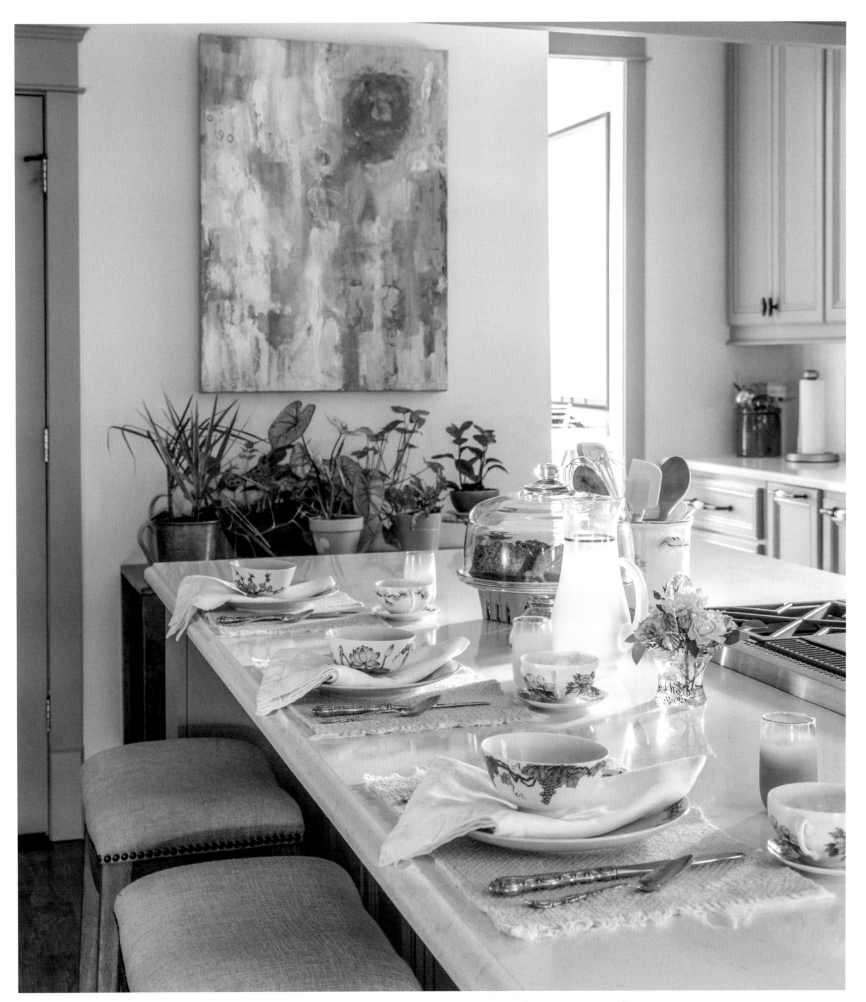

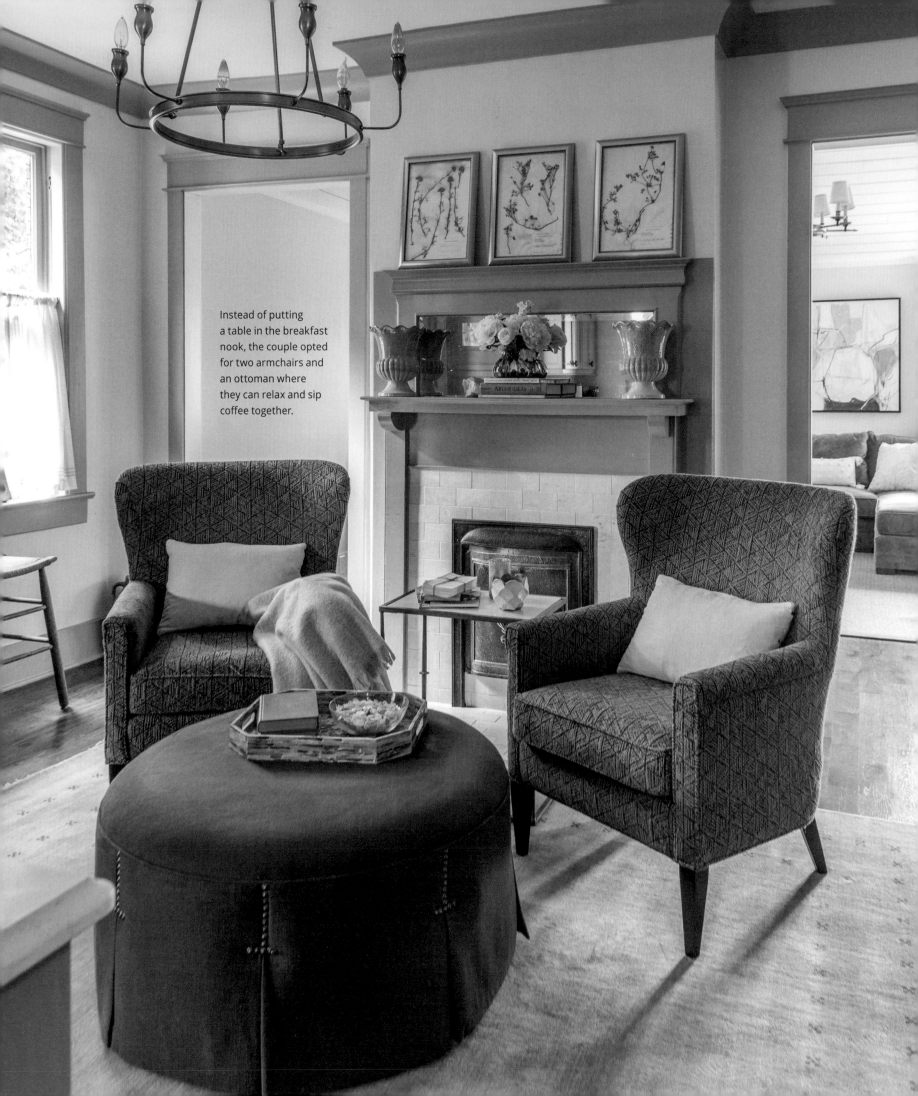

Instead of putting a table in the breakfast nook, the couple opted for two armchairs and an ottoman where they can relax and sip coffee together.

When guests step into the home, Juli's love for antiques and storied collections is immediately evident. Vintage-style armchairs sit at the end of the living room, and small bowls hold sentimental trinkets, like buttons and crystals. "I really just like to be surrounded by things that bring me joy and that are fun and pretty," she explains. "I look for vintage button collections both at antiques shops and online and then I like to sort them by color."

Also evident is Juli's unique mix of styles. Among the antiques and vintage pieces, she sprinkled more modern furniture, like the coffee table and end tables in the formal living room, with traditional Southern aesthetic. "My personal style is eclectic, but I just call it 'knowing what I like,'" she jokes. "I like a mix of current style with vintage pieces, antiques, and family heirlooms."

The kitchen is the showpiece of the home—fitting, since the cottage was a show home and remodeled by a team of architects and designers before the Clendenins moved in. The robin's-egg blue of the cabinetry is echoed around the room and carried into the open-concept breakfast nook through the trim. The range hood commands attention and points to the center of the space without obstructing the room visually. Not surprisingly, this is also Juli's favorite place, because of the community it provides. "Robert and I spend a lot of time there just catching up and visiting with our kids, friends, and neighbors," she says.

Throughout the entire cottage, Juli and Robert kept the color scheme consistent. With a gorgeous mix of neutral shades with blush and blue, the whole home is tied together perfectly, yet each room still has its own identity.

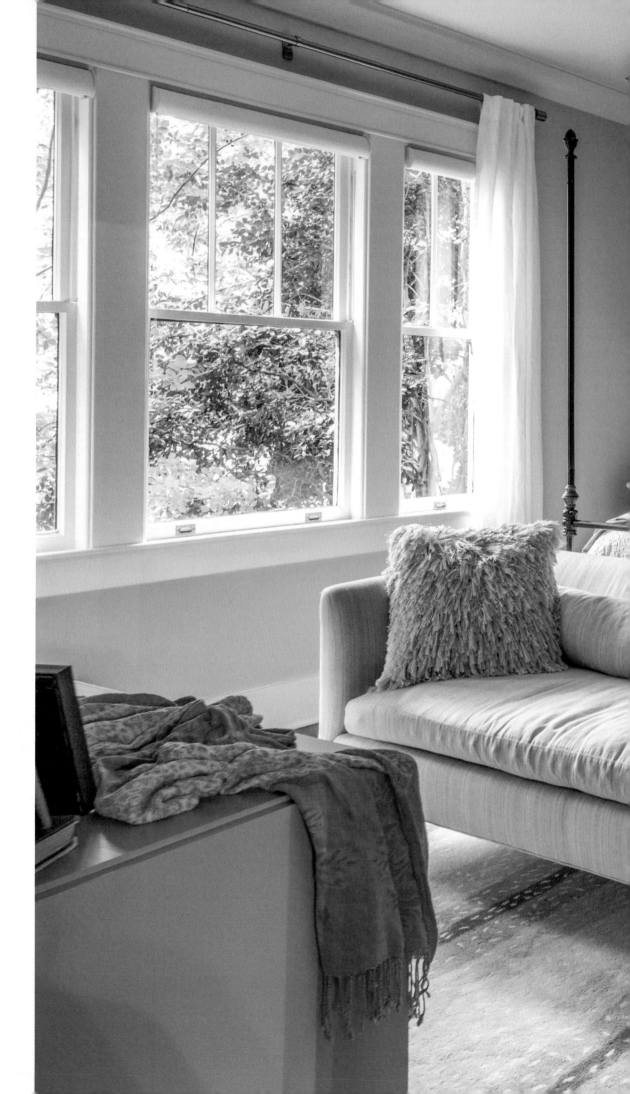

The couple's master suite pulls romantic blush hues into the color palette, creating a space inclined to serenity. Juli let her creativity flow in the room in the way of texture and layers, mixing velvet, linen, fur, and more.

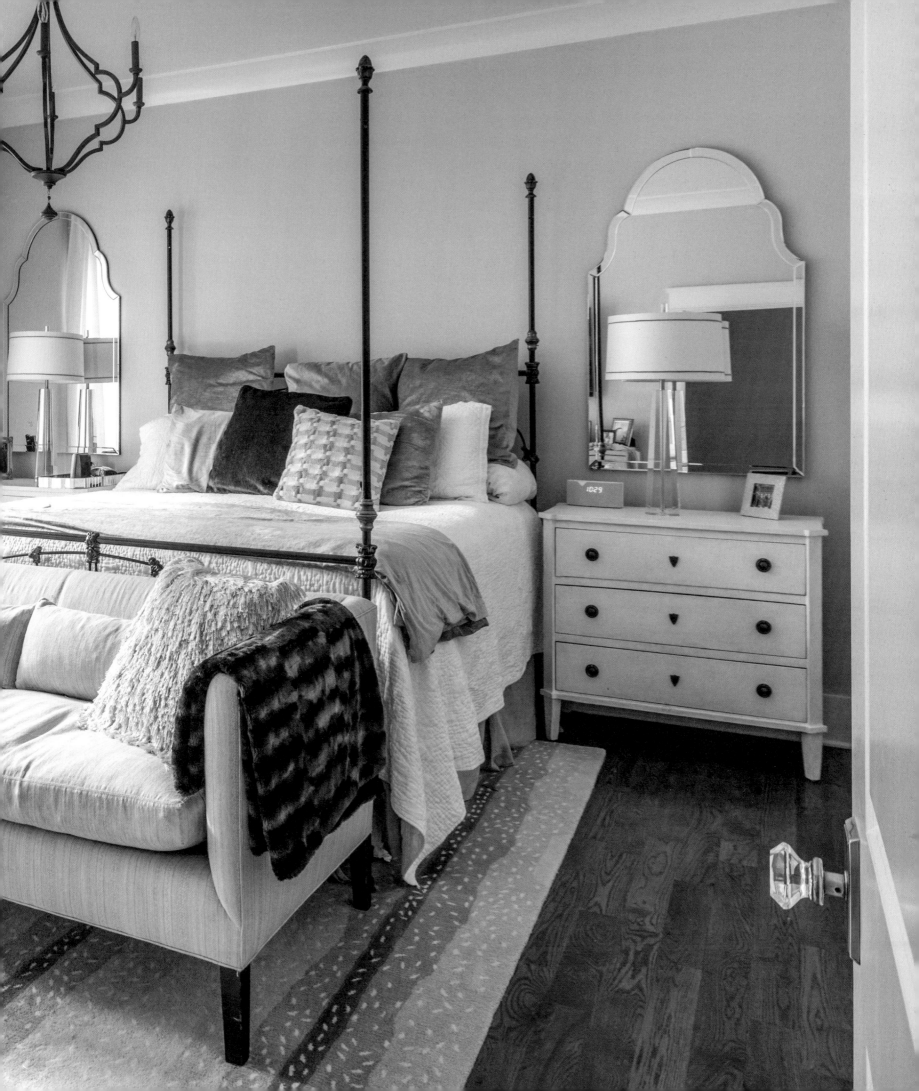

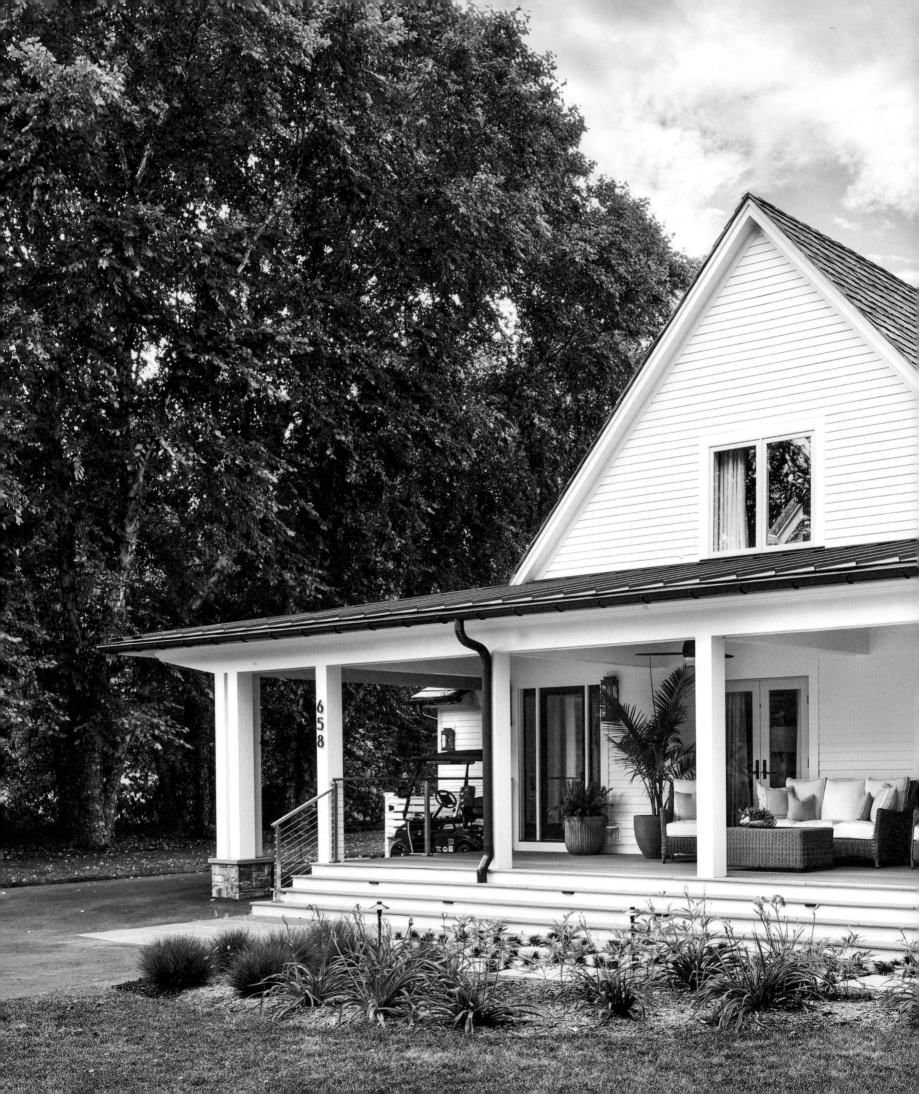

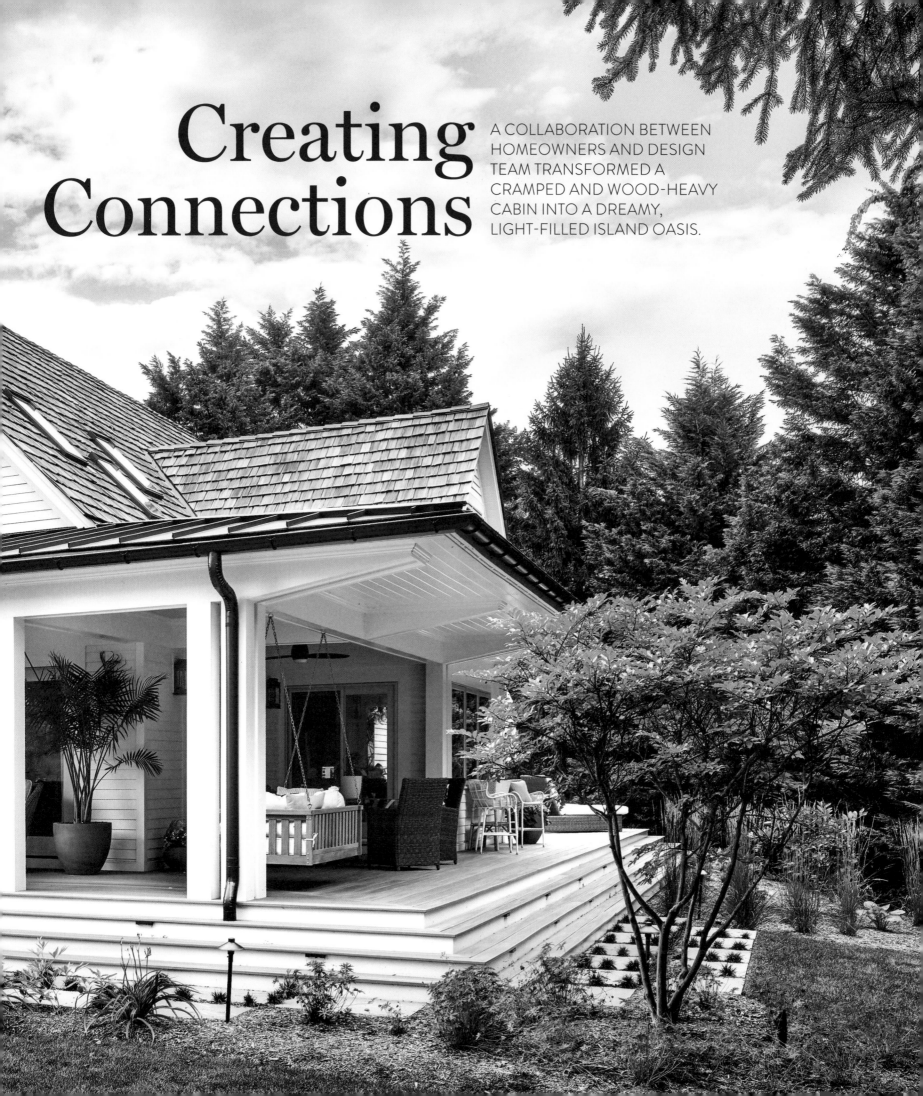

Creating Connections

A COLLABORATION BETWEEN HOMEOWNERS AND DESIGN TEAM TRANSFORMED A CRAMPED AND WOOD-HEAVY CABIN INTO A DREAMY, LIGHT-FILLED ISLAND OASIS.

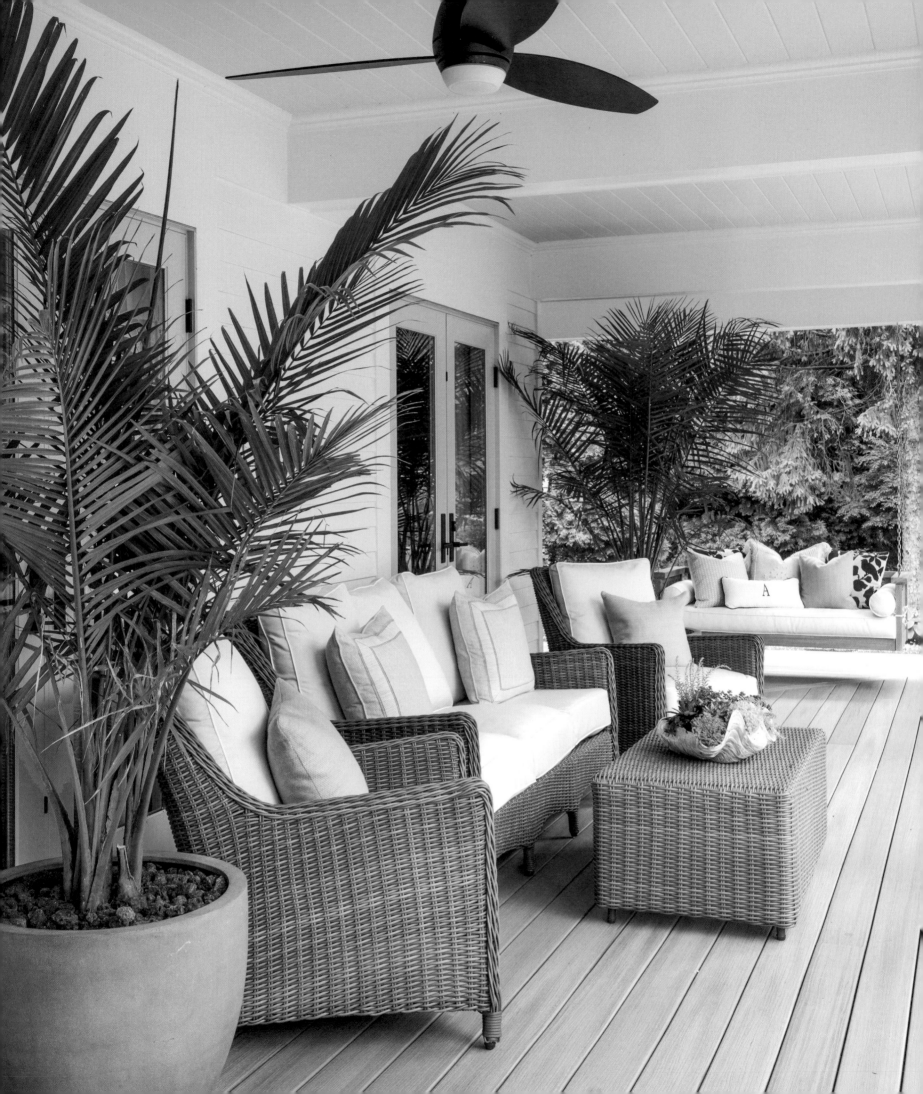

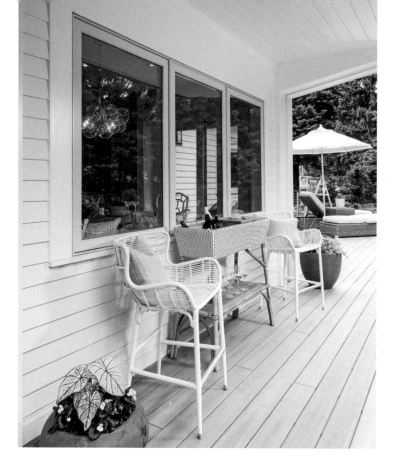

Surrounded by the sparkling water views of the Chesapeake Bay and Magothy River, Gibson Island is the ideal location for a summer getaway just off of Maryland. But when one family purchased their vacation cottage nestled among the lush landscape, they found the home's atmosphere fell flat.

"When the clients first bought it, there was a lot of wood," says interior designer Nancy Harper. "It was almost more like a country cabin than it was like a beach [home]." As a first step in solving that, they took to the interior's planked ceilings and exposed rafters with a bright white shade that Nancy notes went a long way toward changing the feel of the house.

But while they had taken a step in the right direction, they knew they would need help with the renovation as a whole. They brought on architect Jim Rill alongside Nancy, forming a team perfect for expanding the living spaces and updating the home's amenities.

But the update went far beyond that, as the existing structure lacked support for the windows and required all-new framing. The renovation offered an opportunity for adding larger openings, which frame the view outside and helped Jim create what he calls "a strong connection."

"This is an outside neighborhood," Jim says. "It's connected to the bay and to the Magothy River, so it's a very outside vacation feel." He describes the home's previous spirit as "introverted," a problem that was remedied with intentional connections to the yard and outdoor living spaces—which are plentiful.

For a one-of-a-kind touch in the foyer, interior designer Nancy Harper had a local artist paint a sisal rug with a monogram created by a designer in Virginia. The dark wood bench along the wall was one of the pieces the homeowners already owned.

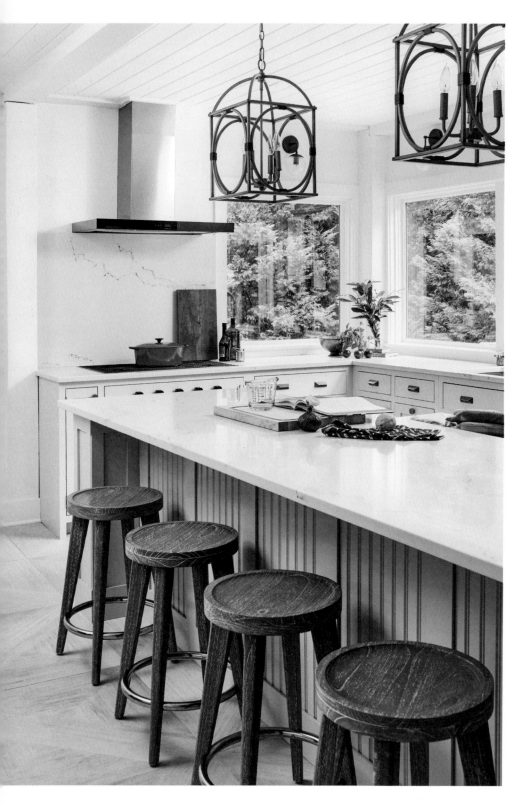

Inside, a watercolor palette backs an assemblage of varied styles—both traditional and modern—that flow together into a cohesive collection that feels seamless. "She really wanted something that felt like an oasis of sorts," Nancy says of the homeowner. "They have very busy lives in Washington, DC, and she wanted something that would be like a center of calm for her."

In and among the blues and greens, pops of coral stand out, and woven textures and natural materials contribute a level of cozy comfort. To facilitate the family's entertaining needs, the design team chose beautiful but durable materials that would stand up to wear, like the ceramic floor tiles made to look like wood parquet throughout the kitchen and dining areas. Extra counter space in the form of a roll-out worktable provides plenty of room for the family's daughter to get creative in the kitchen, but when she's playing outside, plentiful windows allow the homeowner to watch during dinner prep.

And while the dining space provides a gorgeous spot for enjoying the view, the outdoor spaces are the real showstoppers. From the open deck to the screened, heated porch, three of the home's four sides are lined with spaces designed to provide unhindered views of the island while still keeping visitors cozy and comfortable.

Painted in Benjamin Moore's Sea Salt, the kitchen cabinets glow with the light from the oversize windows. The Dutch door provides an opening on the side of the space with no windows, preserving the sight line to the yard.

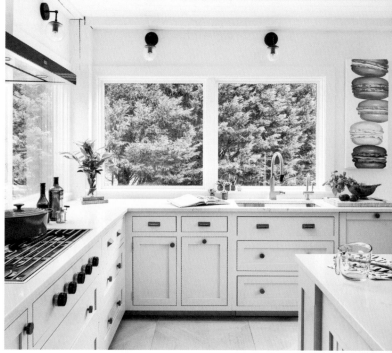

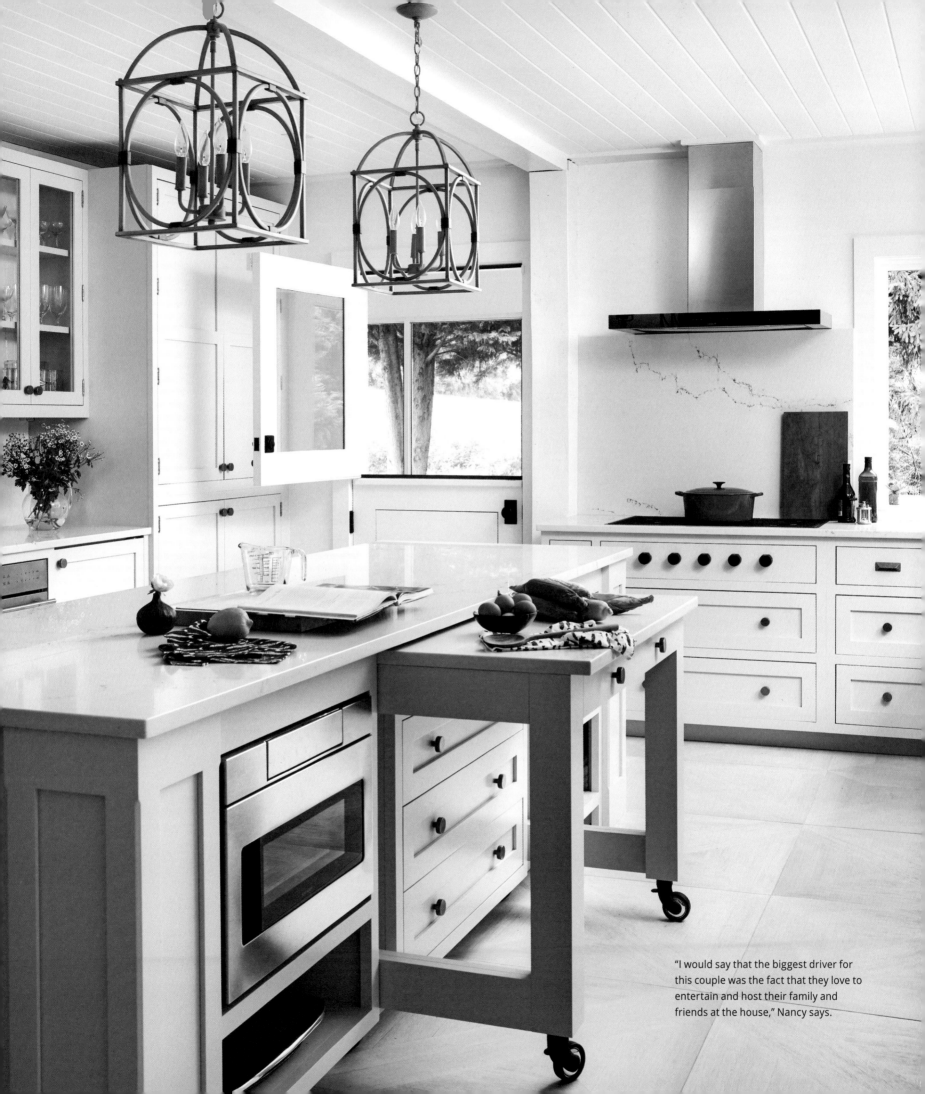

"I would say that the biggest driver for this couple was the fact that they love to entertain and host their family and friends at the house," Nancy says.

While the dining room was originally open to the ceiling line, Jim closed the space in to create an upstairs bedroom for the family's daughter while staying within the home's existing footprint. A chandelier composed of glass spheres was chosen to preserve the view of the outside.

Partly due to zoning restrictions that required Jim to work within the home's setback lines, the porch features a cantilevered overhang that keeps the view wide open. Reflecting the effect below, the stairs run the length of the porch—a choice that Nancy says came up toward the end of the design process.

"We loved that idea, and it worked perfectly with the architecture of the home," she says, noting that it makes for easy flow between the inside and the outside. "You can enter the home from anywhere," she says, "and because they have so many doors to get inside, it just made better sense."

Because of the careful connections crafted between the home's different spaces—as well as the many attractions the island has to offer—the family is able to enjoy their time in the oasis with ease. And with so many spaces to entertain their friends and family, it's easy to create those connections that truly matter.

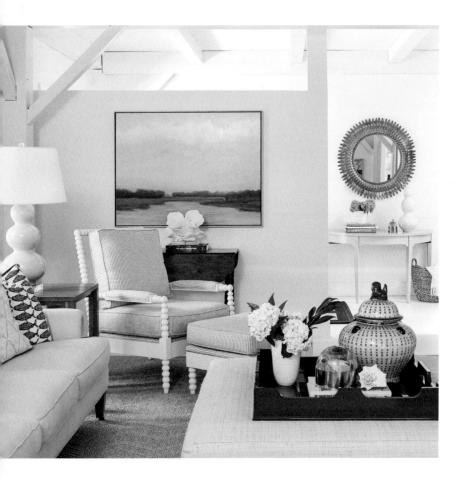

Much of the artwork in the home was purchased during a trip to New Orleans, Louisiana, including a waterscape painting that features a coral-rich sunrise. The work was chosen in part to pull in the homeowners' painted table, above which hangs a sunburst mirror.

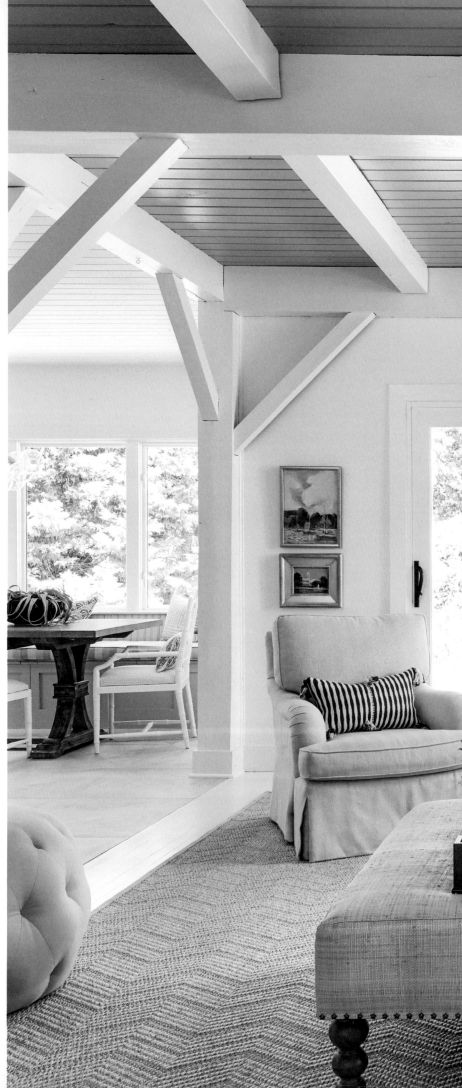

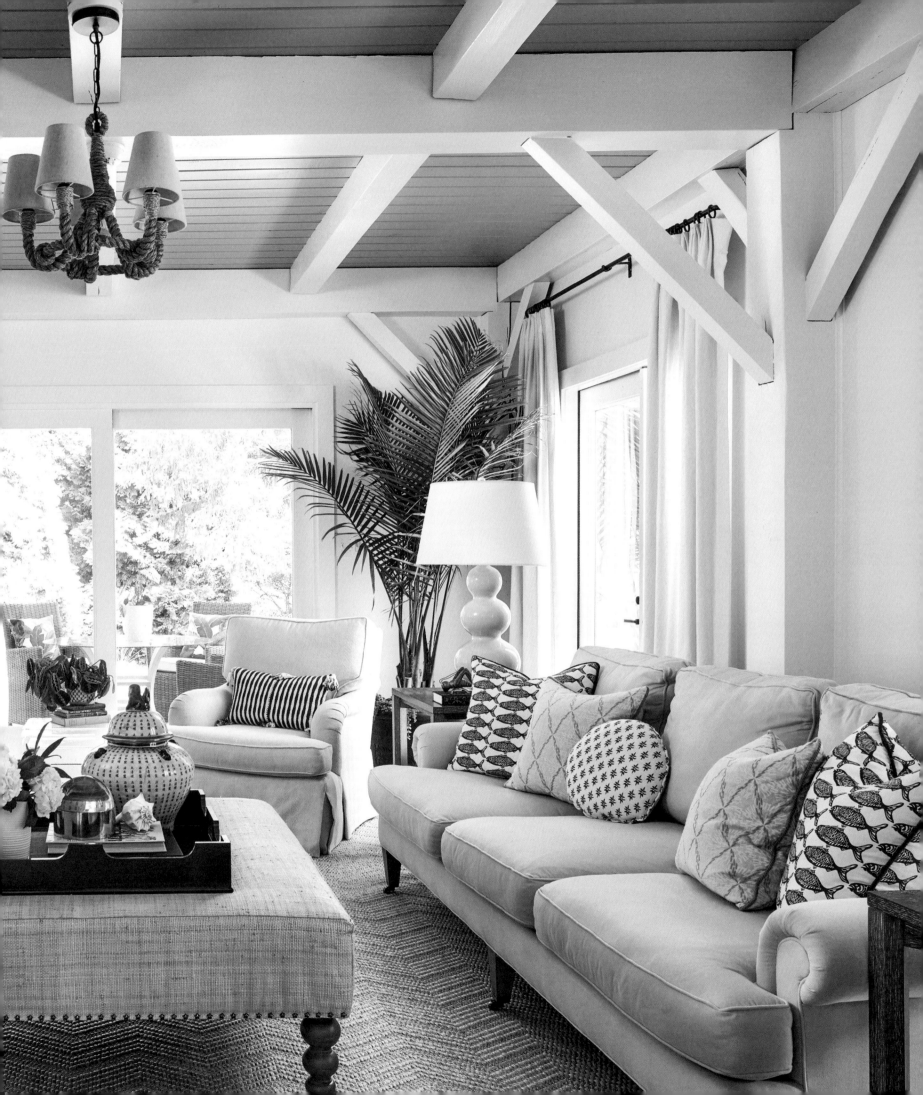

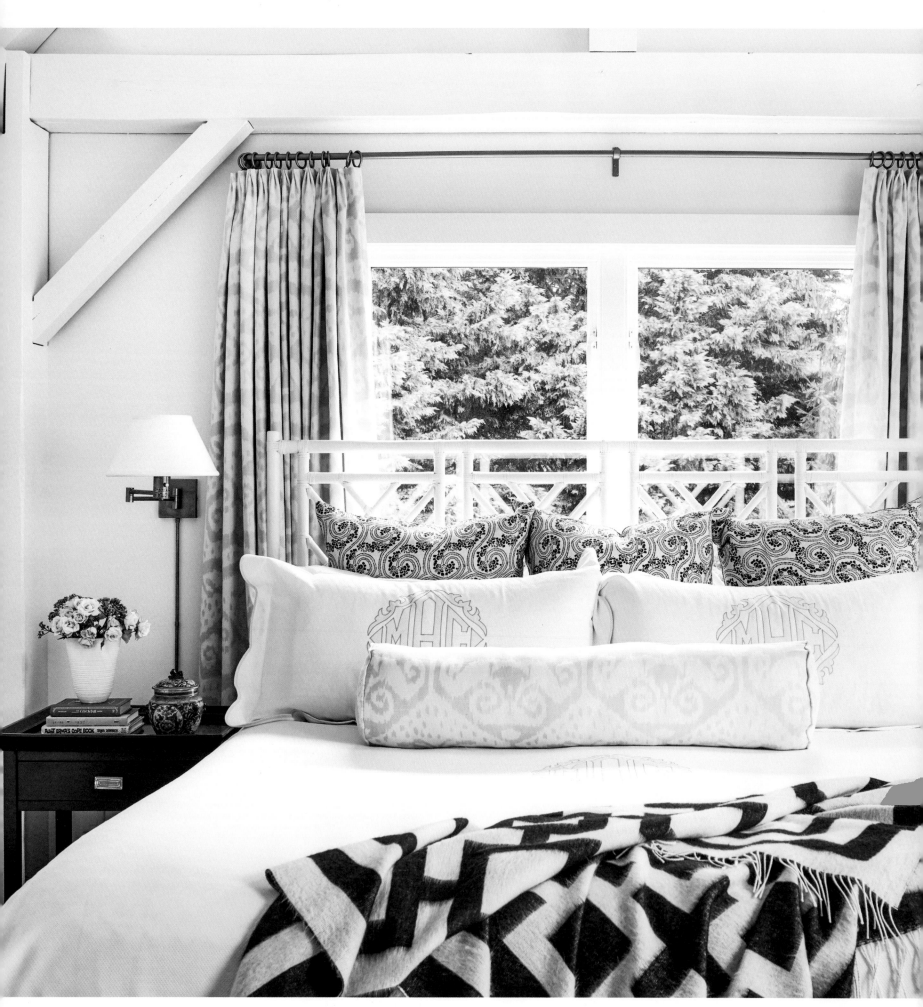

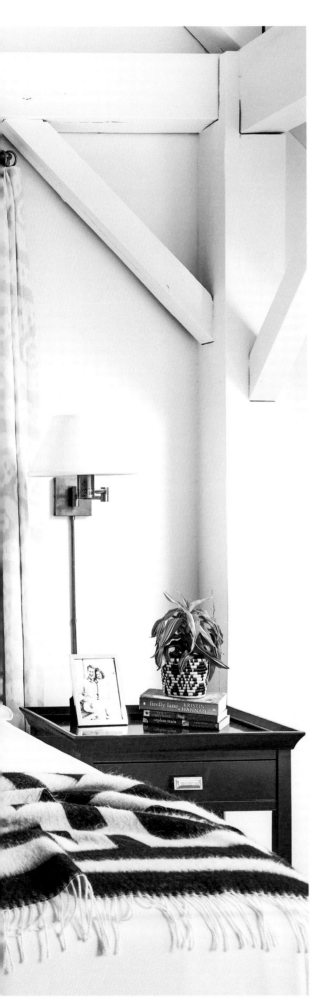

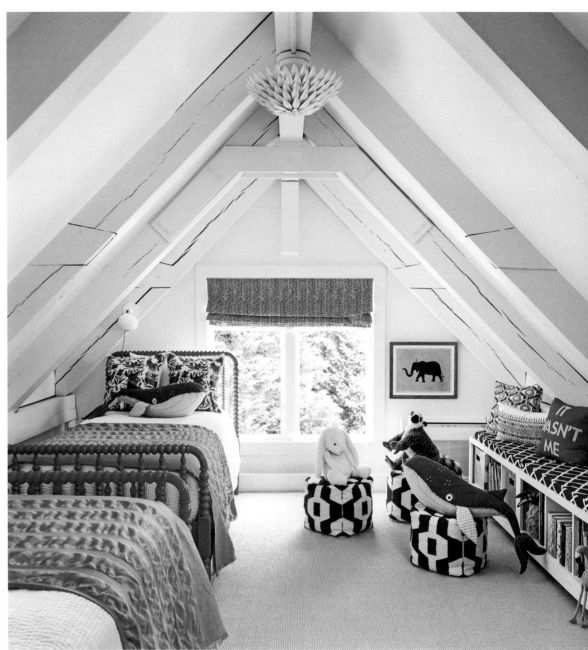

While the homeowners had already purchased the bed and nightstands for the master bedroom, Nancy went in to fill the space with the additional layers it needed. "The room just needed a little bit more contrast," Nancy says. "So, we added some additional pillows, some textiles to kind of bring in some color and be more consistent with what was going on in the rest of the house." The daughter's room, equipped with twin trundle beds for sleepovers, takes a fun turn from the more muted atmosphere of the rest of the home. "[The homeowner] did not want us to feel restrained in decorating her daughter's room," Nancy says. "And she ran everything by her daughter, who was five or six at the time."

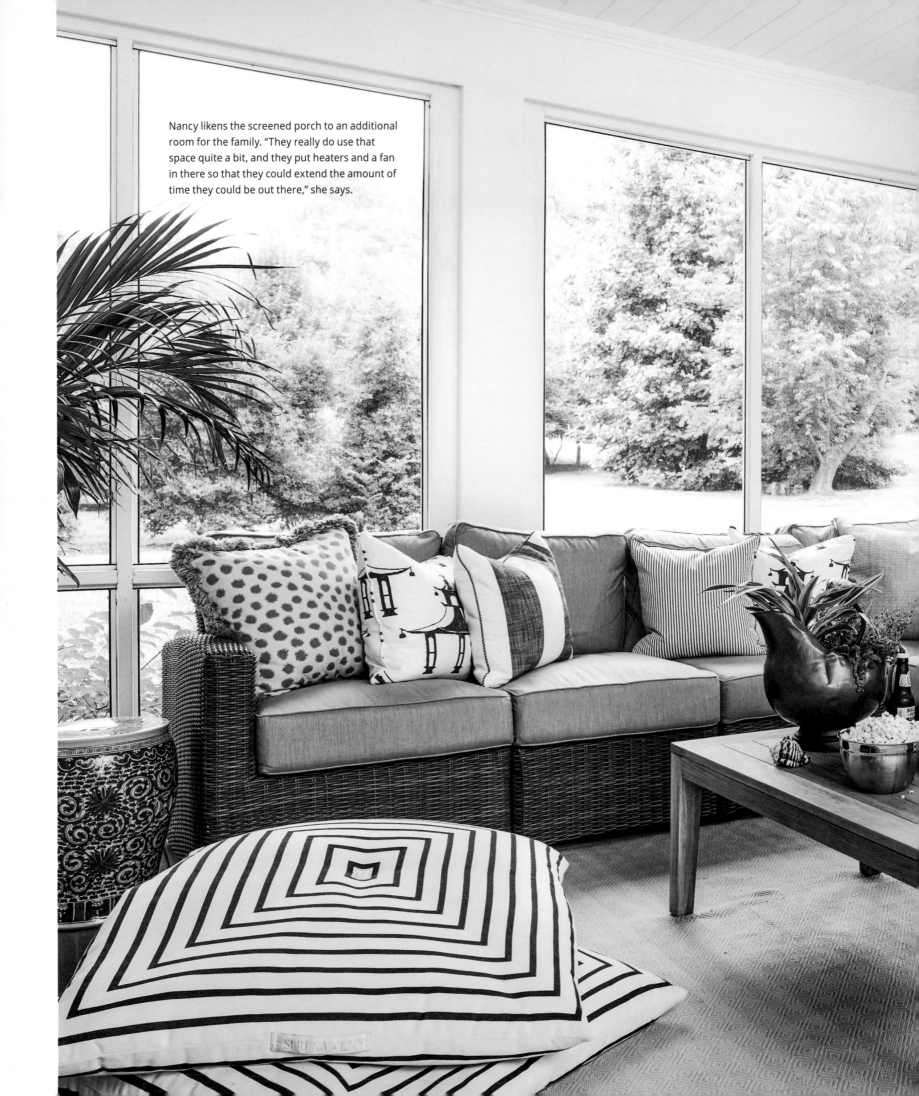

Nancy likens the screened porch to an additional room for the family. "They really do use that space quite a bit, and they put heaters and a fan in there so that they could extend the amount of time they could be out there," she says.

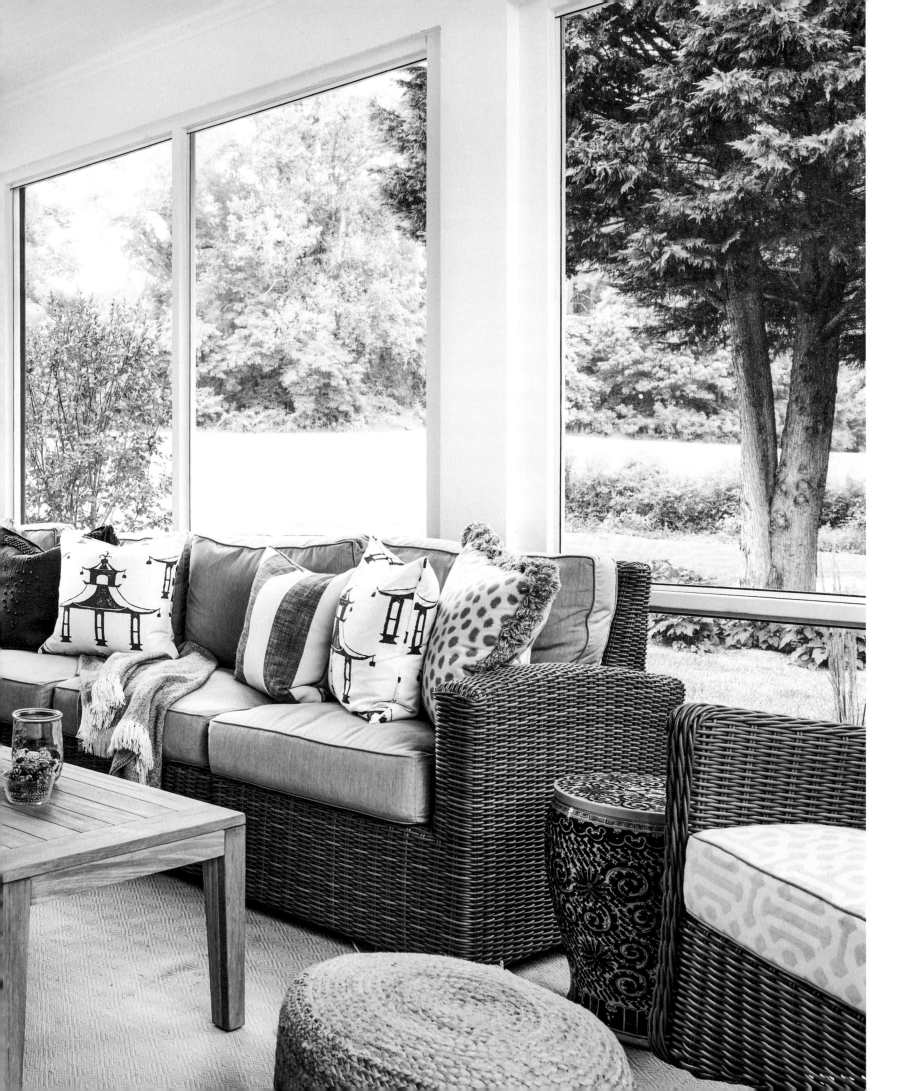

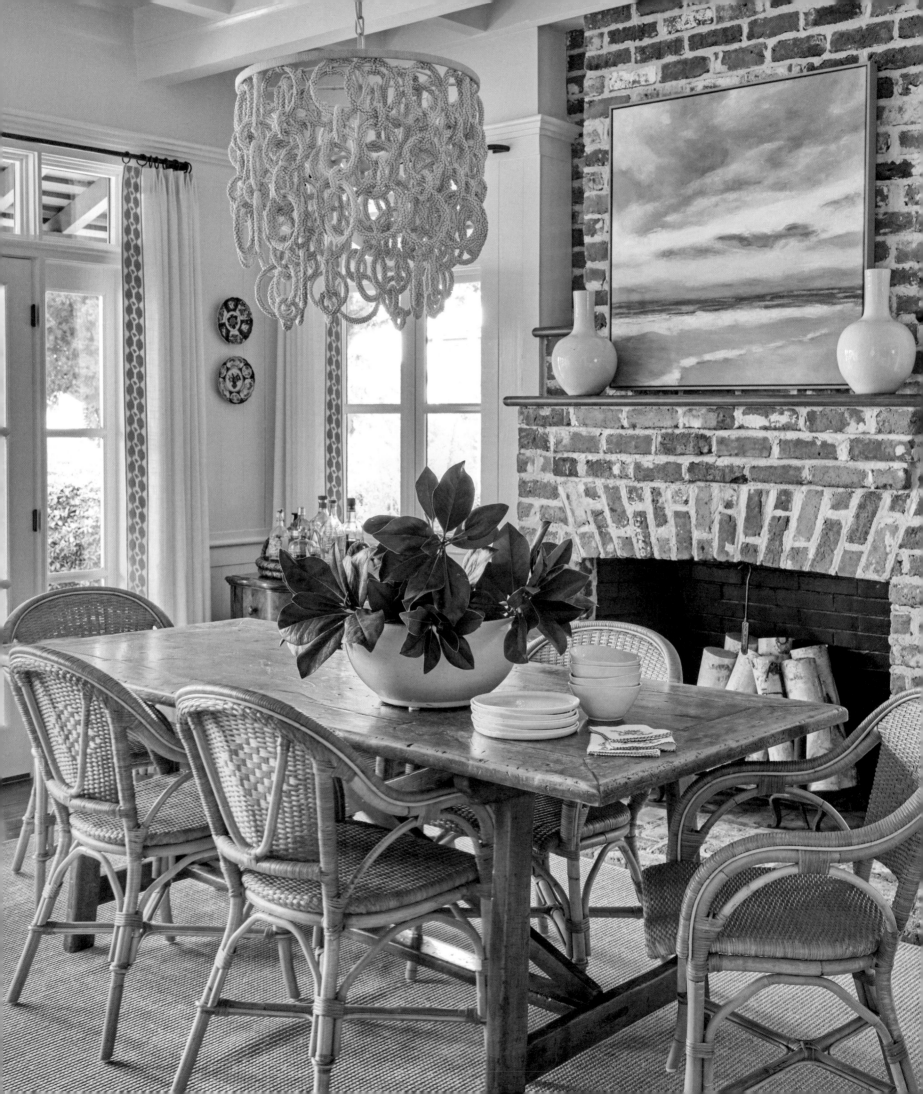

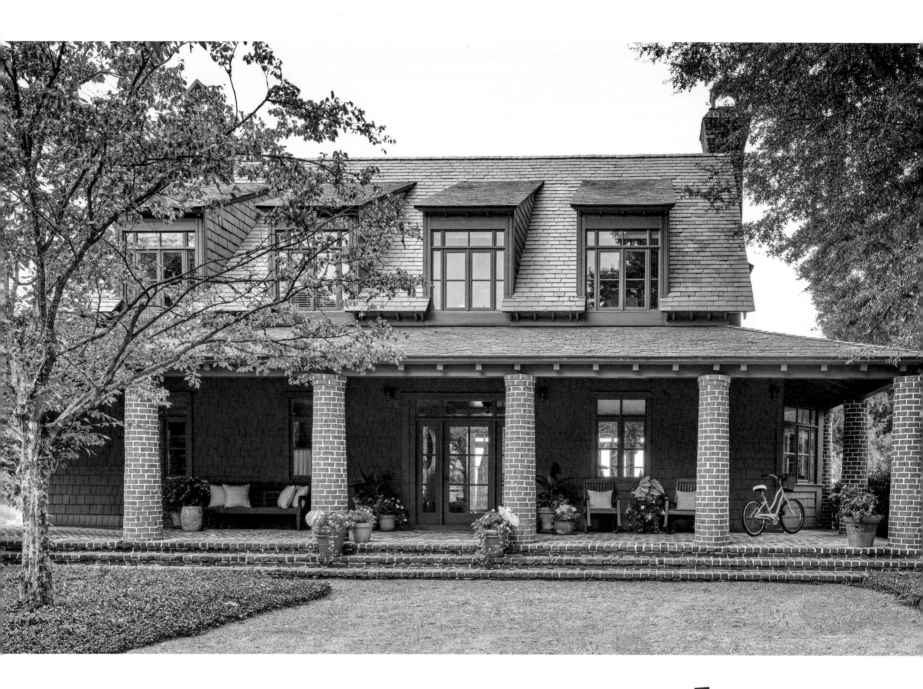

Lowcountry Style on the Links

SHAPED BY ITS HISTORY AND BRIGHTENED BY A DESIGNER'S LOVING TOUCH,
THIS COTTAGE IS RIGHT AT HOME ON A SERENE SOUTH CAROLINA ISLAND.

S ettled on the 18th hole of a golf course that sprawls across the landscape of Spring Island in South Carolina, the Furey home's exterior displays a deep hue that blends with the surrounding view. It's always a surprise, then, when guests first step foot inside and find an interior glowing with bright whites, creamy neutrals, and muted hues.

"It really opens up when you step over the threshold," says Lisa Furey, interior designer and owner of the home that once served as the Spring Island Club golf house. The home's history lingers in the form of marks on the patio brick left behind by golf spikes and angled windows designed to allow golfers to approach for food service. Professional golfer Arnold Palmer frequented the property when it was the clubhouse. "He designed the course," Lisa says.

While the past offers no shortage of charm, it's the view that truly sparked the spirit of the design. With its abundance of glass doors, transom windows, and dormers, the home welcomes both sunlight and stunning vistas of the tidal marsh and Port Royal Sound. "I wake up to a gorgeous sunrise," Lisa says.

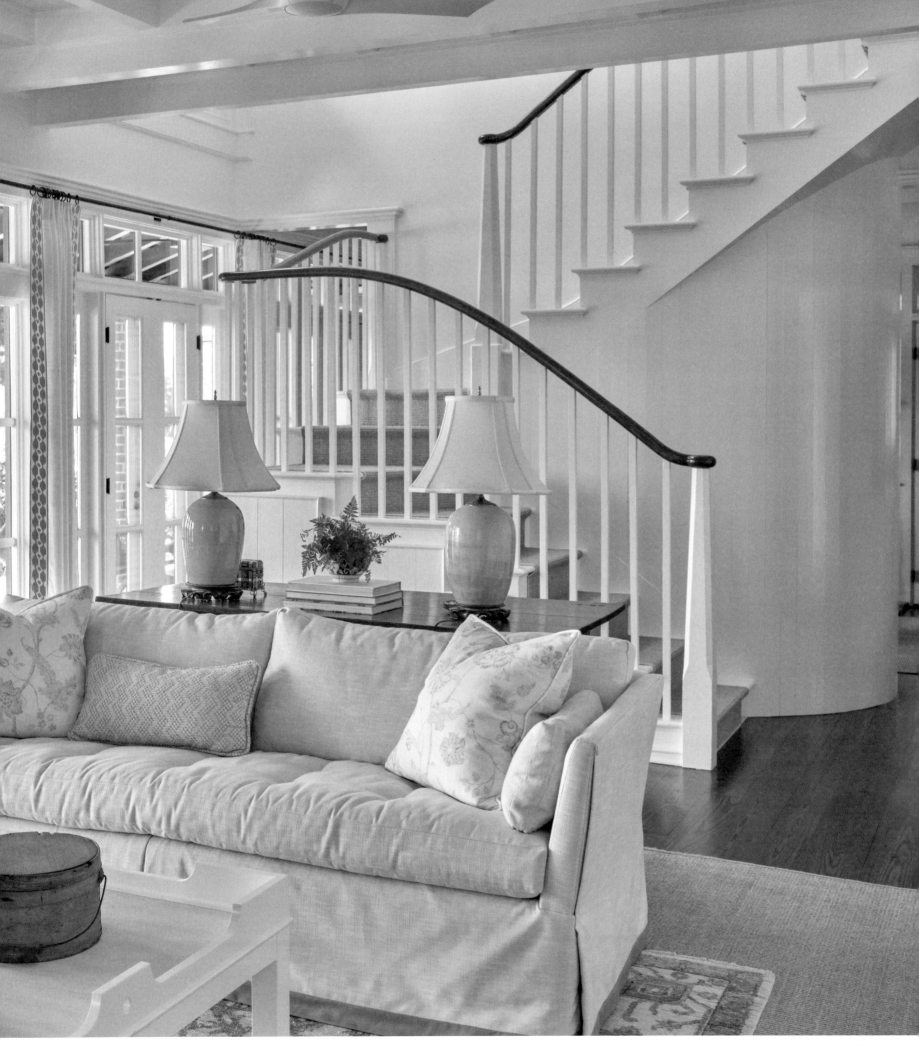

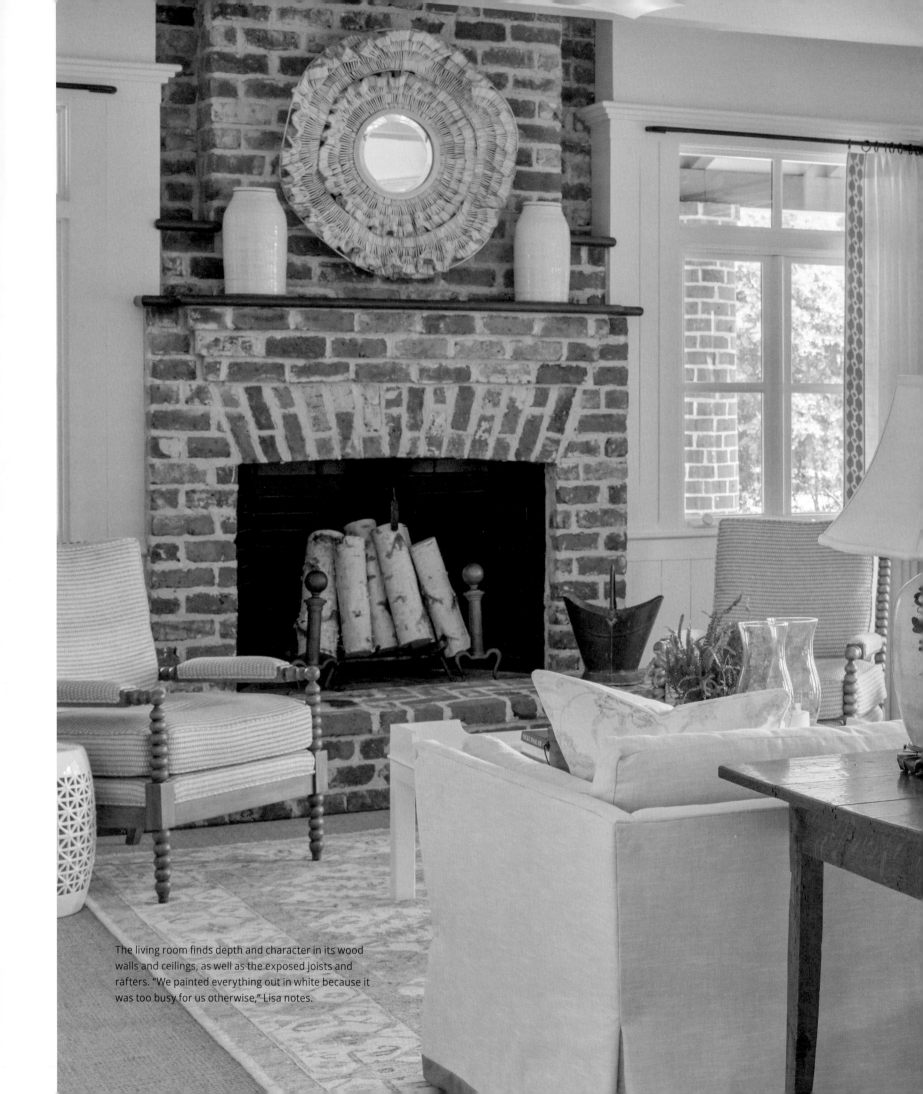

The living room finds depth and character in its wood walls and ceilings, as well as the exposed joists and rafters. "We painted everything out in white because it was too busy for us otherwise," Lisa notes.

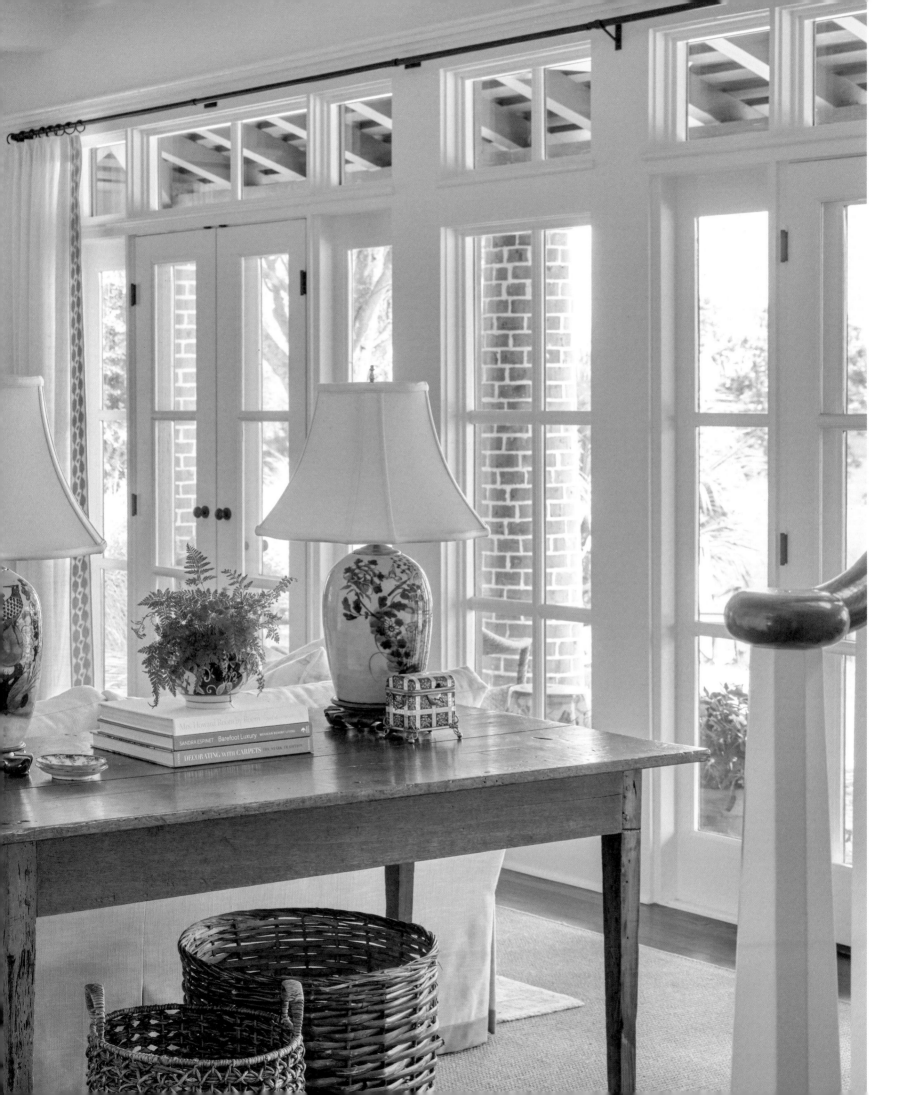

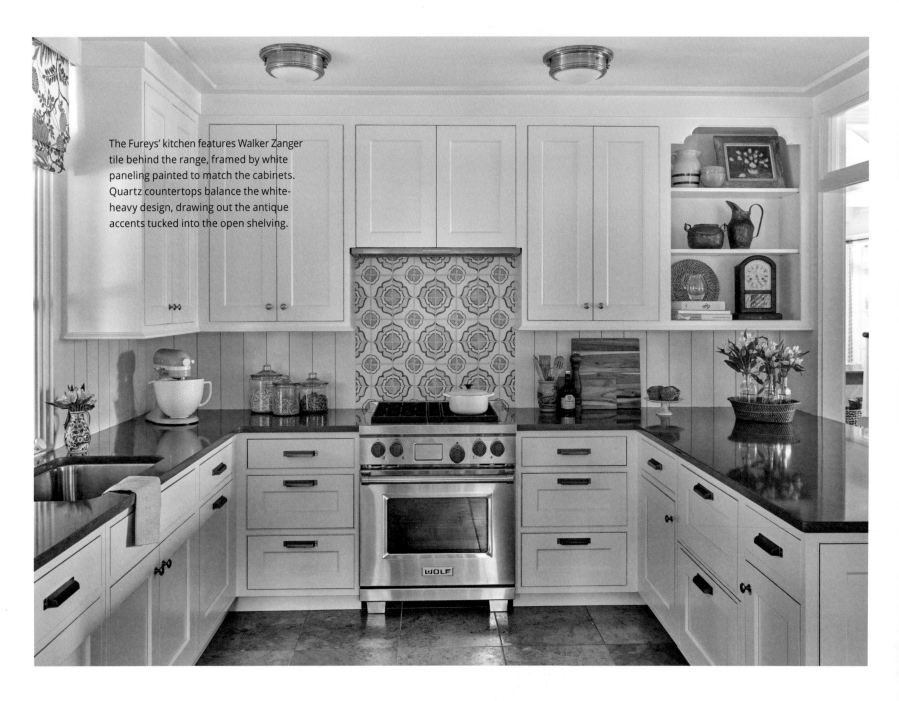

The Fureys' kitchen features Walker Zanger tile behind the range, framed by white paneling painted to match the cabinets. Quartz countertops balance the white-heavy design, drawing out the antique accents tucked into the open shelving.

To keep the inside of the home from competing with the outside, Lisa opted for a range of nature-inspired tones—including gray-greens and soft blues—and organic materials. Starting from the painted foyer ceiling reminiscent of the Southern sky, every space between the home's twin brick fireplaces offers unmatched serenity.

"The home was very well-maintained, but it did not feel like us," Lisa says of when they moved in. Painting, recarpeting, and changing light fixtures were only a few of the changes made to the home, but every update only served to enhance the existing beauty. A coat of Benjamin Moore's White Dove highlights the exposed joists and rafters and the planked walls, and the contrast brings out the warmth of the wide plank antique heart pine floors.

The result is a serene base layer atop which Lisa curated a collection of new and old furniture, including family antiques and pieces that came with the home. "We wanted the house to feel lived-in and collected, but we didn't have everything we needed to do that," Lisa explains. "Several of the pieces we purchased from the owner have been here as long as the golf house was; the hutch in the foyer, kitchen farm table, and living room primitive sofa table are all well-worn, well-loved, and make us feel cozy."

Much of the home's unique personality comes from its scattering of creative design details, like the staircase's rounded base and curved railing, and it's a truth that continues onto the second floor. Multiple dormers result in angled and clipped ceilings throughout the bedrooms, ensuring plenty of cottage charm, and window seats fill a number of the resulting nooks, making clever use of the space. Lisa notes that creative storage was a necessity for the cottage. "Much of the furniture we purchased serves a storage function as well as the obvious function," she says.

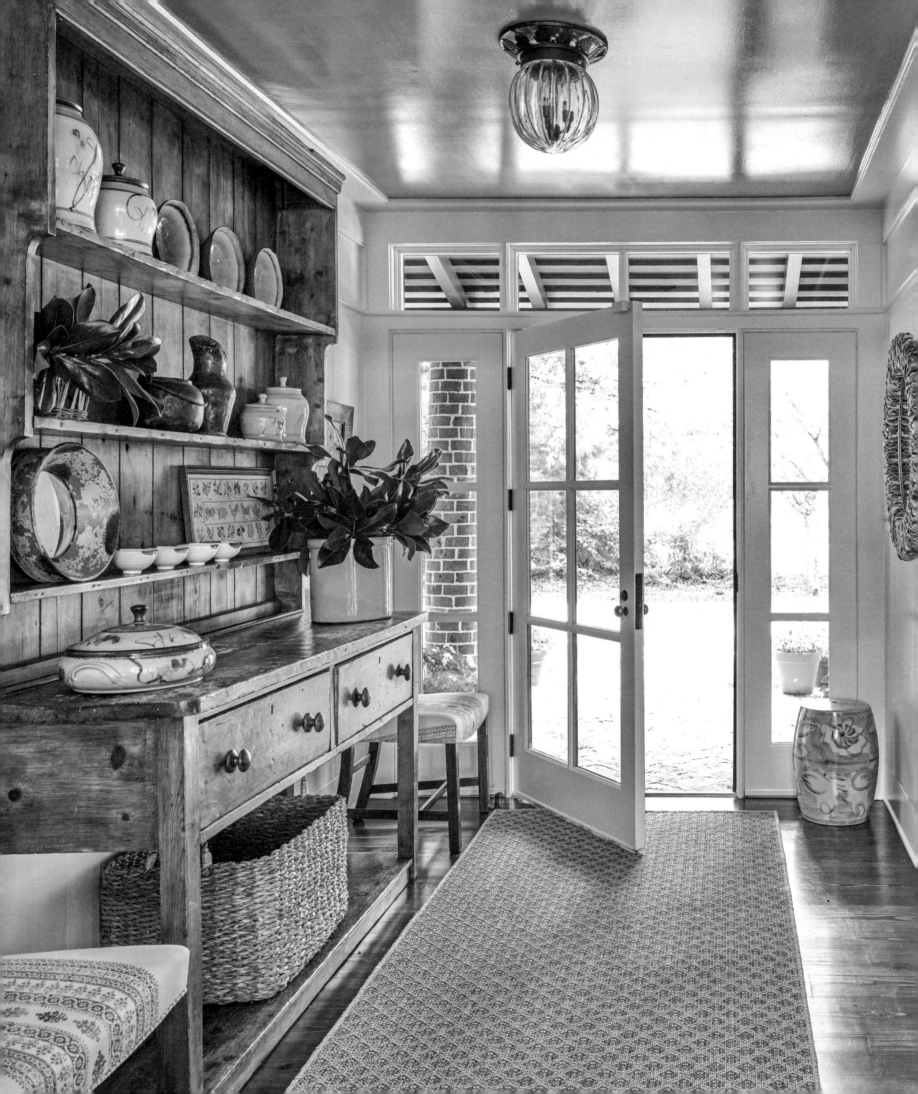

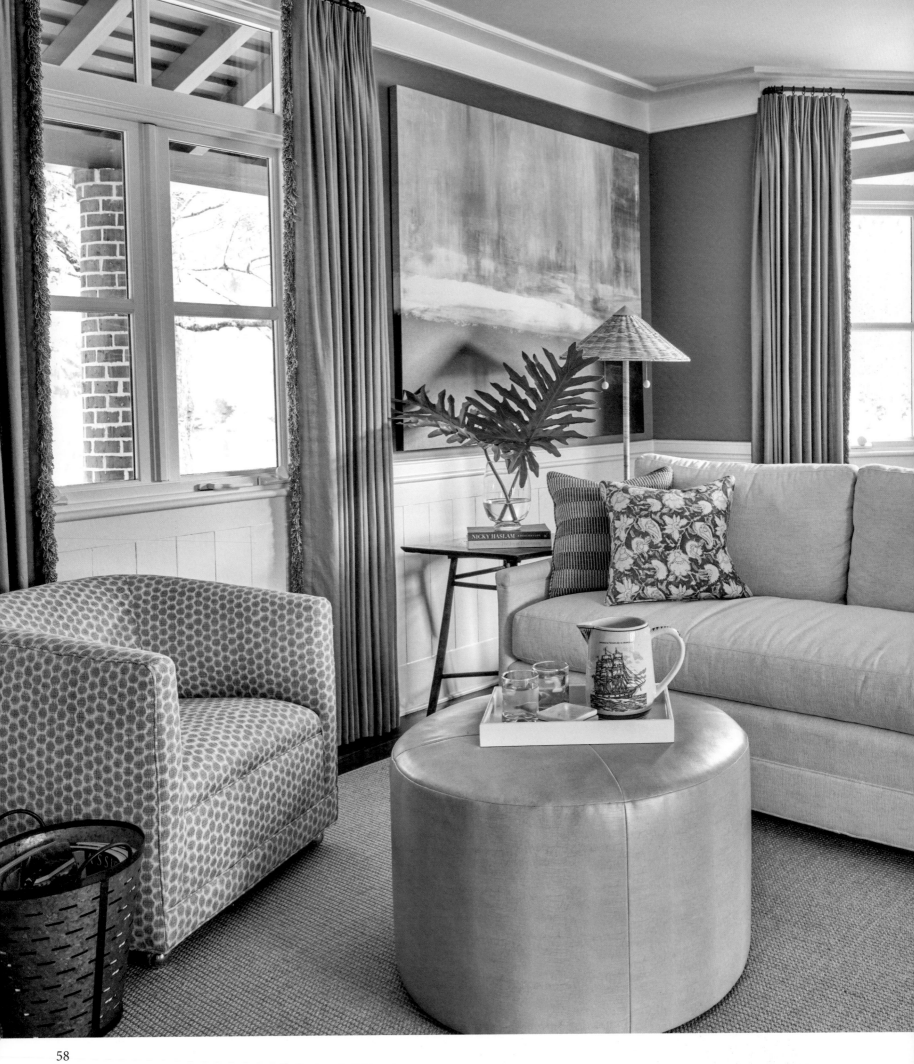

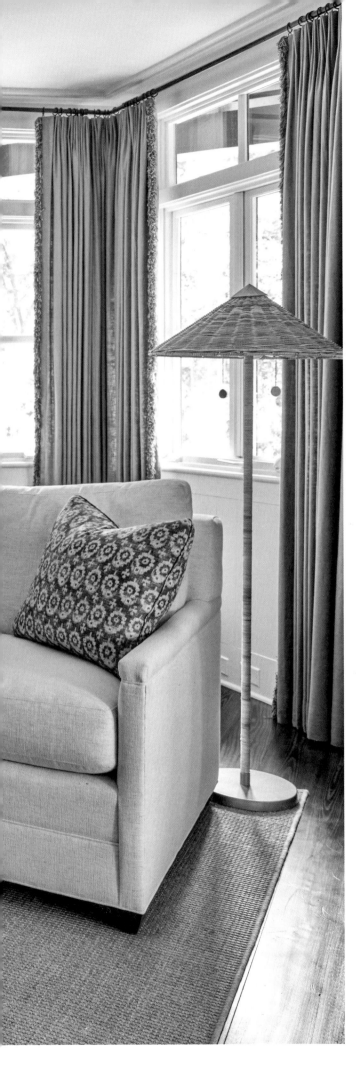

While still serene and ultimately relaxing, the bedrooms are warmed with carefully balanced patterned textiles and textured fabrics. Wooden surfaces and soft brown tones offer a cozy spirit to the guest room, but the master bedroom is all tranquility with its muted blues and greens softening the striking presence of the iron canopy bed.

On both levels of the home, Lisa created the design with the intention of directing the eye to the view. And given her love of that view, it's no surprise that she points to the porch as one of her favorite spaces. "It's where we commune with family and friends and have the best times," she says. With its hand-molded curved brick columns, it's a beautiful sight in and of itself—and the perfect spot for enjoying all that the island has to offer.

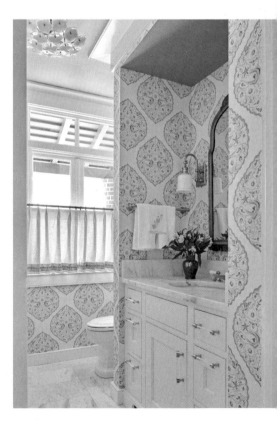

The club chair in the den is a reupholstered piece that belonged to Lisa when she was younger. Behind the sofa, an angular bay window was designed to allow golfers to approach and be served. Even the stairwell offers a view of the landscape, and an antique GE factory pendant light lends patina and historical charm to this corner of the home. The bathrooms offered an avenue for Lisa to use one of her favorite design elements. "I really love wallpaper, but this house didn't need it all that much, because the real beauty is outside, and we have a lot of wall texture between the wood paneling, brick fireplaces, and transom windows," she says. "We left most everything neutral in order to direct the view to where it belongs."

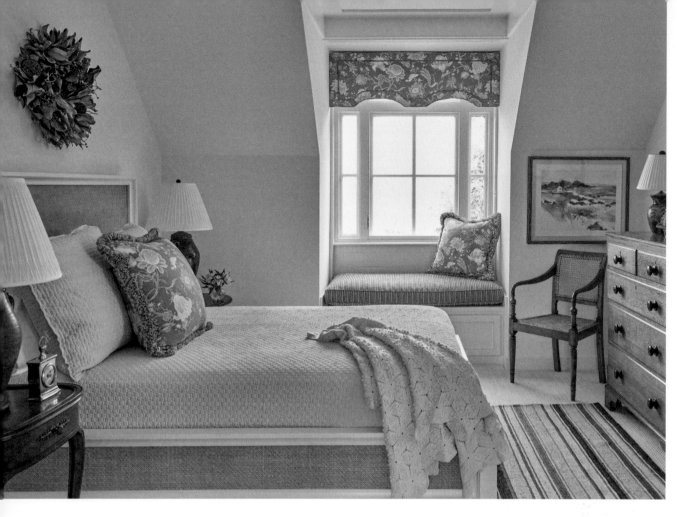

When Lisa and her husband moved into the home, the master bathroom was papered in an outdated gold grass cloth. Rather than remove it, they opted for a more creative solution. "I loved the texture but not the color," Lisa notes. "I learned they could spray it white, because it was glued so well that they weren't worried about it." The result was a fresh finish that Lisa calls "clean and tactile."

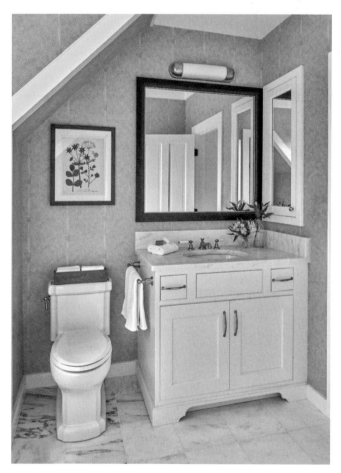

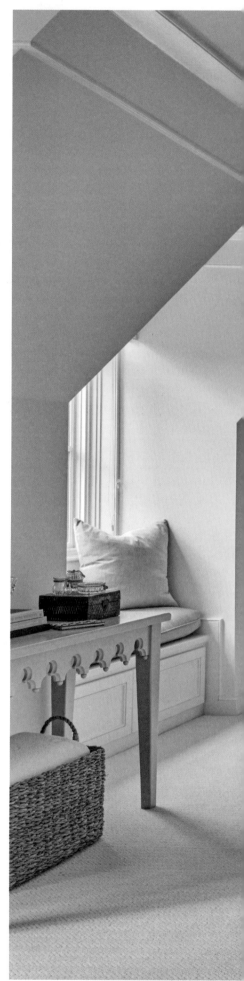

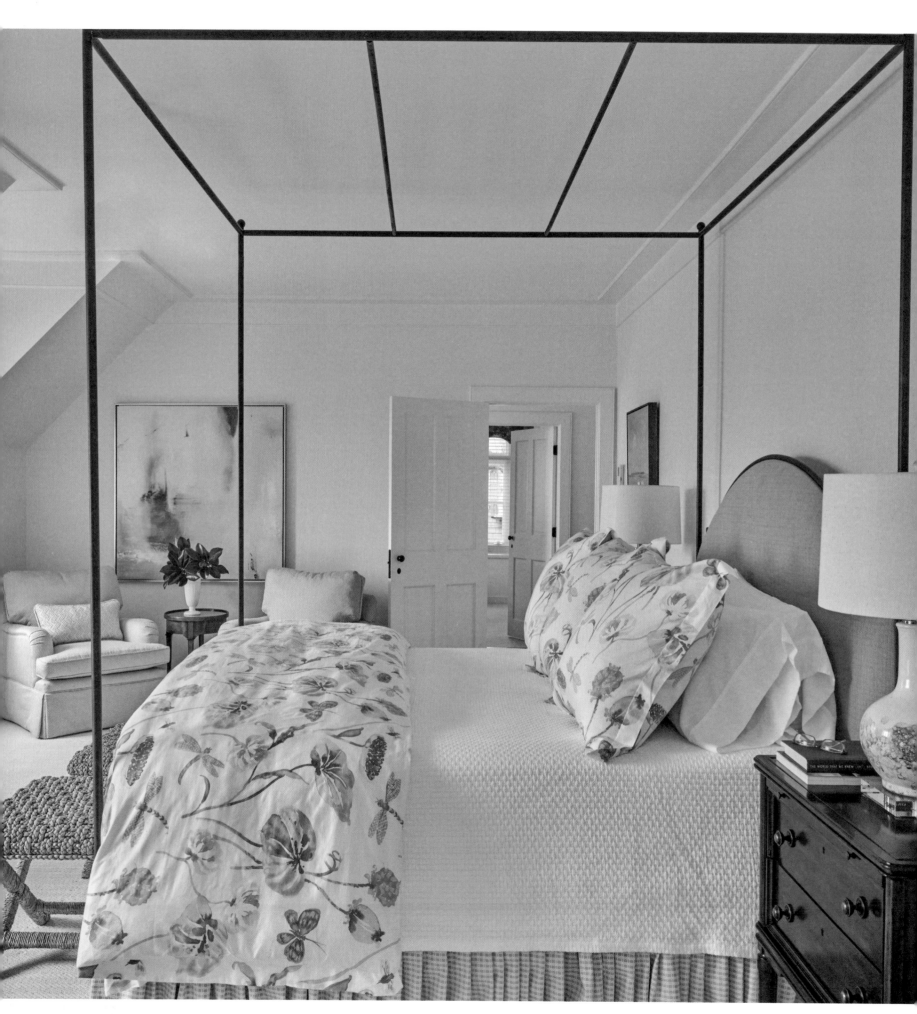

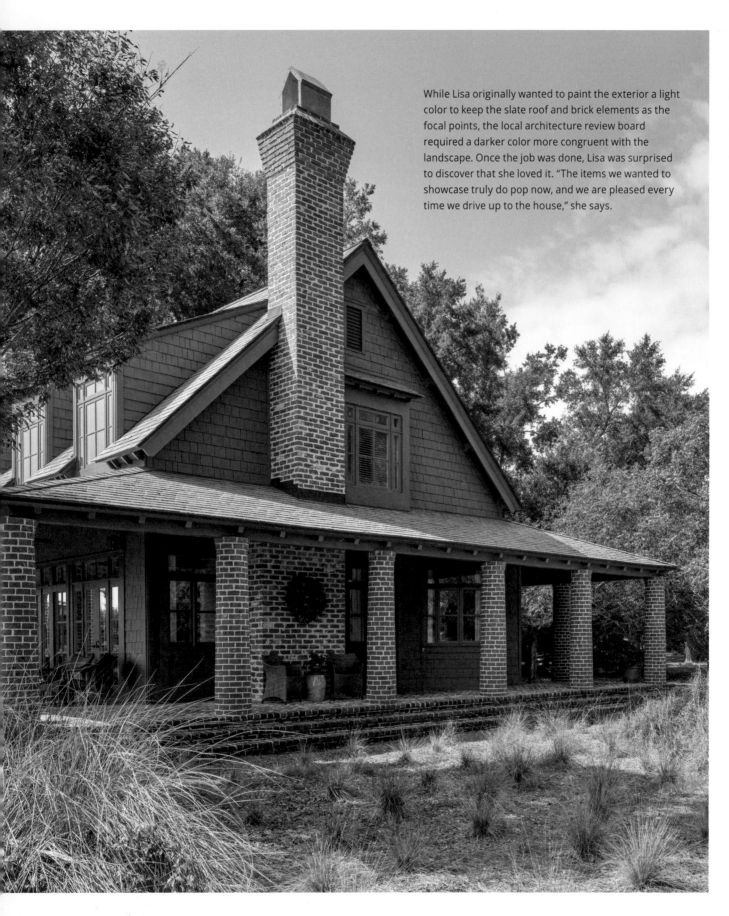

While Lisa originally wanted to paint the exterior a light color to keep the slate roof and brick elements as the focal points, the local architecture review board required a darker color more congruent with the landscape. Once the job was done, Lisa was surprised to discover that she loved it. "The items we wanted to showcase truly do pop now, and we are pleased every time we drive up to the house," she says.

Lisa and her husband originally became interested in Spring Island six years before they were able to move there. "We initially built in Palmetto Bluff, South Carolina, but wanted something more private where we would know all of our neighbors," she says. "So, we arrived here." While the property initially included more land, it wasn't until the plot was parceled that it became attainable for the couple.

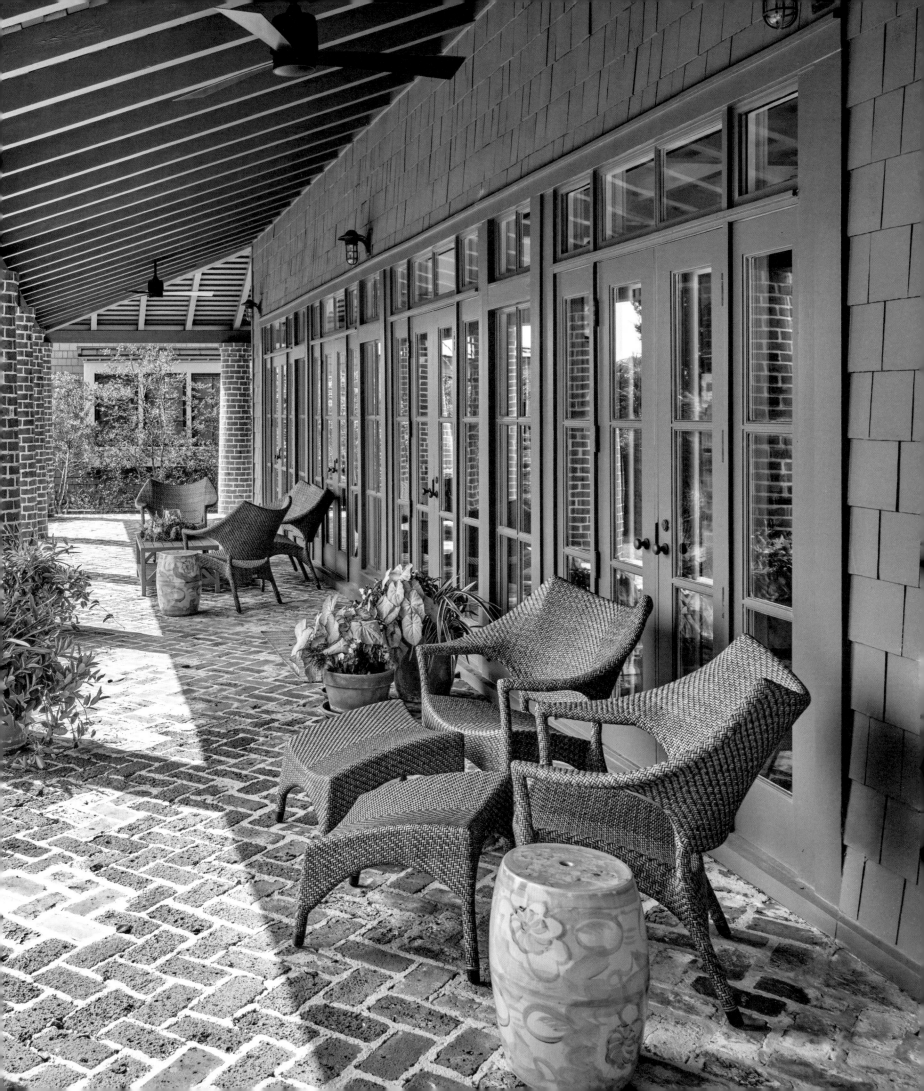

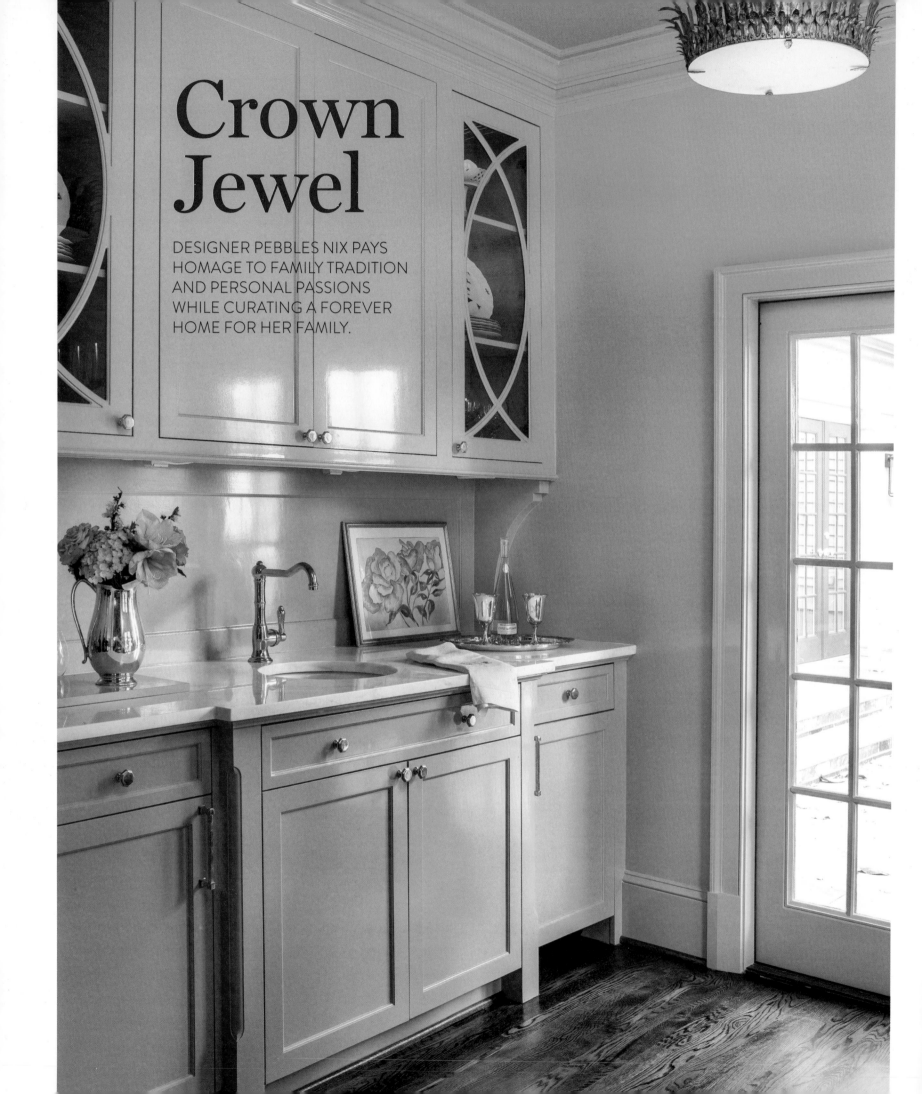

Crown Jewel

DESIGNER PEBBLES NIX PAYS
HOMAGE TO FAMILY TRADITION
AND PERSONAL PASSIONS
WHILE CURATING A FOREVER
HOME FOR HER FAMILY.

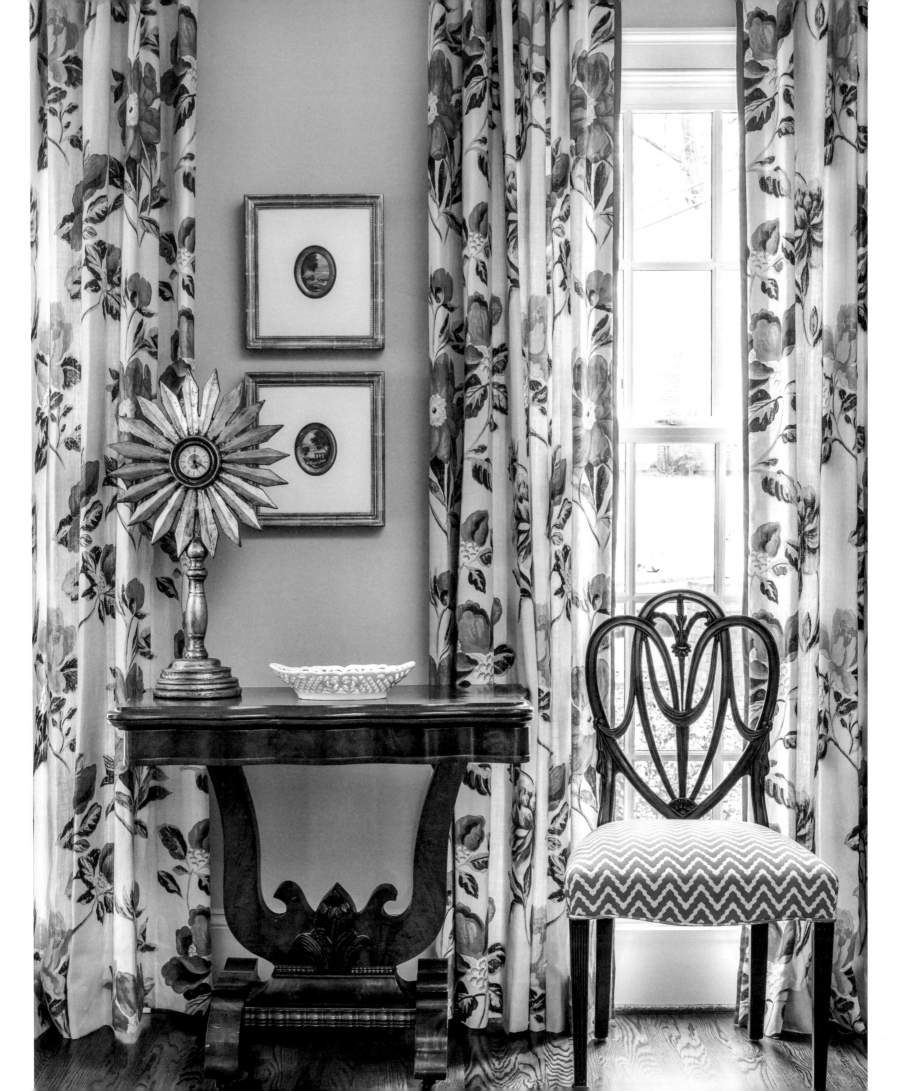

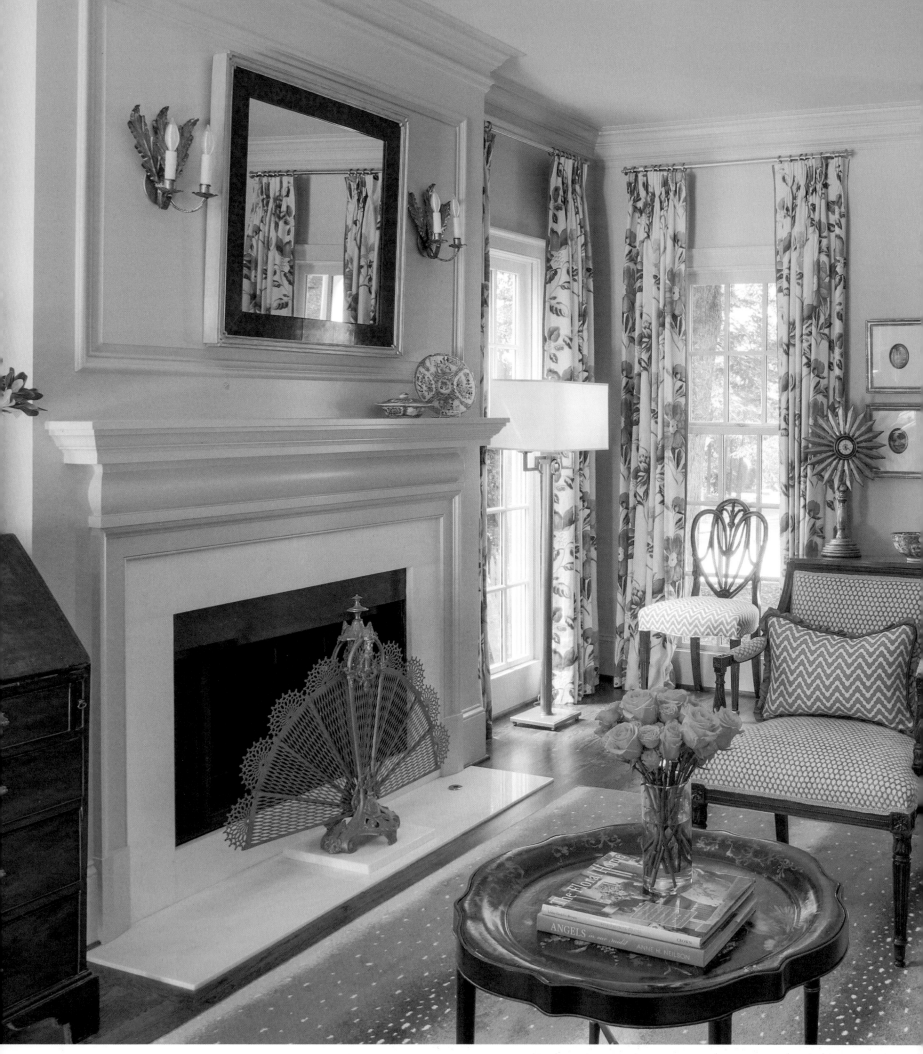

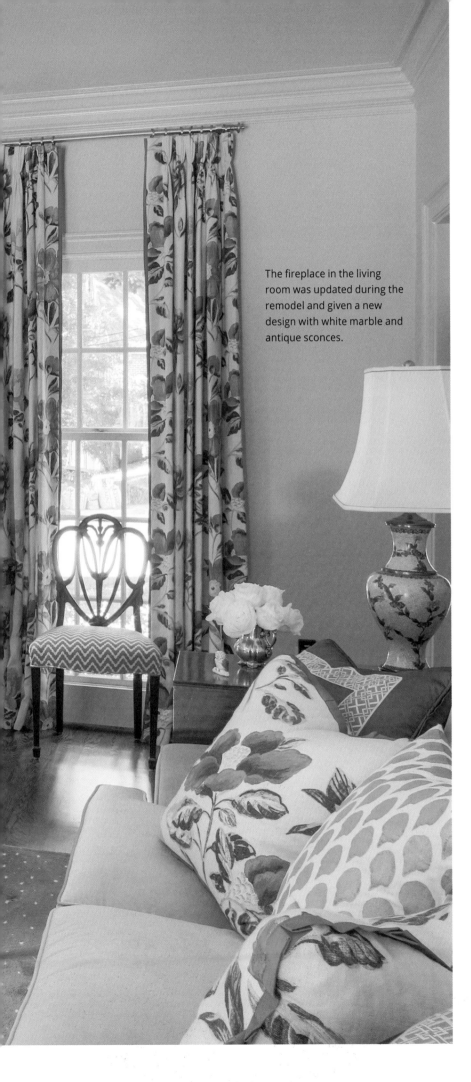

The fireplace in the living room was updated during the remodel and given a new design with white marble and antique sconces.

When Atlanta, Georgia-based designer Pebbles Nix took on the project of updating her home, she decided there was no time like the present to create a family-friendly haven perfect for welcoming and hosting loved ones. As self-proclaimed extroverts, Pebbles and her husband, Robert, and their young son, Guy, knew they would need a space to entertain their groups of friends and prepare their once-a-month extended family dinners. "We wanted it to be a fun and happy home," says Pebbles. "You can feel comfortable in every room. We use the entire house, and that's what we wanted."

The designer first discovered her love of interiors and décor from her late mother. From her knowledge of antiques to her natural way of creating a welcoming atmosphere, Pebbles says her mother made sure her family always had a comfortable yet beautiful place to come home to. After moving to Atlanta to enroll in design school, Pebbles ended up making the city her permanent residence and gained experience by working for a residential designer and a hospitality design firm before striking out on her own in 1998 and opening Pebbles Nix Interiors in 2005.

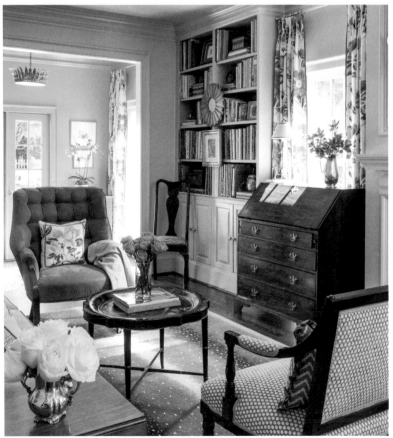

Designer Pebbles Nix says guests typically enter through the back of her home and the newly designed pink bar. "I knew I wanted to paint it pink," says Pebbles. "It's like a little jewel box—a friend of mine first called it that." The piece of rose artwork that sits on the bar was painted by Pebbles's late mother.

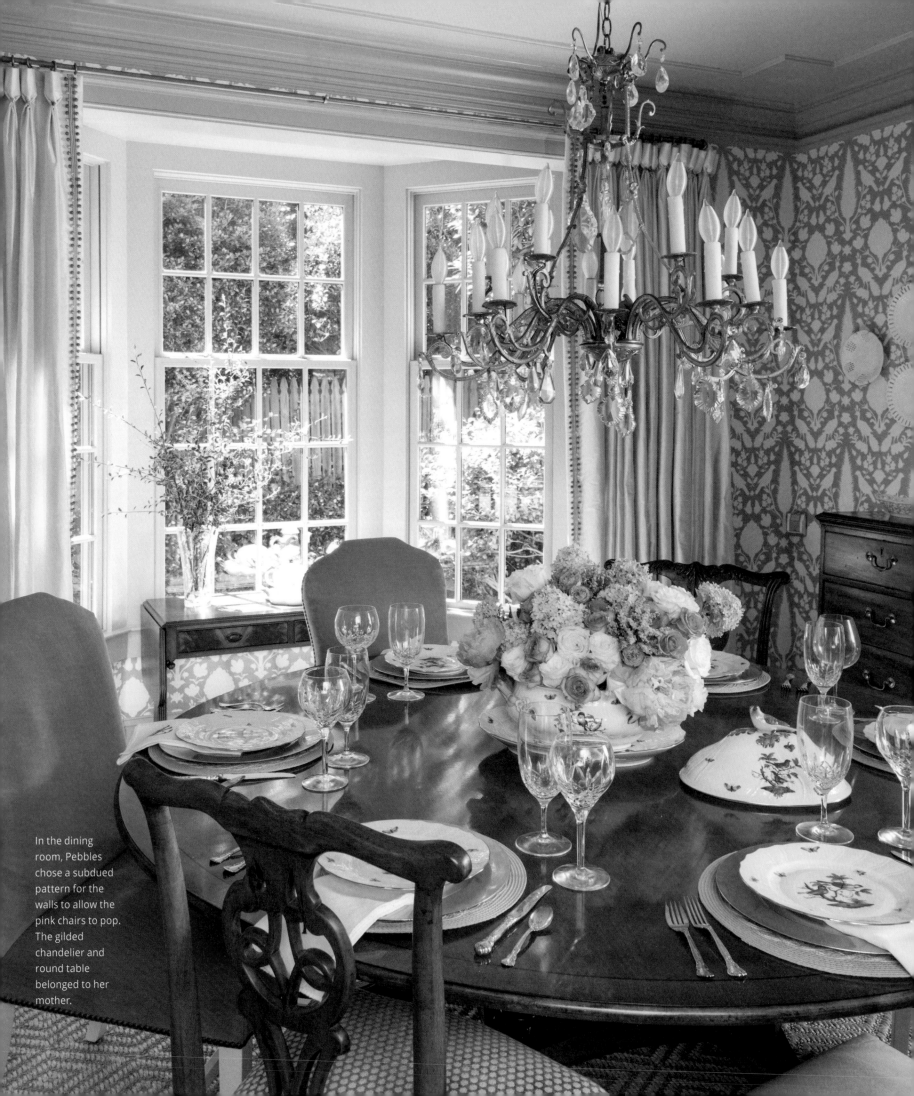

In the dining room, Pebbles chose a subdued pattern for the walls to allow the pink chairs to pop. The gilded chandelier and round table belonged to her mother.

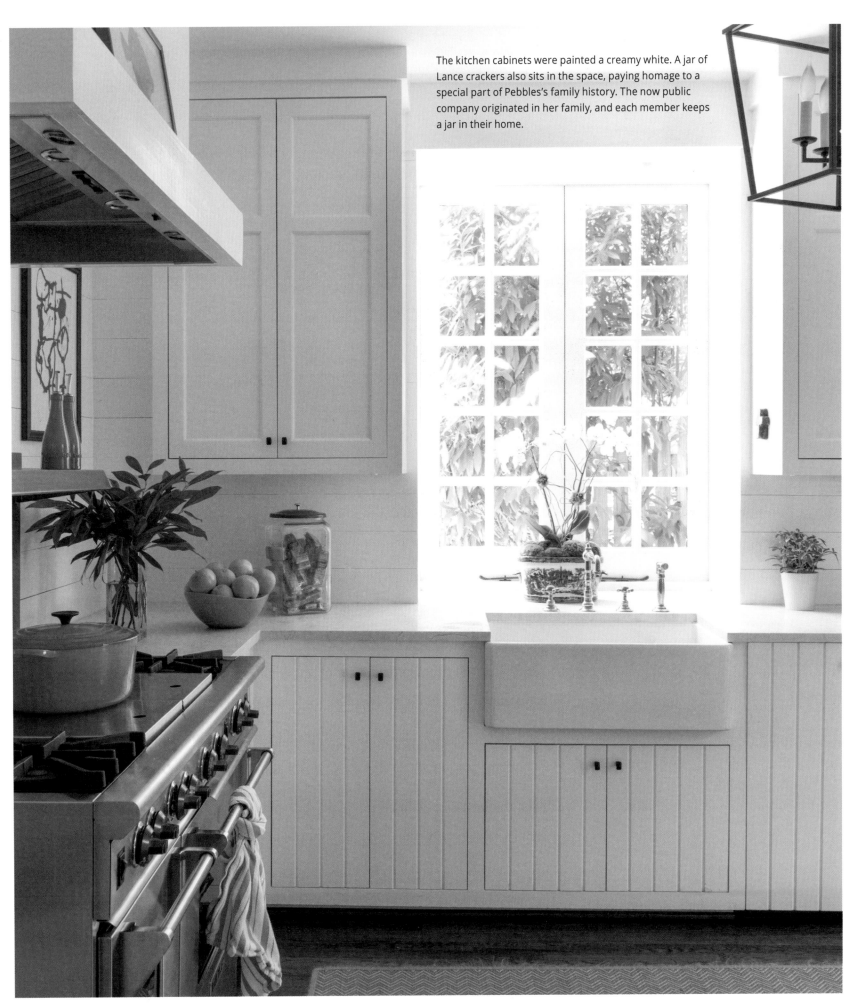

The kitchen cabinets were painted a creamy white. A jar of Lance crackers also sits in the space, paying homage to a special part of Pebbles's family history. The now public company originated in her family, and each member keeps a jar in their home.

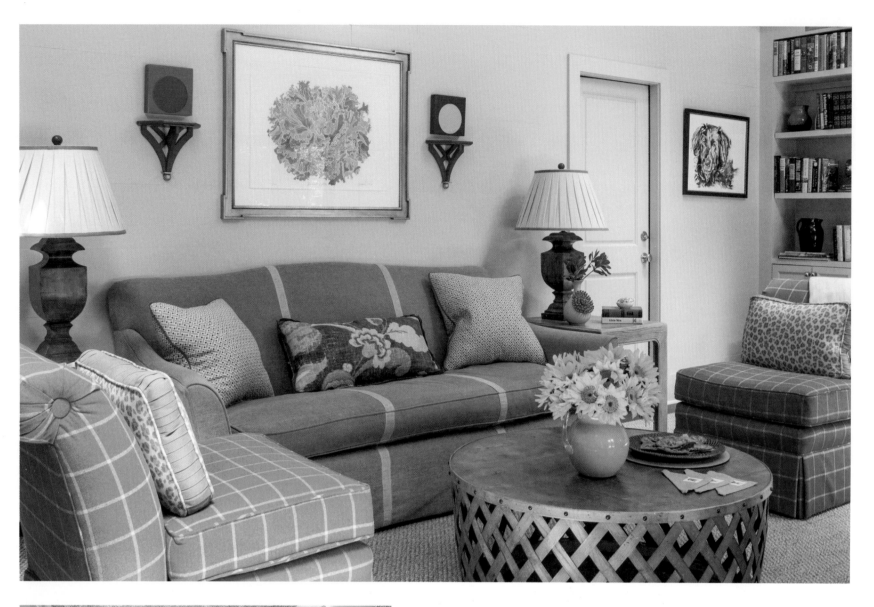

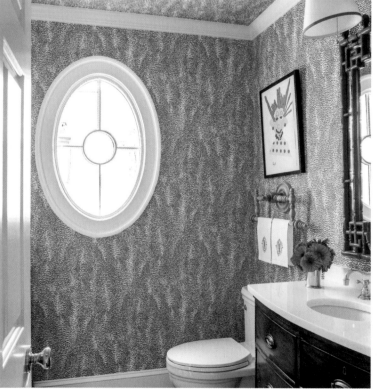

When Pebbles and her family first moved into their home, they realized it needed a little more work than they originally thought. After taking a couple of years to mull over their wants and needs for the property, they then began working with Wright Marshall, owner of Revival Construction, on the design and architecture before beginning the renovations. "After my mother passed away, I channeled my grief into my design work and rebranding to Pebbles Nix Interiors," says Pebbles. "It's truly been a labor of love." The family knew they needed to replace the house's windows and siding and wanted to remodel the powder room, which also acts as a laundry room. They worked with an architect to elevate the rustic exterior to a more formal Colonial style and added plenty of creative and functional updates.

While the designer says she loves all of the rooms in her home too much to pick a favorite, each space is filled with special touches, family heirlooms, and storied pieces. Pebbles has a passion for mixing the old with the new and wanted each room to have a combination of things she grew up with and things she and her husband have collected together. "I really feel like every room

Pebbles says the den is the heart of her house and has plenty of natural light. The powder room is adorned with red wallpaper and Pebbles's son's portrait of her is framed next to the mirror.

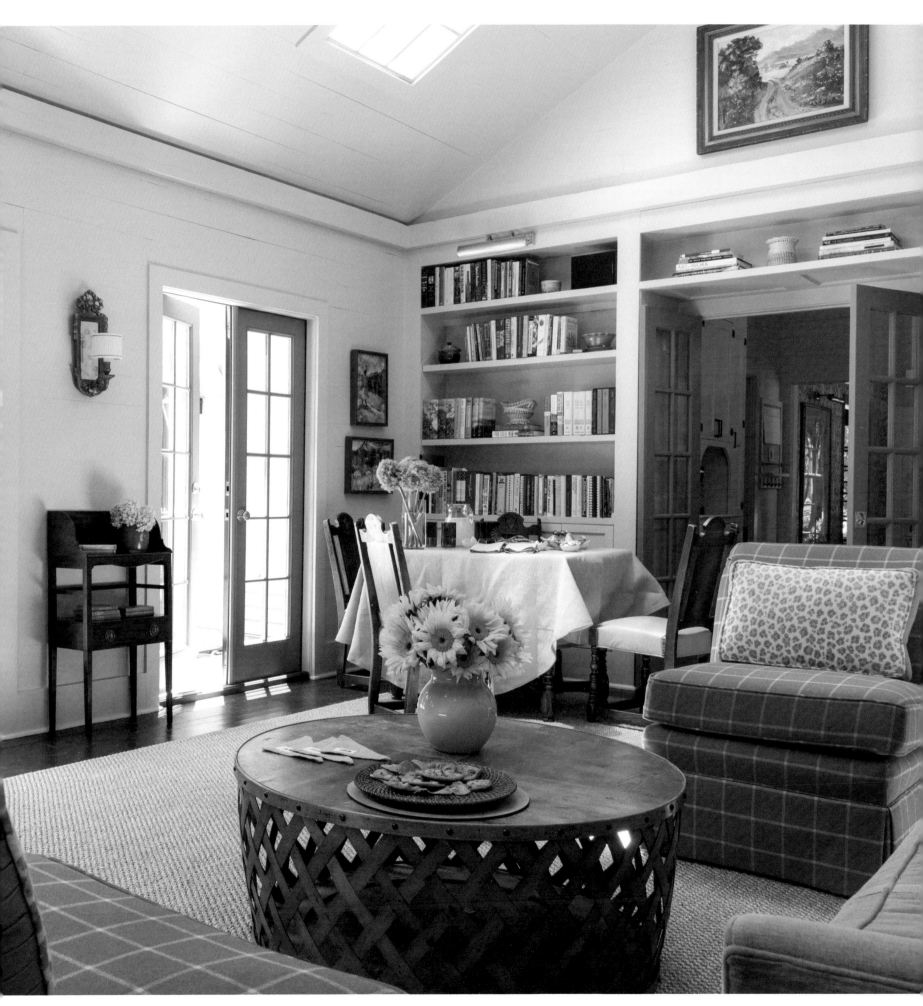

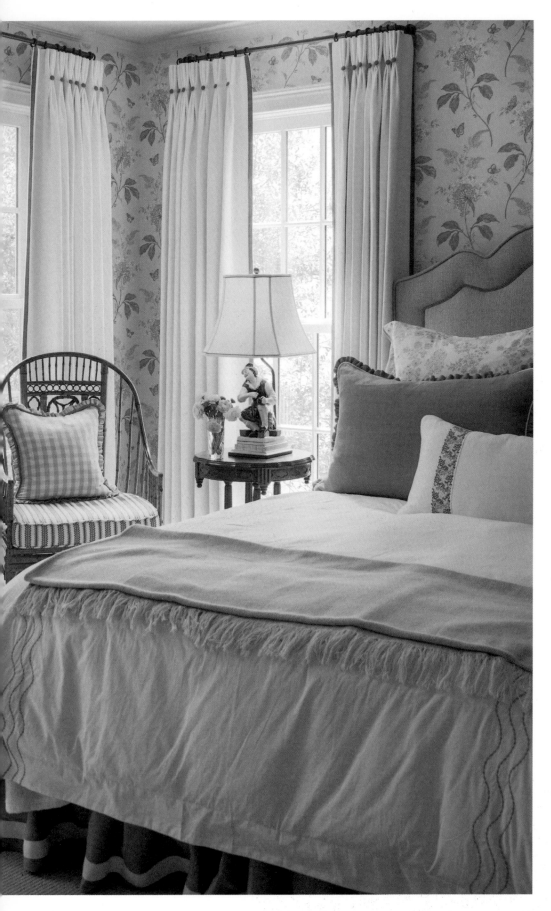

needs a touch of whimsy," she says. One of the house's most eye-catching details—the pink bar area—is not only a tribute to Pebbles's favorite color, but also to her grandmother, Pinky, and her mother, Pokey, who also shared a passion for the happy hue. The vibrant space opens up onto the patio, which is outfitted with pink chairs, and makes the ultimate statement when guests enter the home.

The theme of family history continues throughout the house, while Pebbles and Wright also worked to make each space feel intentional and cozy. In the living room, an updated white marble fireplace balances the warm caramel and pink tones. The round, black decoupage coffee table belonged to Pebbles's mother, while one of the antique side tables belonged to her husband's family. The designer says the den is the heart of the house and acts as a family hangout and breakfast area. The art above the custom sofa was a fixture in Pebbles's childhood home, and watercolor paintings of her dogs flank each side of it. The light and bright kitchen only required creamy white paint on the cabinets and new hardware from the Matthew Quinn Collection. "The renovation process was so great for me to experience, because it gave me more insight for my clients," says Pebbles. "It really was not a stressful project, and we couldn't be happier with the way it turned out."

A small, serene guest room is furnished with feminine touches and a peaceful color palette of greens, blues, and lilacs. Above right: A sitting nook outside the master bedroom is complete with a blue-and-white settee and some of Pebbles's mother's porcelain collection.

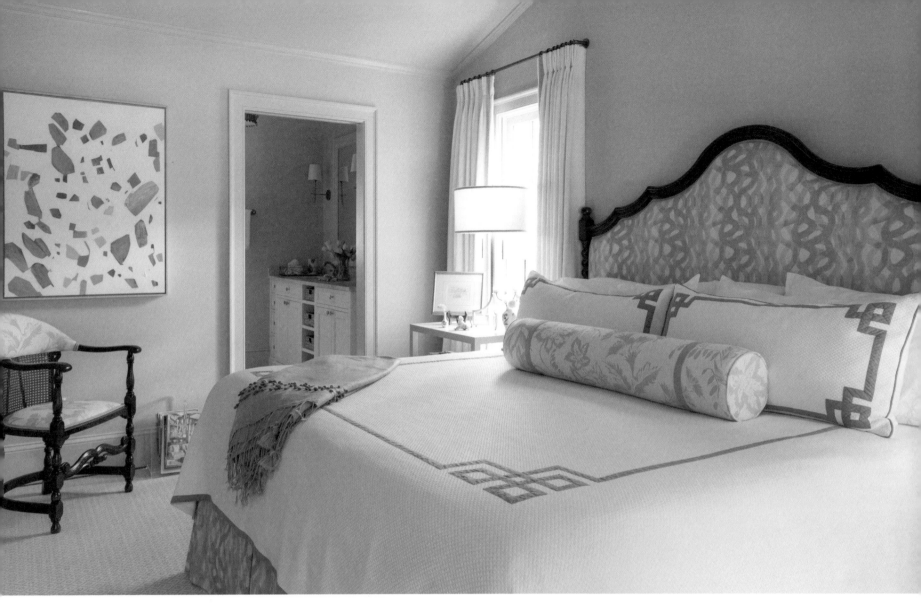

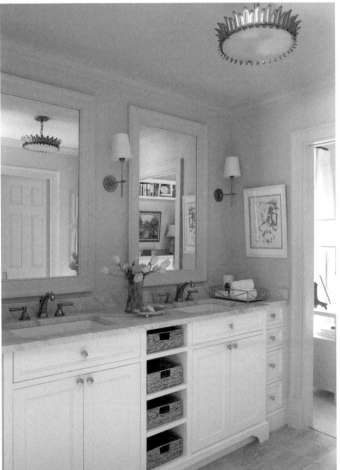

The master bedroom has a peaceful atmosphere with blue-gray bedding and newly added built-ins that add plenty of storage. The master bathroom features unlacquered brass fixtures and floor tiles that mimic weathered wood.

73

SUMMER

HOMES HUGGING THE COASTLINE EXHIBIT THE VERY BEST
IN WATERSIDE LIVING. LAKE HOUSE PORCHES WELCOME
WARM RAYS, AND BEDROOM HAVENS PROVIDE THE
IDEAL GETAWAY DURING THE SUMMER MONTHS.

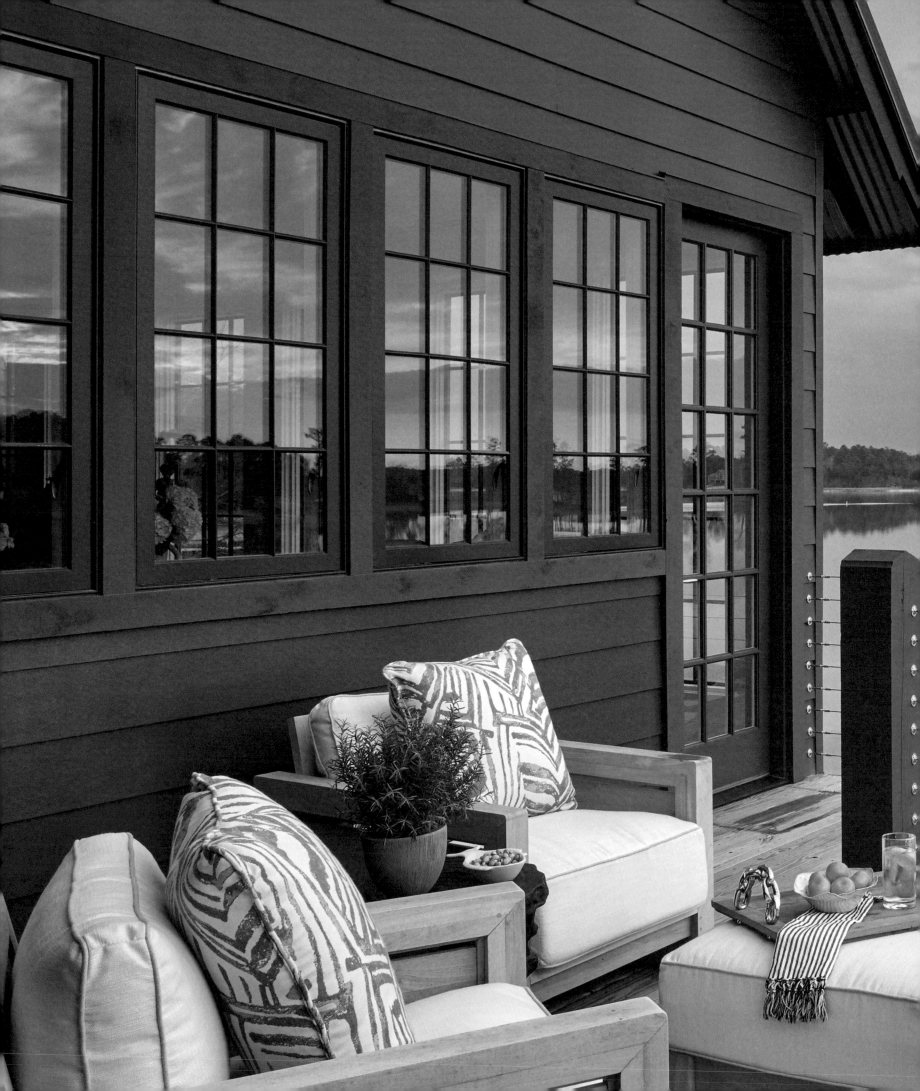

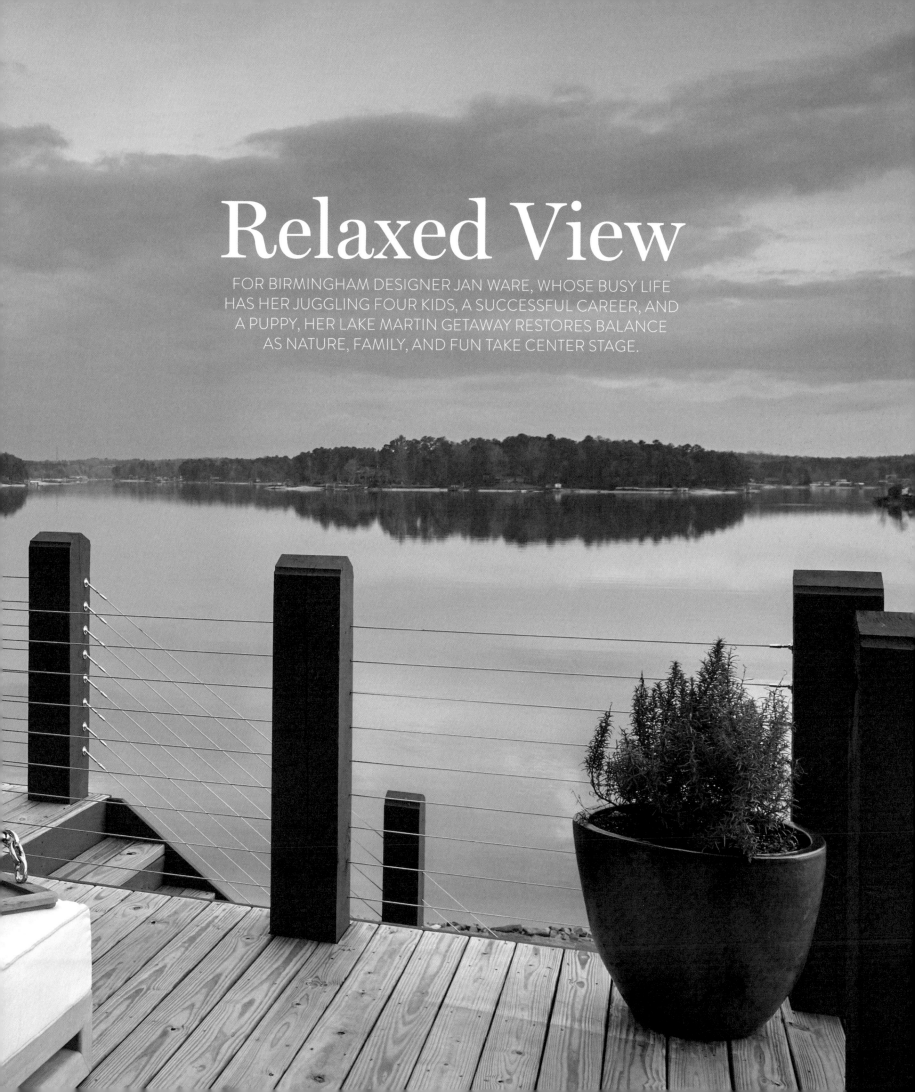

Relaxed View

FOR BIRMINGHAM DESIGNER JAN WARE, WHOSE BUSY LIFE
HAS HER JUGGLING FOUR KIDS, A SUCCESSFUL CAREER, AND
A PUPPY, HER LAKE MARTIN GETAWAY RESTORES BALANCE
AS NATURE, FAMILY, AND FUN TAKE CENTER STAGE.

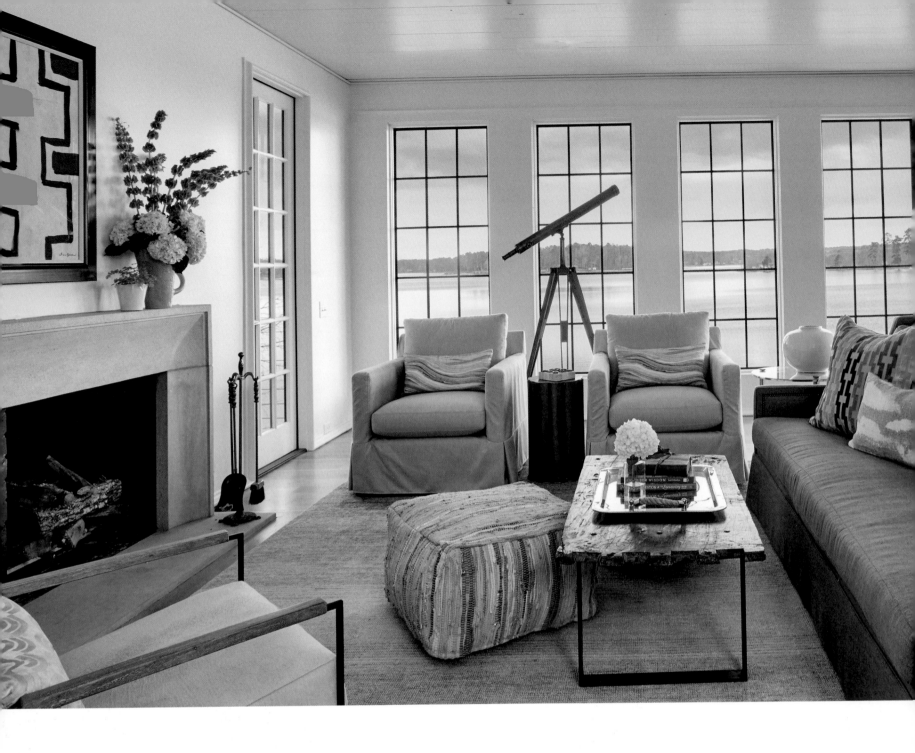

The story of how Birmingham, Alabama, designer Jan Ware and her family ended up in their lake cottage is one of those meant-to-be tales. In their early married life, Jan and her husband visited friends from Atlanta, Georgia, who had a house at Lake Martin in Alabama. "We'd always been Gulf Coast people," says Jan. But after a weekend at Lake Martin, their heads were turned. In fact, the house next door was in foreclosure and was situated on a beautiful lot, so they started to hatch a plan. Upon further inspection of the house, however, the couple realized it was too much to take on. "It was a hexagonal, cinder block house," says Jan. "We would have had to start over." So, they looked elsewhere for something more affordable for their young family. The bungalow they found satisfied their modest needs. "It was perfect for us at the time. We made it fit—the two of us and our four kids," says Jan, without a hint of irony. But the couple kept their eye on the foreclosed-on property. Patience paid off, and when the time was right for their family, they bought the house on their dream lot.

The Wares hired Richard Long of Long & Long Design in Birmingham to help them create an environmentally sympathetic, family-friendly, design-worthy escape. Jan threw out her standard approaches to in-town houses in favor of more site- and second-home-specific goals. "I did not want a large house with a high vaulted ceiling," she says. "It would have been too much wasted air conditioning." Instead, she was interested in a contemporary cottage feel where family and friends could land and not feel crowded. "We comfortably sleep 14 with beds," she says.

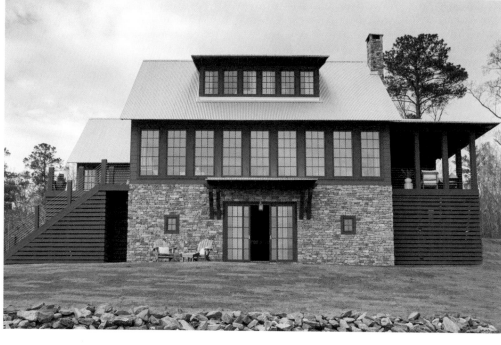

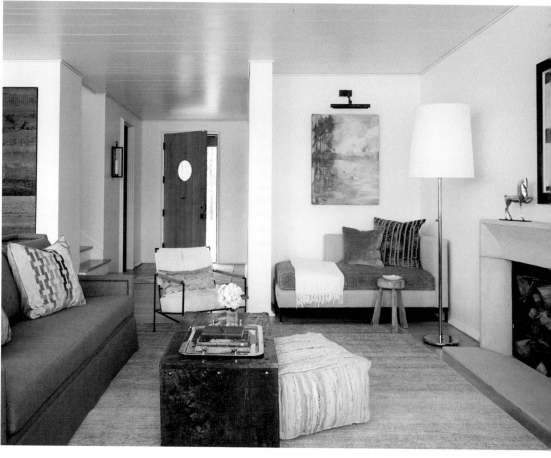

The living room suggests an effortless elegance with patinaed surfaces, a vintage coffee table Jan found in North Carolina, and practical Sunbrella fabric on the club chairs. An African Kuba cloth hangs over the mantel. Underscoring Jan's all-about-the-lake approach to living, the house blends into the landscape rather than dominating it. Stacked moss rock stone provides the foundation with shiplap siding above.

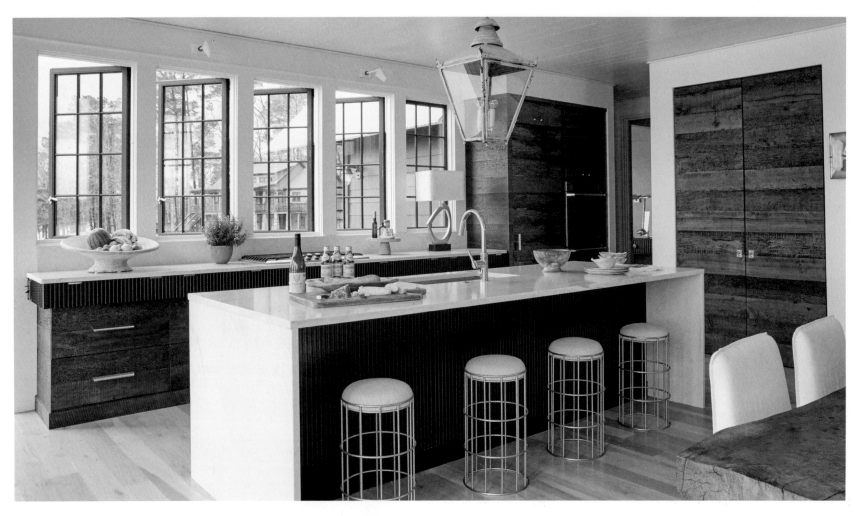

As a rule, Jan resists the open-plan kitchen/family room concept, but she made an exception for the lake house. "I think open-concept living sometimes makes a house lose a bit of its charm." she says. "But at the lake, it makes sense. Here, we cook and talk and relax together." The cabinets and pantry doors are custom designs made of antique beechwood with unlacquered brass fixtures. The Noir brass counter stools are small in scale and maintain the airy feel in the room. Jan bought the 1800s live-edge wood table years ago and put it in storage until she found a use for it.

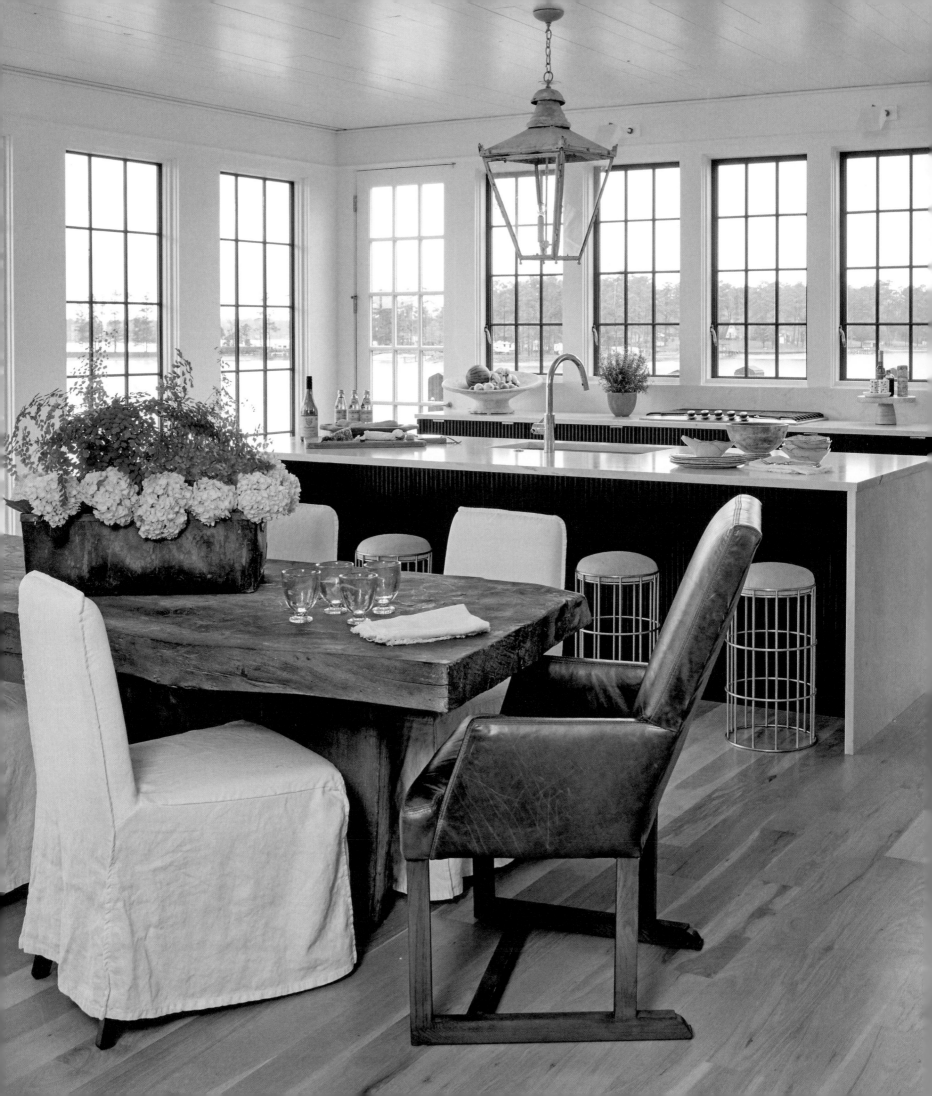

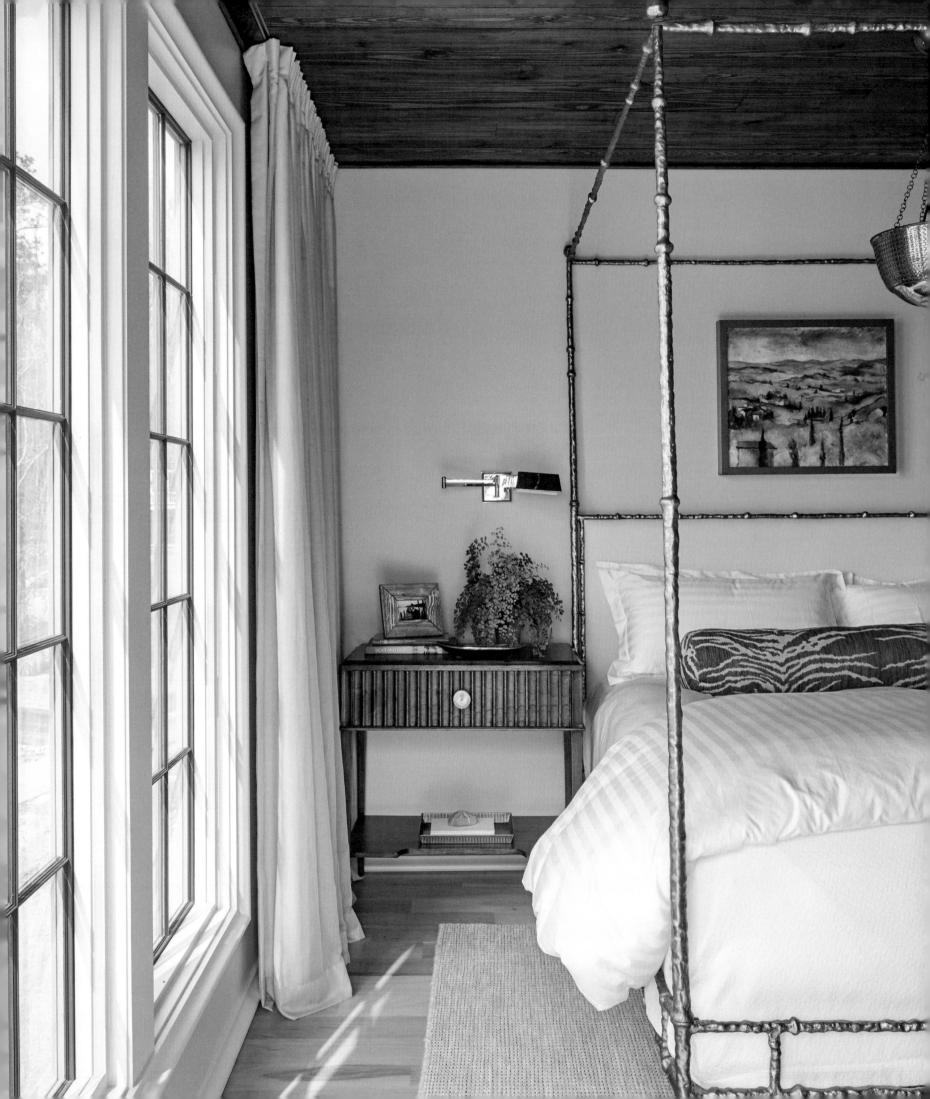

Jan also went with a different approach for the living spaces. "I'm usually not a fan of open-concept living. I like every room to have its function." But the lake was different. Her children love to cook, and they all take part in the process when there are no teenage sports, fundraisers, and meetings to distract. The kitchen, dining room, and living room share common space, where cooking, eating, and hanging out mingle.

In every room, windows line the walls, inviting the watery vista into the house. Curtains are minimal, designed for privacy and framing views rather than as decorative statements. The designer refrained from installing recessed lights, preferring natural light during the day and lantern and sconce light once the sun falls. "I'm all about the vitamin D when we can get it, and then I rely on lamps and ornamental light when we need it," she says.

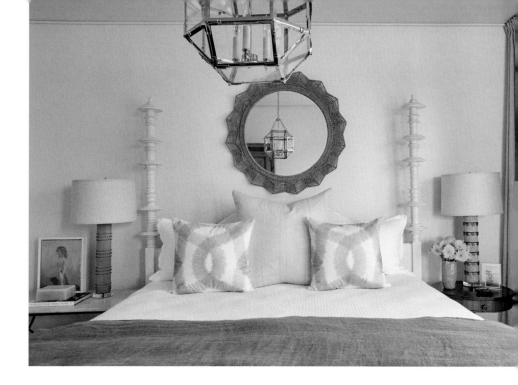

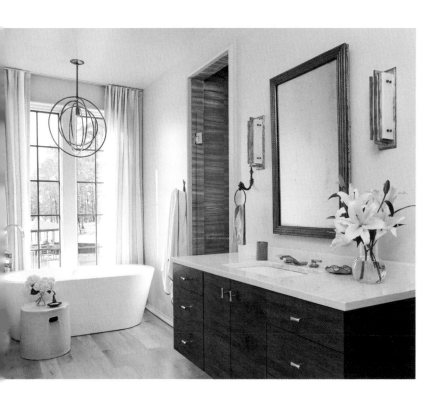

Jan wanted to make the master bedroom "rustic yet refined," a balance she achieved with a faux bamboo brass upholstered bedstead and a raw-wood ceiling that makes the dimensions of the room feel more intimate. The petite guest bedroom comes together in shades of serene white and gray. The floating console in the master bath helps maintain the modern, minimal spirit of the room.

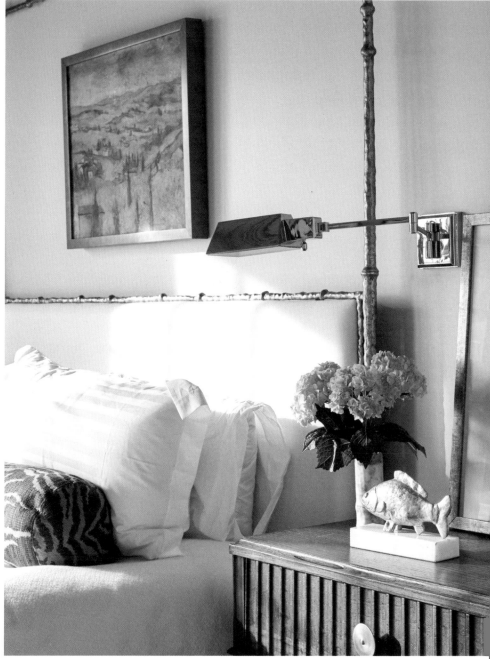

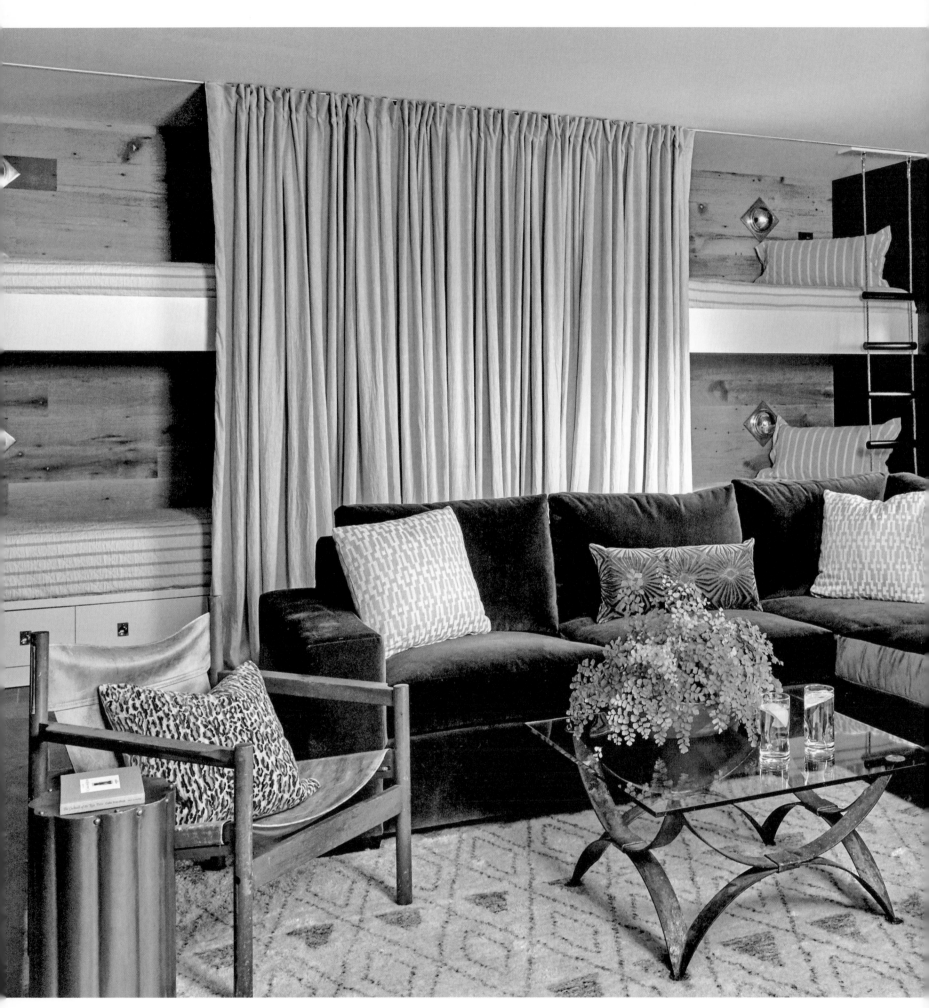

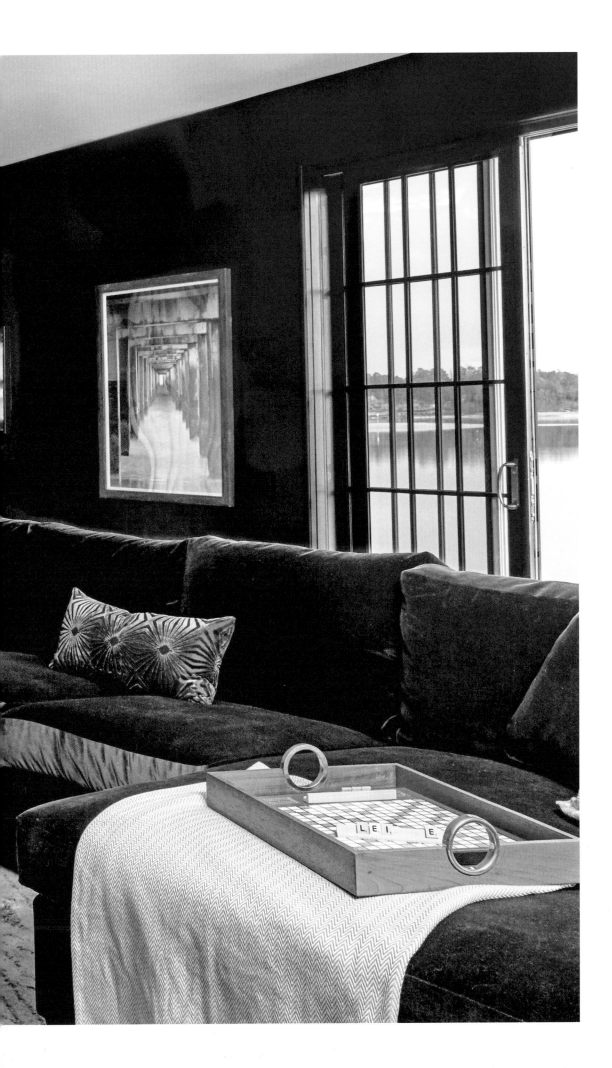

Jan insisted on push-out casement windows rather than the traditional crank casements because she wanted to keep the hardware to a minimum and the view as pristine as possible. Unobscured, the colors of the landscape play a big part in the colors of the paint and fabric she chose. "I love a sort of lichen color—the gray-green-blue that you see at Lake Martin," she says. Linen upholstery fabrics evoke the home's surroundings of air, water, and trees, and the patina of unfinished wood throughout provides further complement.

Accents of unlacquered brass in the lights and fixtures, flower arrangements assembled from the garden, and patterned pillows bring in bold colors. But Jan keeps those decorative elements confined to small shots in keeping with the relaxed style of a family getaway. "We're mostly on the boat," says Jan. "Or we're piled in the media room." In this home, fun and comfort take precedence, while style is woven into the fabric and spirit of the cottage.

In the media/bunk/pool room, a velvet upholstered sectional makes for easy relaxing in front of a movie. The built-in bunks offer overflow beds when the children have guests.

A Storied Seaside Cottage

CREATED TO ACCOMMODATE A NEVER-ENDING FLOW OF FRIENDS AND FAMILY, THIS CHARMING GUEST COTTAGE OFFERS A GLIMPSE OF HISTORY.

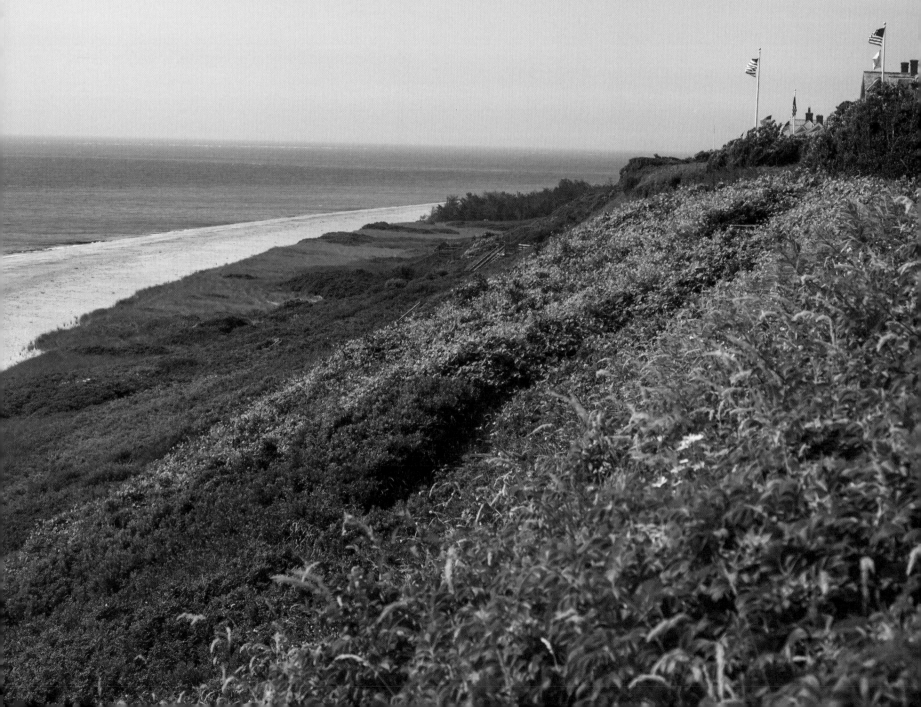

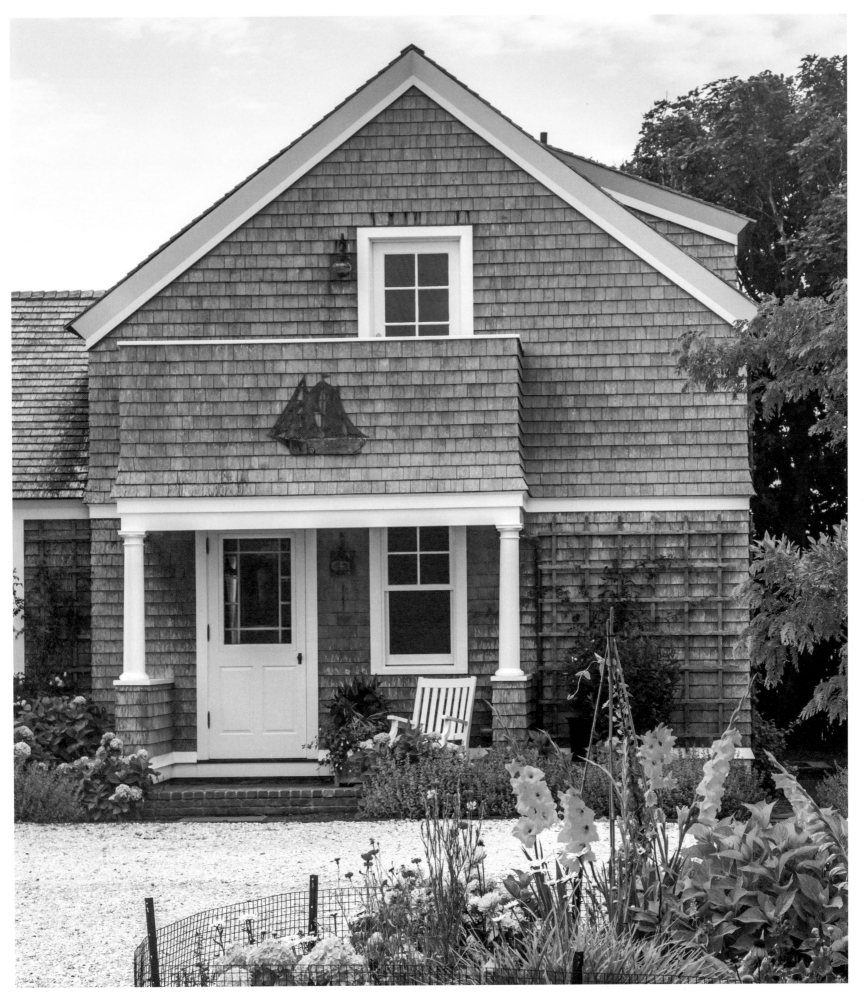

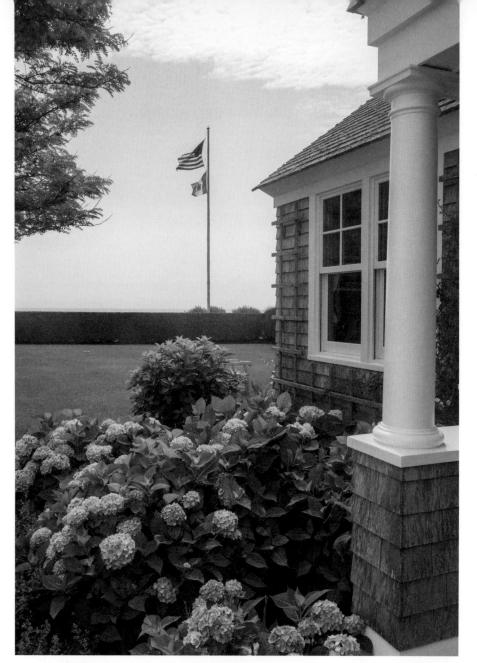

isit Beth and Fred Singer's three-story guest cottage on Nantucket, Massachusetts, and you may find it difficult to believe that the structure was built in 2008. "The design team was inspired by my client and her great-great-grandfather," says interior designer Anne Dutcher, who has worked with the Singer family on multiple projects, including the main house that sits alongside the light-filled cottage. "His name was Edwin Amesbury—he was one of six sons, who all became sea captains."

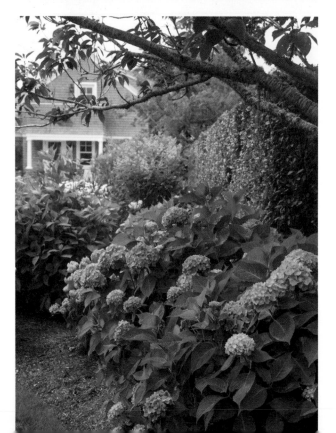

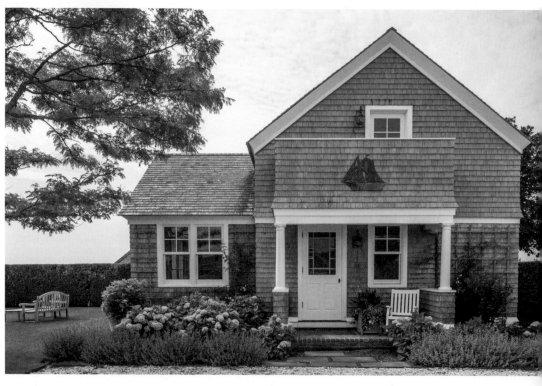

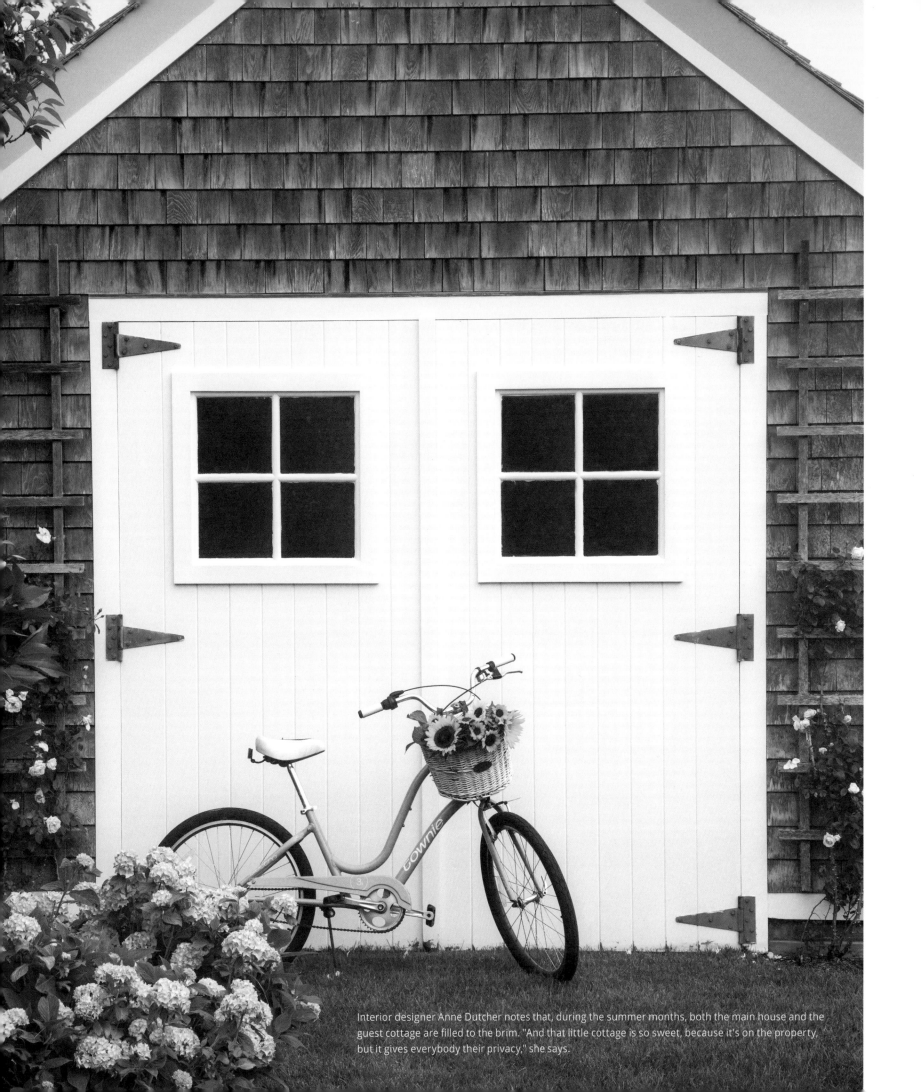

Interior designer Anne Dutcher notes that, during the summer months, both the main house and the guest cottage are filled to the brim. "And that little cottage is so sweet, because it's on the property, but it gives everybody their privacy," she says.

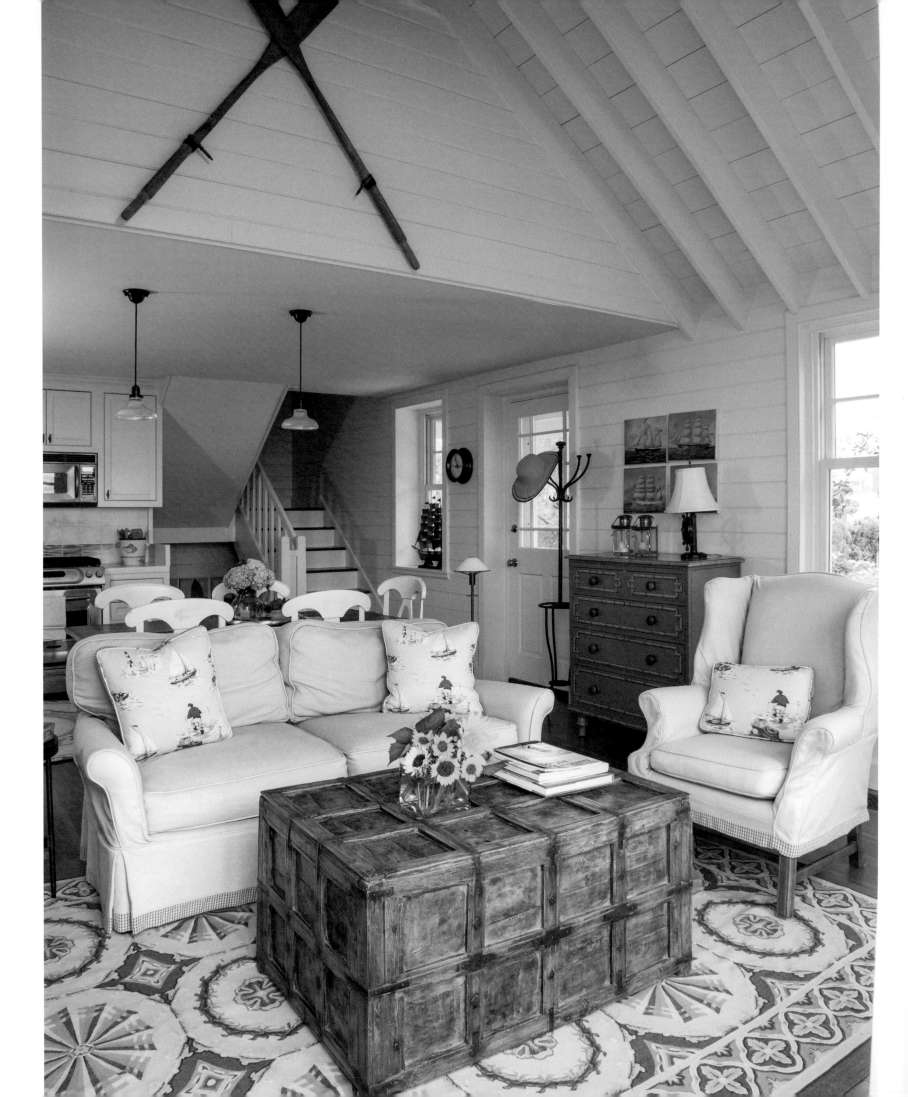

The family history was an important part of the design process, which Anne approached with the intention of preserving the homeowner's family history and honoring the island itself. From the open living room to the dreamy master suite on the third floor, a mixture of Beth's family heirlooms and antiques sourced from around the island cover the walls and occupy all available surfaces. "It's kind of an homage to [Beth's] family and her seafaring ancestors," Anne says.

Although they are dressed in updated upholstery, the sofa and wing chairs in the living room—along with the antique coffee table they surround—were passed down through Beth's family. In the dining room, a pine hutch lined with antique Wedgwood china is a contribution from her husband's side of the family.

And throughout it all, Anne included a smattering of nautical-inspired accents, like the Claire Murray rug on the kitchen floor and boat cleats on the cabinets and drawers. The backsplash, made of custom tile, serves as both a centerpiece and a conversation starter, as it showcases a scene of the island as it might have appeared around the turn of the 20th century—when the main house was built—along with Captain Amesbury's ship, the *S.D. Carleton*, and Nantucket's famous Sankaty Head Lighthouse.

A pair of antique boat oars hangs over the living room, adding a focal point to the open ceiling space. Below, a dresser featuring a nautical finish sits beneath a set of vintage paintings found on the island.

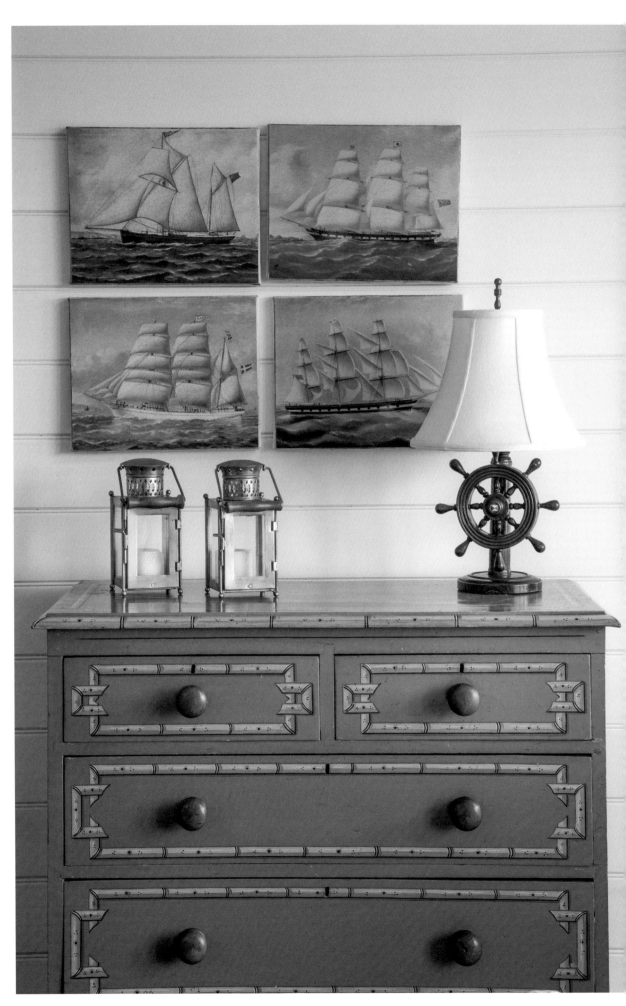

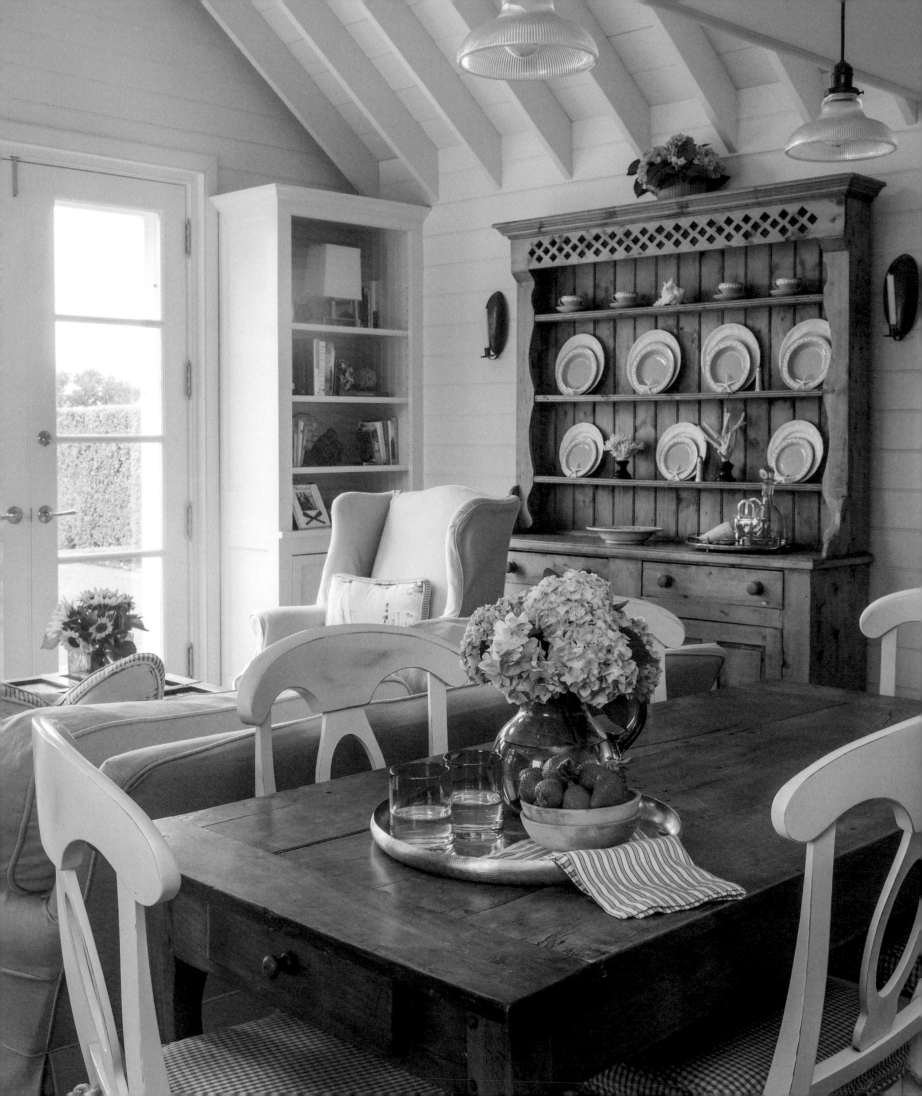

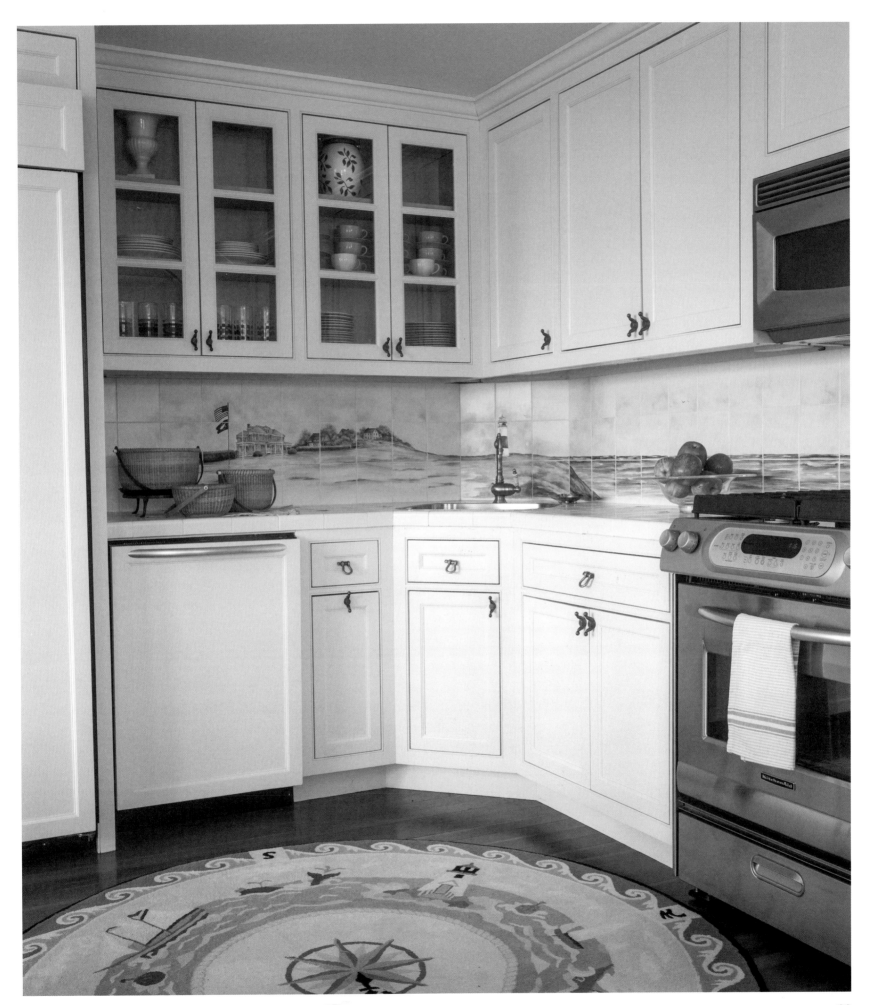

The guest room takes a warmer turn, breaking away from the airier tones that saturate homes along the coast. "Beth wanted some color," Anne explains. "She was a little tired of all the white and blue and green, so we said, 'Let's do something different in here.'" The earthy shade of the walls complements the pair of antique beds flanking a single nightstand, above which hangs a sailor's valentine—a framed piece of shell artwork that was popular in the 18th and 19th centuries. "Almost everything was found on-island," Anne says of those antiques that weren't contributed by Beth's family. "We really wanted to support local businesses and keep as much on-island as we could."

In the lower level, which houses a bunkroom, Anne translated the nautical theme into a fun, lighthearted atmosphere, using bright-colored fabrics to create a space perfect for kids.

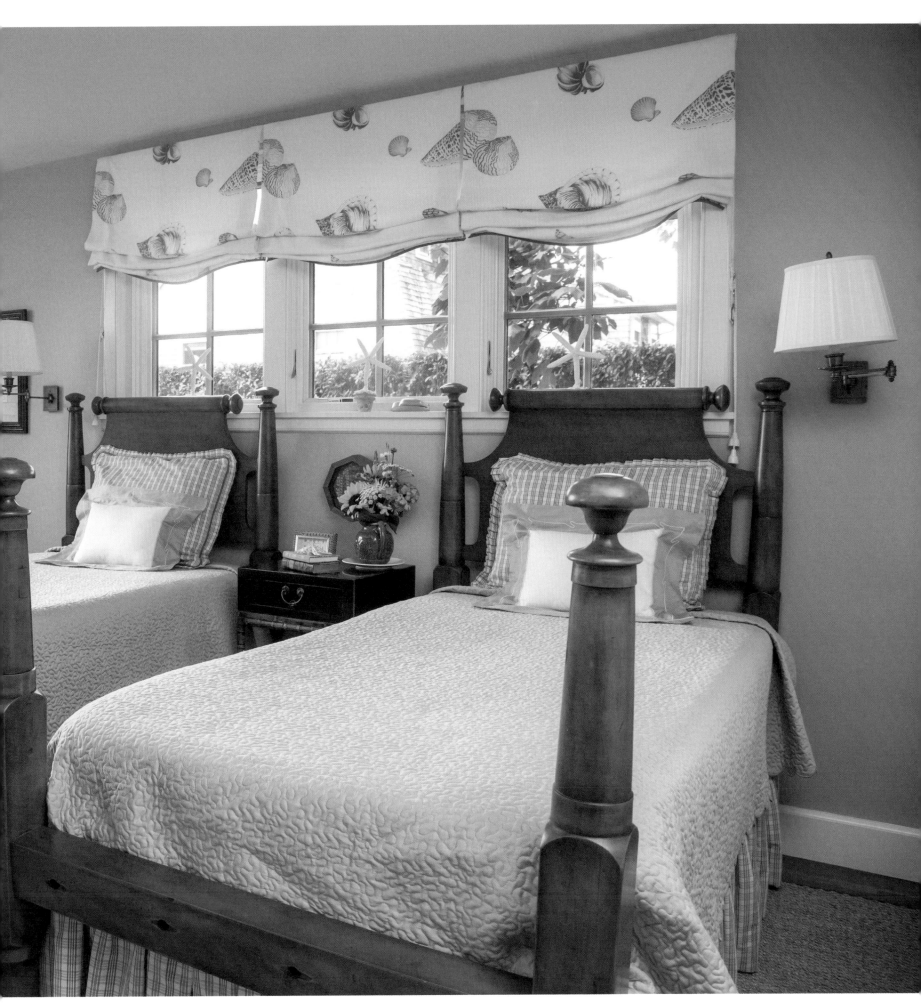

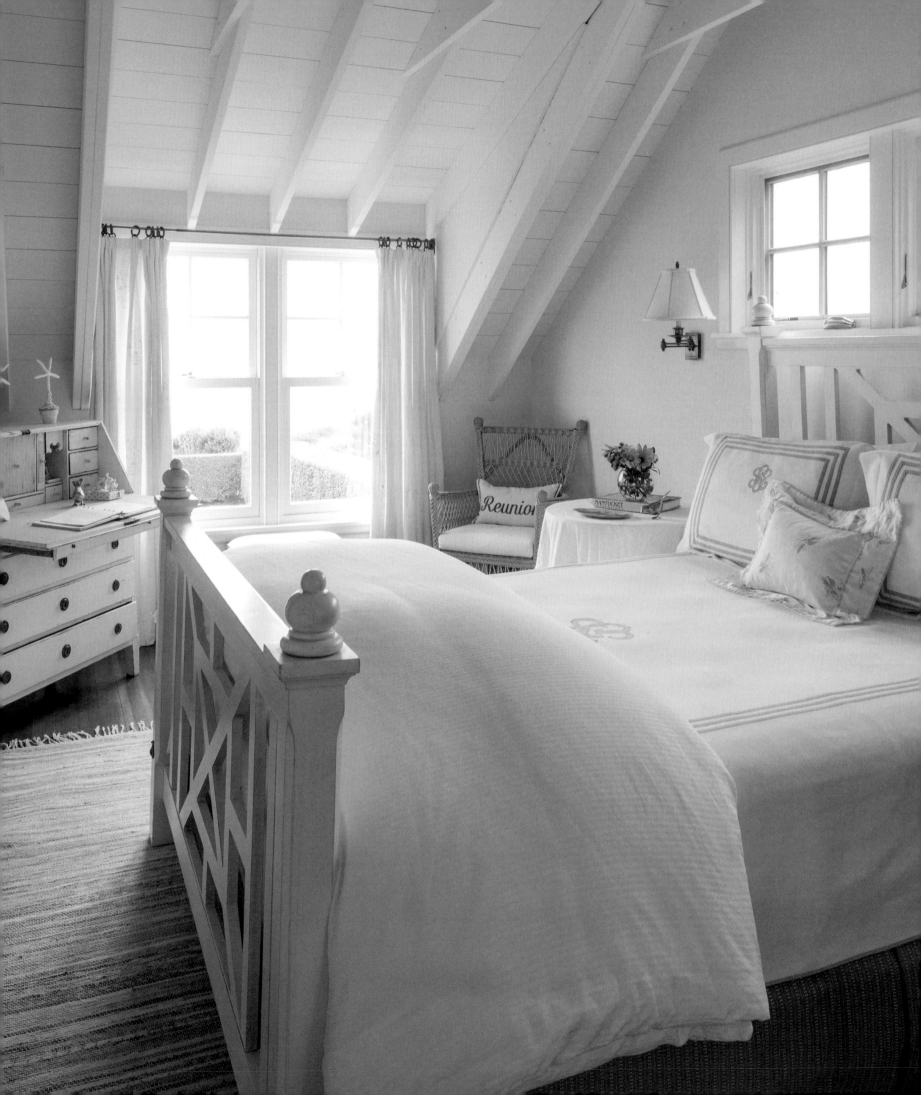

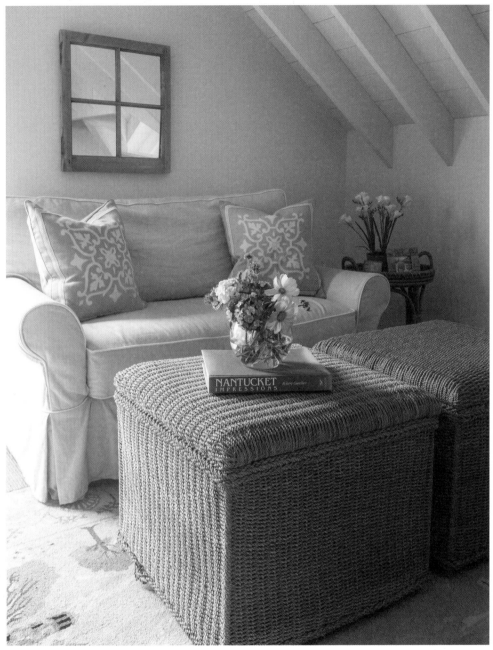

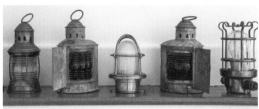

A group of maritime lights collected from antiques shops around the island injects a touch of historical character to the bright-white stair landing.

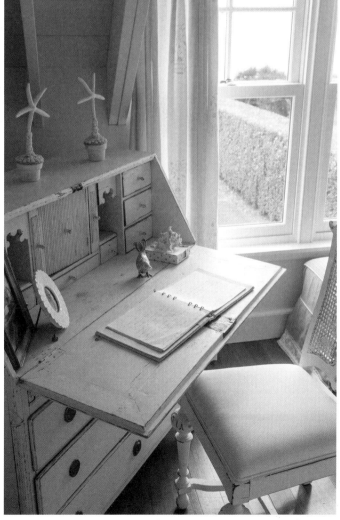

While the antiques do continue upstairs into the master suite, which fills the entire top floor, they take a back seat to the calming shades of white designed to create a haven for visiting friends and family. "We incorporated some antiques in there, but the space itself feels a little more updated, modern, and definitely more transitional," Anne says, noting that certain elements tie into the main theme of the house. With white-on-white surfaces dominating the room, the design finds its interest in the high planked ceiling and beams, along with subtle details like the Matouk bedding and vintage shell chandelier.

Overall, the effect is enough to make anyone feel at home, which—since Anne calls the house "a busy little cottage"—was paramount. And with such a charming balance of the rich history and relaxing spirit of the island, it's no surprise that guests keep coming back.

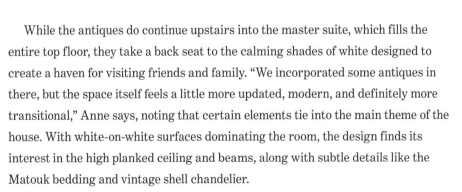

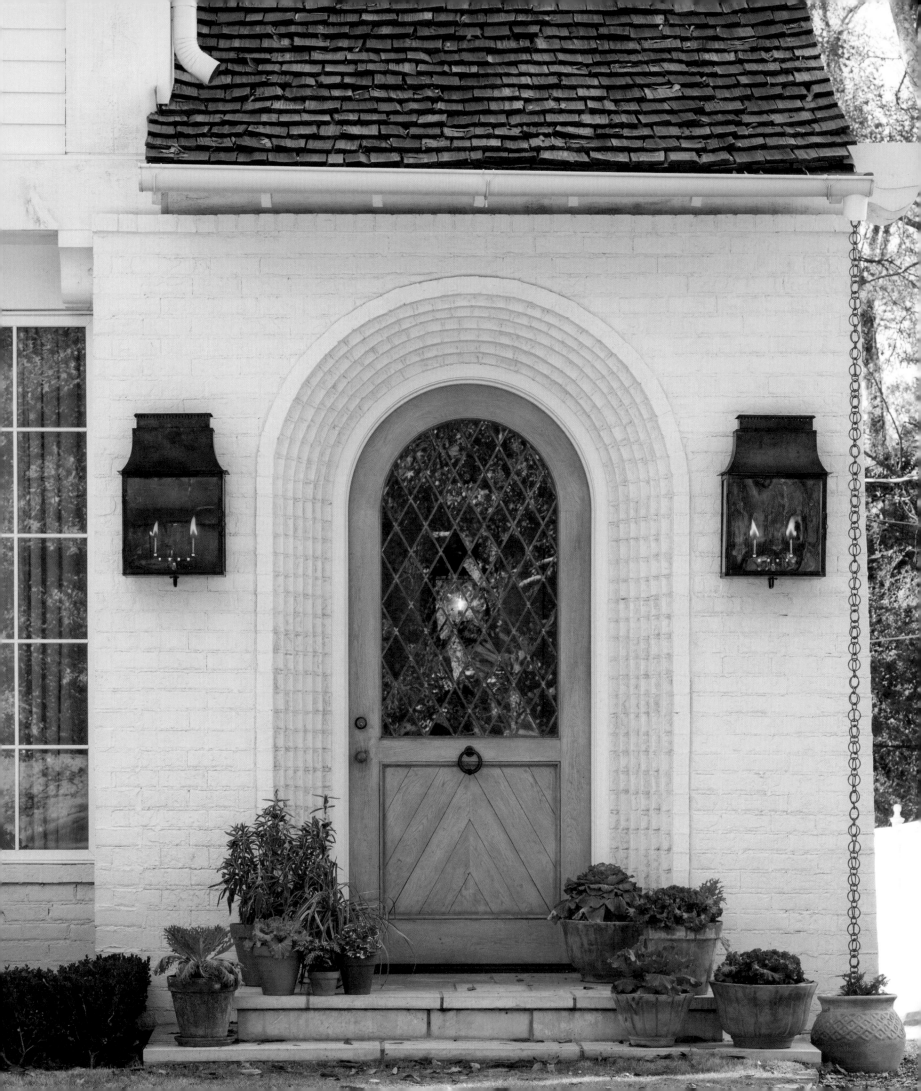

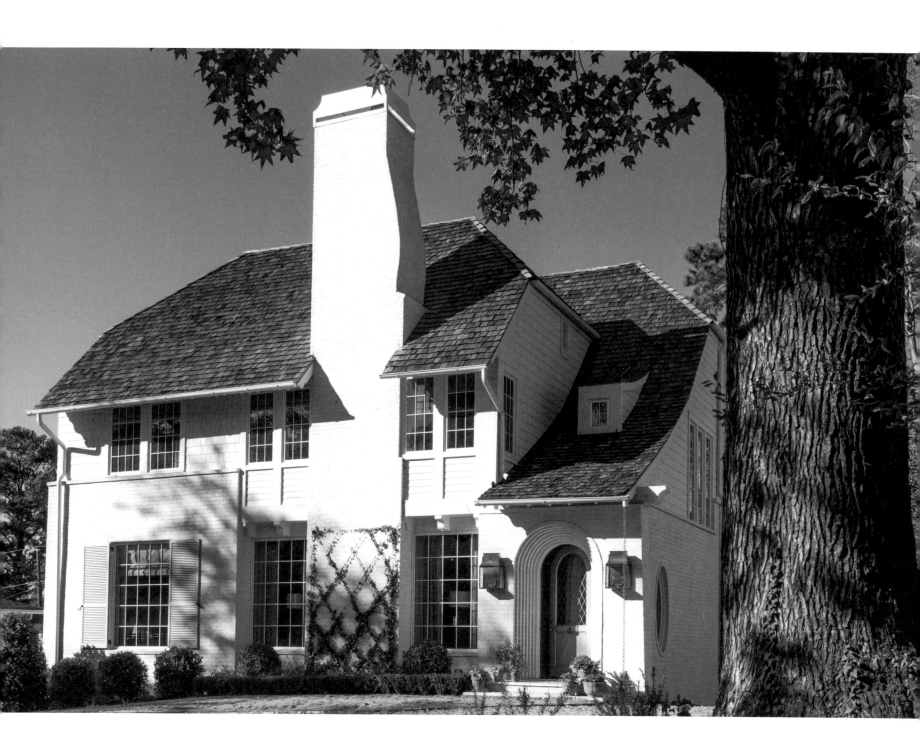

First Impressions

THE WELCOMING EXTERIOR OF THIS HOME IS ONLY
A PEEK AT THE BEAUTY THAT LIES WITHIN.

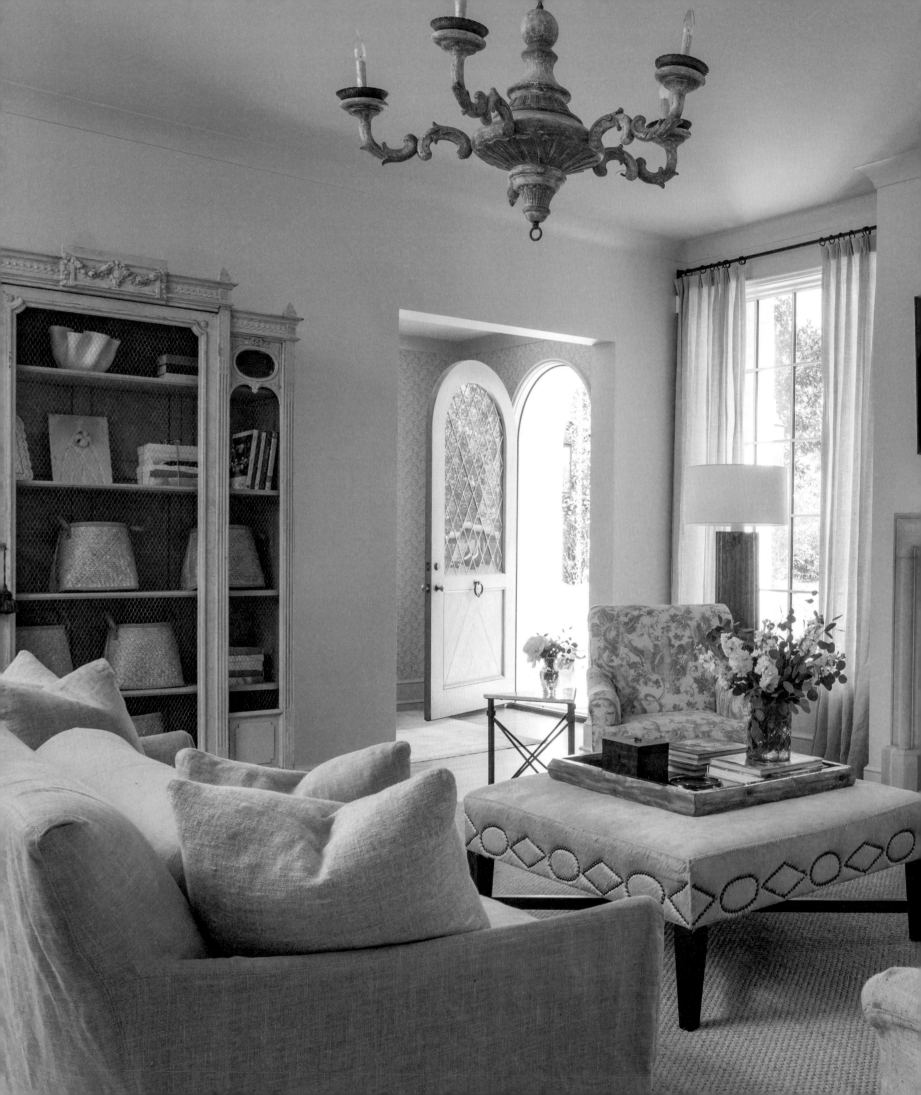

From the first glance you get at the Gentrys' Alabama home, you're sure to be captivated. Its large chimney with an ivy-laden trellis brings attention to all the gorgeous windows of the home, but it's the stunning front entrance that beckons you closer. Large double-flame glass lanterns flank the doorway, and a French mansard roof sits overhead. Architect Richard Long designed a stylish entry that narrows into the arched Tudor-style front door, making it a focal point of the exterior.

Once inside, the interior envelops you in hospitality with a warm color palette, wood accents, and soft linen furnishings. In the living room, the eye is immediately drawn to the ornate French-style chandelier above, while a lightly colored leather ottoman with nailhead trim and dark wood legs acts as a coffee table for the space. The limestone fireplace with detailed trim is also a prominent feature. Highlighting the French influence she wanted in the home, homeowner Rachel Gentry added a distressed wood china cabinet filled with antiques and family treasures.

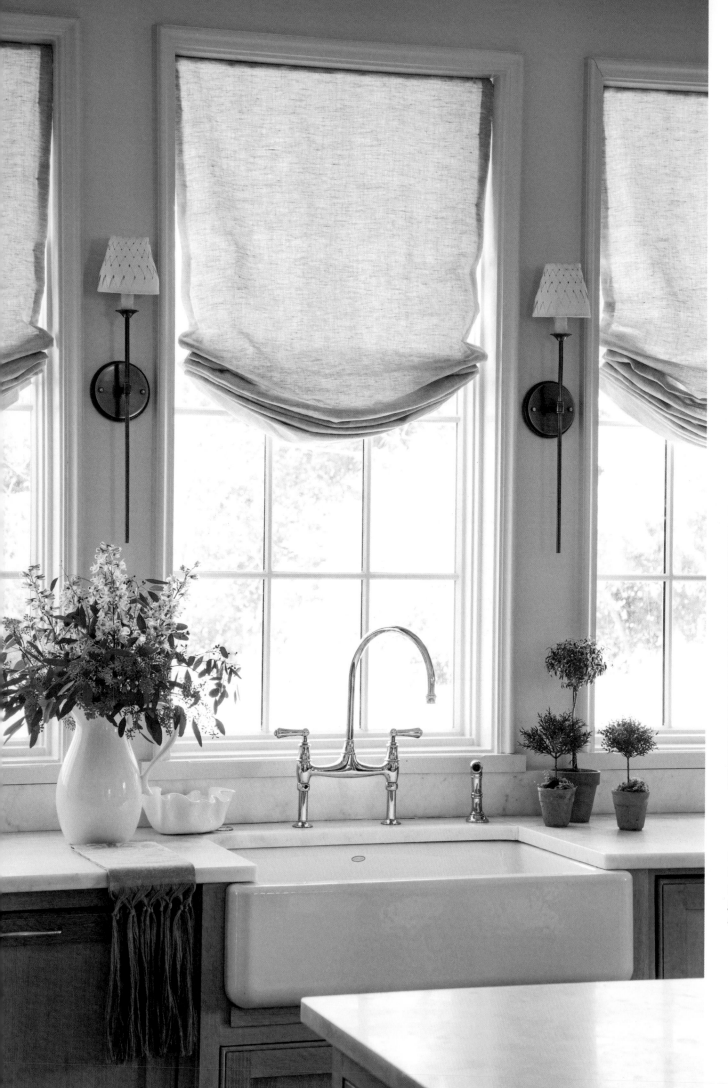

Rachel and interior designer Meredith Sherrill had fun mixing metals in the kitchen, including gold sconces that hang right above the platinum faucet.

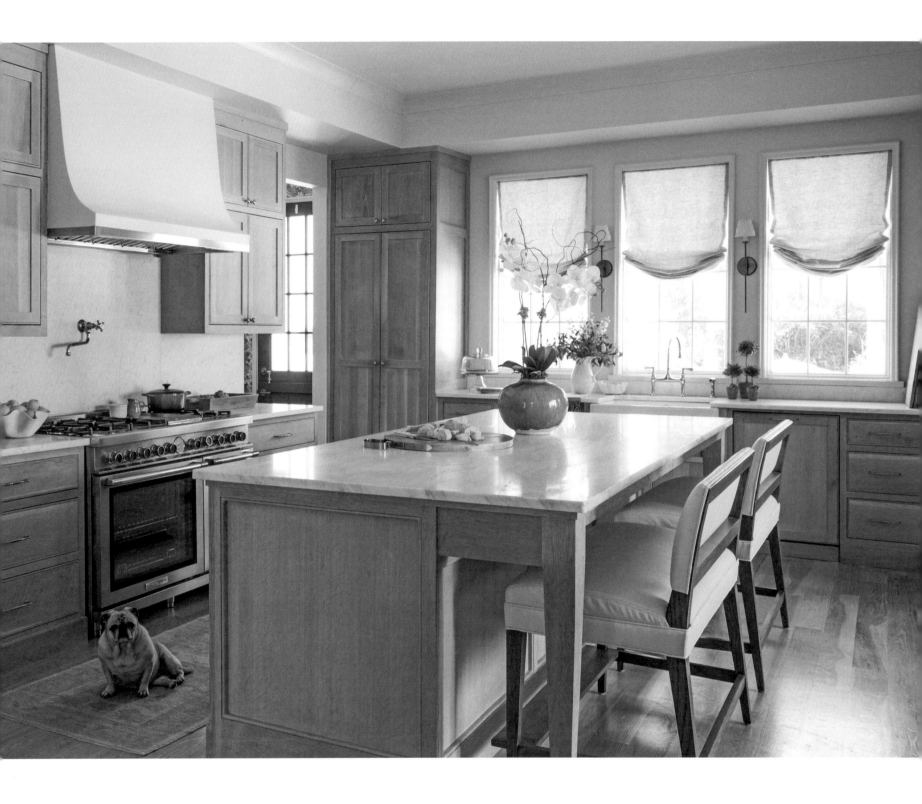

The open-concept kitchen is sophisticated but cozy with light wood cabinetry acting as a grounding element in contrast to the light and airy marble countertops and backsplash. A favorite feature of the kitchen is the wall of windows with linen Roman shades that let in plenty of natural light. For an elegant accent, Rachel hung gold sconces in between the windows. In addition to the French-country style of the space, aged elements like terra-cotta pots, rubbed brass hardware, and a farmhouse sink give the interior an Old-World feel that Rachel hadn't originally planned for, but ended up falling in love with.

Elegance is exemplified in the dining room, particularly by the crystal-laden gold chandelier that hangs right above the farmhouse-style table, creating a beautiful blend of Parisian chic and French country. On one side of the room, Rachel displays her collection of silver next to antique oyster plates, which she admits she doesn't currently collect but hopes to one day. Below, a dark wood buffet with detailed etching provides storage for the family's china.

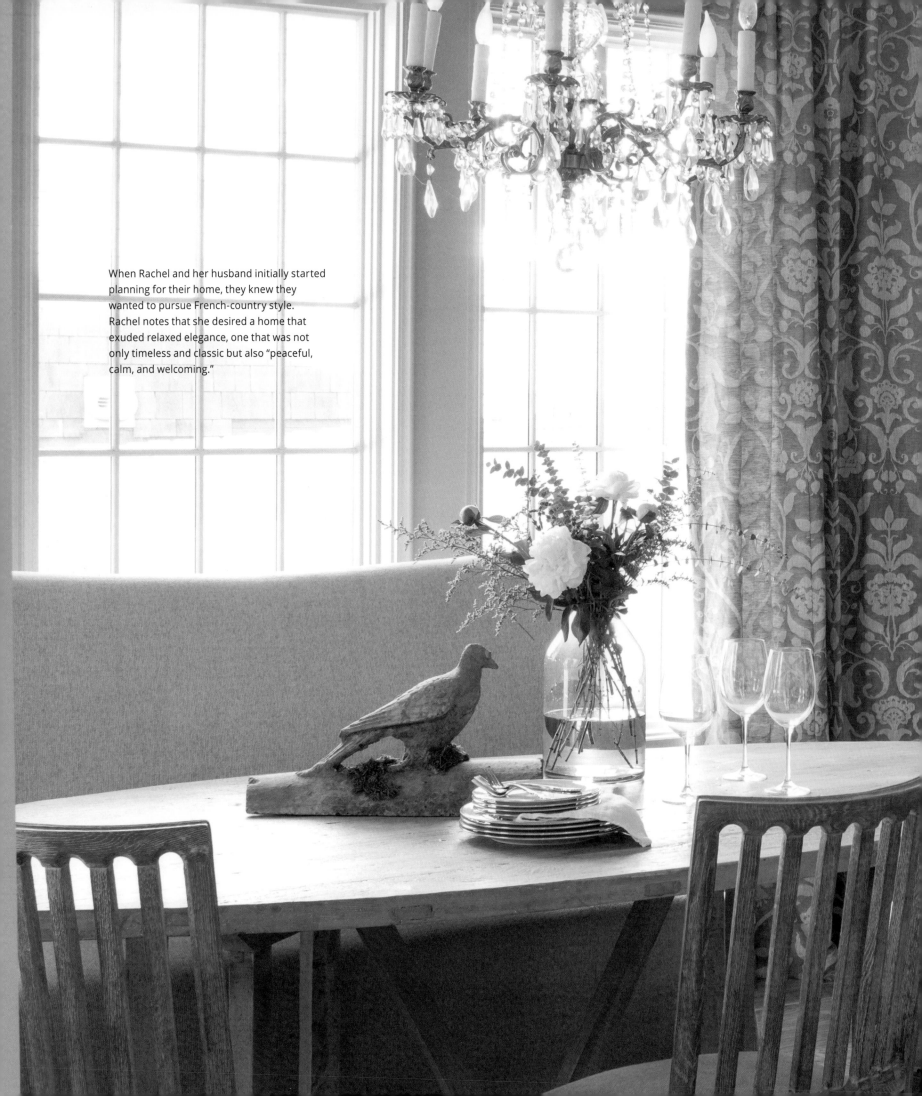

When Rachel and her husband initially started planning for their home, they knew they wanted to pursue French-country style. Rachel notes that she desired a home that exuded relaxed elegance, one that was not only timeless and classic but also "peaceful, calm, and welcoming."

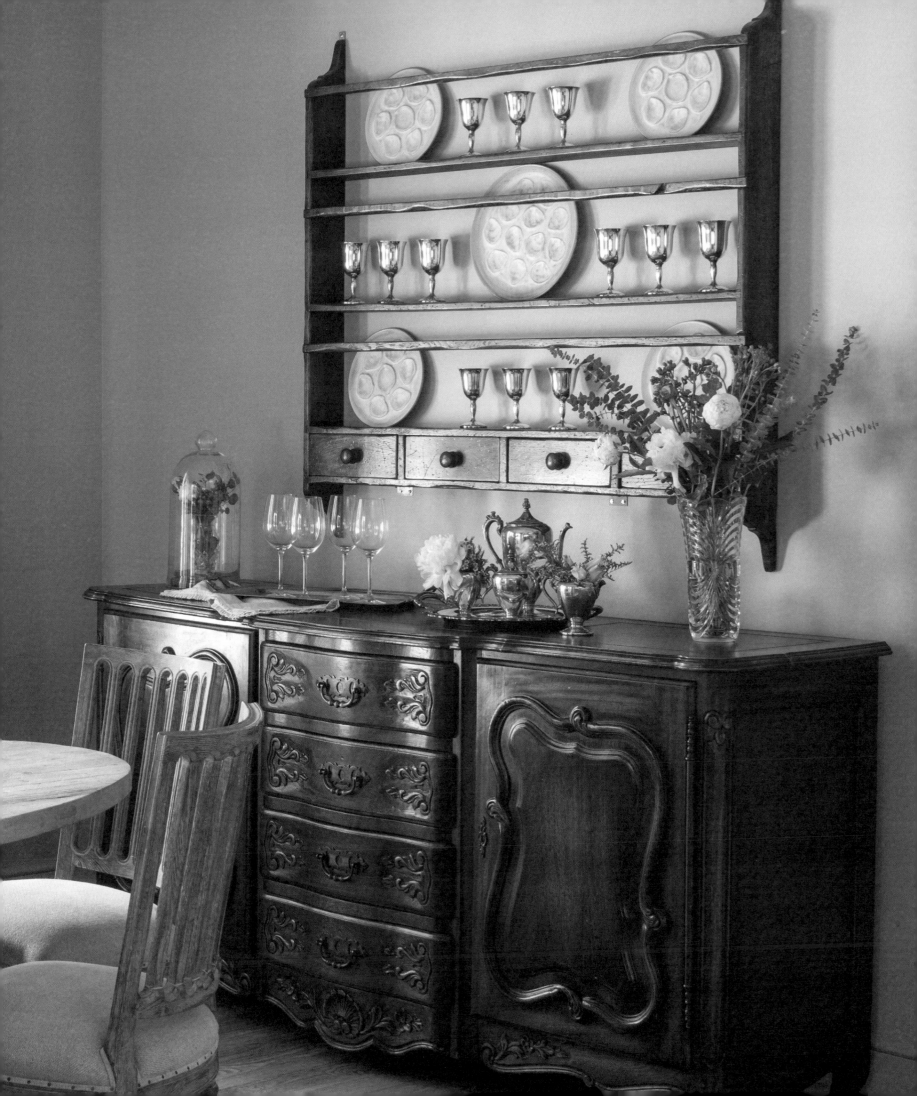

The master suite is a tranquil retreat for the couple. Their black iron bed with linen-upholstered headboard is a beautiful blend of contemporary lines and classic style. The couple's interior designer, Meredith Sherrill, had the unique idea of highlighting the lines of the canopy bed with two rattan-shaded lamps with gold arms that are installed above the headboard. The warmth of the rattan shades echoes the vintage-style wood-and-wicker bench under the large window in the space. In the master bath, the mix of contemporary and classic styles continues with a sleek, modern tub; a gilded French-style stool; and hexagonal tiles, which provide a pop of visual interest.

From floor to ceiling, the Gentrys' home is exactly what they had hoped for when they first started building in 2017. Timeless and classic, the house might be a new build, but the warmth and coziness that fill it provide a comforting welcome to all who enter, even from the first impression.

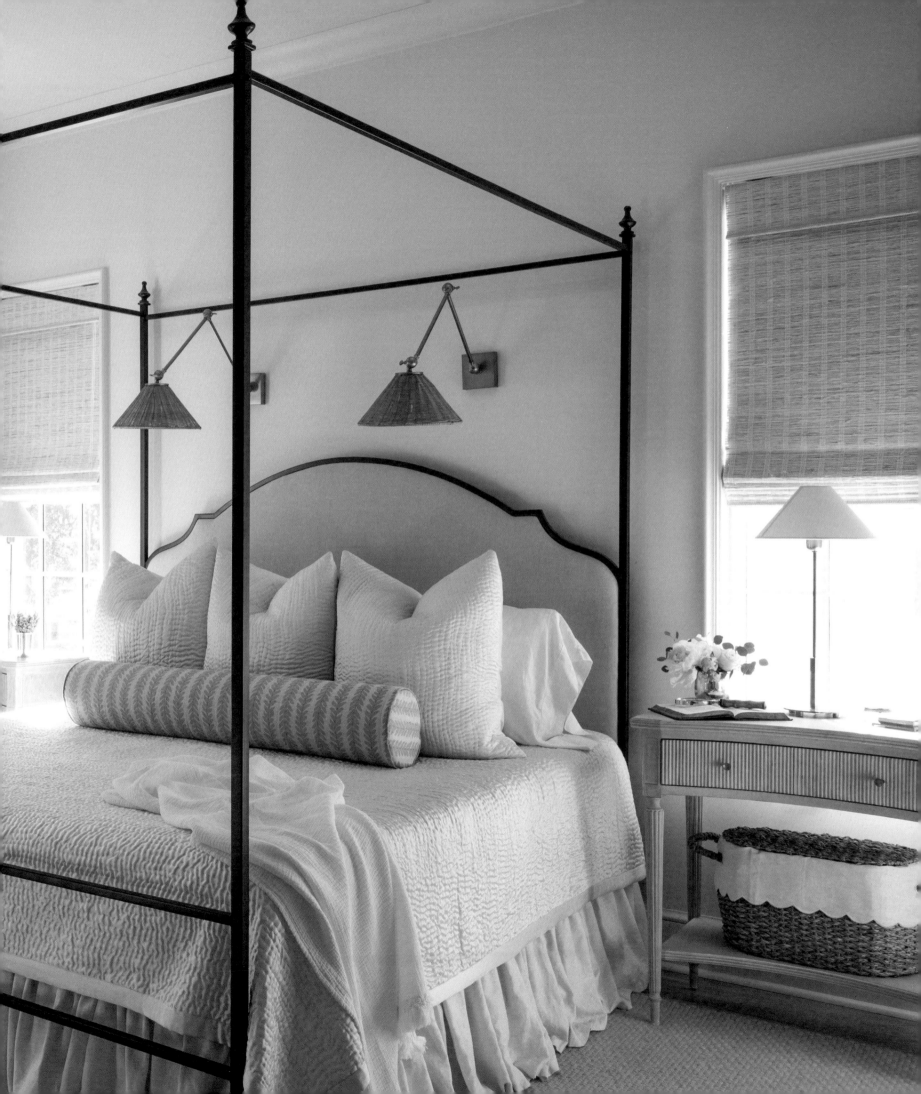

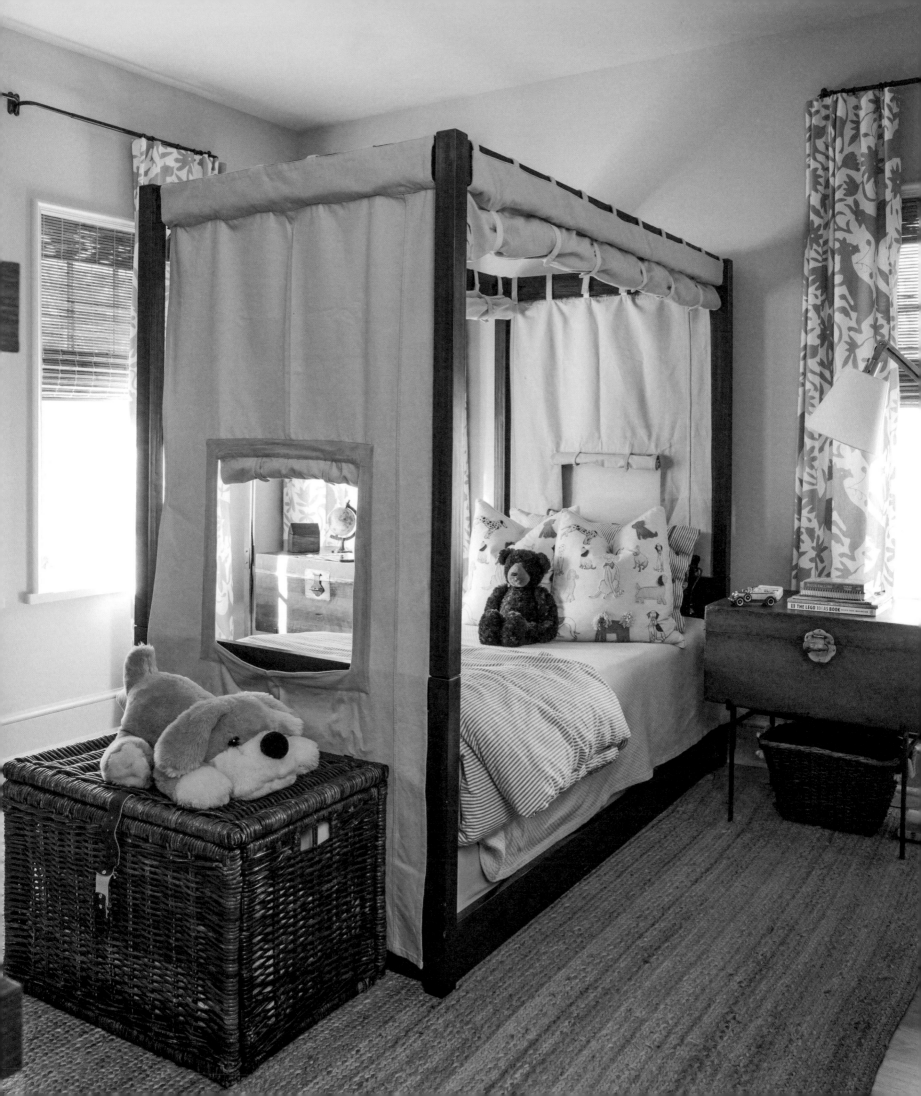

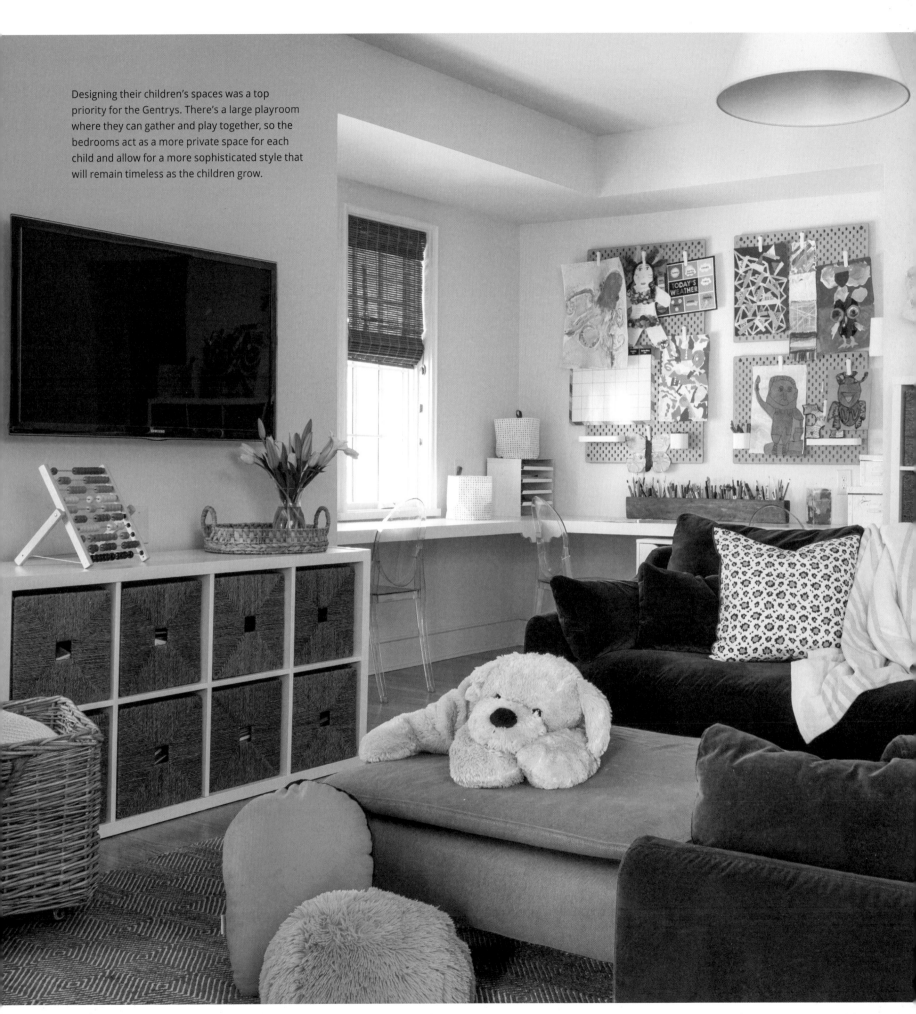

Designing their children's spaces was a top priority for the Gentrys. There's a large playroom where they can gather and play together, so the bedrooms act as a more private space for each child and allow for a more sophisticated style that will remain timeless as the children grow.

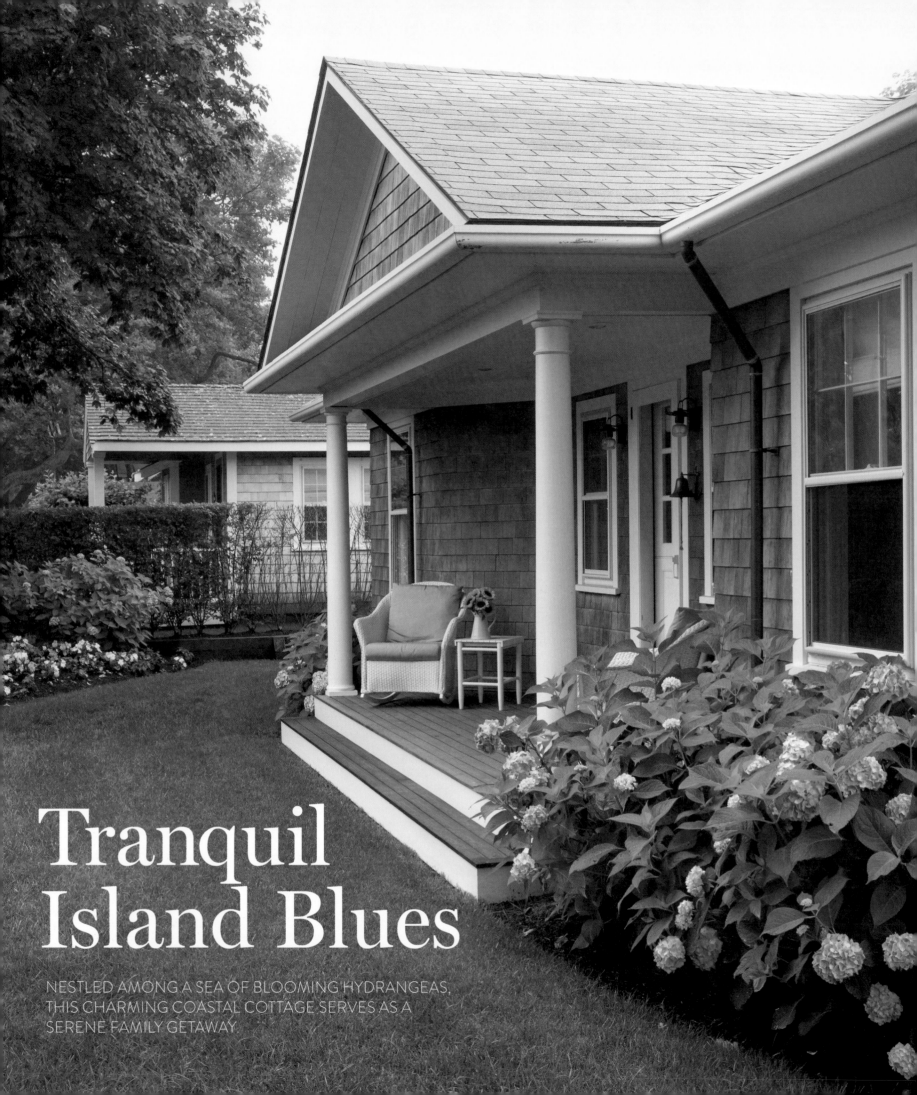

Tranquil Island Blues

NESTLED AMONG A SEA OF BLOOMING HYDRANGEAS, THIS CHARMING COASTAL COTTAGE SERVES AS A SERENE FAMILY GETAWAY.

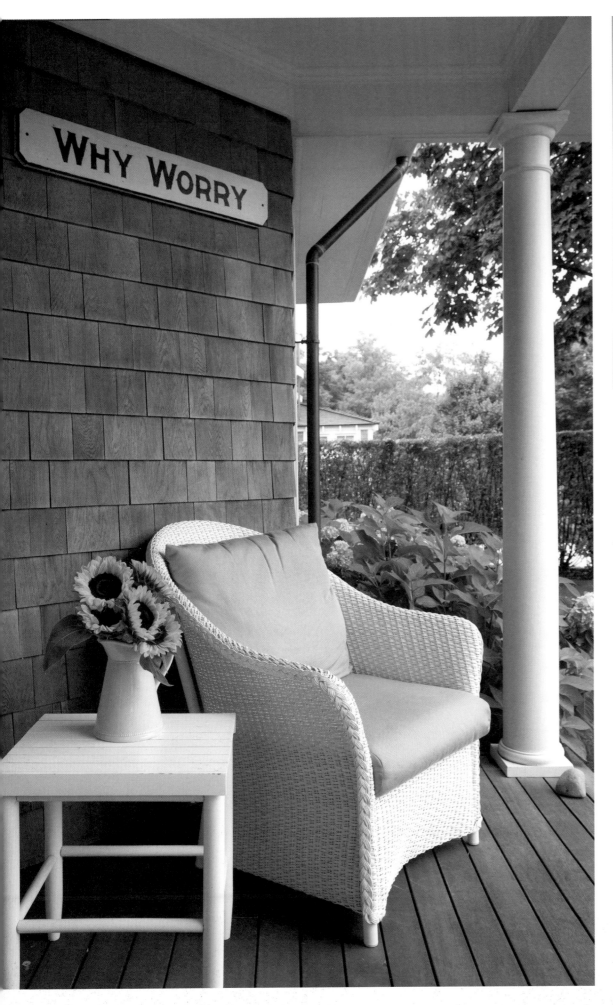

A s you approach the front porch of Julie Forgaard's seaside cottage, the wooden quarterboard reading, "Why Worry" sets the tone for this New Hampshire family's idyllic vacation home on the historic island of Nantucket, Massachusetts. Each room beyond the welcoming Dutch door hosts a cozy, comfortable place specifically designed for family.

The Forgaards purchased the quaint Siasconset cottage in 2009—but their love affair with coastal retreats started long before then. Julie is quick to share that she's been a beach person all her life. She grew up in New Jersey, spending her summers on the Jersey Shore, and as an adult she has explored nearly all of the New England coasts with her family. Before buying their beach bungalow, the Forgaards had been renting homes on Nantucket for nearly 10 years. "When the market dropped, we looked at each other and said, 'If we're ever going to buy a beach house, this is the moment,'" Julie recalls.

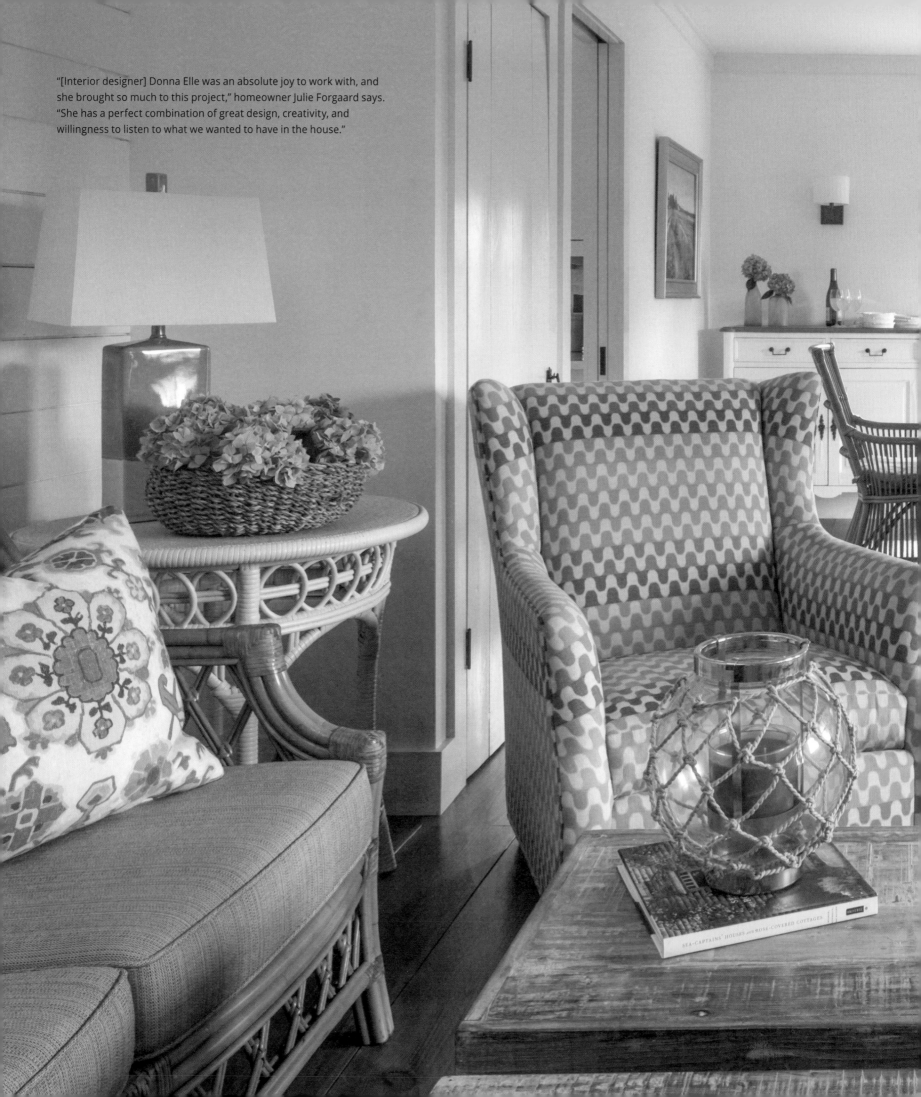

"[Interior designer] Donna Elle was an absolute joy to work with, and she brought so much to this project," homeowner Julie Forgaard says. "She has a perfect combination of great design, creativity, and willingness to listen to what we wanted to have in the house."

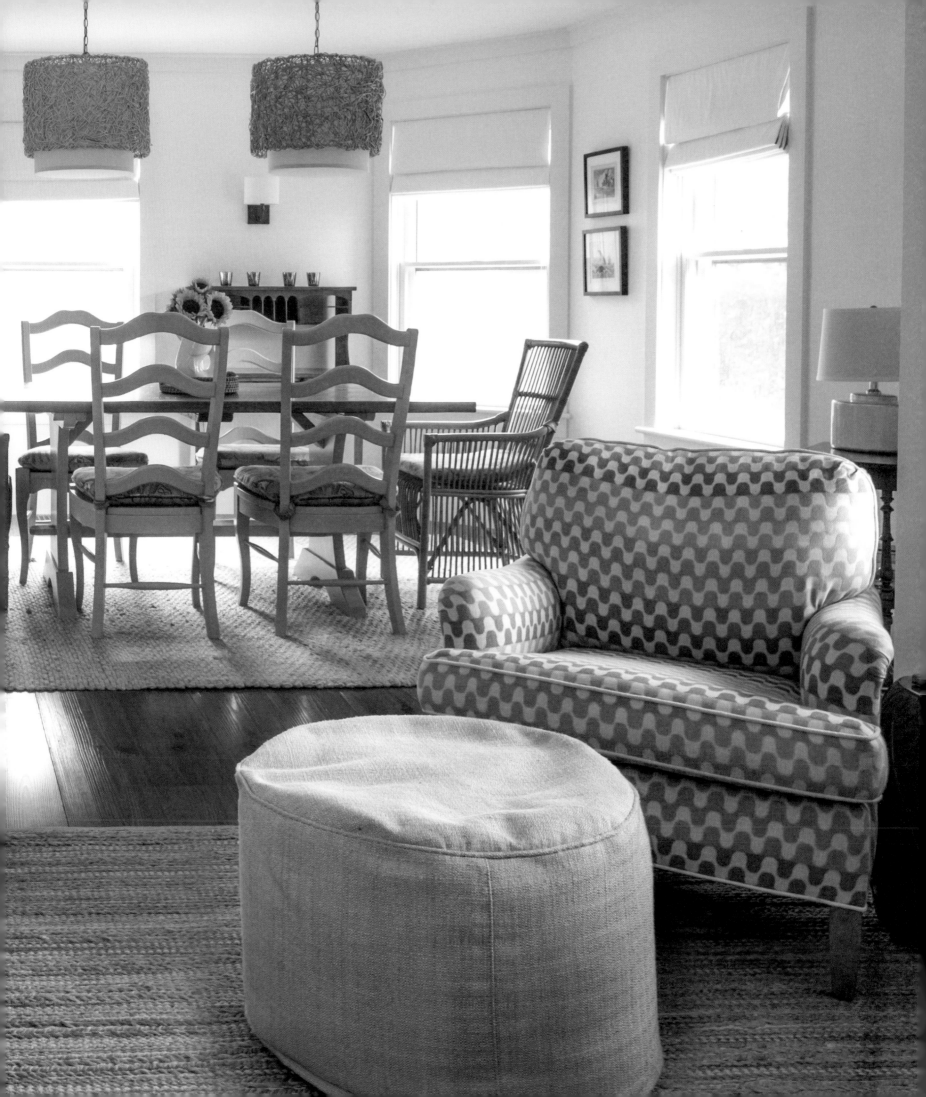

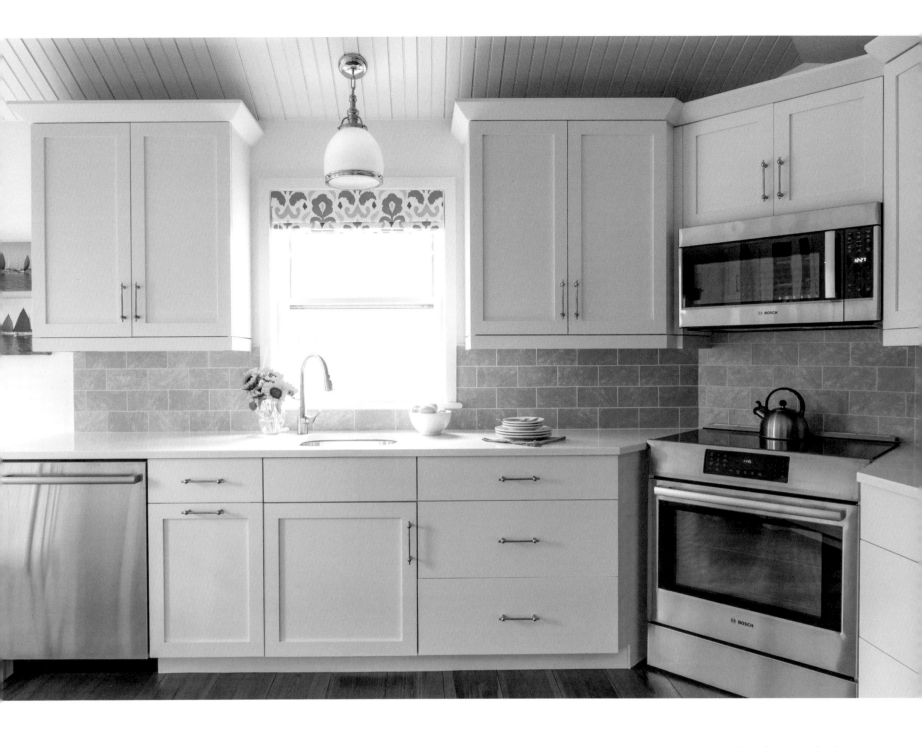

At first, the cottage was "just a summer house," Julie says, noting it was an older property that was originally built on piers. "It had no heat to speak of, and you could see straight through the gaps in the floorboards. You couldn't use it at all in the cold months, and that was something we really wanted to be able to do." After living in the home for a number of years, thoughtfully taking their time to identify the needs of the home, they decided to make the necessary changes to enjoy the cottage year-round.

With the help of Nantucket interior designer Donna Elle, the Forgaards forged a creative and comfortable renovation plan and design scheme, and together they layered the cottage with stylish, livable design elements dressed in peaceful blues that mirror vibrant hues found on the island. Julie's love for a timeless blue-and-white motif seamlessly married with Donna's excitement to explore the classic hue in a fresh way. "I'm a blue girl; always have been and probably always will be," Donna says. "No matter if it's mixed with another color, painted, tile, or textile—it is my interpretive dance throughout my interiors."

Donna's thoughtful eye for design was key to weeding through the quagmire of decorative choices ahead of the family. "This is old Sconset, Nantucket, feel with a nod to the bungalow era," she says. "Personally, my heart resonates with cottage and traditional style, and I love the challenge of interpreting modern elements."

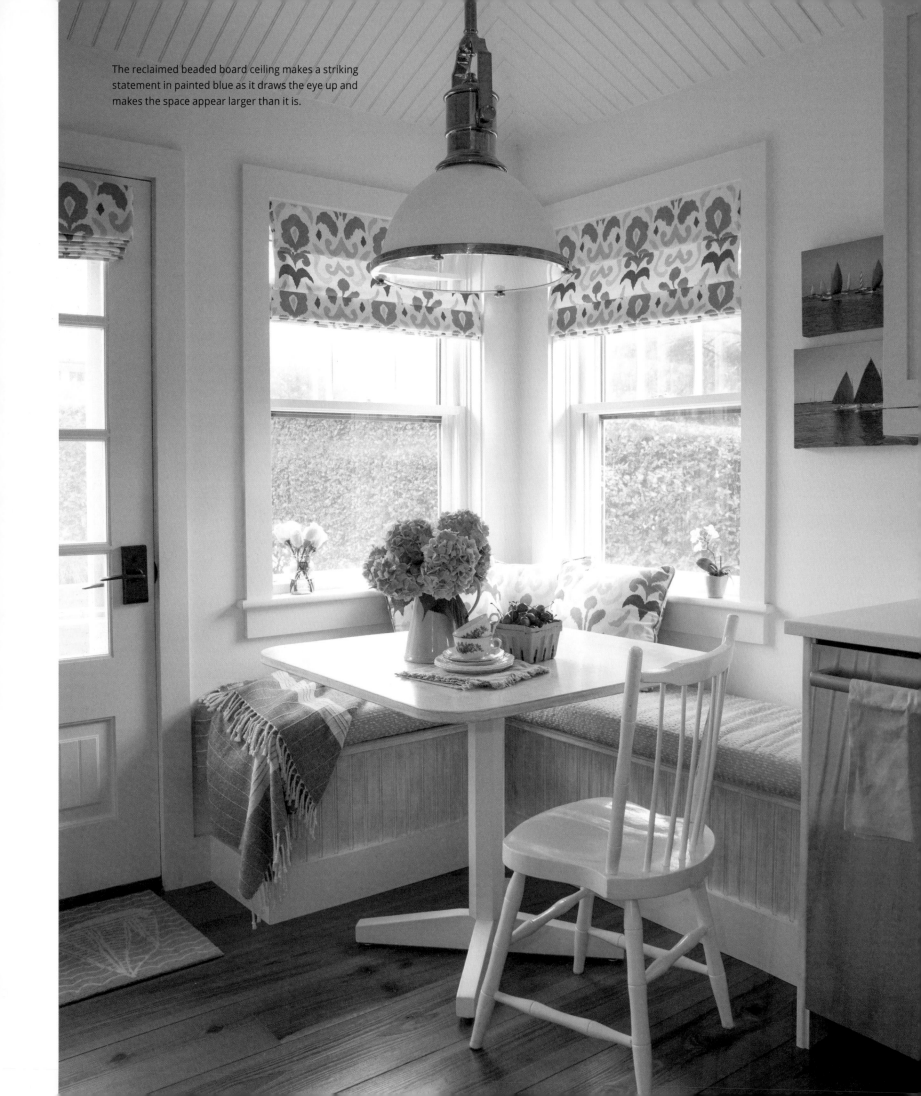

The reclaimed beaded board ceiling makes a striking statement in painted blue as it draws the eye up and makes the space appear larger than it is.

Throughout the renovation, they chose to keep everything true to its original character. "Our goal in doing the renovation was to keep it exactly as it was, as much as possible. We really didn't want to change the interior or add square footage," Julie says. "What we wanted to do was make it livable year-round."

And while the home's footprint stayed nearly the same, the house itself was in such abysmal condition that a gut renovation was essential. The entire island is a historic district, so getting permit approvals often proved a challenge. But Julie and her family welcomed the hurdles as a worthwhile experience. "It was a challenging process, but I'm so happy we went through that because it really was beneficial," she says. After two years of tedious design work, the cottage renovation was completed in 2015.

"Every time we go there, we are struck by the fact that we love this house," Julie says. "We just love being there. It is cozy and charming and so livable. It's really just a perfect place."

"My favorite thing about the house is our bedroom," Julie says. "It's a little square room with the painted peak ceiling. When we crawl into bed in there, it just feels like we're in this little jewel box. It is so charming with the bank of windows behind our heads with the breezes blowing. It really is a beautiful little room."

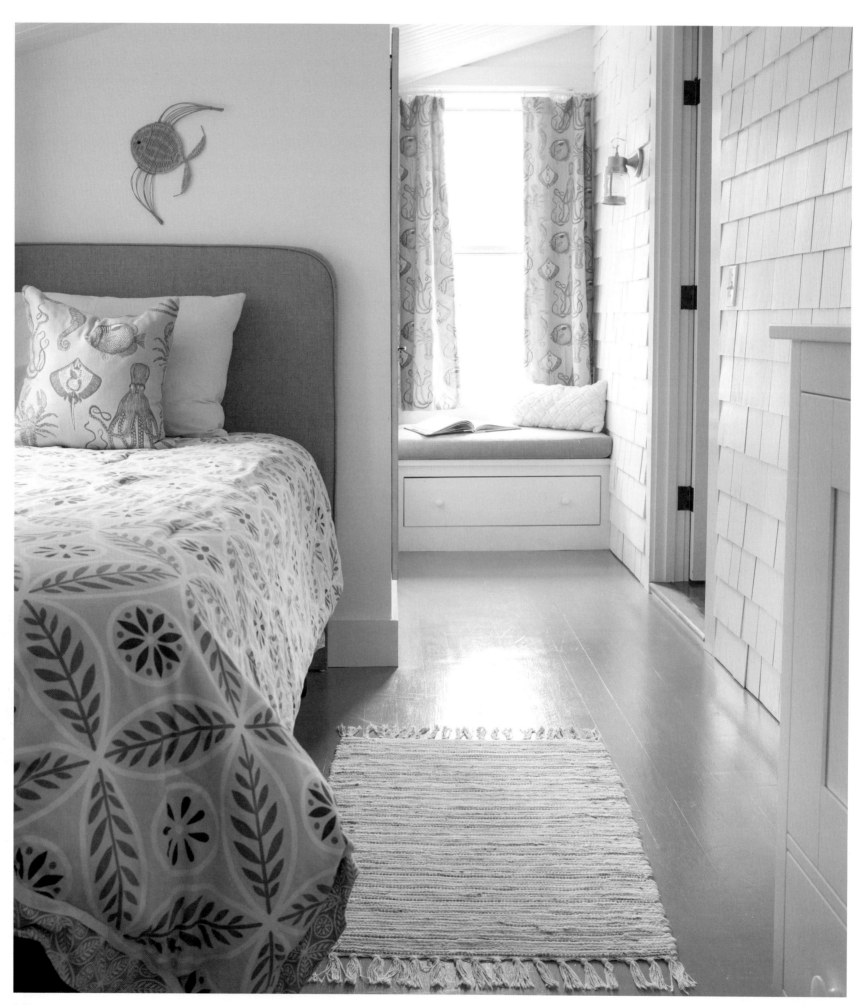

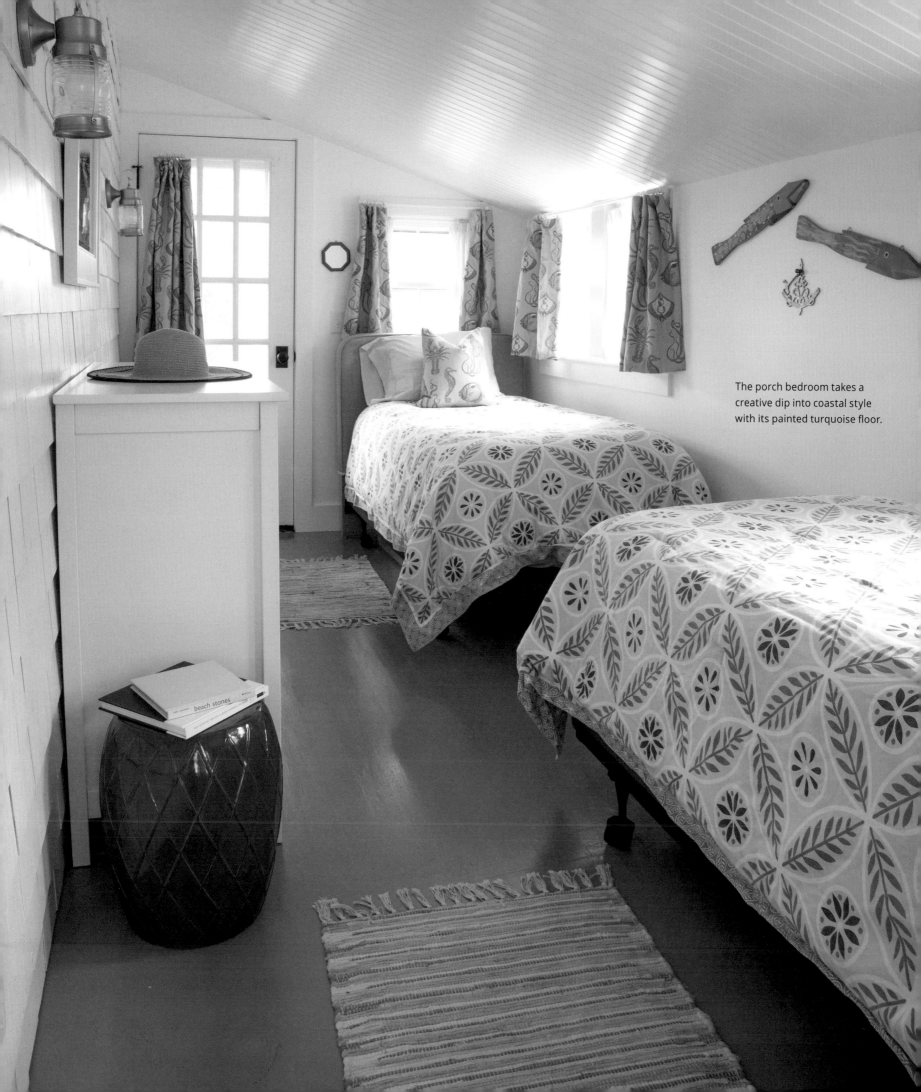

The porch bedroom takes a
creative dip into coastal style
with its painted turquoise floor.

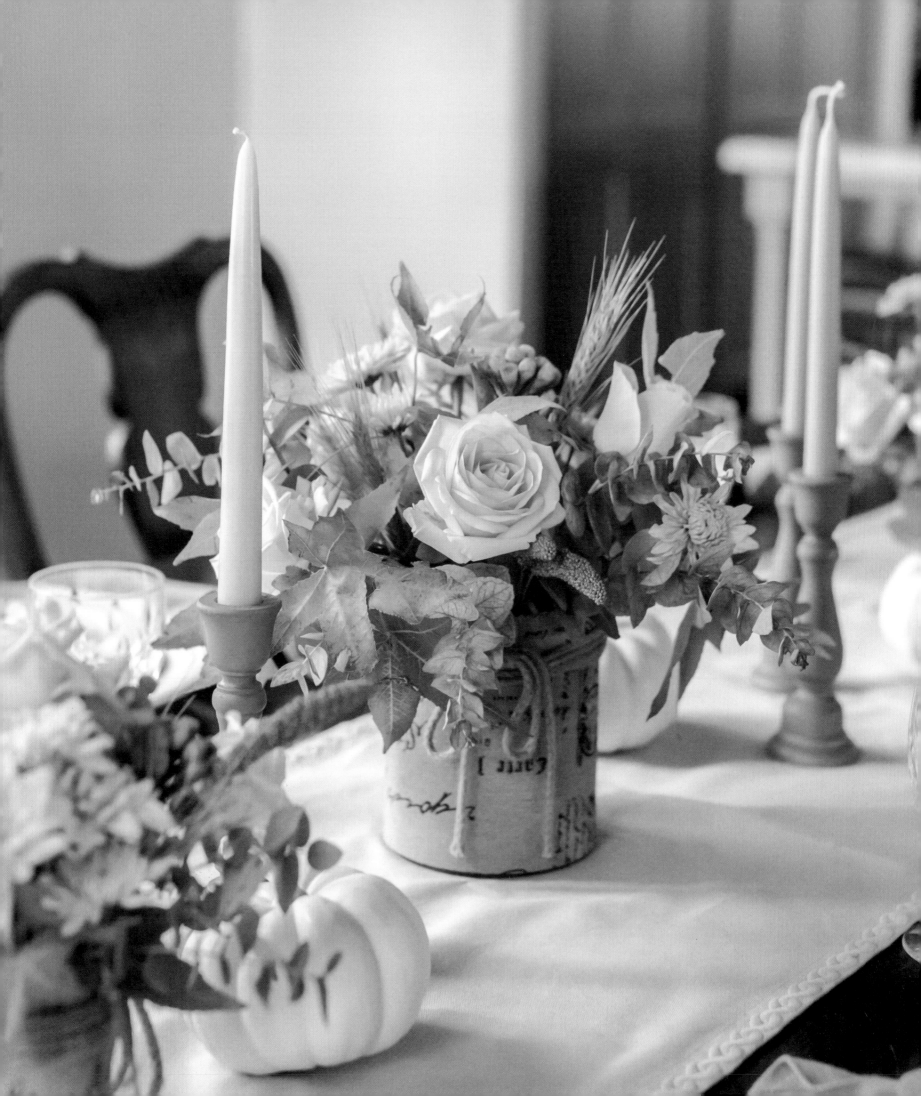

AUTUMN

MOUNTAIN VISTAS PROVIDE STUNNING BACKDROPS FOR
GARDEN COTTAGES DRESSED IN RICH FALL COLOR. COZY
SPOTS FOR ENJOYING THE SEASON ENCOURAGE RELAXATION
AND GATHERINGS WITH FAMILY AND FRIENDS.

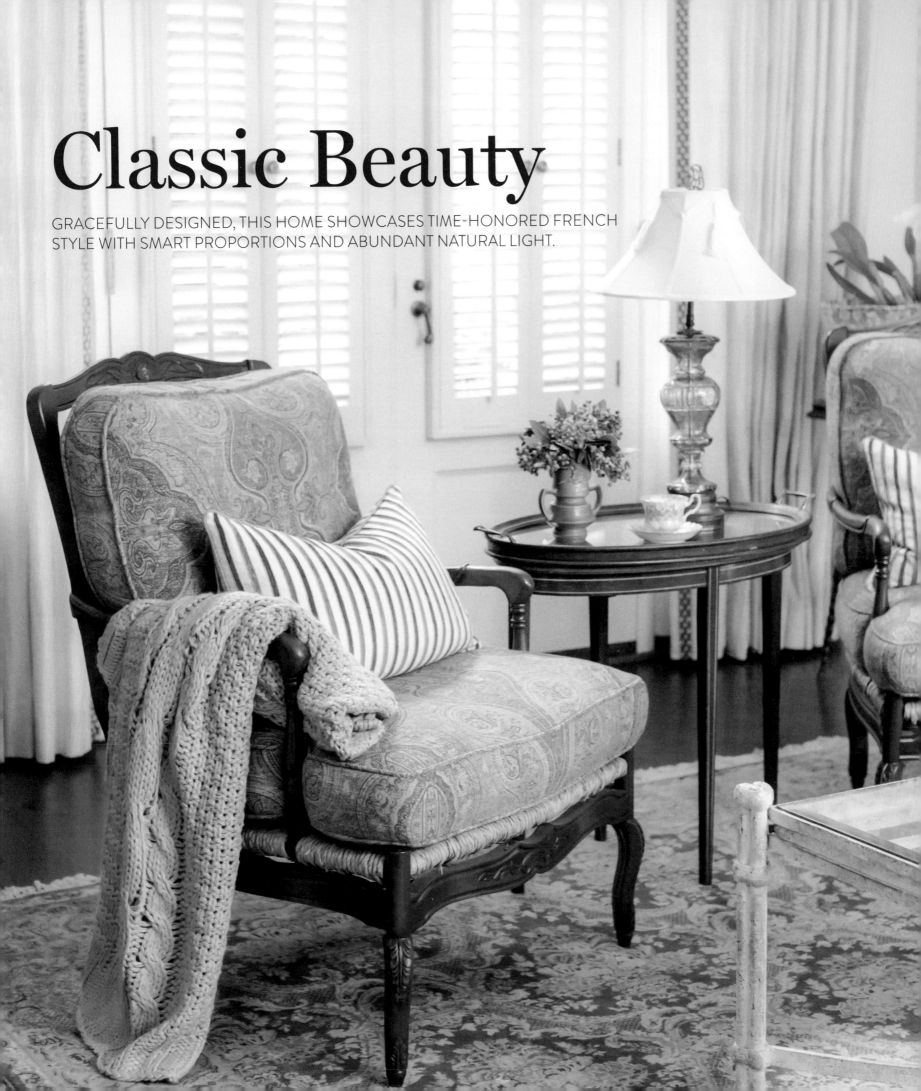

Classic Beauty

GRACEFULLY DESIGNED, THIS HOME SHOWCASES TIME-HONORED FRENCH
STYLE WITH SMART PROPORTIONS AND ABUNDANT NATURAL LIGHT.

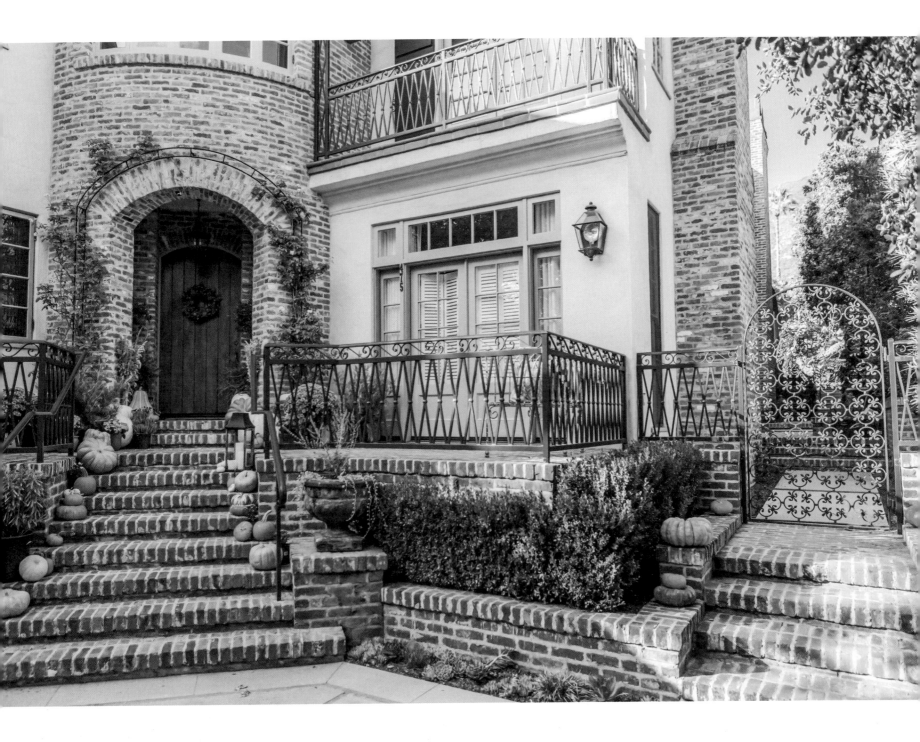

Having been in the construction business for more than 30 years in the San Gabriel Valley of Southern California, Tom and Mary Rose Courtney decided the time had come to build their own home. The couple worked with architect Bob Leese to create a design that was not only unique but also had a traditional feel. The Courtneys were also influenced by one of the South's premier architects, A. Hays Town, who was famous for his use of salvaged building materials like antique elements and aged wood, and the couple began to gather the historical finds needed to make the project a reality.

A New Orleans-style French influence is apparent in the Courtneys' design for the home's exterior entry, featuring a welcoming front porch arch, gas lights, and brick details. Upon entry, the hallway opens to a stairway leading to the second level where all of the bedrooms reside. With just over 4,000 square feet, the home's floor space is equally shared between the bedrooms and other living spaces.

The living room, with its 13-foot ceilings, shuttered French doors, and archways, feels more like a sunroom than a formal living area. The wood doors and ceiling details are made of Douglas fir, including the fireplace with its hand-carved medallions. The library features beautiful walnut

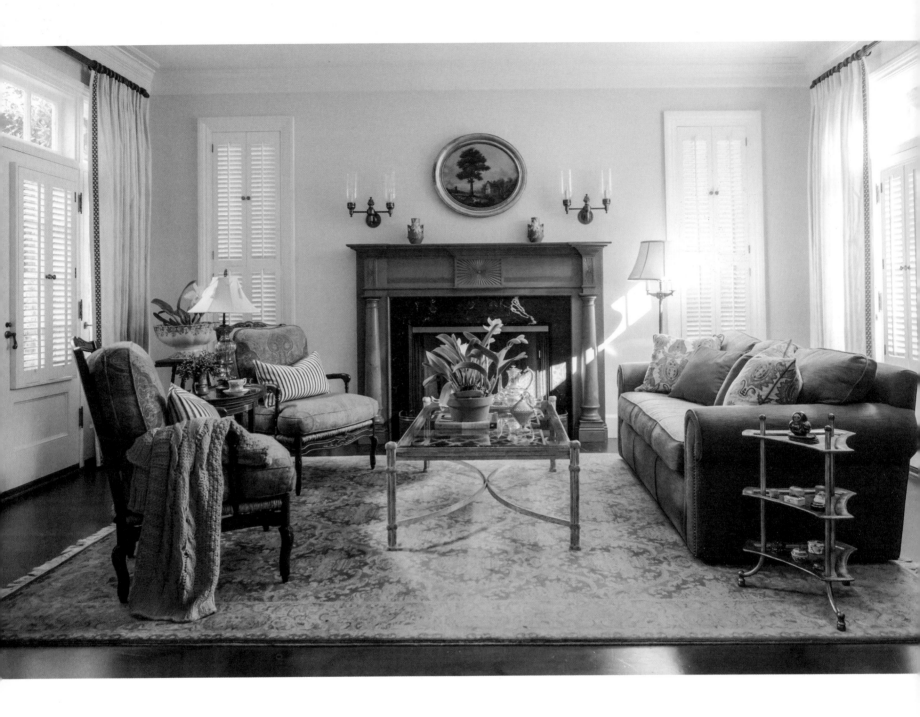

paneling and includes a Murphy bed to accommodate guests. Using a French-country style for the interiors with an eclectic mix, Mary Rose knew she wanted to include furniture she had treasured for years. She updated the upholstery and added new pillows to some pieces while placing antiques here and there, like a French writing desk, custom buffets, and credenzas that look like antiques.

The informal dining room features a round table for daily dinner and two custom-made leaded glass windows, which were designed using historic references by the owners. A small adjoining family room provides a cozy area to visit with family or guests.

With a blue-green hue, the kitchen cabinetry was handcrafted for a classic warm and ageless appeal. Reminiscent of Acadian style, the backsplash consists of French tile adding warmth and complementing the coral-colored walls and décor in the dining room. The countertops are Michelangelo marble, which features tones of blue winding through the natural pattern. The cabinetry in the kitchen area and family room and the hutch in the dining room were all handcrafted by a local company, Expression in Wood.

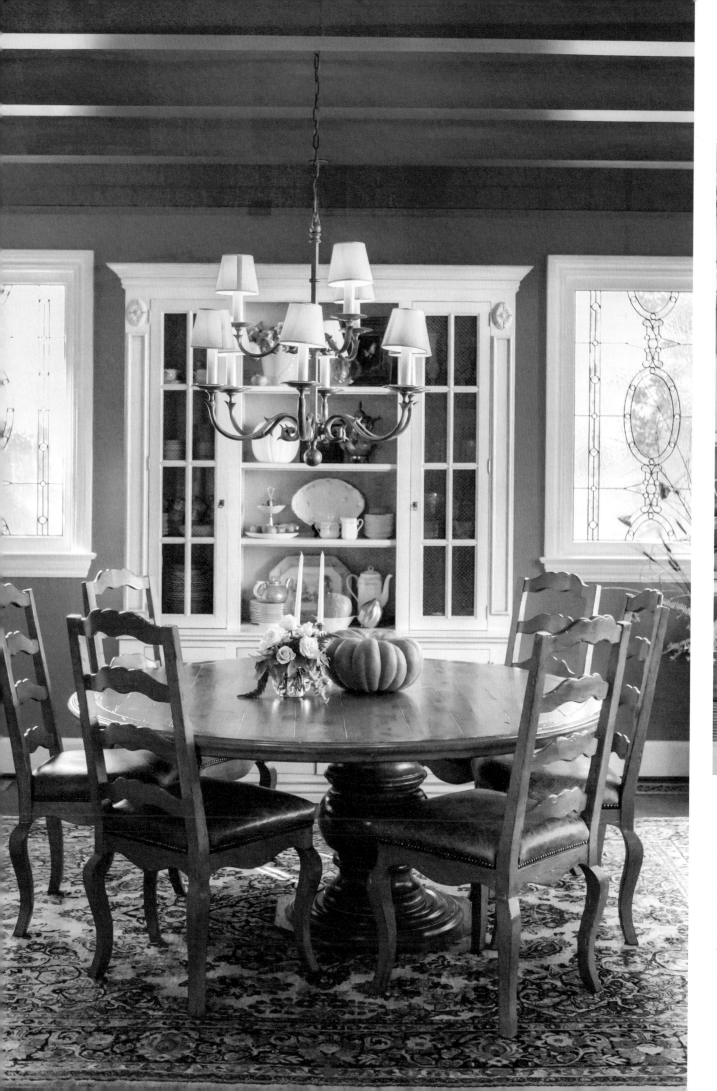

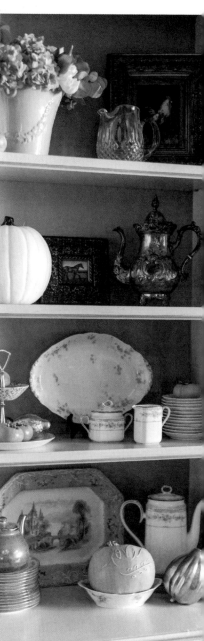

"Our family loves to cook and dine together, which is why we wanted an open concept with higher ceilings in the dining and kitchen areas," says Mary Rose. A custom buffet is a showcase for collected heirloom trays, pedestals, and serving pieces allowing a lovely display of tall proportions.

125

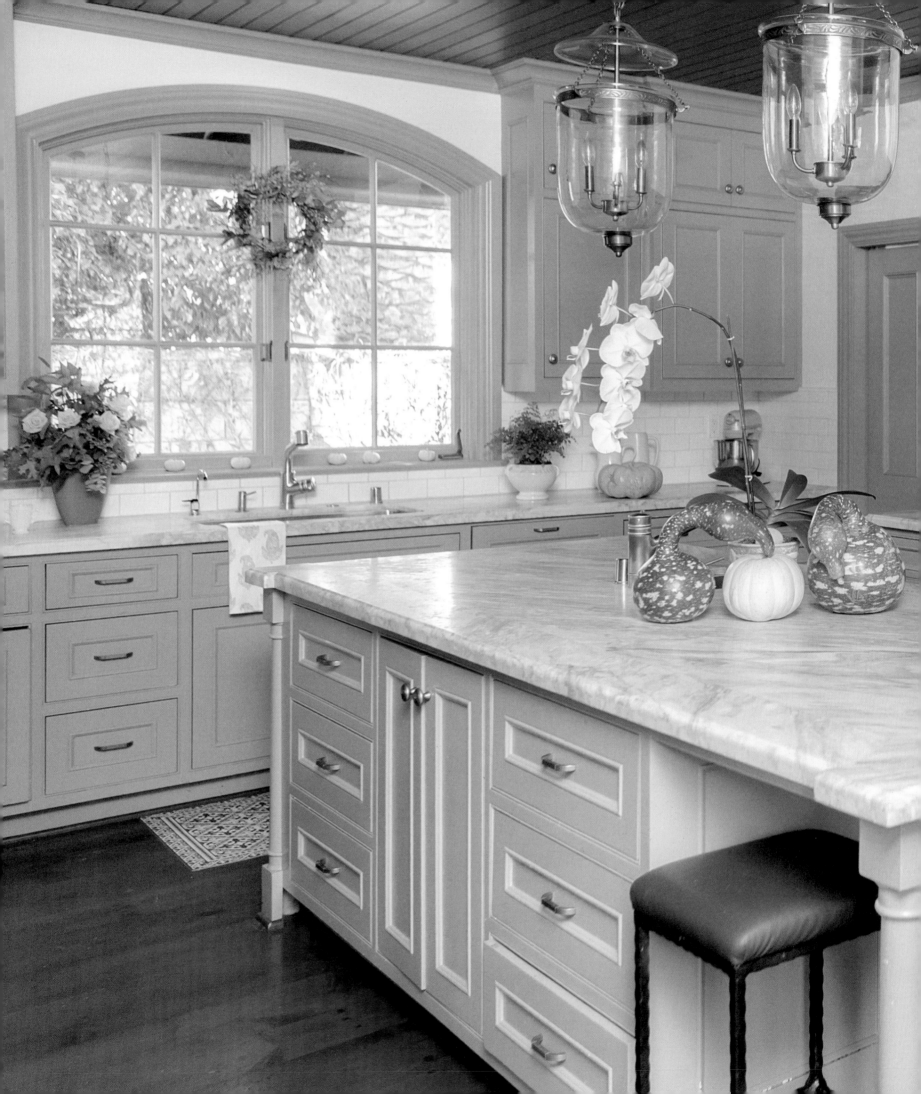

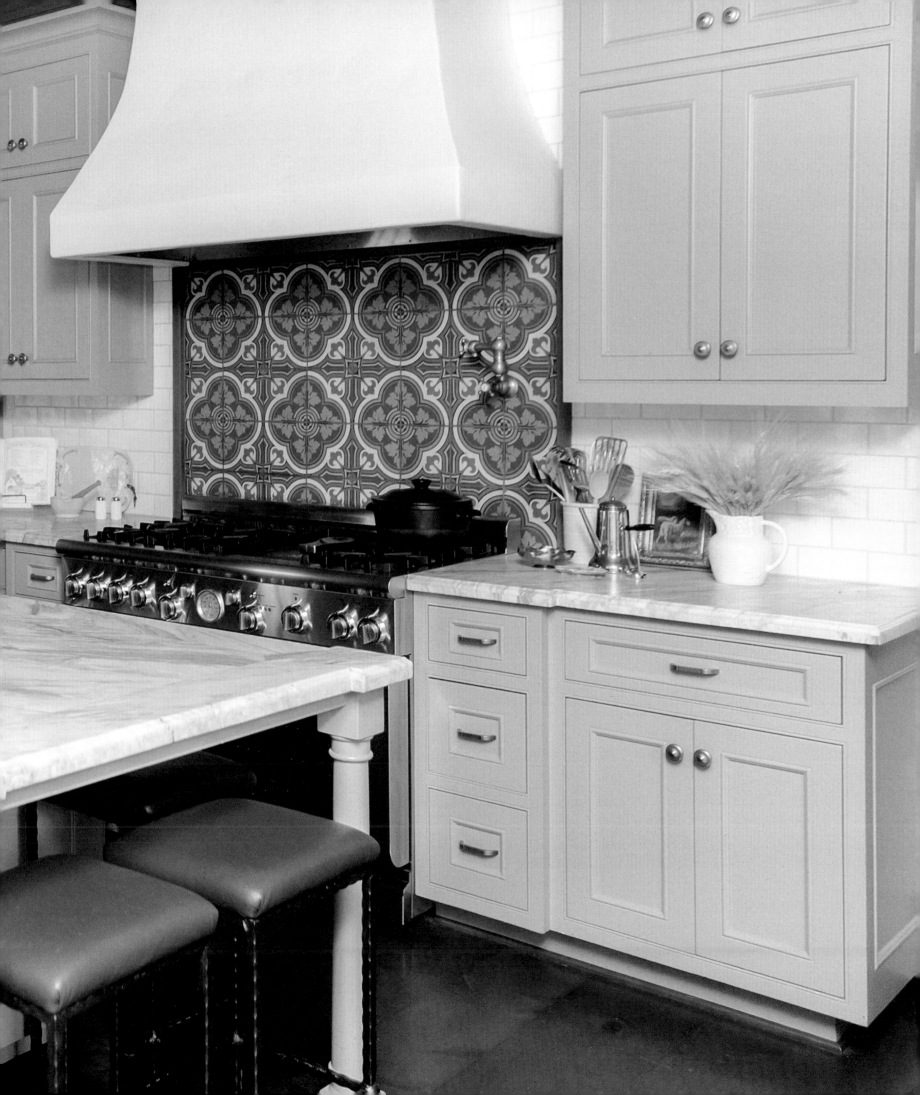

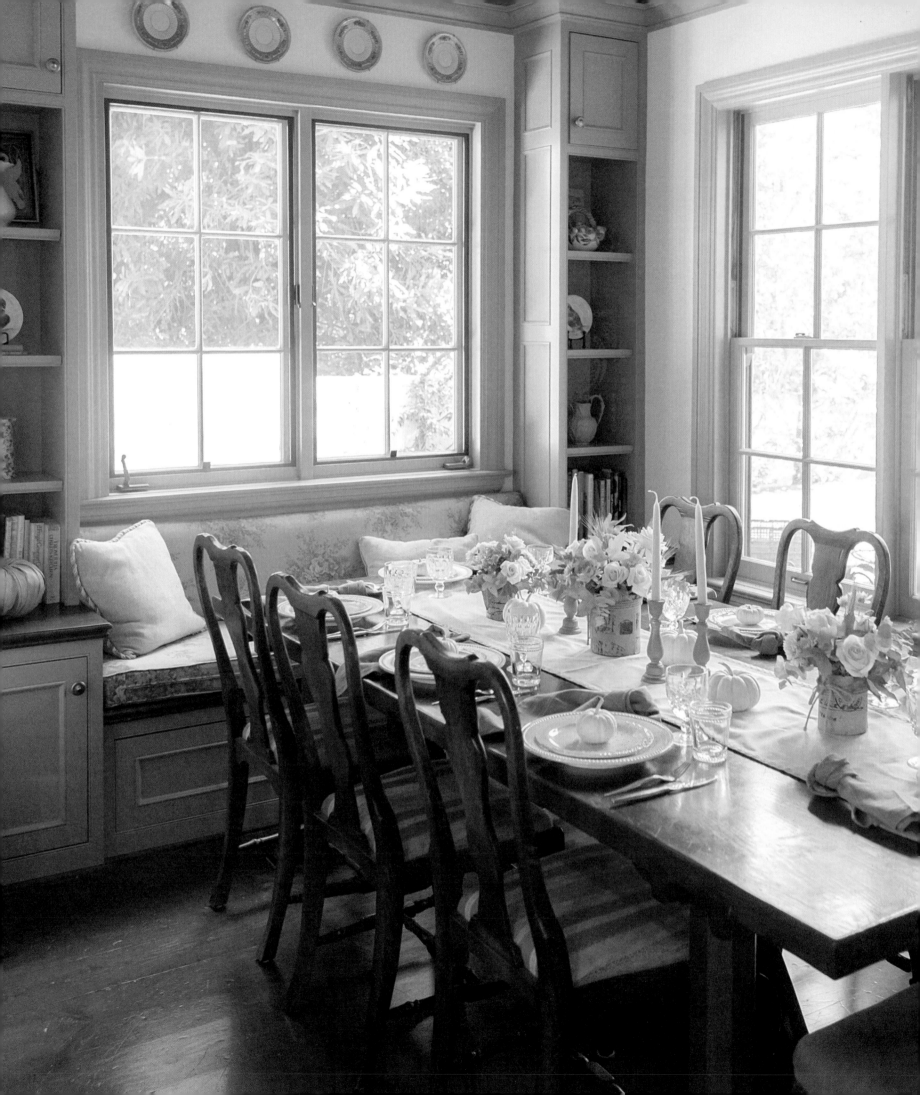

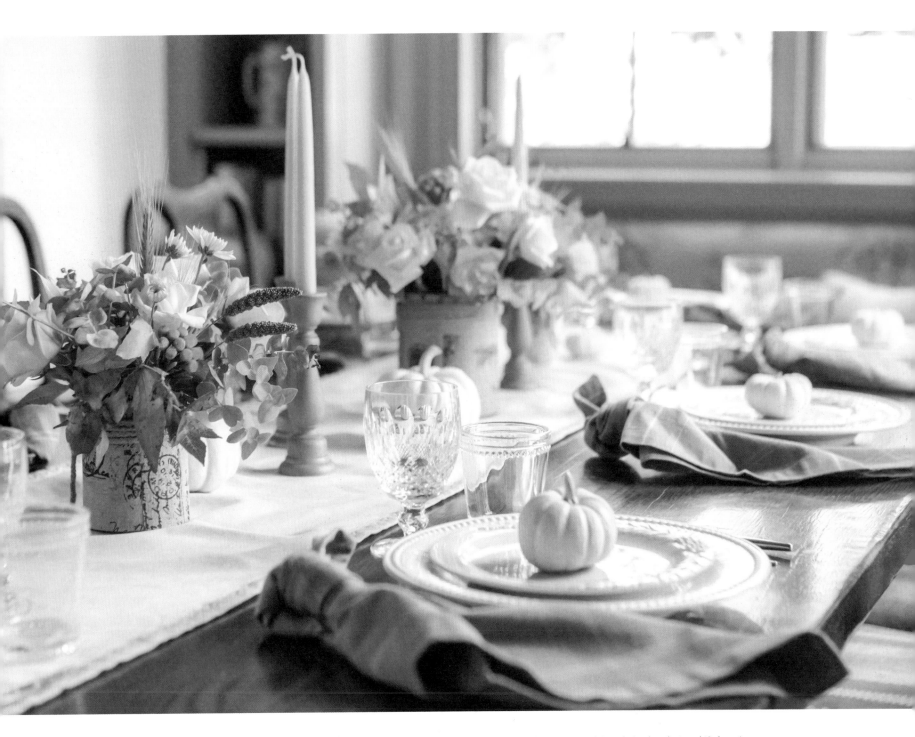

Welcoming guests to dine together, a harvest tablescape is set for eight with white pumpkins, vases of 'Peach Avalanche' and 'Sahara' roses grown in California, locally grown dahlias, eucalyptus, and fall leaves. Tapers in wooden candleholders add a bit of elegance to the setting along with plaid napkins. Fabrics in the family room and kitchen are classic Ralph Lauren patterns that emphasize the design. The window seat nook adds convenient additional seating to the kitchen table.

Outside are comfortable areas to relax and entertain with dark rattan furnishings accented with black-and-blue patterned pillows. The back of the home provides a restful outdoor room arranged with plush furniture in light gold upholstery. Garden landscaping continues the home's classic style with inspiration from New Orleans, but the plants were carefully chosen to adjust to the climate in Southern California where they need to be drought tolerant. The garden is filled with plants like magnolias, azaleas, banana trees, and crepe myrtles, and the design also includes a pool bath behind the cabana, which is a classically designed structure.

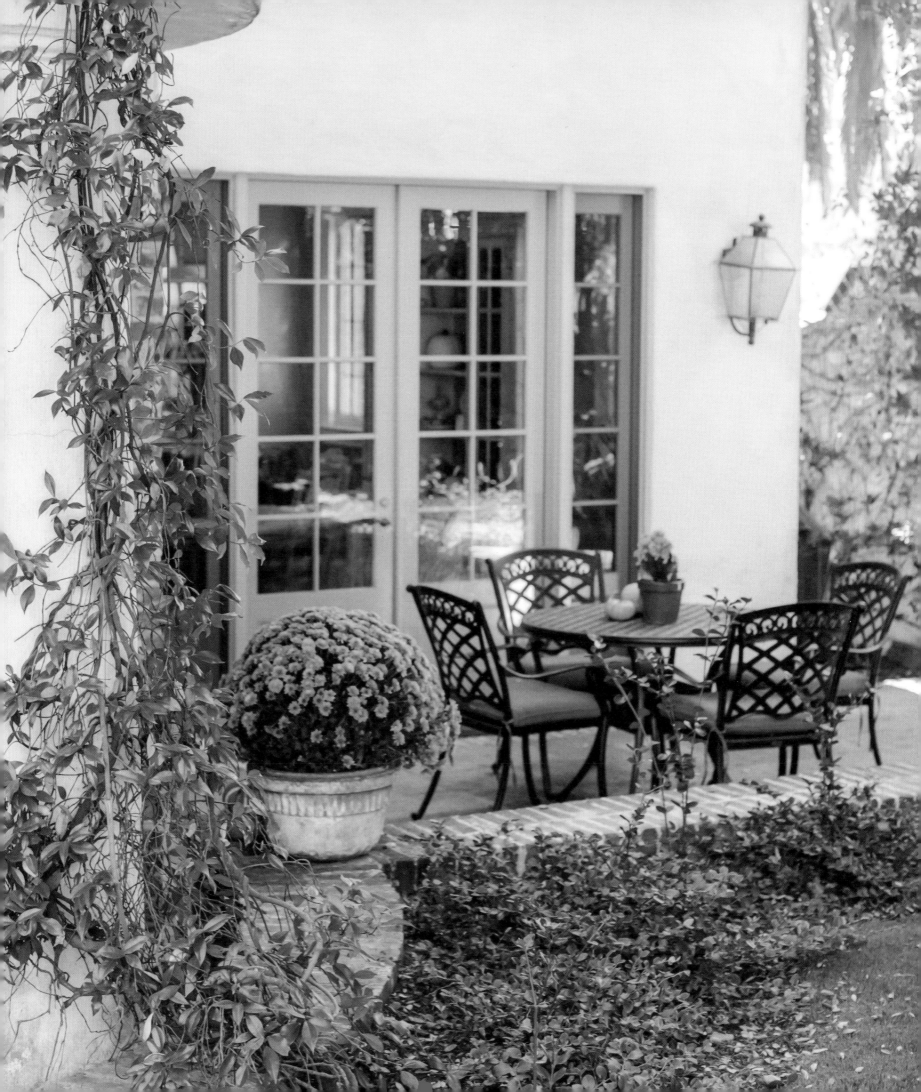

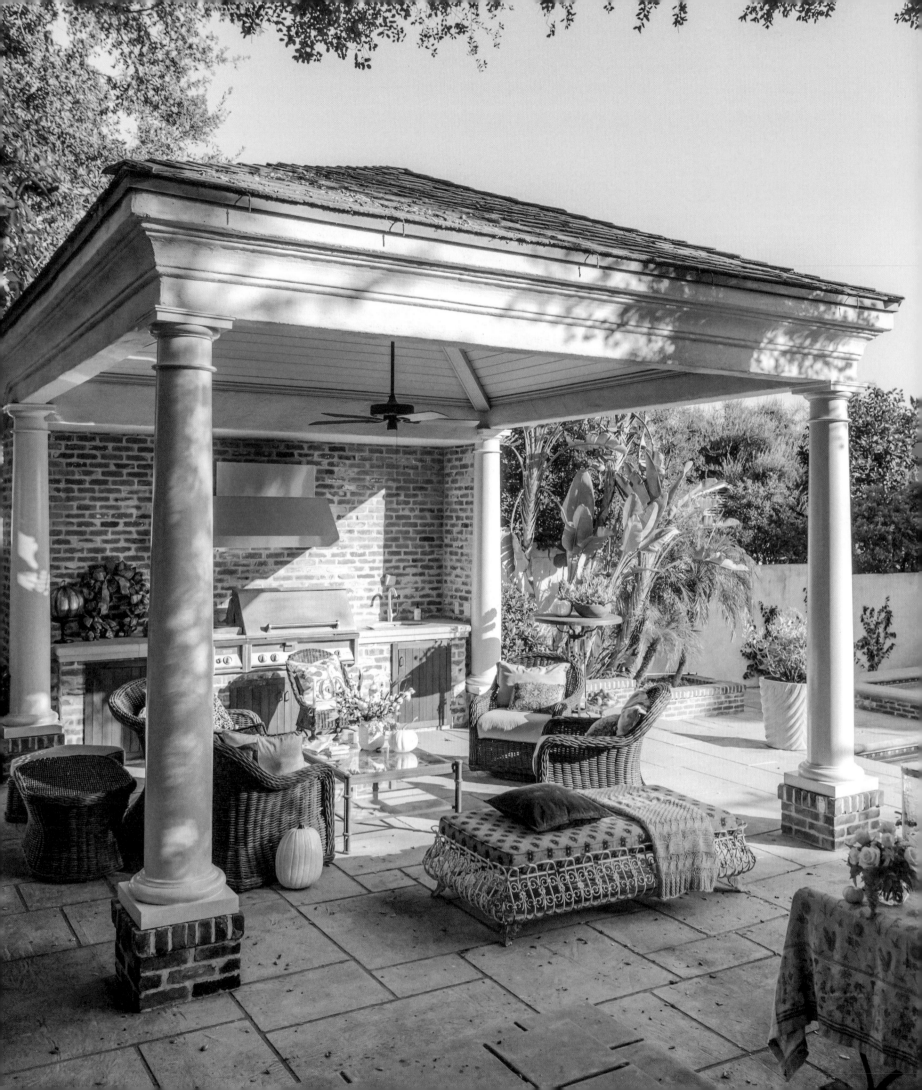

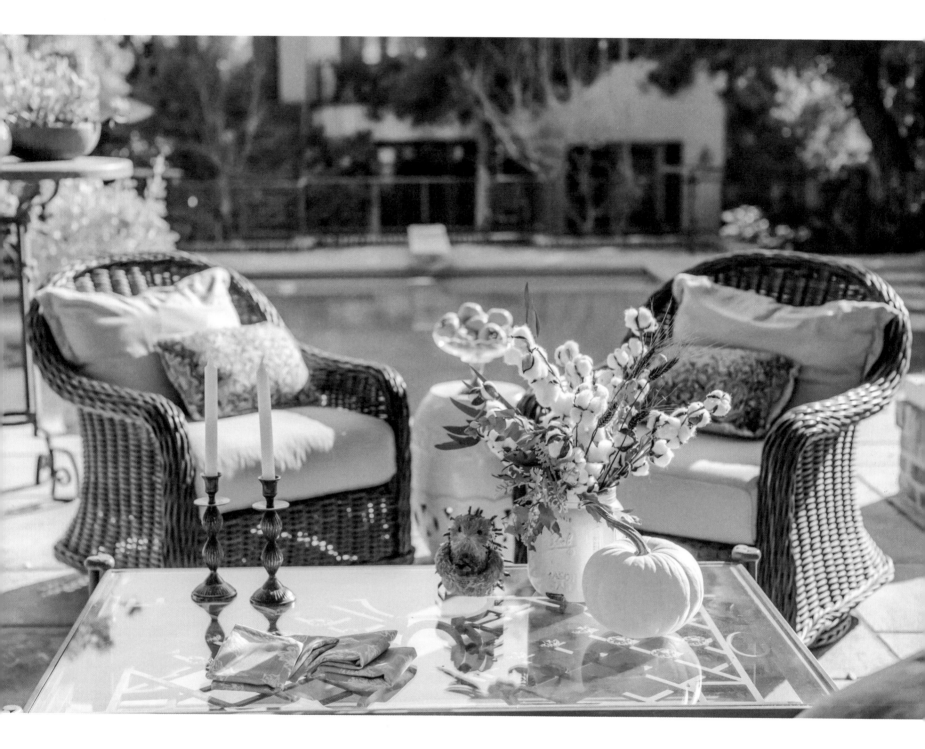

The back porch is styled with pumpkins and mums to create a seasonal feel. The cabana and outdoor kitchen are an ideal location for an autumn evening at home.

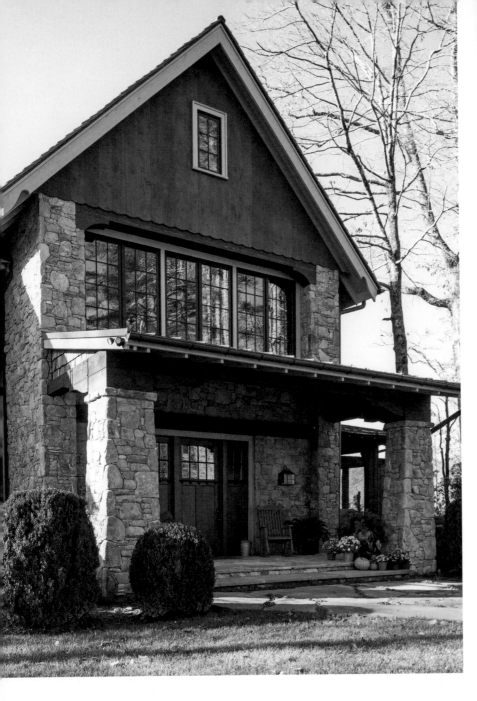

Preserving the Past

SEE HOW THESE HOMEOWNERS METICULOUSLY PRESERVED MORE THAN 25 YEARS OF THEIR BELOVED MOUNTAINTOP MEMORIES—ONE ROOM AT A TIME—THROUGH A NEW HOME BUILT WITH RECLAIMED MATERIALS SALVAGED FROM THE HISTORIC INN AT MILLSTONE IN CASHIERS, NORTH CAROLINA.

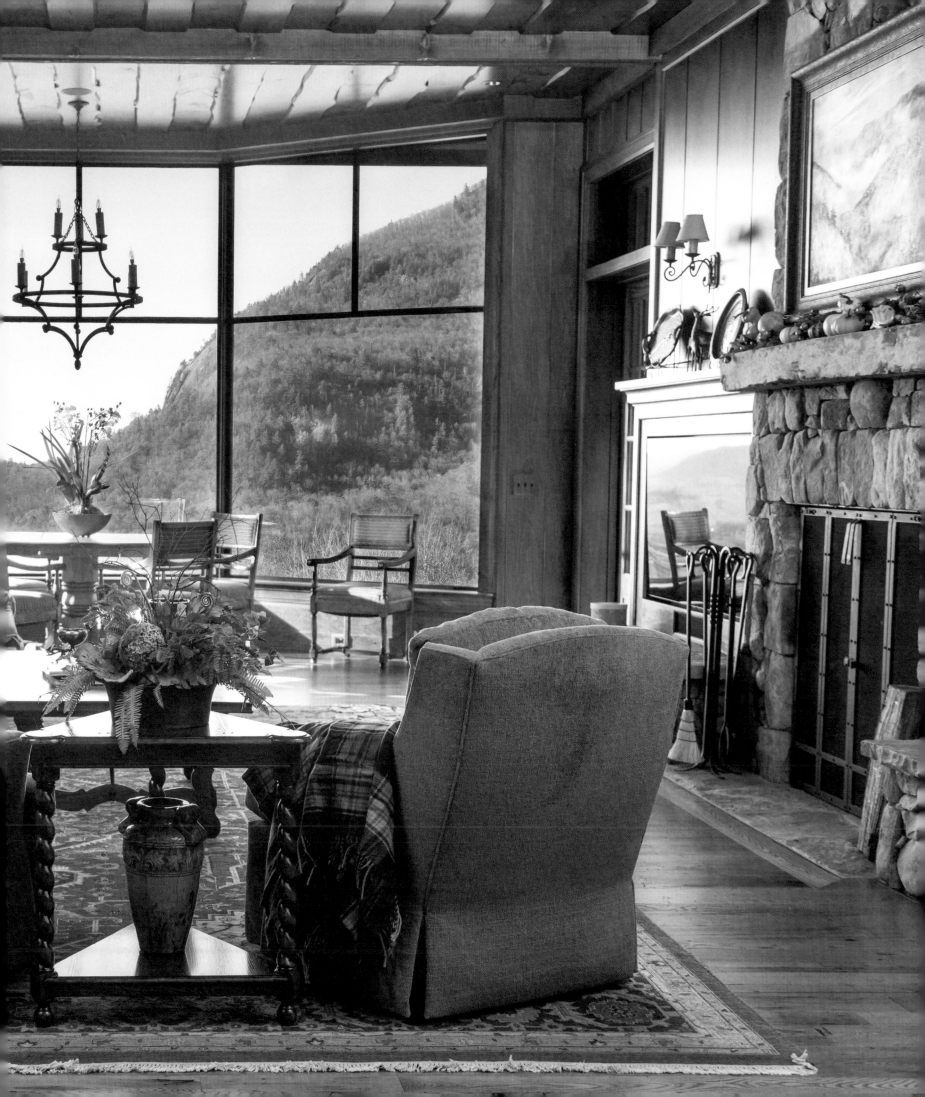

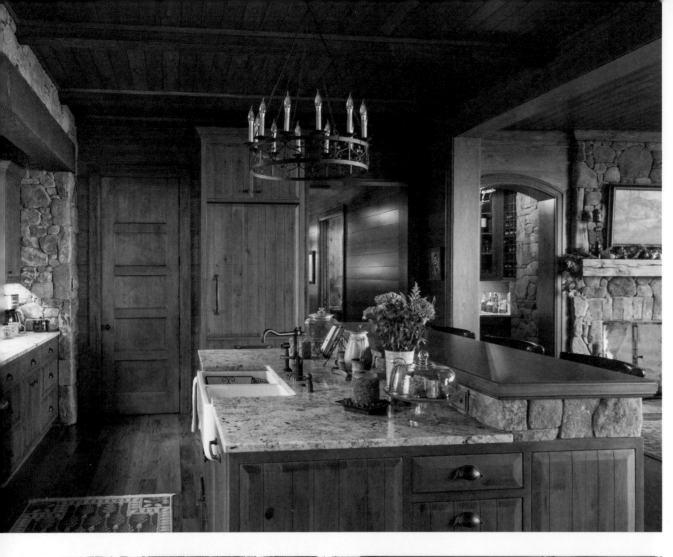

Barbara and Charlie Tickle's home in Cashiers, North Carolina, celebrates a rich history and unique sense of place with a number of reclaimed elements from the historic Inn at Millstone. The millstone that once hung above the fireplace in the main living room of the inn was incorporated into the backsplash above the stove in the kitchen.

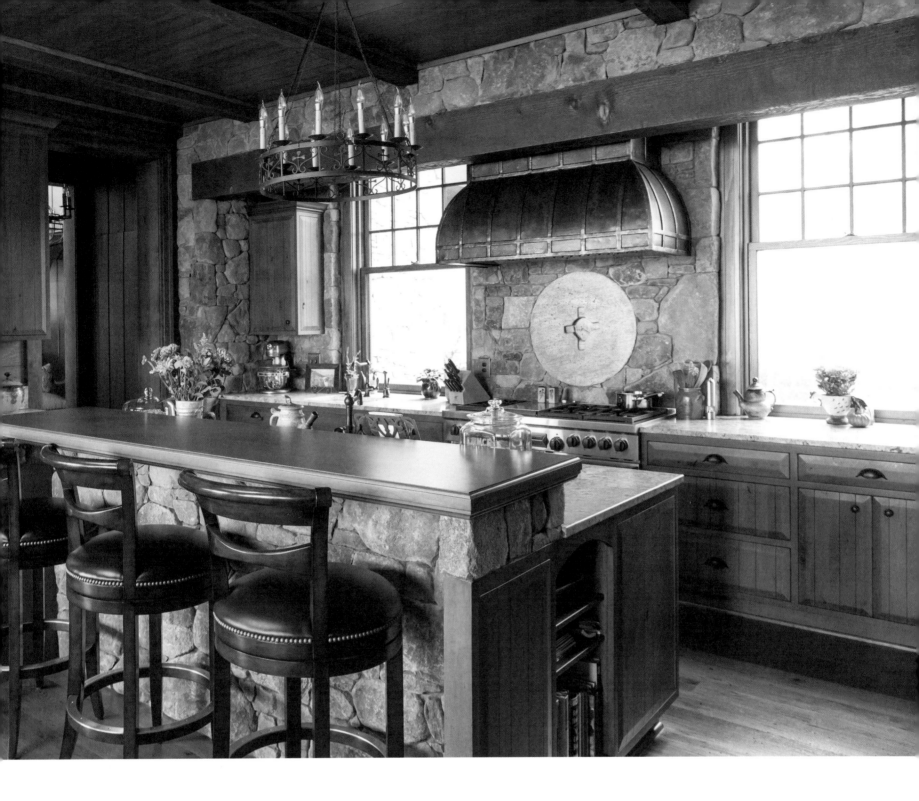

For nearly three decades, retreating to the cool North Carolina mountains to escape the sweltering Alabama summers as well as to enjoy the vibrant fall foliage has been a tradition for Barbara and Charlie Tickle and their family. Perched high in the hills with breathtaking views, the charming little community of Cashiers, North Carolina, holds a lifetime of precious memories that are fondly recalled each and every time the couple returns to this special locale.

"We have been coming to this area for years," says Barbara. "We always stayed at our favorite place, the Inn at Millstone, before finally

building our own home in Mountaintop in 2005," she adds.

A historic property with a rich and storied past, the Inn at Millstone had originally been built as a vacation home in the 1930s by the Stoddards, a New York couple who summered there for 10 years before the area even had power. The Stoddards eventually sold their vacation home, which then became The Silver Slip Lodge. Since then, the property has taken on multiple owners and name changes over the decades before becoming the fabled Inn at Millstone. Sadly, in 2011, the inn was closed and boarded up for three years. Hearing that it might soon be for sale, Barbara and Charlie kept a close eye on the property so they might snap it up when the time was right.

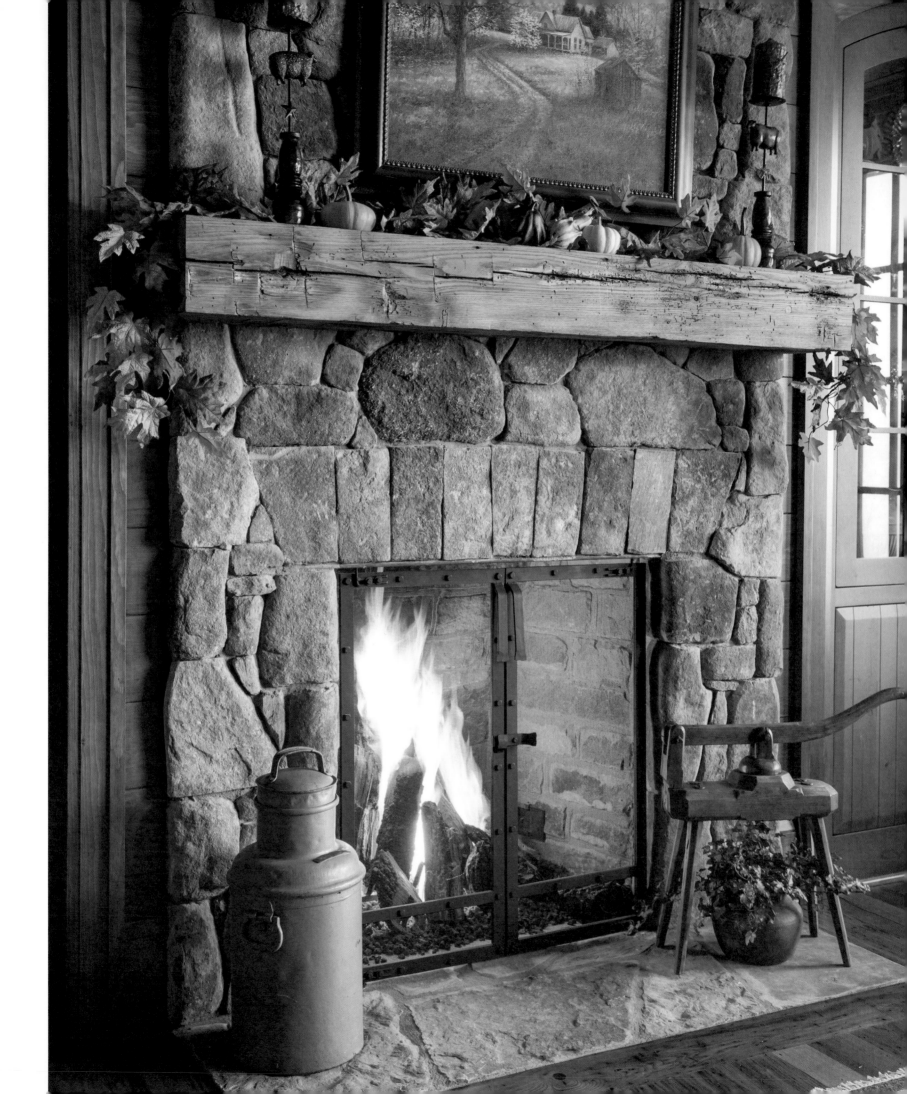

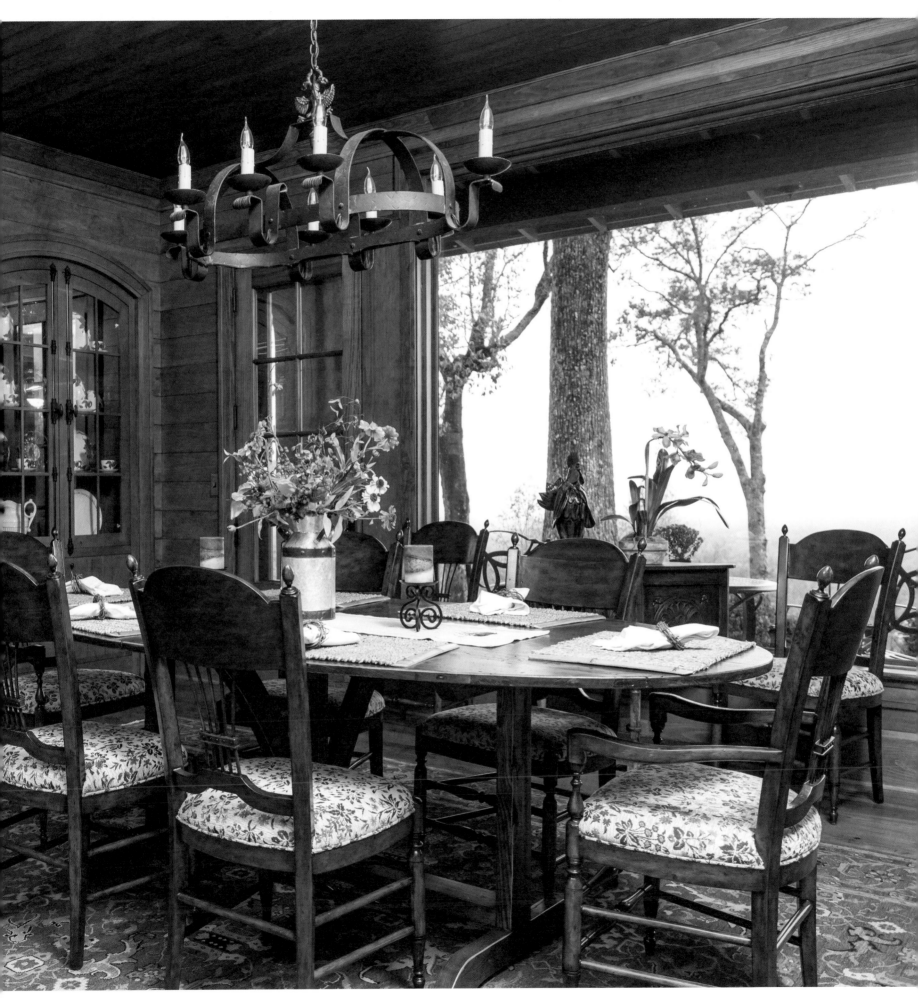

"My tenacious husband picked and picked until we finally closed on it in March 2014," Barbara says with a laugh. "Unfortunately, the inn had fallen into disrepair, so we salvaged everything we could. We had no intention of taking it down, but it was too far gone," she says.

The couple worked with local team Maxine and Jeff Sikes, owners of both The Global Craftsman and Curated Home, to restore and preserve every possible remnant from the original Inn at Millstone to incorporate into their new home. Jeff disassembled everything he could from the old property, and Maxine helped Barbara pull the interiors together.

"We wanted to put it back as close to the original as possible," says Barbara, "which was a challenge because of the predominantly gray-and-white color palettes popular today. It's almost impossible to recreate an earth tone 1930s look," she jokes.

To avoid disturbing the character of the original property, the couple decided to build their new home on the same footprint as the inn. They called on architect Mark Paullin of Charlotte, North Carolina, and local builders Dearl Stewart and Dave Parmelee of Dearl Stewart Construction to help execute their vision.

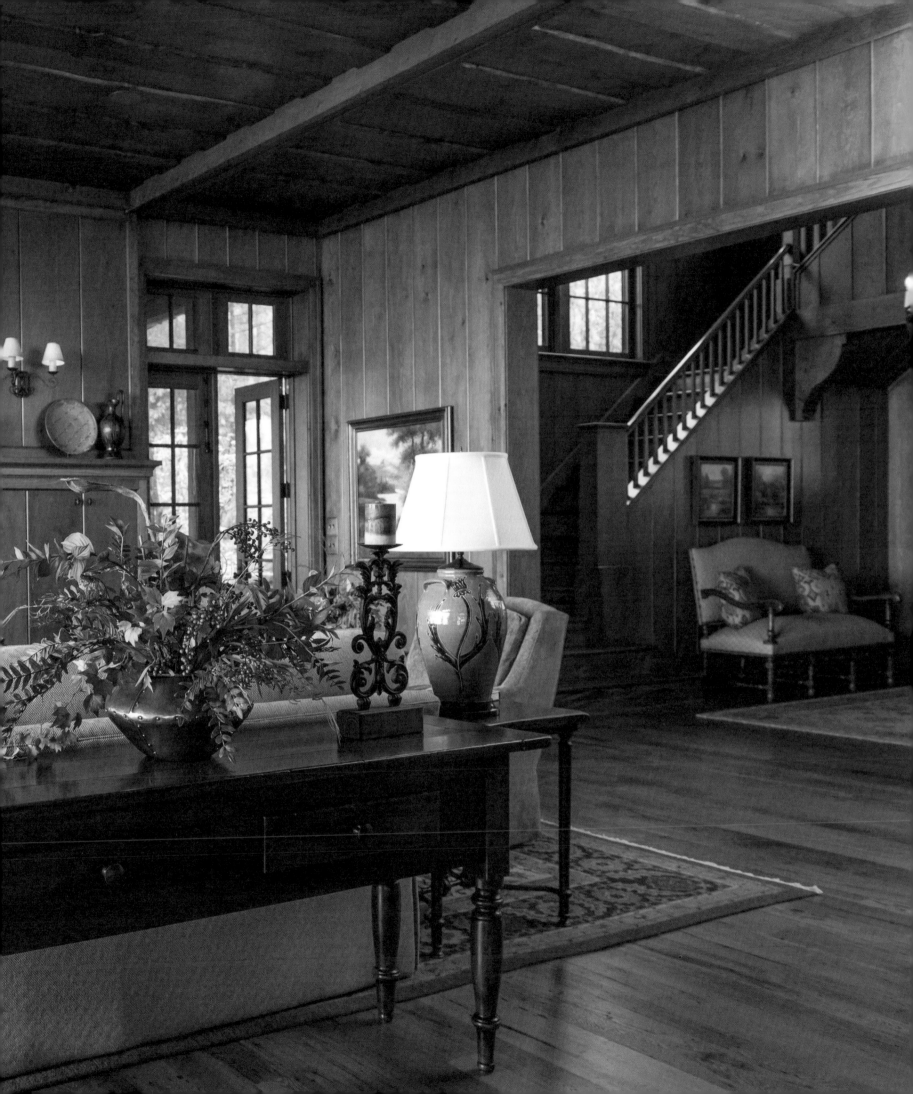

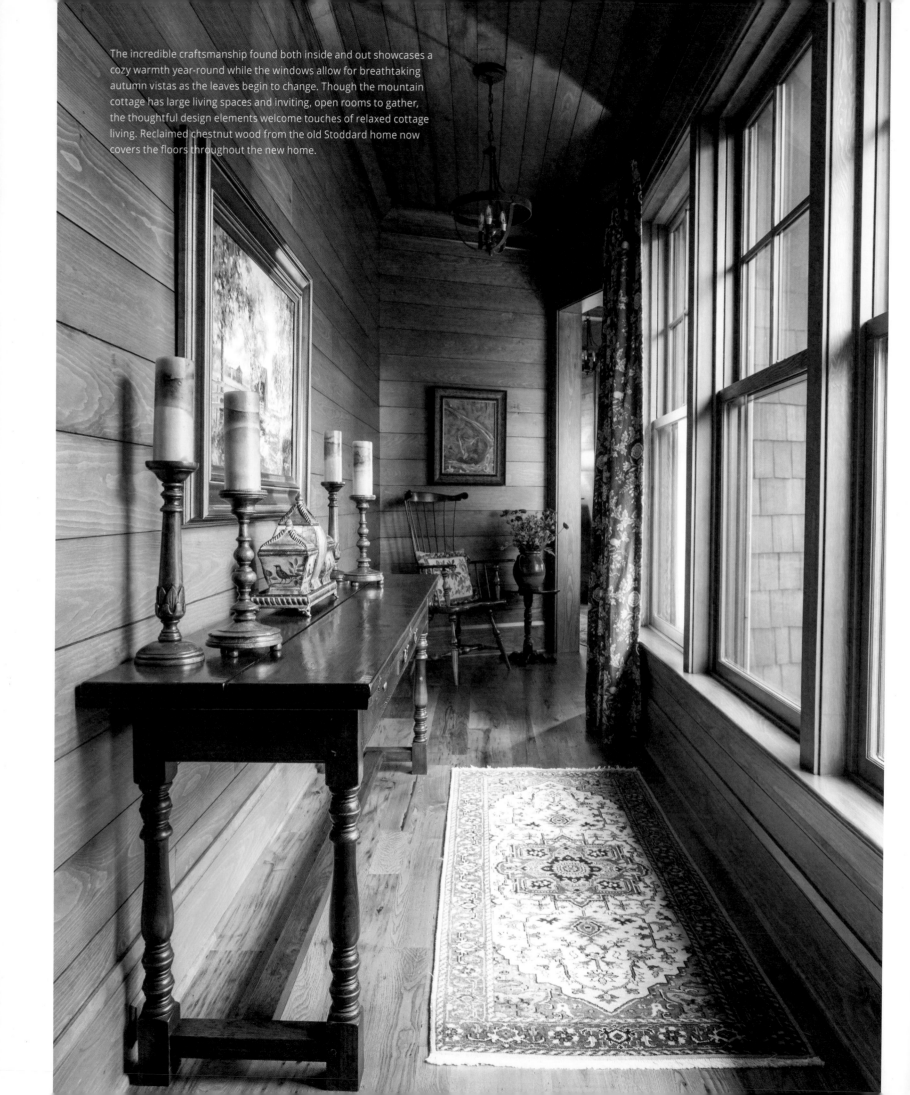

The incredible craftsmanship found both inside and out showcases a cozy warmth year-round while the windows allow for breathtaking autumn vistas as the leaves begin to change. Though the mountain cottage has large living spaces and inviting, open rooms to gather, the thoughtful design elements welcome touches of relaxed cottage living. Reclaimed chestnut wood from the old Stoddard home now covers the floors throughout the new home.

"They all did such an incredible job with our Mountaintop home, so we knew we could trust them to do the same here," says Barbara. "Everyone had the sensitivity of the historical piece we were trying to achieve, and the craftsmanship is outstanding," she adds.

Special features that were reclaimed from the original construction include the chestnut wood that now covers the floors throughout the new home as well as the ceiling and walls in the study. The millstone that was above the fireplace in the main living room of the inn now resides above the stove in the kitchen, and the signs and keys from all the original rooms at the inn now hang on the new bedroom doors.

"This home has incredibly taken on the spirit of the old Inn at Millstone," says Barbara. "We've had nonstop company since we moved in—everyone here is warm and inviting, and that's why we love Cashiers," she says. "And of course, autumn is the absolute best—pumpkins, apples, the smells, the colors of the trees—it all makes me smile."

White planked walls, ample windows, and comfortable furnishings set the scene for a tranquil mountain getaway. As a nod to the home's location, the couple salvaged signs and keys from all the original rooms at the Inn at Millstone; the placards now hang on the new bedroom doors.

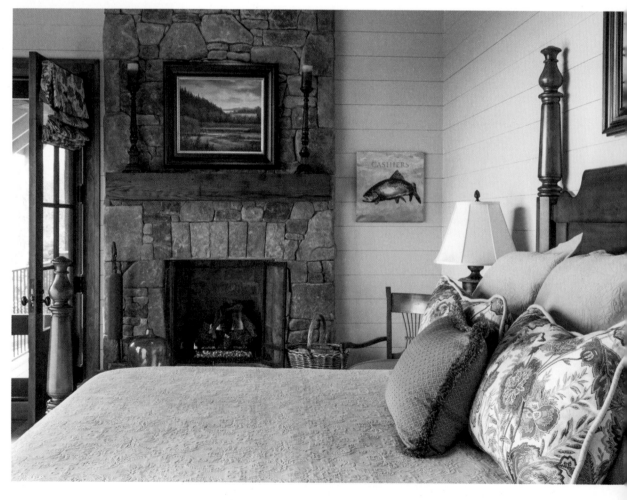

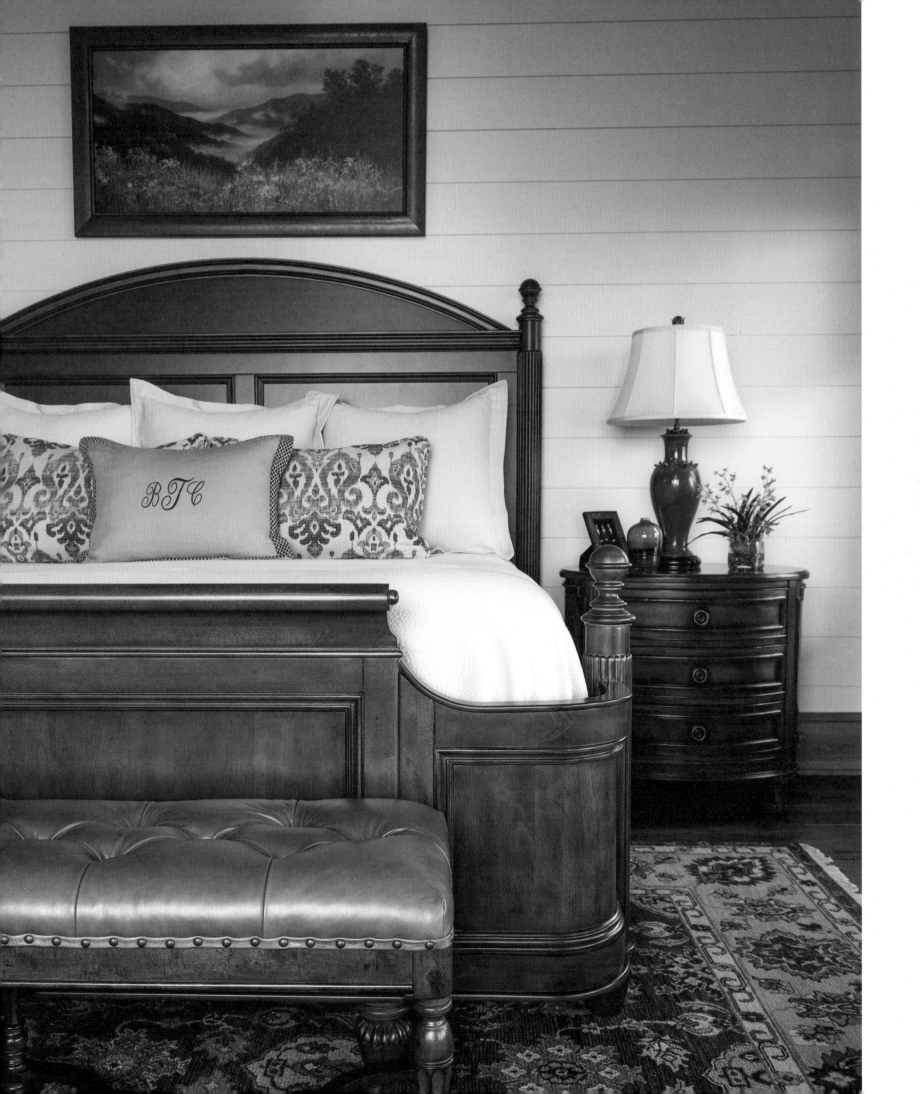

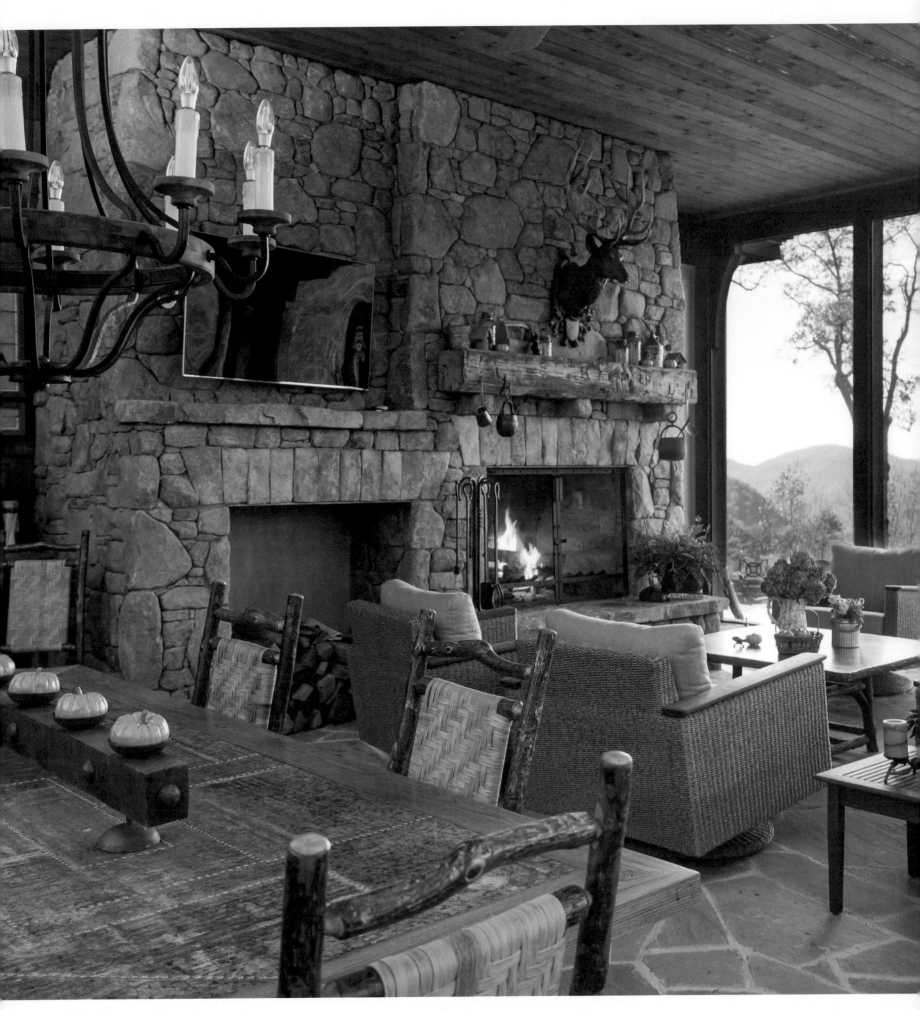

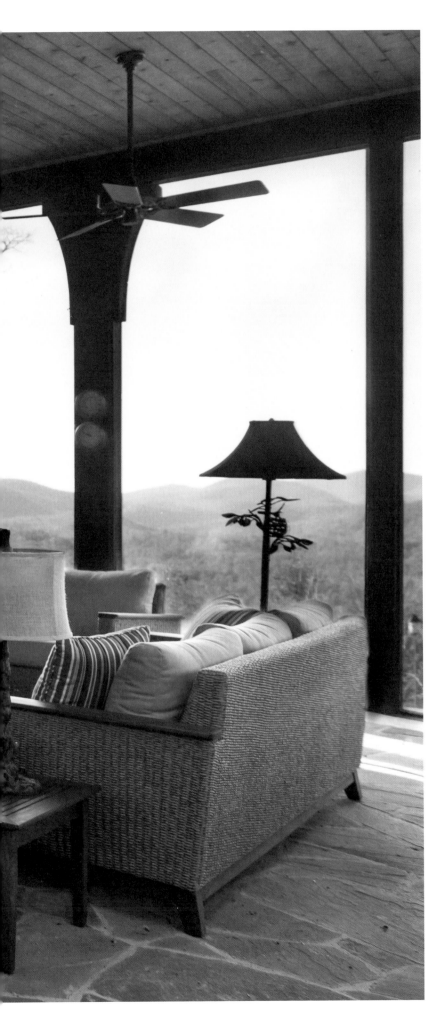

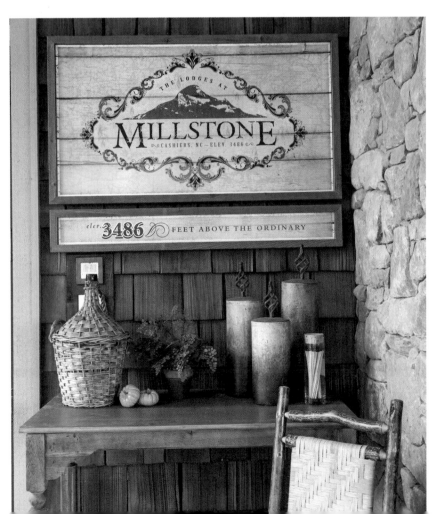

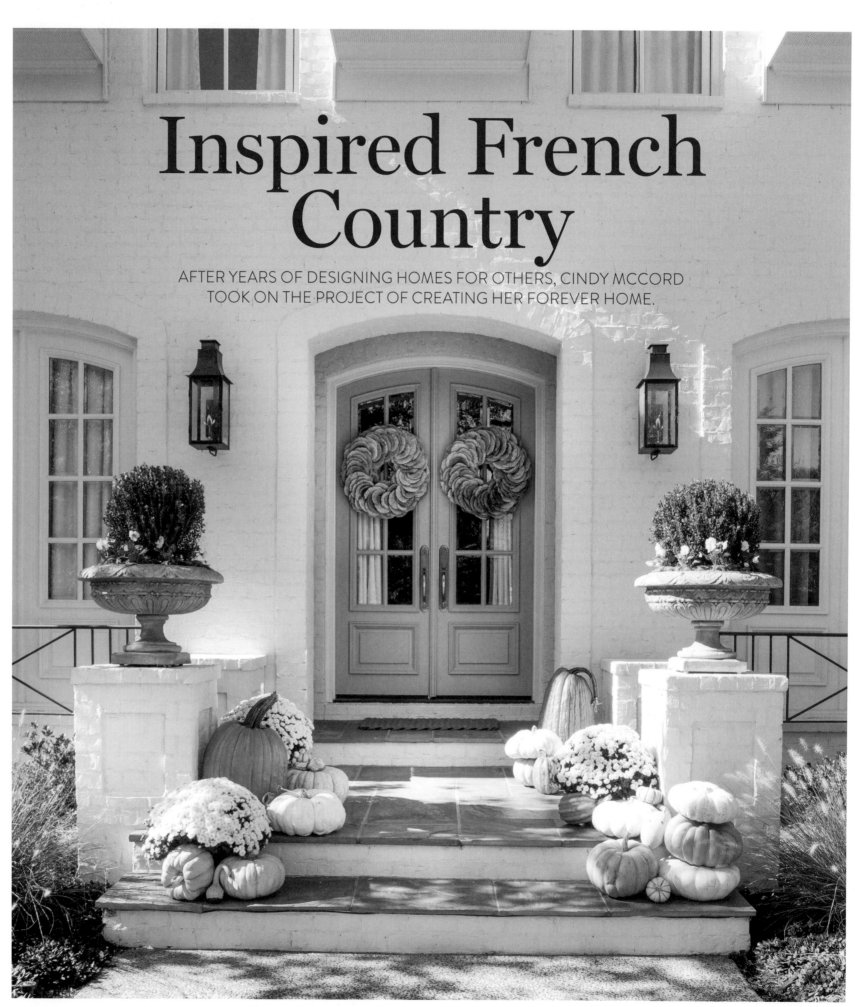

Inspired French Country

AFTER YEARS OF DESIGNING HOMES FOR OTHERS, CINDY MCCORD
TOOK ON THE PROJECT OF CREATING HER FOREVER HOME.

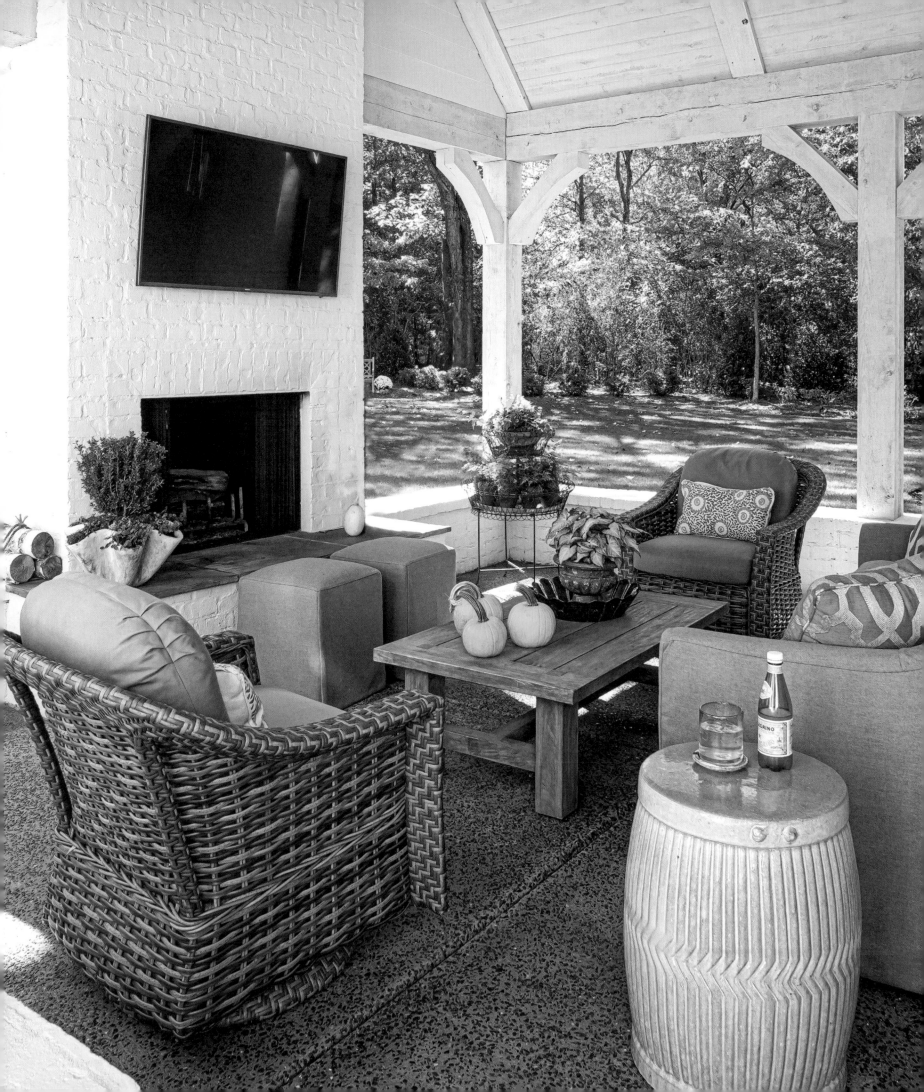

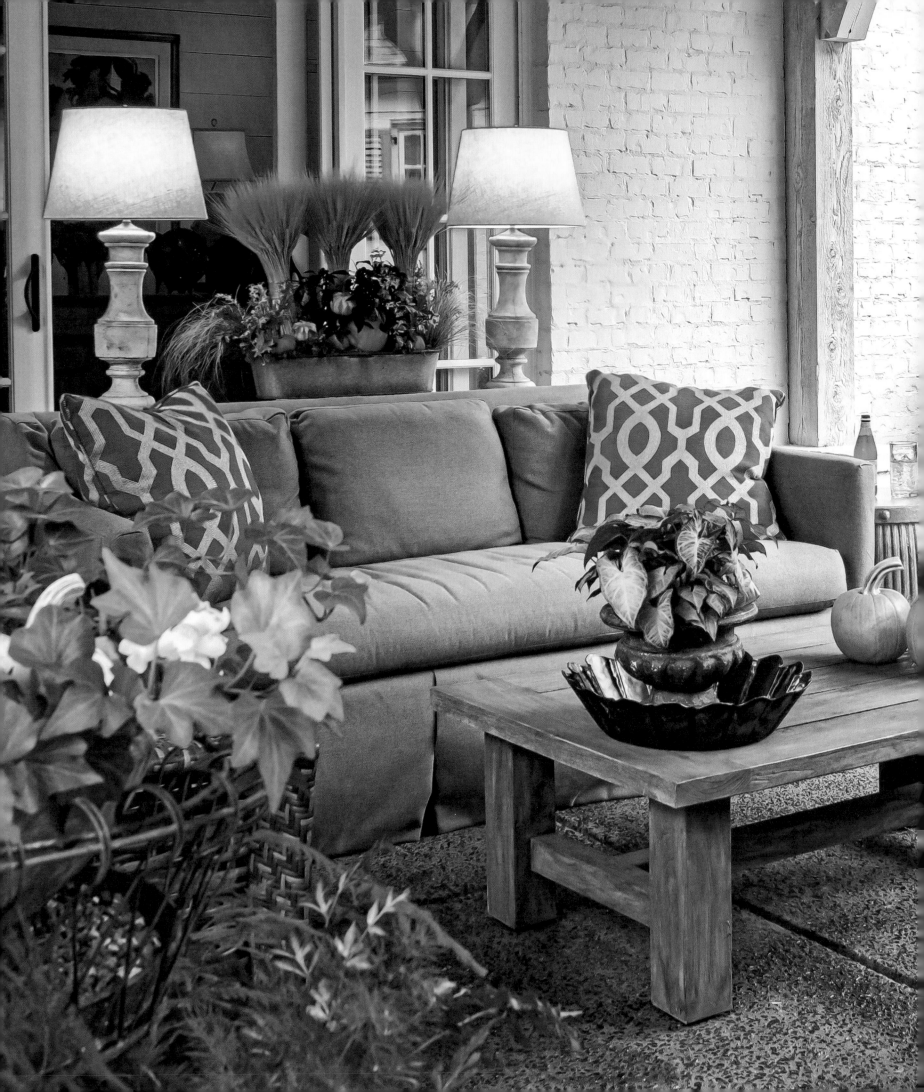

As an interior designer, Cindy McCord spends her days envisioning each client's dream home, so when it came time for her and her husband to build their forever home in their beloved Tennessee town, she had a good idea of what she wanted.

Cozy, comfortable, and traditional, their home is perfectly suited for the couple, their three children, and their three pets to grow into, all thanks to Cindy's practical yet stunning design. "We built the home to our needs," Cindy explains. "We took the time to design around our lifestyle as totally empty nesters when all the children were gone."

The home is designed in a horseshoe layout, almost enclosing the backyard to create a sort of secret garden for the family. The covered back porch is nestled in the center of the layout and, not surprisingly, is the spot where the family spends the most time, especially during the autumn months. "Everywhere we go in the home, we can see our porch," Cindy says. "We spend all of our time out there. We get our blankets, light a fire, and it's so fun."

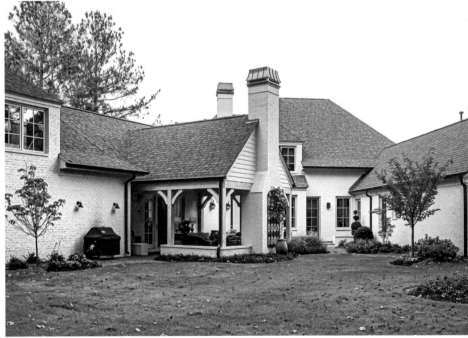

While French country is the design style of her own home, it's not the only way interior designer Cindy McCord designs her clients' homes. "I design homes all over the spectrum in style," she says.

151

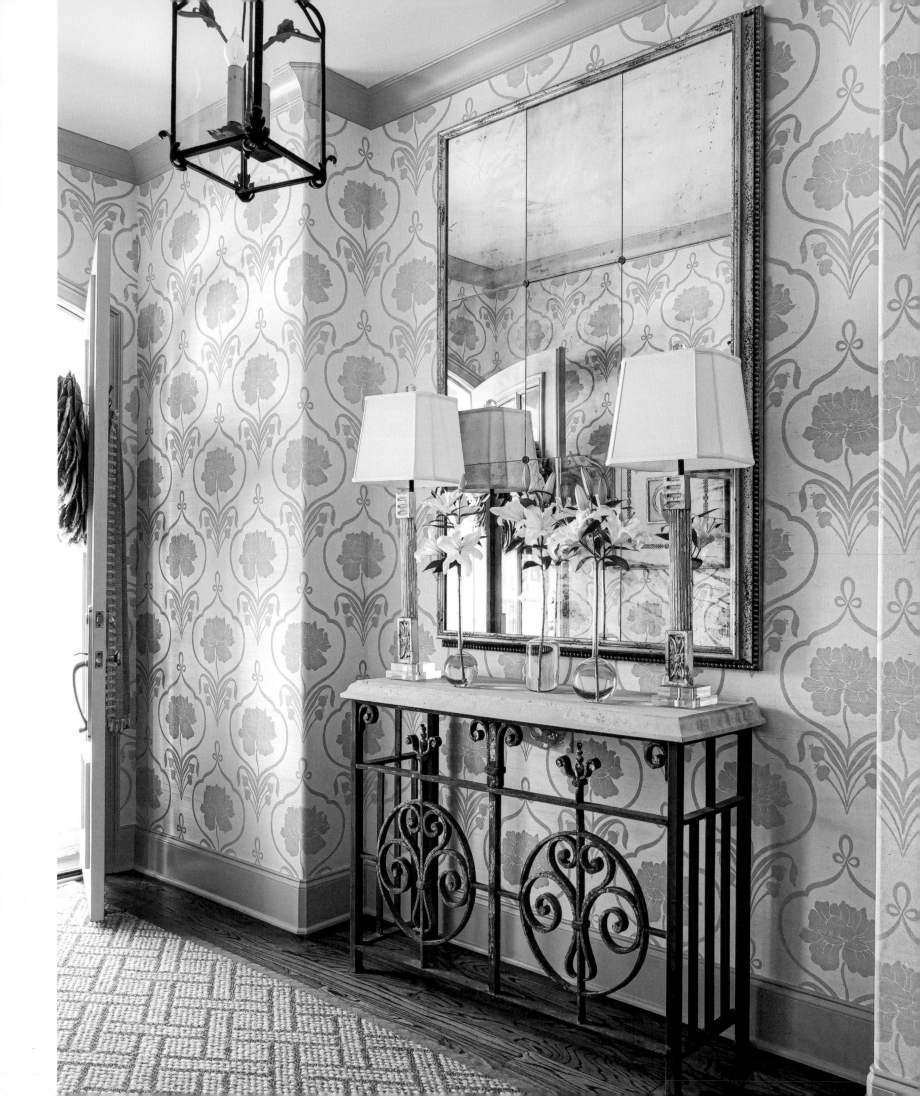

Inside, Cindy went for a neutral color palette and played with pattern and texture throughout the home. "I love simple French-country style," she says. "I love light and airy." The foyer offers a peek into the rest of the home, with elegant floral wallpaper and a large mirror above a console table which contrasts with a painting of a rural barn and a rustic lantern overhead—a beautiful blend of sophistication and comfort.

The living room brings in a pop of color, with two blue couches echoing the aqua blue sky in a piece of art that hangs in the space. Cindy notes that the space changes throughout the year as she switches throws, pillows, drapes, and other décor with the seasons.

Cindy says that the key to having both a durable and beautiful home is to "keep your fabrics and rugs very textured and simple and add a little bit of elegance through your accessories, like lamps and pillows."

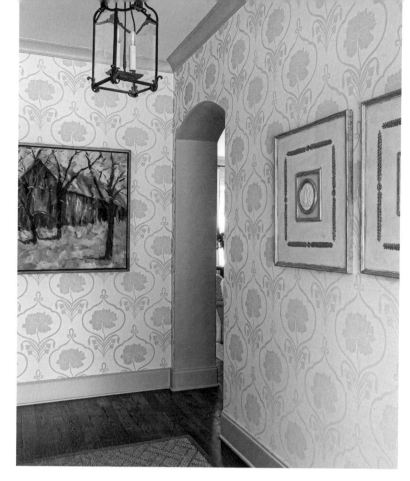

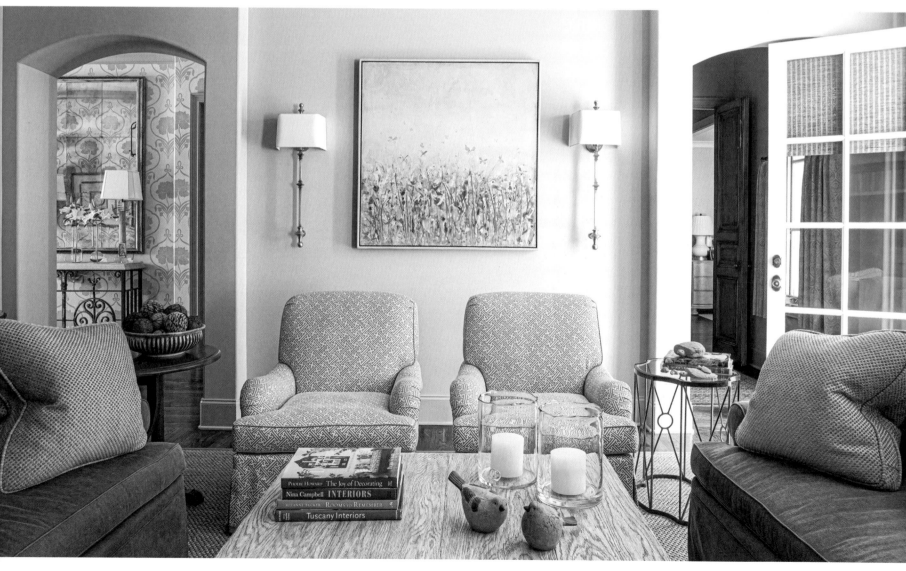

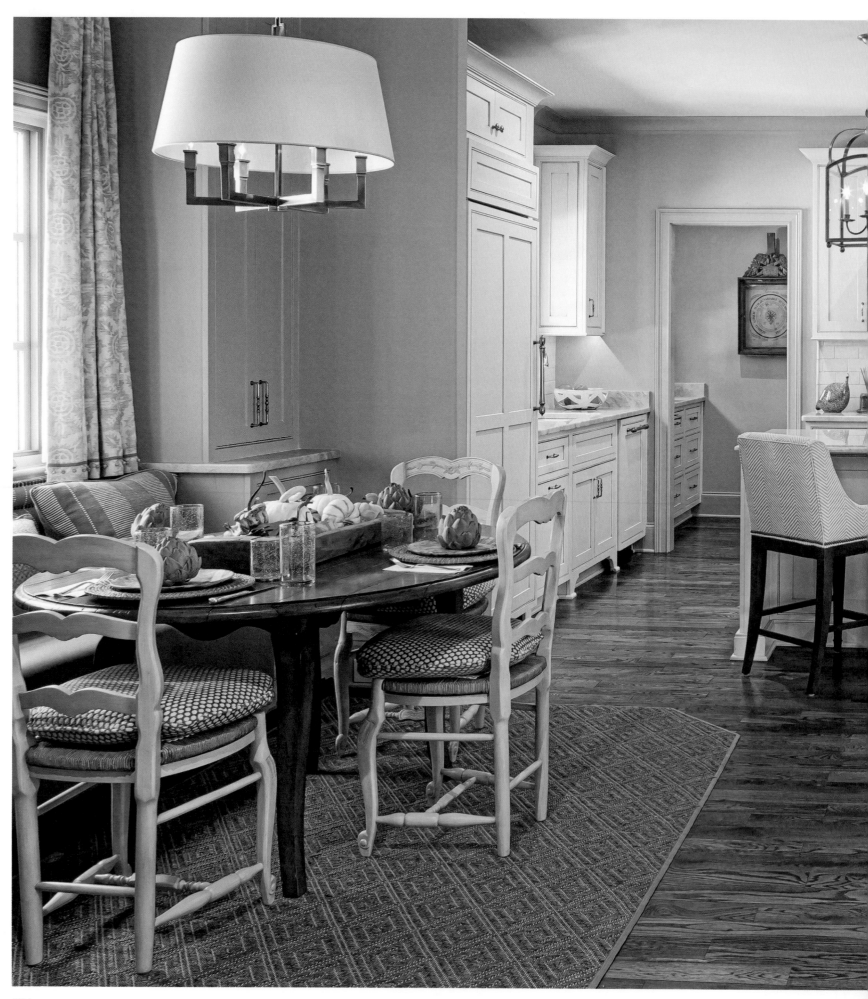

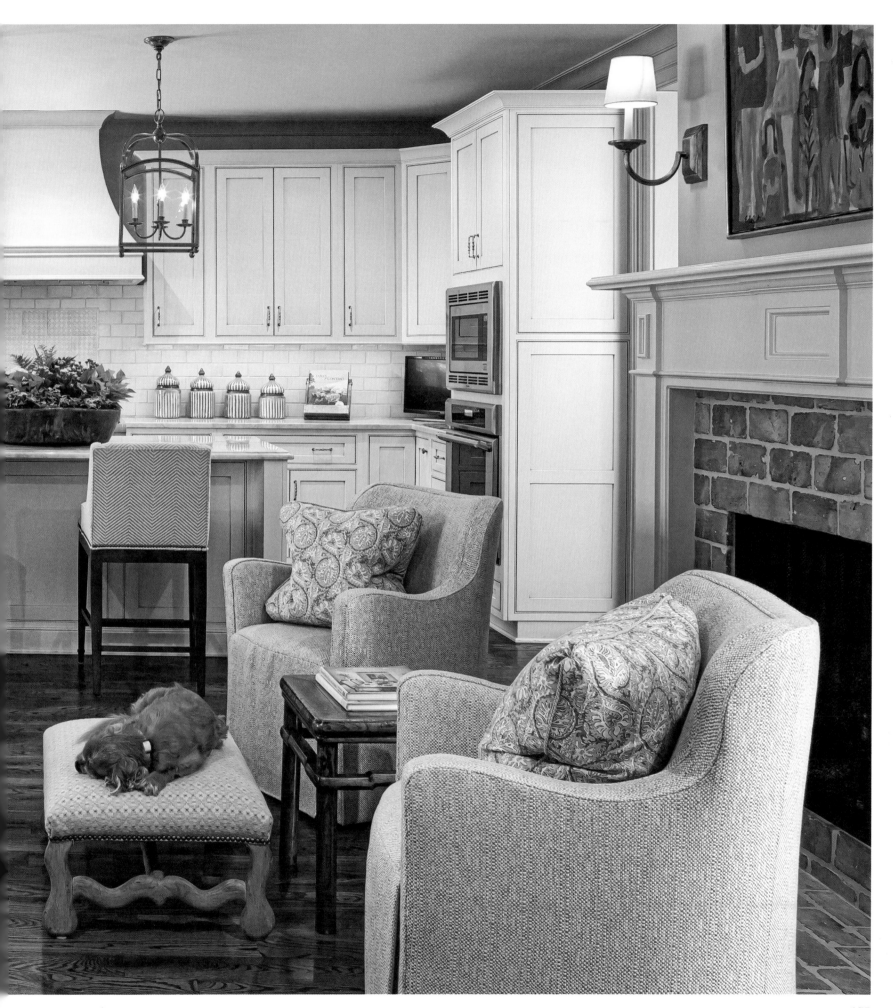

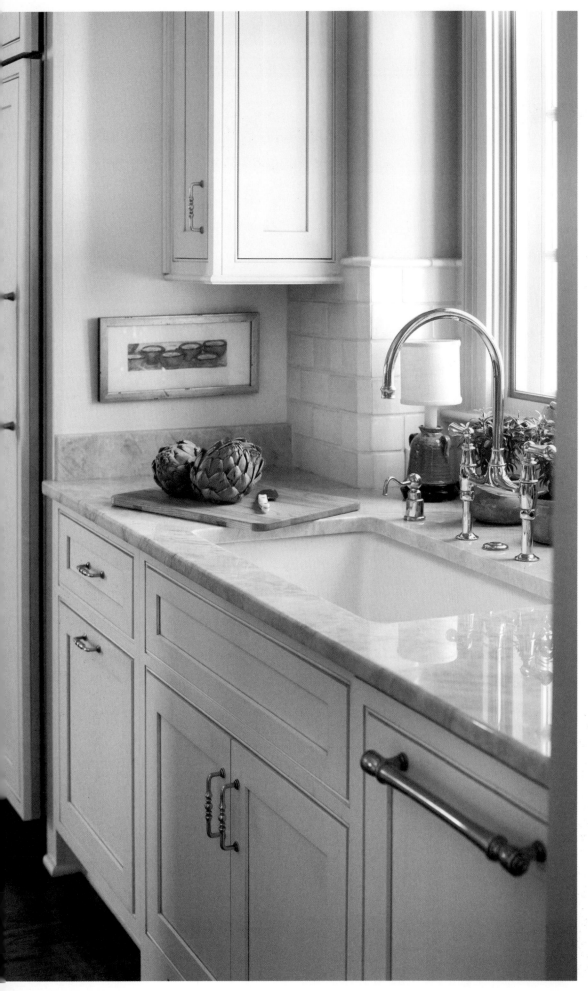

The sophisticated yet relaxed style carries into the open-plan kitchen and breakfast nook area, with space to sit and enjoy morning coffee while looking out onto the couple's beloved porch and garden. The kitchen takes an updated look on traditional style. Gorgeous paned cabinetry with rubbed brass hardware mixes perfectly with the vintage-style silver faucet. The space is an embodiment of Cindy's design philosophy of making spaces both beautiful and livable. "I work with so many clients that have pets and children, and there is a way to have a happy medium," she says. "You can have a home that is durable and looks elegant, too."

The charming breakfast nook and sitting area off of the kitchen is a spot for the entire family to enjoy relaxing mornings together. Whether sipping coffee in the cozy armchairs beside the fire or lounging on the built-in bench next to the table, there's plenty of space for everyone, even the family's two Cavalier King Charles spaniels and their pet cat.

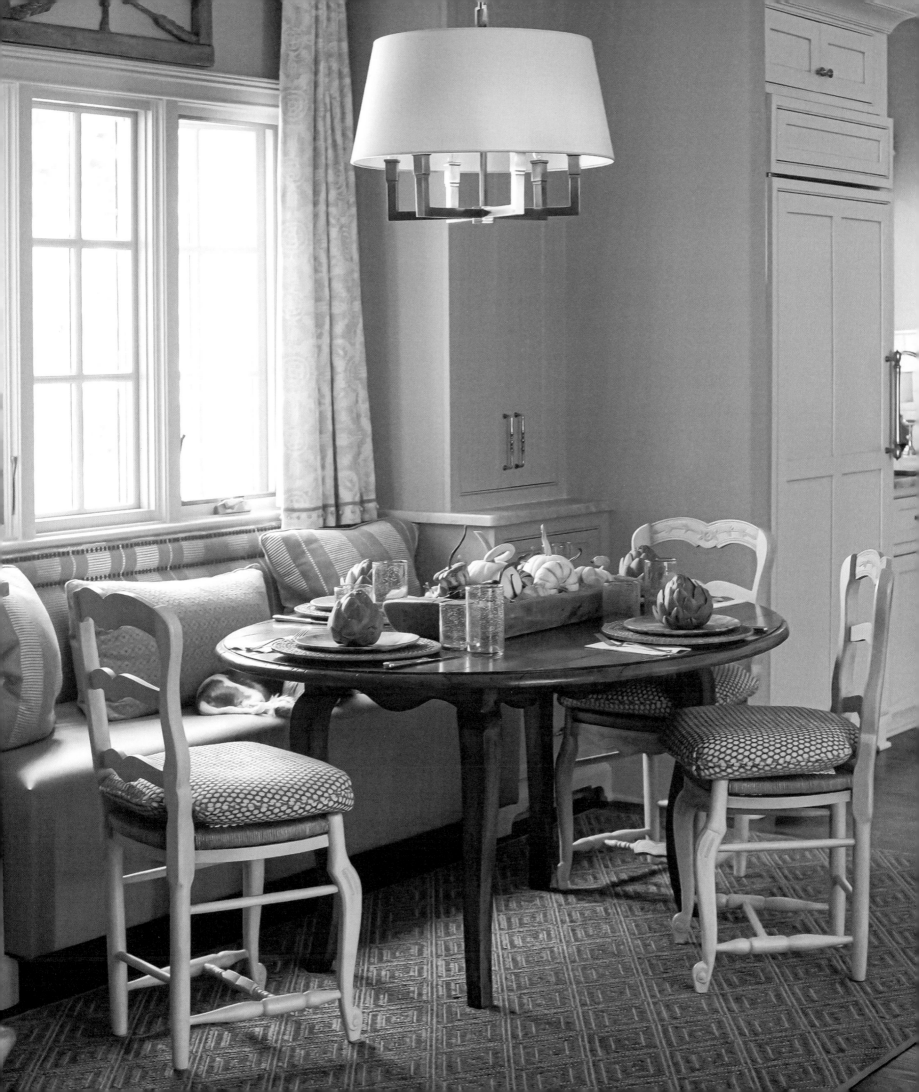

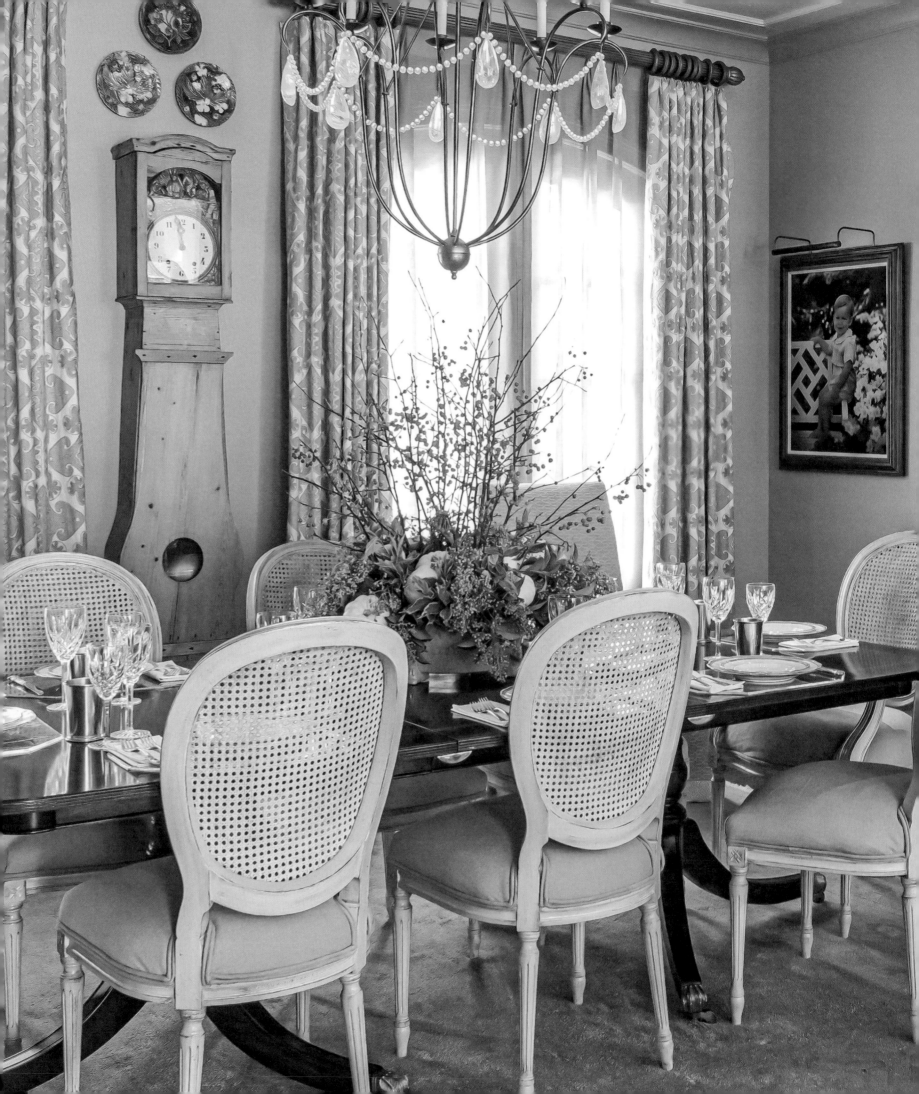

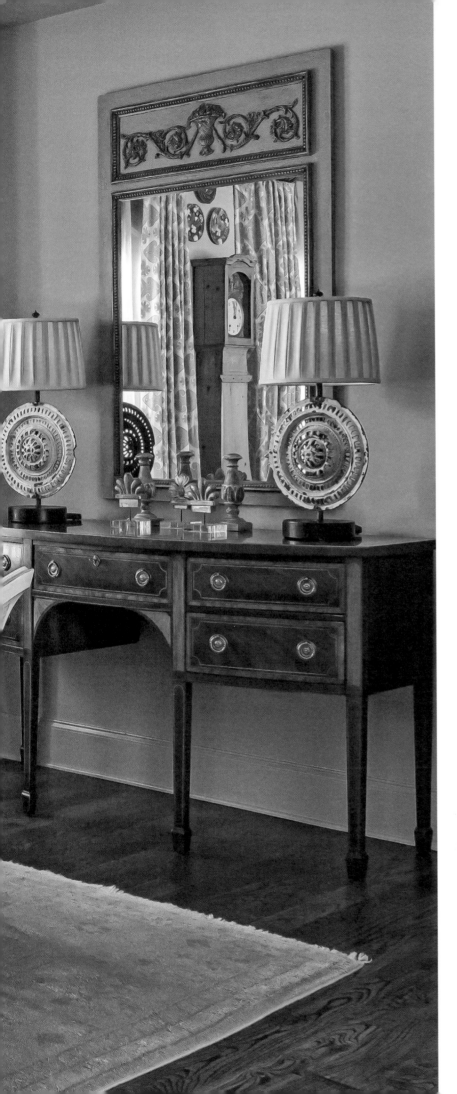

Cindy took a more elegant approach in the dining room, with cane-back chairs surrounding a large wood table. An antique grandfather clock commands the space with subtle sophistication. Cindy chose patterned drapes to add interest to the room. "I like to start with things a little plain and then enhance it," she explains. "When you're not mixing way too many patterns and colors, it's easier to come off as a little more elegant from time to time but still stay durable with the textures of the fabrics."

Even with the gorgeous interior and perfectly laid out design, the family can't help but find themselves outside on their well-loved porch. With the fire roaring and her family snuggled together watching their favorite shows, Cindy admits that nothing inside can beat it.

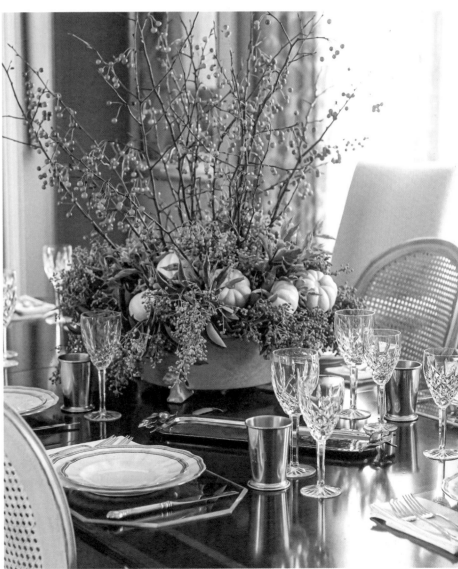

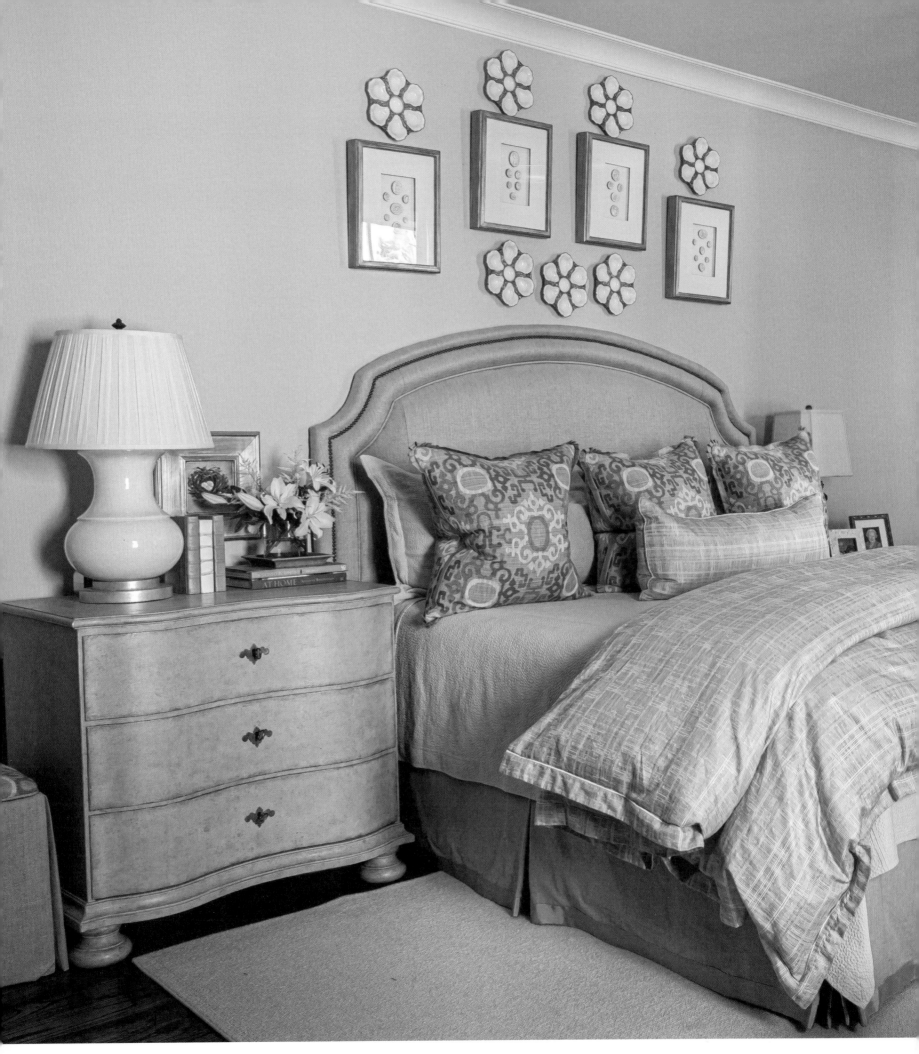

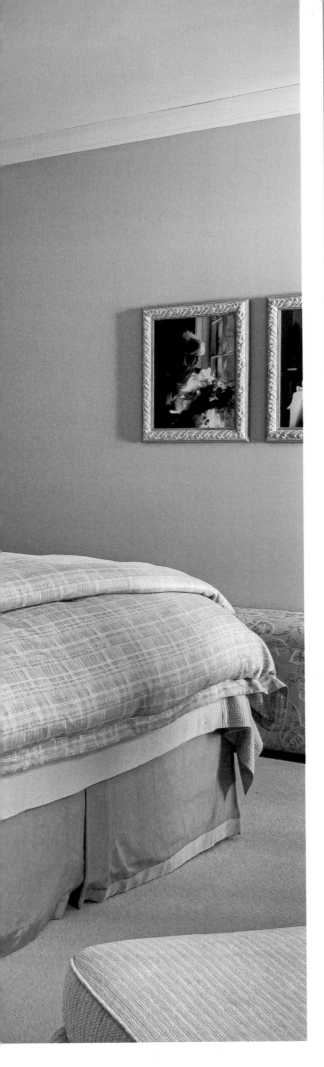

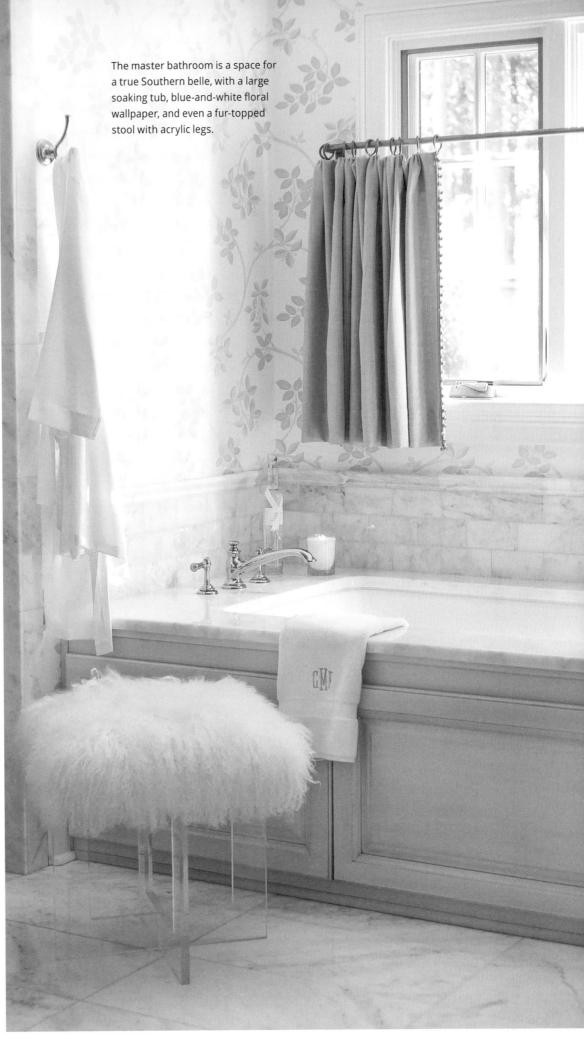

The master bathroom is a space for a true Southern belle, with a large soaking tub, blue-and-white floral wallpaper, and even a fur-topped stool with acrylic legs.

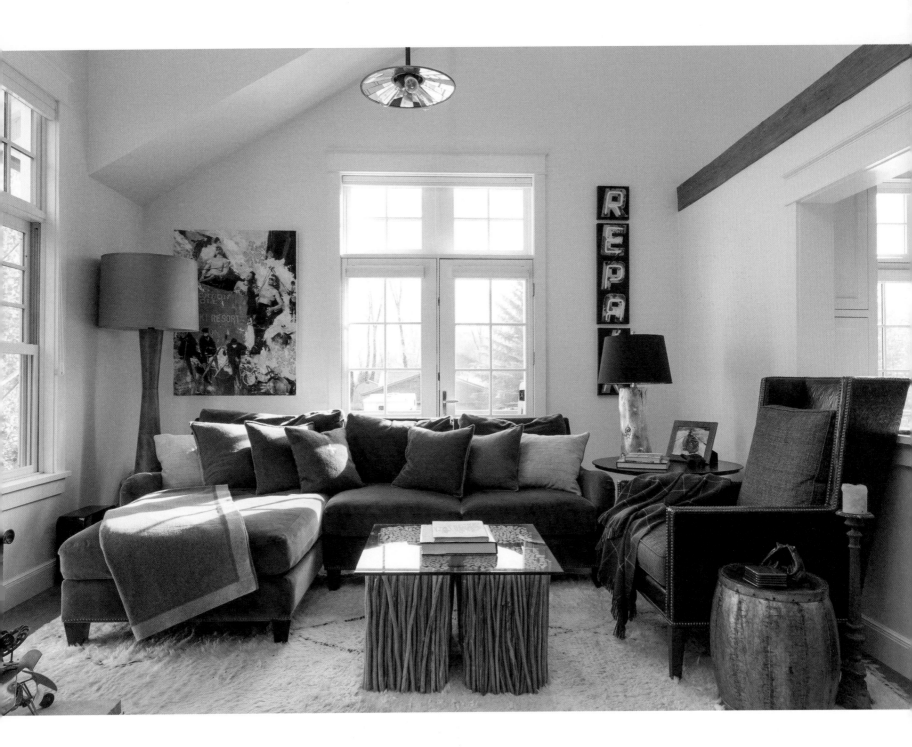

Eclectic Design

HIDDEN AWAY IN THE MOUNTAINS OF WYOMING, THIS HOME PROVIDES
REFINED, COMFORTABLE STYLE WITH A DASH OF HISTORY.

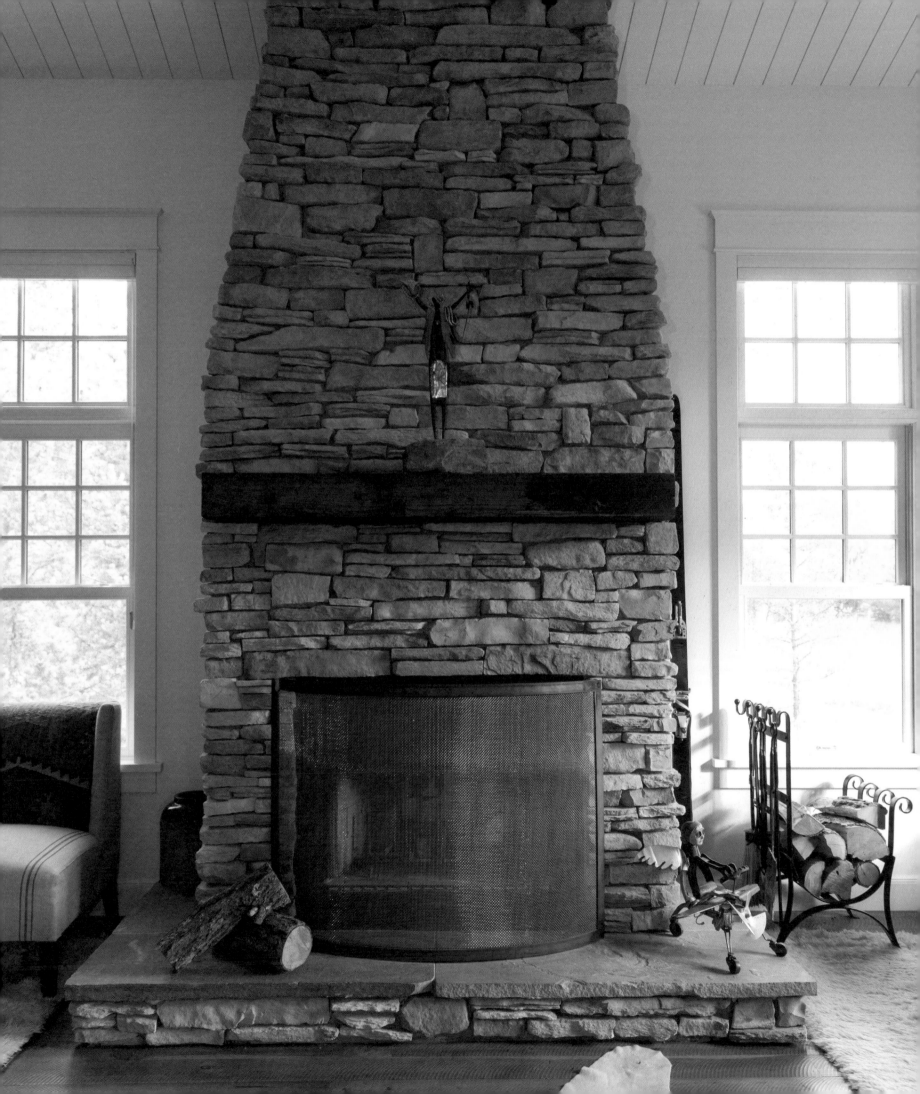

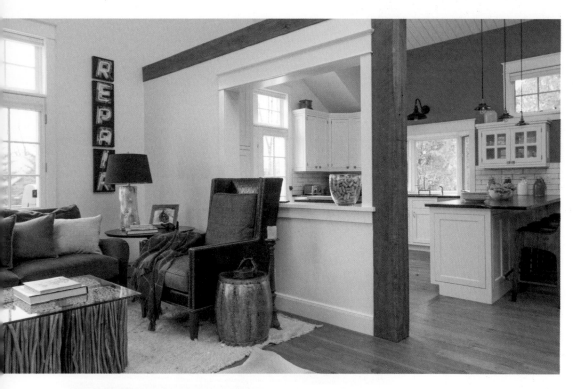

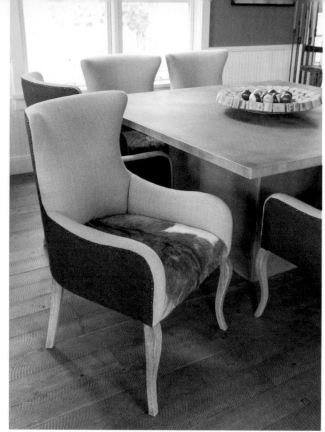

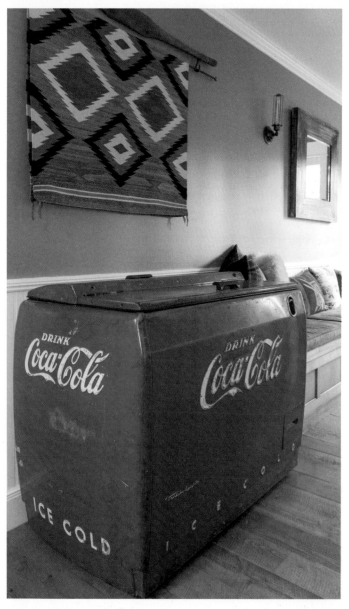

When it came to decorating her clients' mountain home in Wilson, Wyoming, Kate Binger, founder of interior design firm Dwelling, had a clear goal for the space. "We wanted to honor the heritage of the West as well as the farmhouse architecture," Kate says.

To accomplish that, Kate and her team incorporated mountain-style elements into a space that maintained the comfortable airiness of farmhouse design. From the stone fireplace in the living room to the wooden ceiling beams throughout the home, rustic details are balanced by vaulted ceilings and stretches of white surfaces.

"My clients gravitate toward a refined masculine aesthetic," Kate notes, adding that the design style was inspired by some of the homeowners' original furniture and art that was sourced from Orange County, California, and Santa Fe, New Mexico. "I assessed those pieces, which were important to them, and focused on hard surfaces that would enhance that style," she says.

Touches of natural materials, like the leather club chair and twig table that sit not far from the hearth, give a nod to the home's stunning surroundings. But the farmhouse elements in the design find their balance in refined, contemporary touches, like the goat hide chairs that sit in the dining room. "When I found those at the Las Vegas, Nevada, market, I fell in love with the balance of their masculine materials and feminine legs," Kate says, noting the way the French legs counterbalance the square, steel table.

In nearly every room in the home, vintage and antique pieces, like the Coca-Cola cooler in the entryway, add to the character of the design and provide a subtle contrast to the modern vibes. "The magic of eclectic design is pulling the most unique aspects of each genre and gently intertwining them," Kate says. "When I curate antiques and rustic elements together, balancing them with clean lines and modern colors is key."

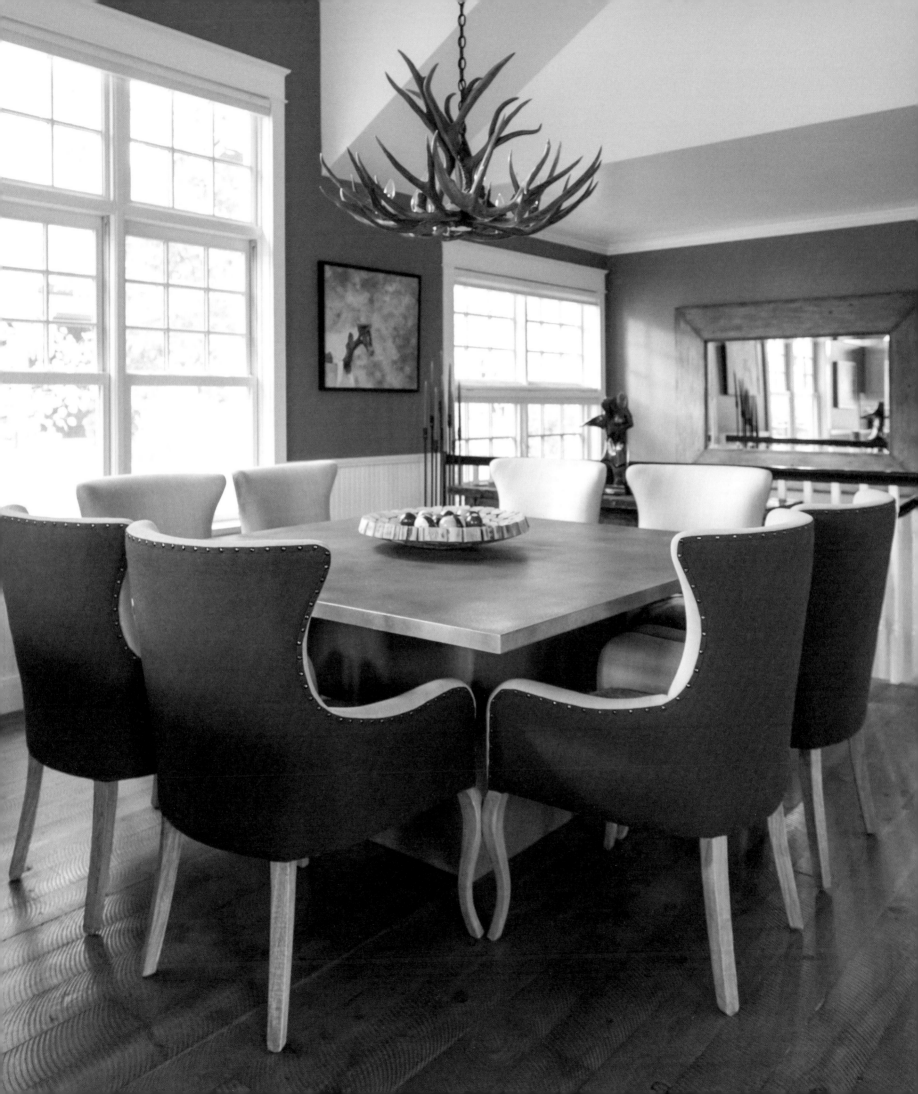

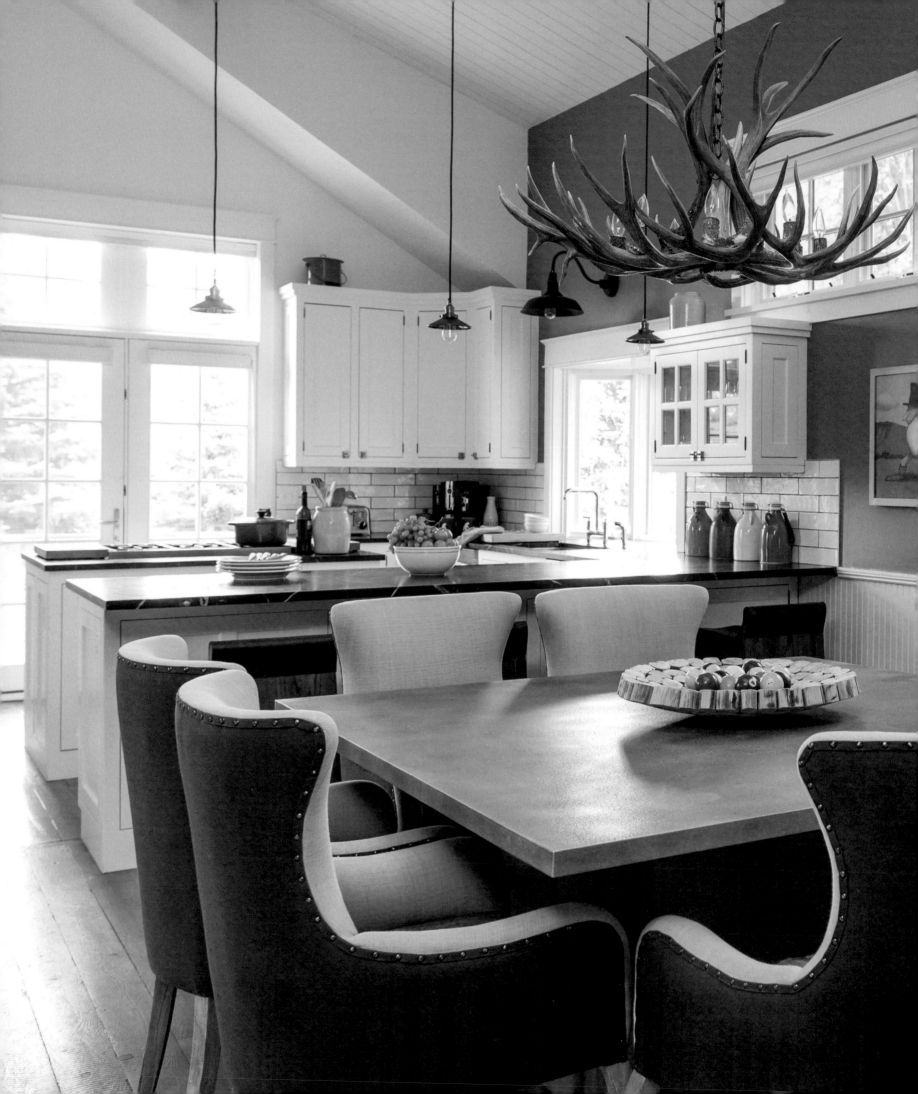

Upholstered in charcoal and almond linens, the dining chairs demonstrate the expert juxtapositions that Kate utilized throughout the design. The antler chandelier is a classic choice for many mountain homes, and a rustic wooden bowl on the table holds a collection of billiard balls for a touch of color.

In the kitchen, classic design choices are elevated by a number of standout details, like the butcher block placed throughout the space for convenience during dinner prep. White cabinets and subway tile create a soft contrast with warm gray walls and dark countertops, and the beautiful view out the bay window over the kitchen sink makes the chore of washing dishes less daunting.

Wooden barstools topped with leather are both a comfortable place for guests to enjoy one another's company and an eye-catching detail of the design, and a set of brightly colored jugs on the counter contributes a splash of personality to the space.

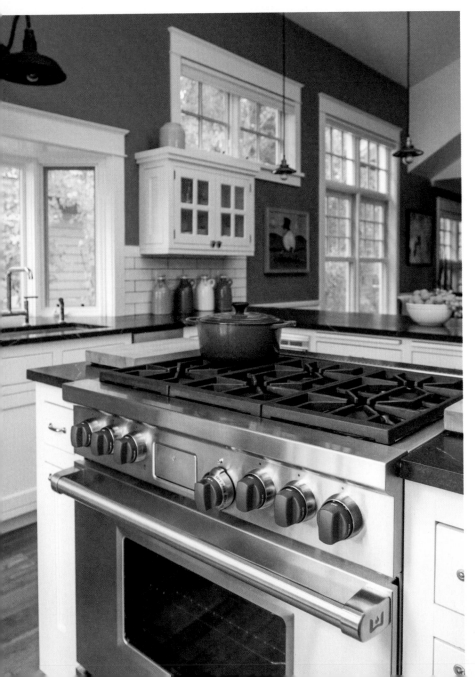

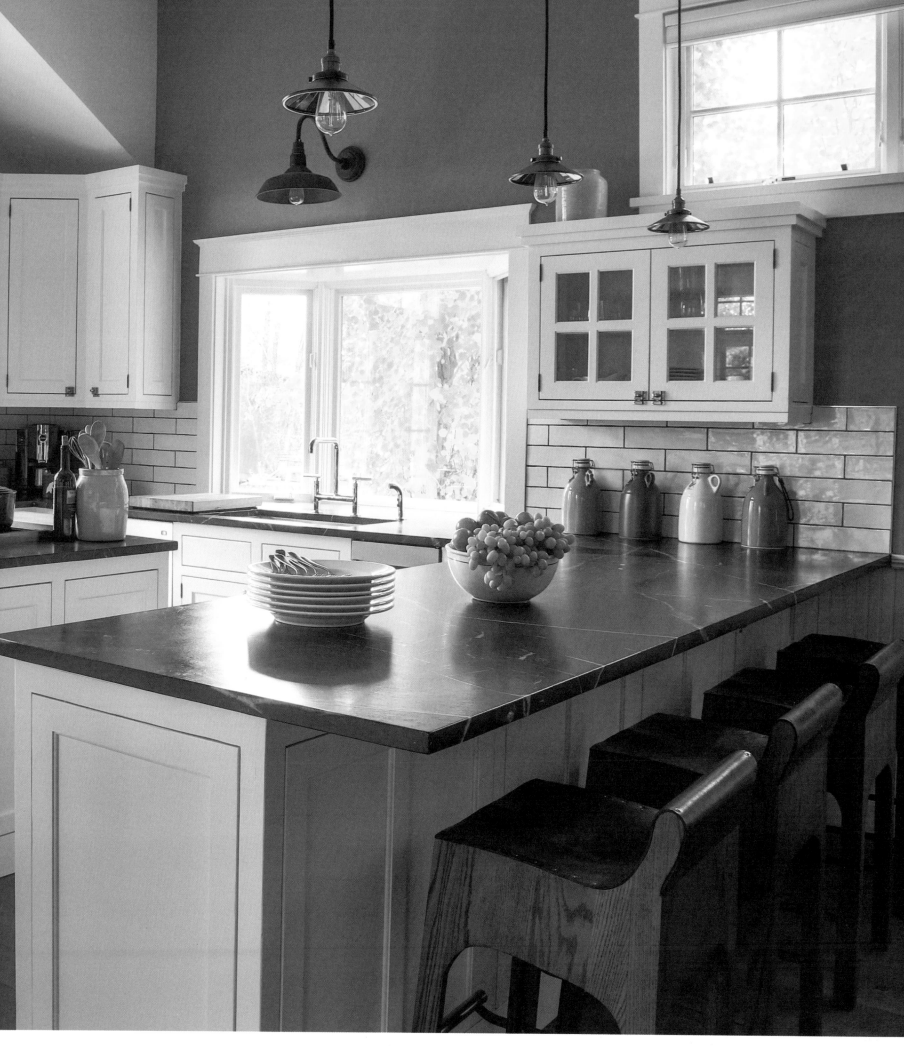

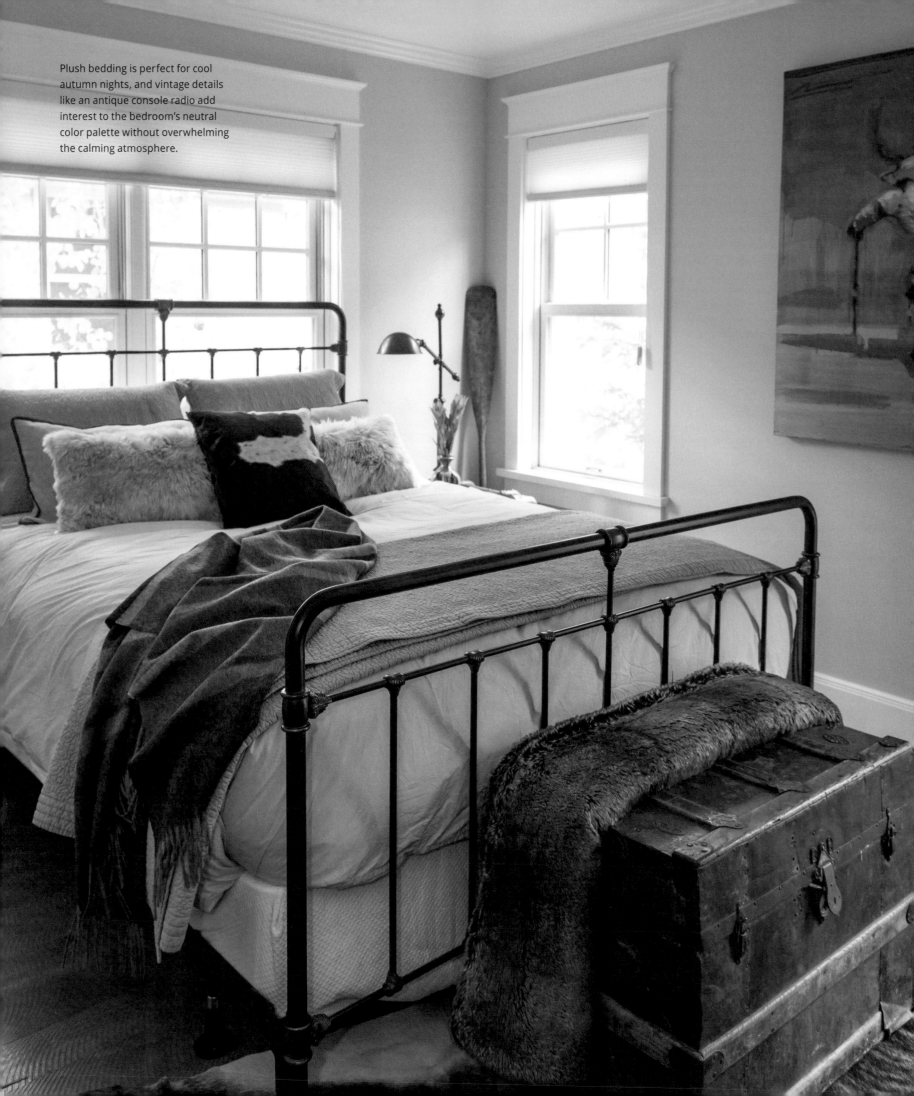

Plush bedding is perfect for cool autumn nights, and vintage details like an antique console radio add interest to the bedroom's neutral color palette without overwhelming the calming atmosphere.

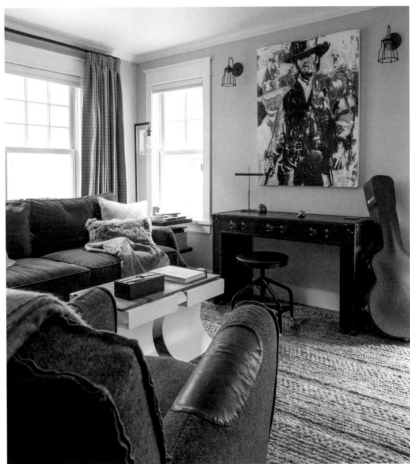

The home's bedrooms up the coziness factor with welcoming neutrals, rich gray tones, and layered textures. Clean lines paired with details like cowhide throw pillows and varnished wood surfaces maintain the masculine character found in every room, keeping the spaces comfortable for everyone.

Kate's original goal for the project extended to the home's exterior, where regional flair is evident in every detail. Various outdoor spaces, including the firepit and the rocking chairs on the porch, draw together friends and family alike, inviting everyone to sit back and enjoy the unique beauty Wyoming has to offer.

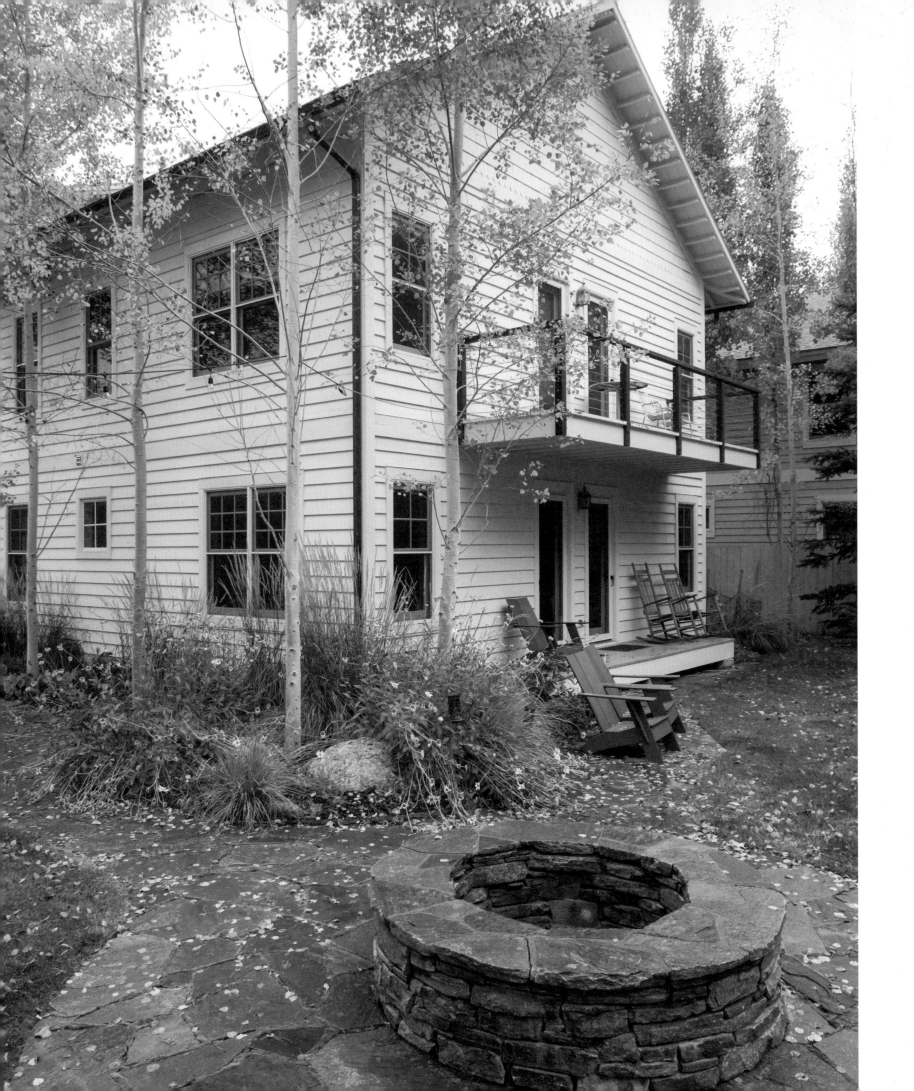

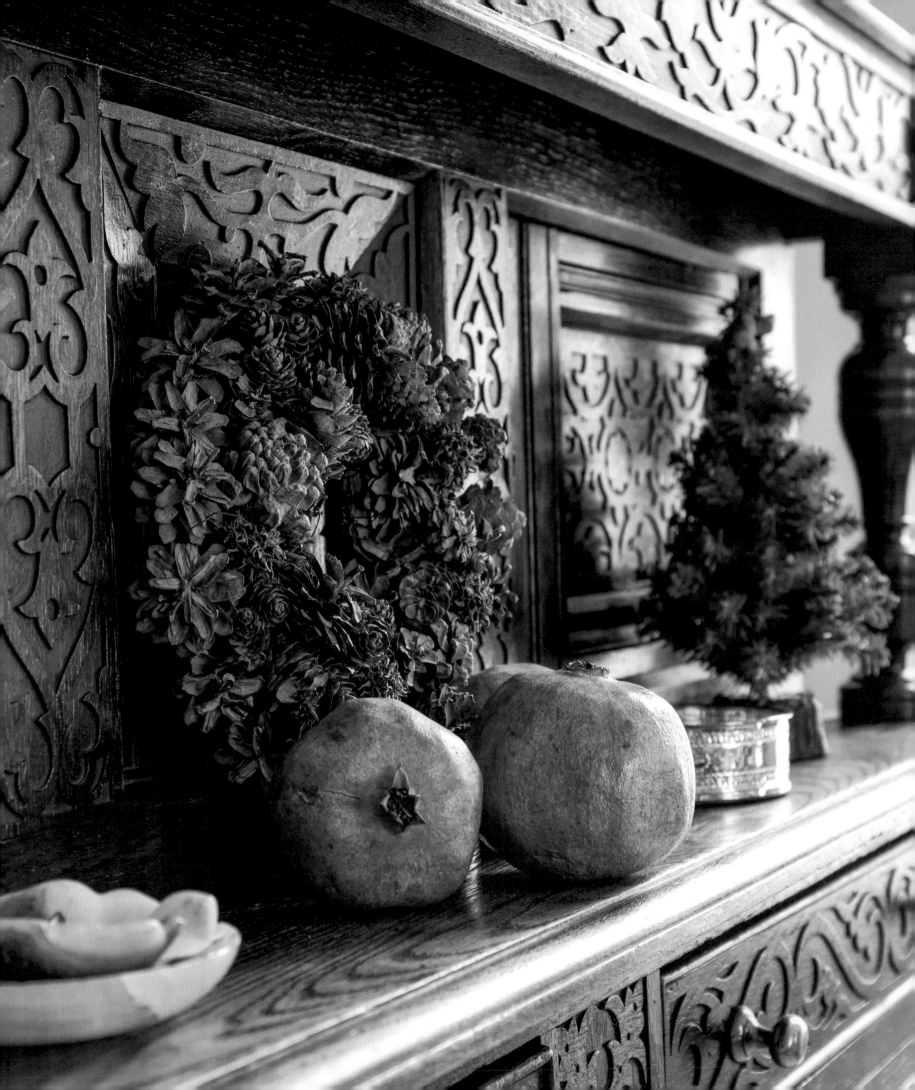

WINTER

HOLIDAY COTTAGES AND WARM FIREPLACES SHARE SEASON'S GREETINGS WITH SNOWY VIEWS. PERFECT FOR HOSTING INTIMATE PARTIES OR WELCOMING LOVED ONES, GREENERY-DRAPED ENTRYWAYS AND TWINKLING TABLESCAPES SING WITH THE SPIRIT OF WINTER.

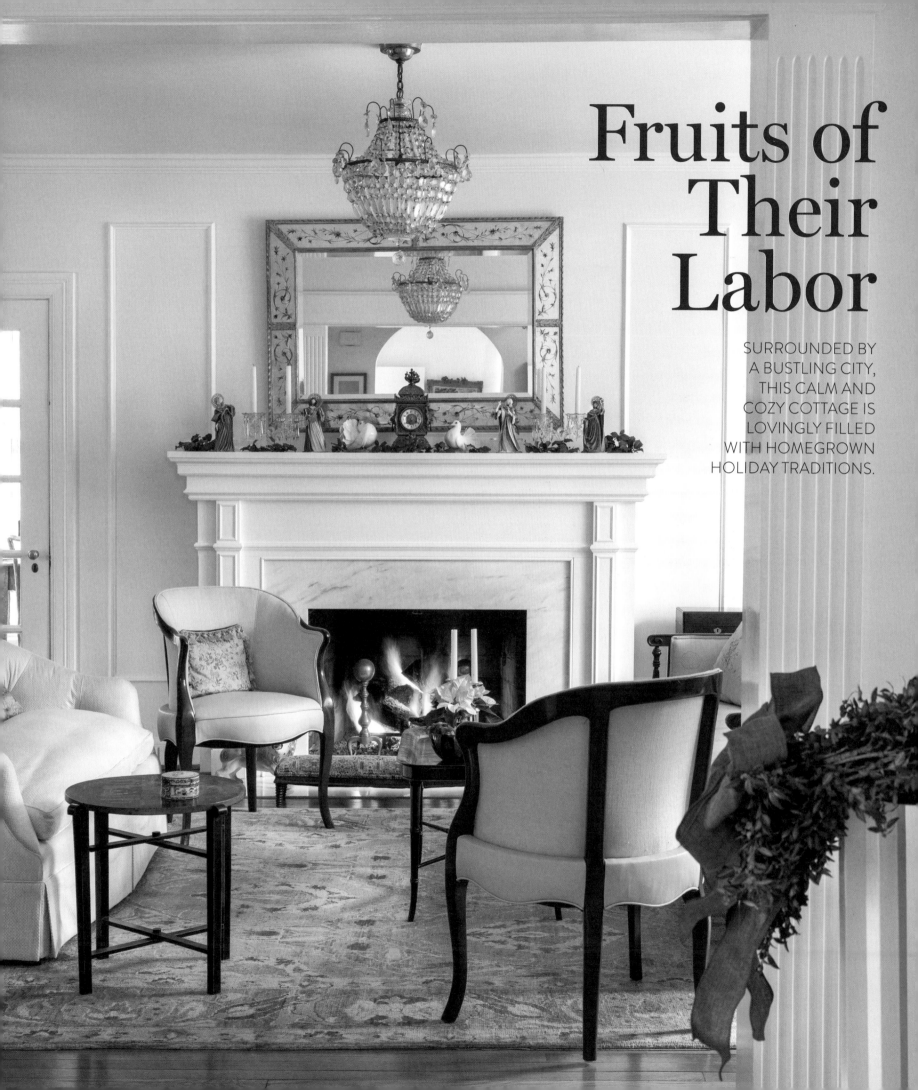

Fruits of Their Labor

SURROUNDED BY A BUSTLING CITY, THIS CALM AND COZY COTTAGE IS LOVINGLY FILLED WITH HOMEGROWN HOLIDAY TRADITIONS.

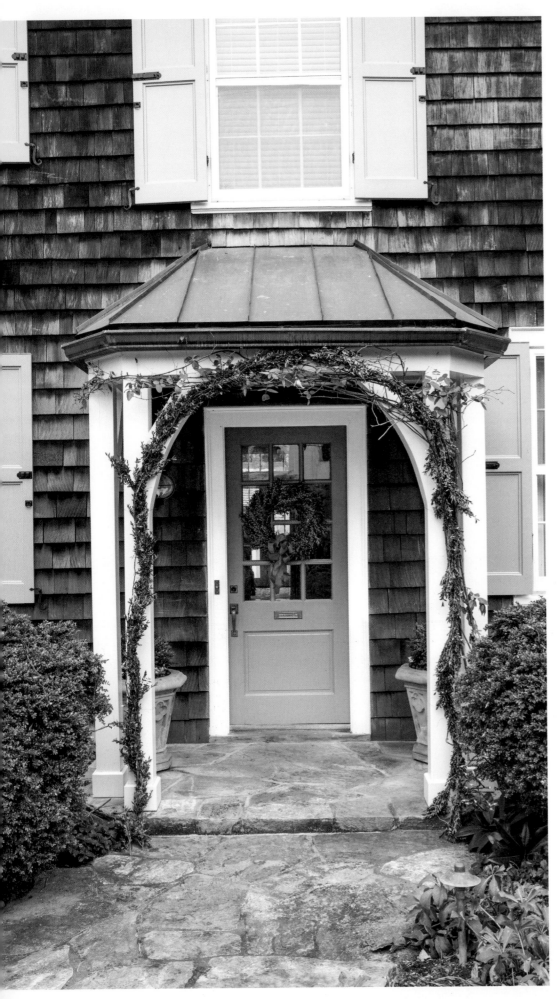

For Leslie and Scott Fritz of fritz&gignoux landscape architects, Christmas preparations begin in the spring. "We use layers in our decorating and plan ahead in the garden for the flourishes," Leslie says. "From year to year, we rotate the plant flourishes with a focus on keeping it simple. We make sure we have the plant material we'll need for decorating at Thanksgiving and the holidays."

The two grow everything in their garden in Washington, DC, where they created their own patch of the country in the middle of the city. Entering the Arts & Crafts cottage at Christmastime, you can see the fruit of the Fritzes' labor in subtle touches of fresh greenery and sprigs of red berries complemented with hand-tied velvet bows and hemlock pine cone clusters. "For the holidays, we use *Ilex verticillata* berries from the garden [and] dried honeysuckle berries from our 'Alabama Crimson' honeysuckle," Leslie says, noting that garland and a boxwood wreath are "holiday staples."

But the holiday preparations don't end there. "Once the greens are up, we unpack our boxes of treasures from around the globe," Leslie says. "The glass, ceramic, and carved wood figures add so much character and charm to our simple framework."

Their "boxes of treasures" include ornaments passed down from family and collected from their own various travels. Pieces picked up at the Christmas markets in Austria rest alongside finds from their daughters' adventures in Asia, and the tree is topped off with a German wax-and-velvet angel that belonged to Leslie's grandmother. "So, the tree literally has ornaments from all over the world on it," Leslie says.

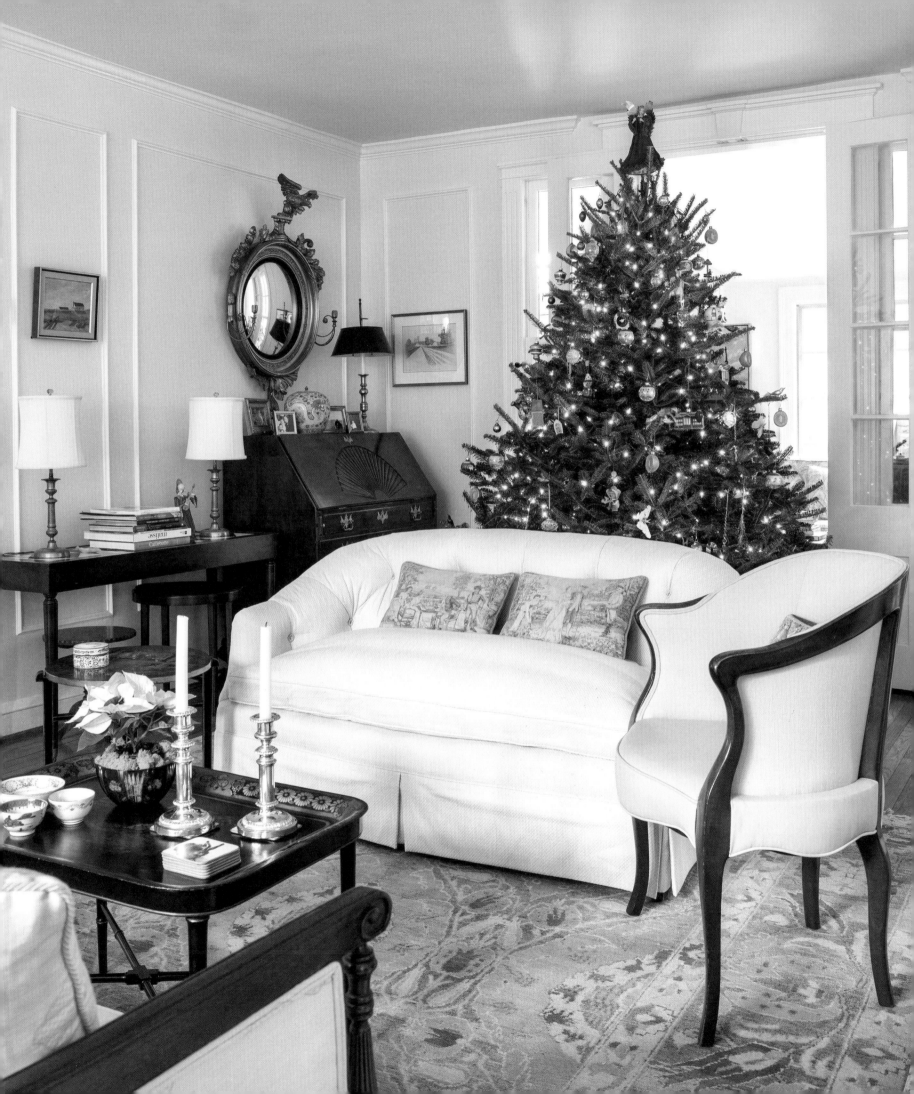

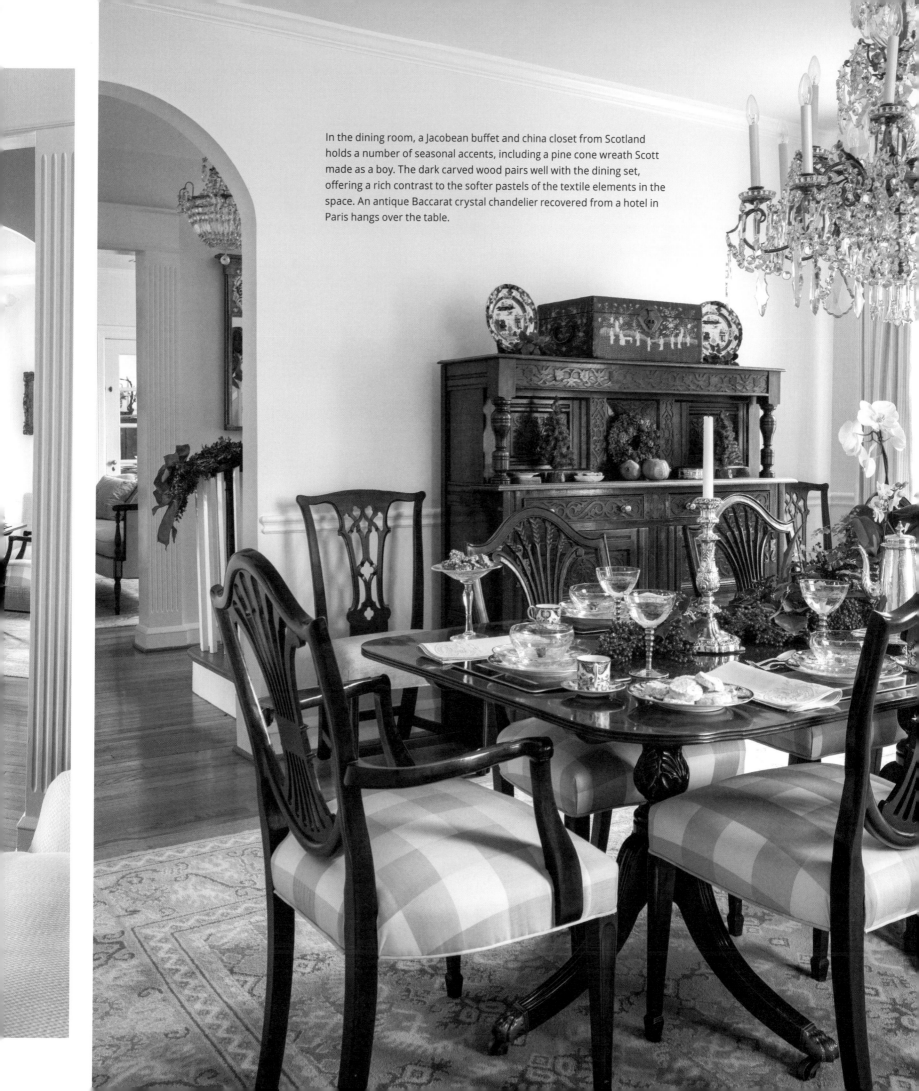

In the dining room, a Jacobean buffet and china closet from Scotland holds a number of seasonal accents, including a pine cone wreath Scott made as a boy. The dark carved wood pairs well with the dining set, offering a rich contrast to the softer pastels of the textile elements in the space. An antique Baccarat crystal chandelier recovered from a hotel in Paris hangs over the table.

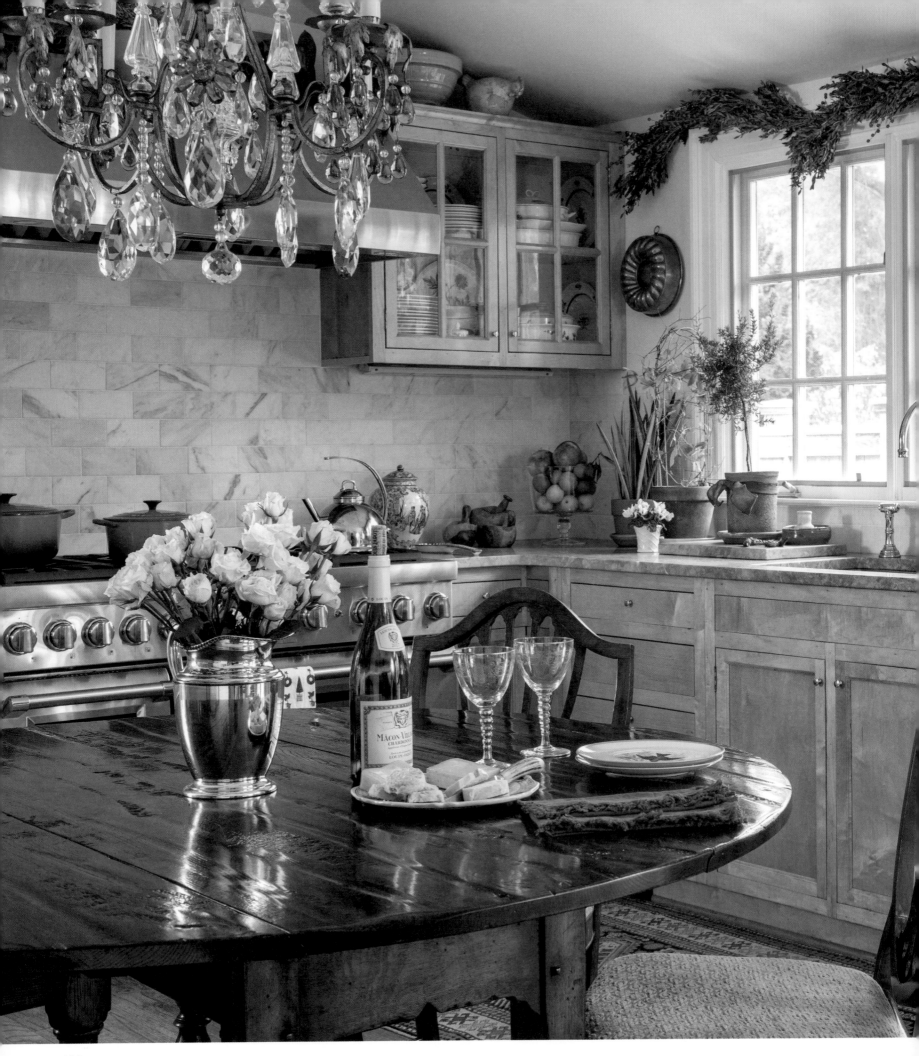

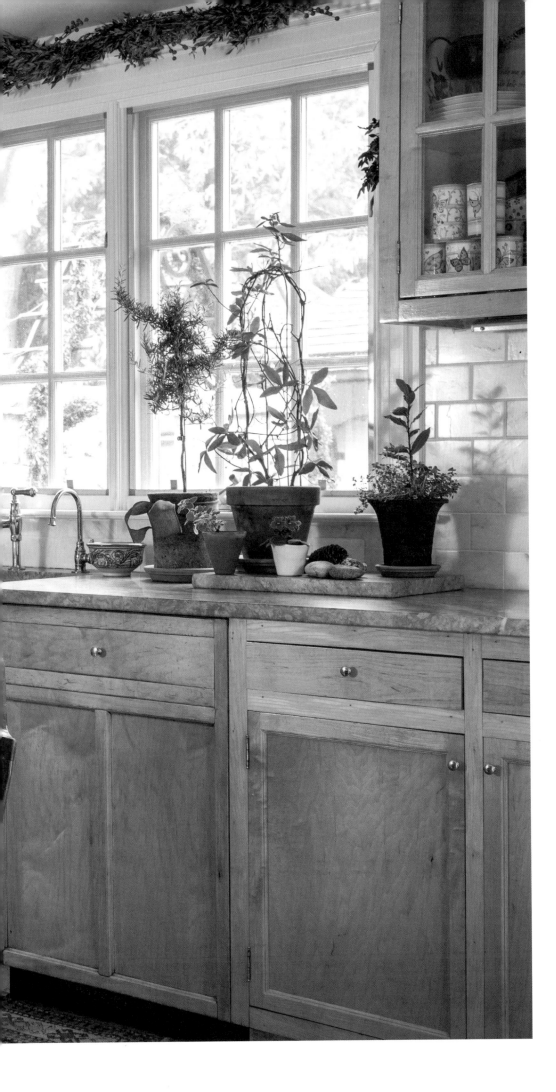

From baking Christmas morning croissants and attending music services at the beautifully decorated Washington National Cathedral to hosting a buffet-style holiday dinner for the neighbors, the Fritzes enjoy a number of holiday traditions accented by the warm lights they love to hang on the cottage's exterior. And on Christmas Day, every memory made is laced with the scent of cinnamon, nutmeg, ginger, and the other spices Leslie infuses the home with every year.

Whether in the carefully cultivated greenery or the collected figurines, it's easy to see how important the holiday season is to the Fritz family. And in one way or another—from planning the garden to keeping an eye out for new treasures during vacation—thoughts of Christmas stay with Leslie and Scott all year long.

Curly maple cabinets lined with a cheerful robin's-egg blue lend the kitchen a warmth made more welcoming by the various potted plants that grace the counter and the greenery above the window.

The family room, which Leslie and Scott added to the house themselves, features an abundance of windows that serves the dual purpose of letting in plenty of light and providing a view of the garden, creating the flow between the indoors and outdoors that the couple wanted.

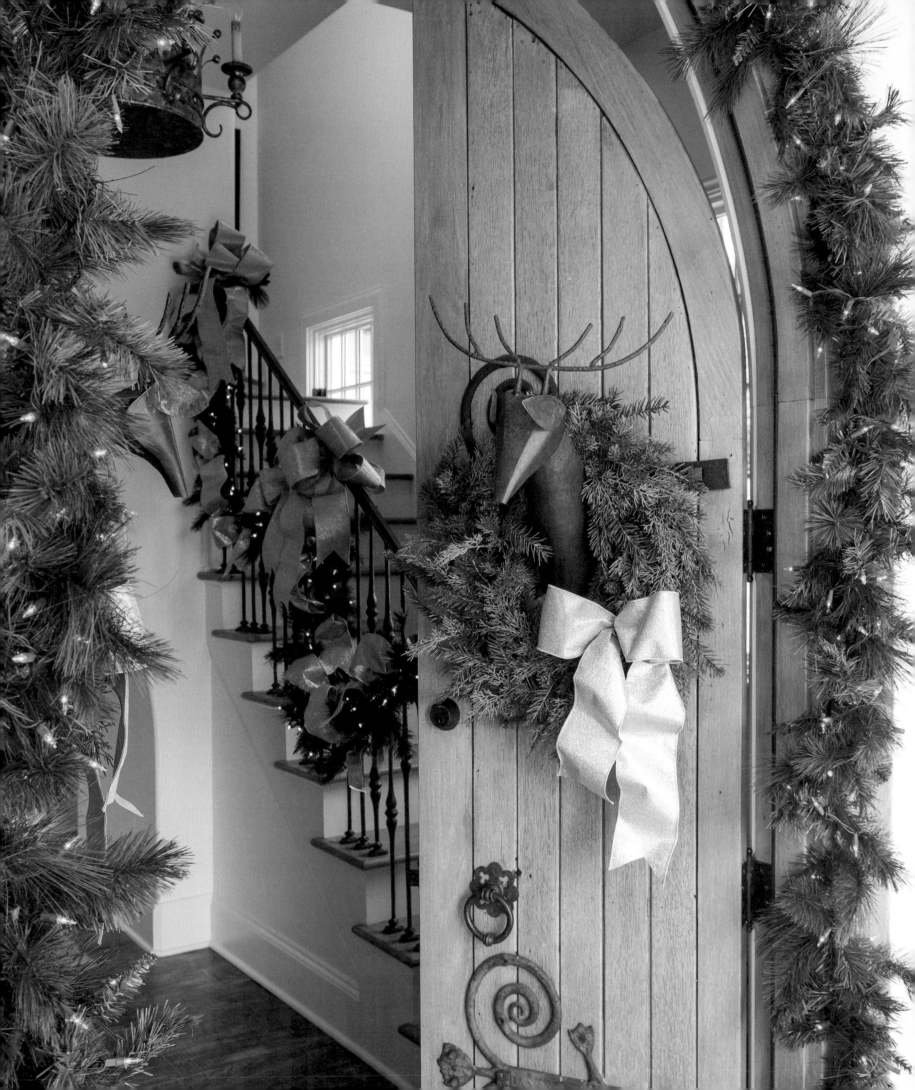

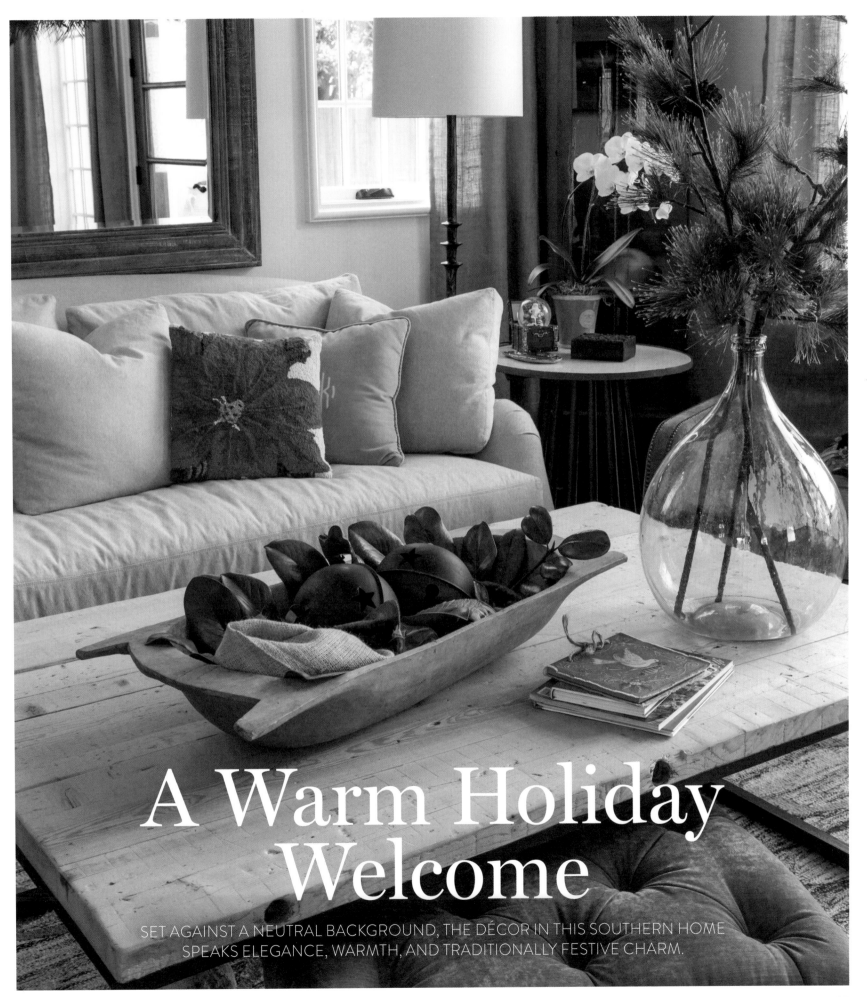

A Warm Holiday
Welcome

SET AGAINST A NEUTRAL BACKGROUND, THE DÉCOR IN THIS SOUTHERN HOME
SPEAKS ELEGANCE, WARMTH, AND TRADITIONALLY FESTIVE CHARM.

I f you visit the Hortons during the holiday season, chances are you'll be greeted at the door by a pair of whimsical reindeer. They're one of Judy Horton's favorite pieces, and combined with iron scrollwork, lively wreaths, and elegant bows, they're the perfect introduction to the timeless Christmas cheer that permeates the home. Beyond the arched wooden doors, rich greenery fills every room, and each space is accented with the warmth of the season in a way that invites guests inside for a long stay.

Because the Hortons moved into the home in August of 2017, Judy had little time to complete all of the many preparations for the approaching holiday season. To meet the tight deadline, she enlisted the help of local floral business FlowerBuds for the tree, wreaths, and other greenery. "I met with him at first to tell him I wanted more of a natural look," she says of owner Ray Jordan. "I think the house lends itself to that, and it's the style that I like."

Rustic woods, natural materials, industrial details, and touches of antique character give the home plenty of timeless elegance, and the traditional gold and red seasonal décor fits the spirit of the home with an effortless air of festivity. Vibrant garlands and swags drape mantels and banisters, wreaths ornament windows and mirrors, and plush, lively throw pillows featuring oversize poinsettias and patchwork trees provide pops of cheerful color to every corner.

Even the home's outdoor spaces get the holiday treatment, with pops of red and green calling out the rich tones of the surrounding landscape. A pair of miniature trees tops the stone table, seamlessly blending with the natural materials of the space. Opposite: Sparse ornaments featuring traditional motifs and beaded garland in red and gold only enhance the natural beauty of the tree, which was decorated by FlowerBuds. The stair banister sports a more neutral theme, with shimmering golds and twinkling lights softening the deep green garland.

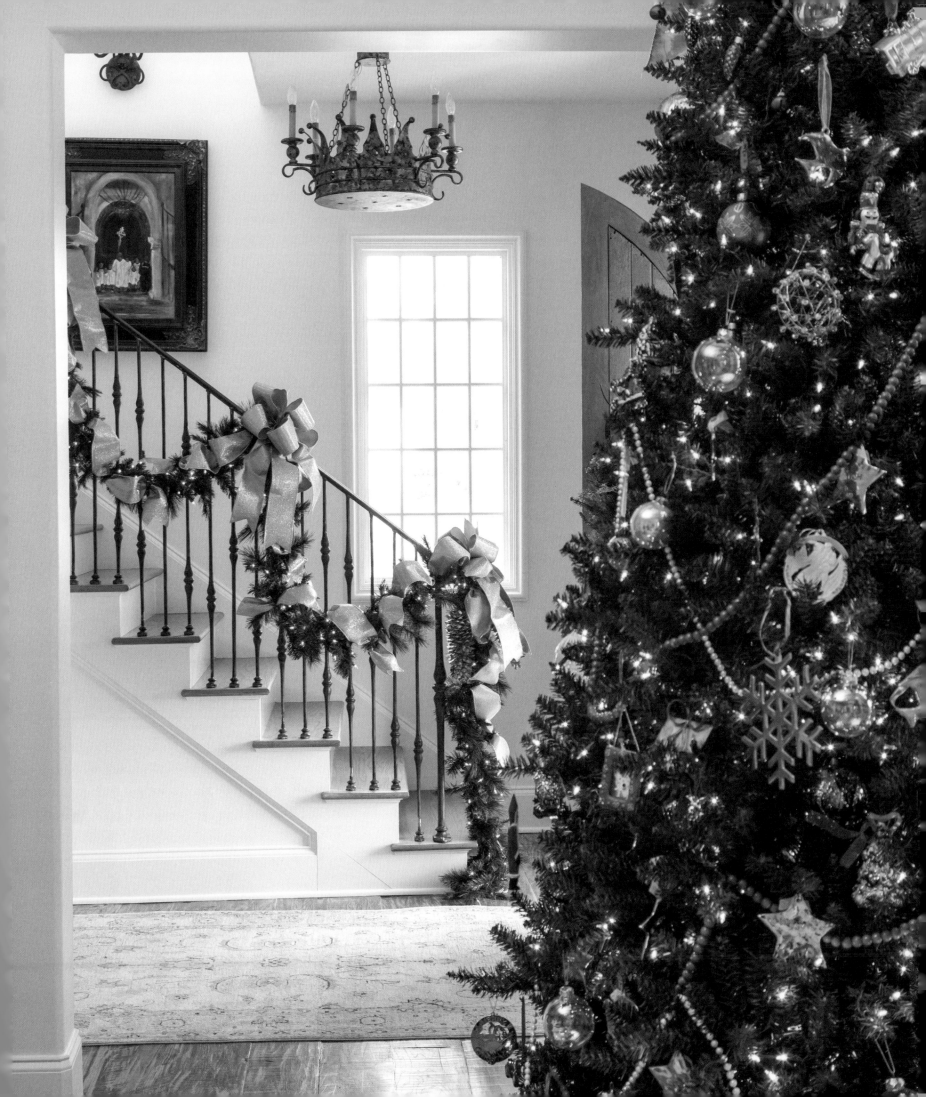

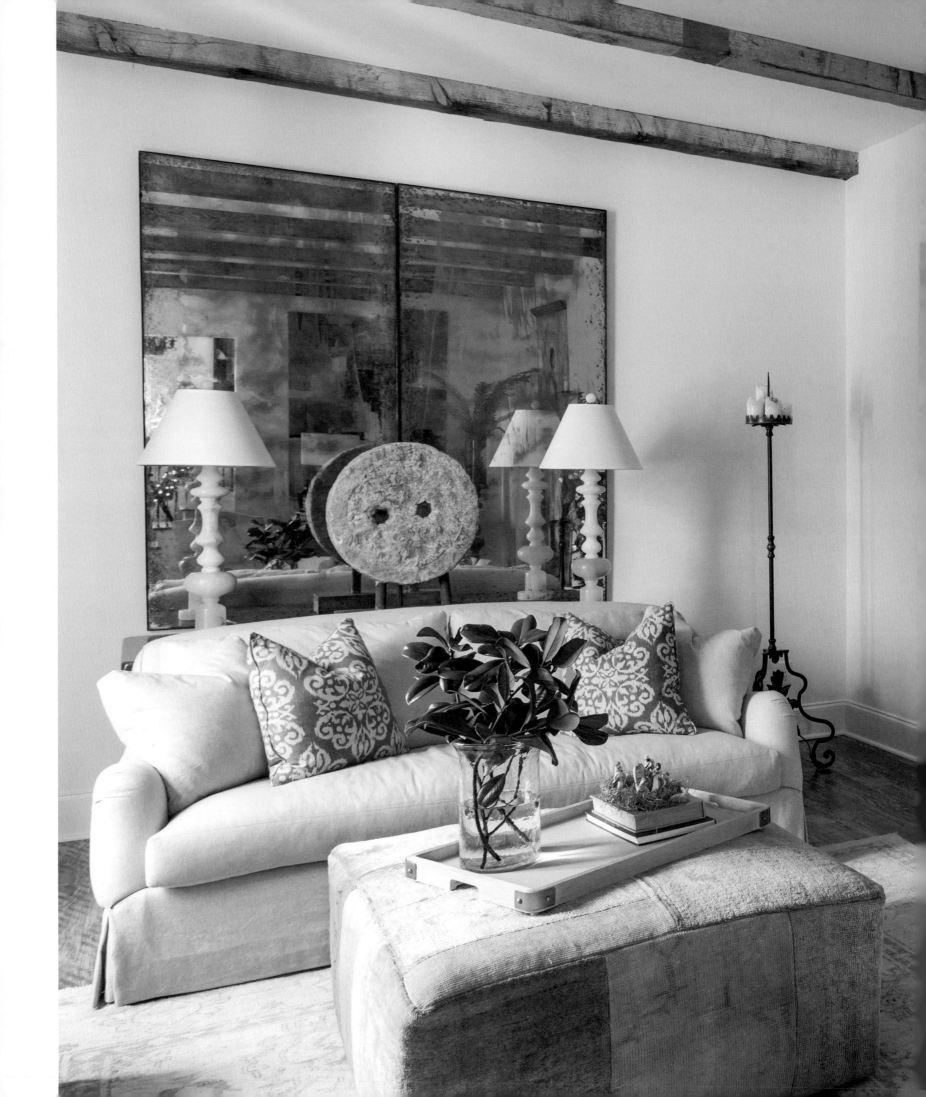

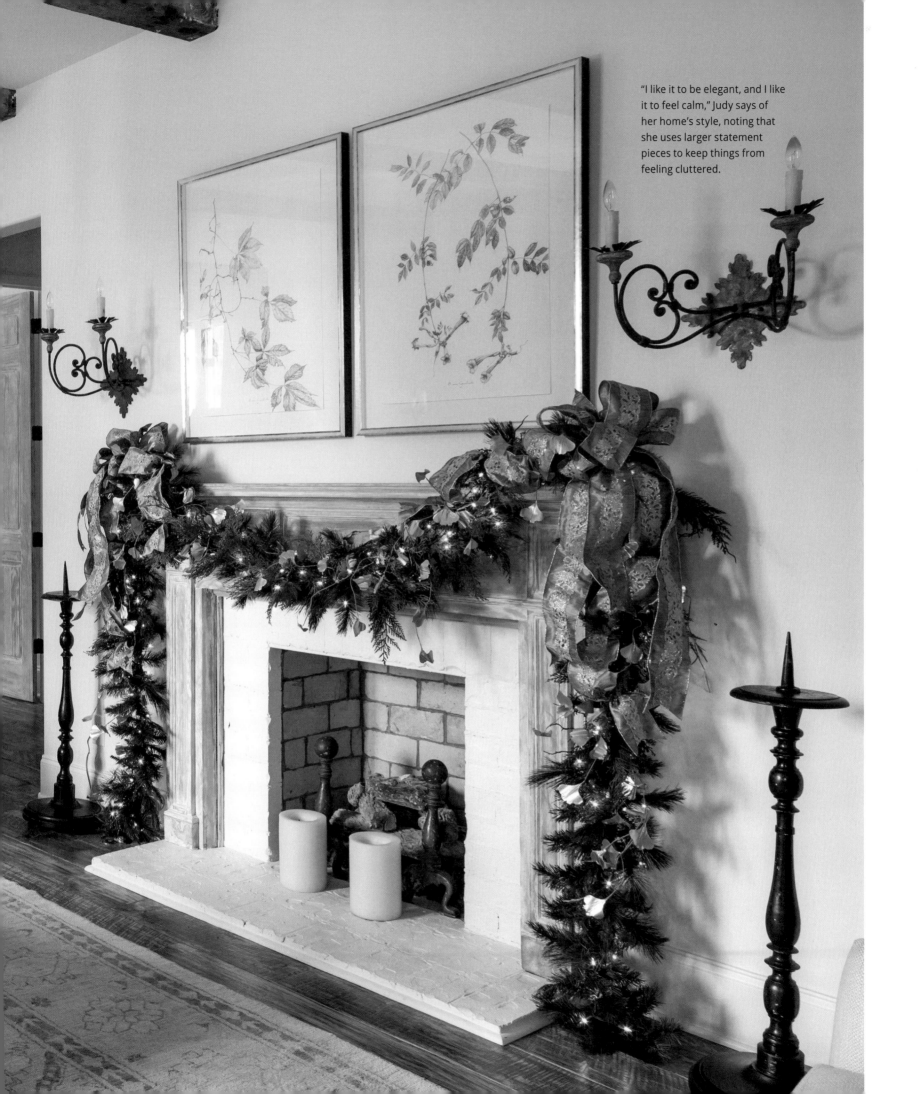

"I like it to be elegant, and I like it to feel calm," Judy says of her home's style, noting that she uses larger statement pieces to keep things from feeling cluttered.

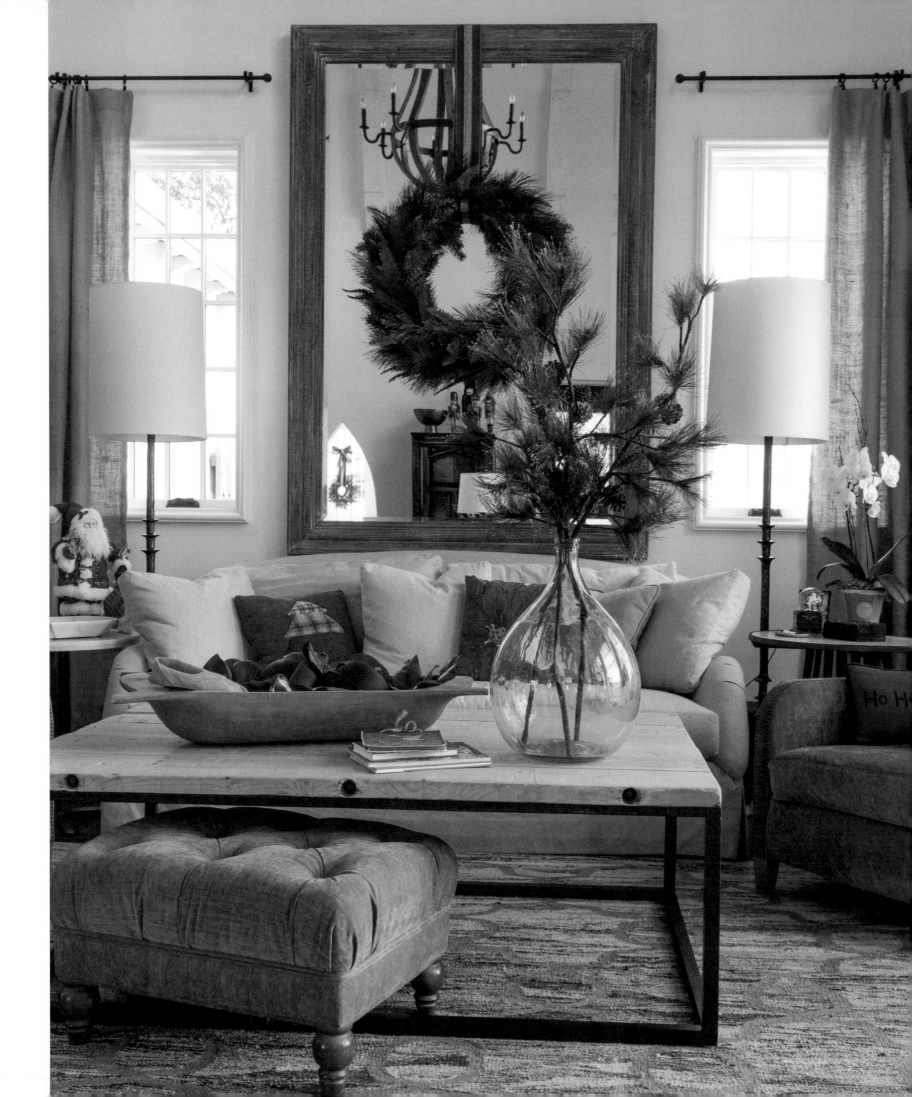

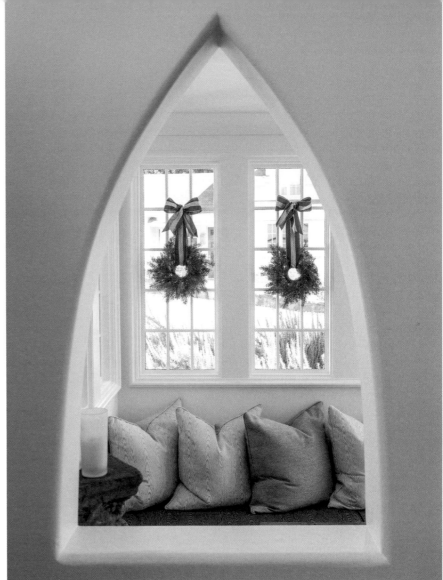

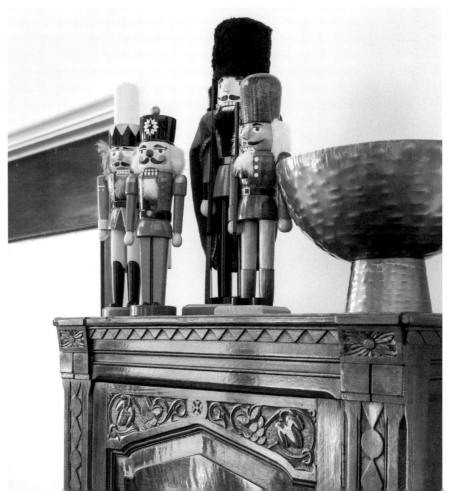

Standing guard atop an intricately carved wooden cabinet, Judy's collection of nutcrackers started nearly 40 years ago. "We had a German friend who, when my daughter was born, gave her a nutcracker every year for five or six years from Germany," she says. Opposite: A bundle of pine branches bursting from a clear glass vase combines the rustic beauty of a winter forest with clean contemporary lines, and a wooden bowl filled with oversize bronze bells and magnolia leaves adds a touch of Southern charm.

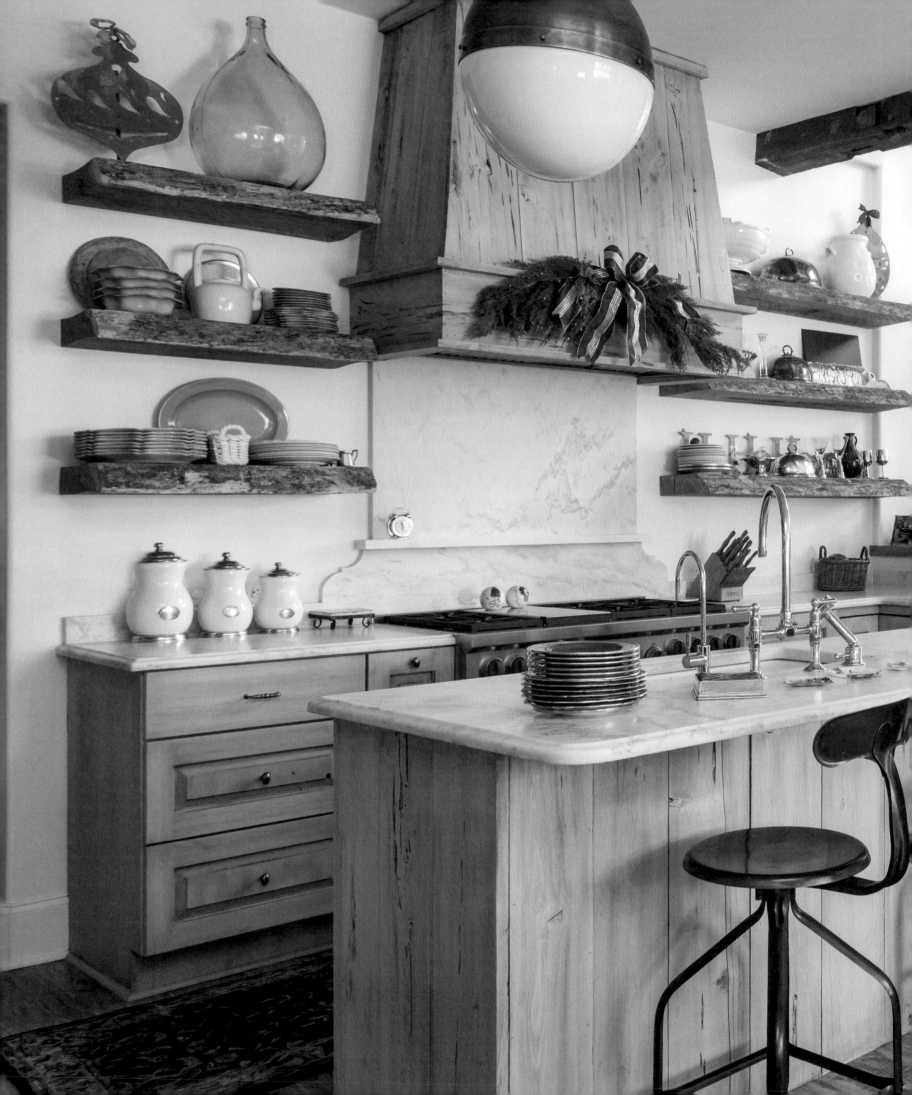

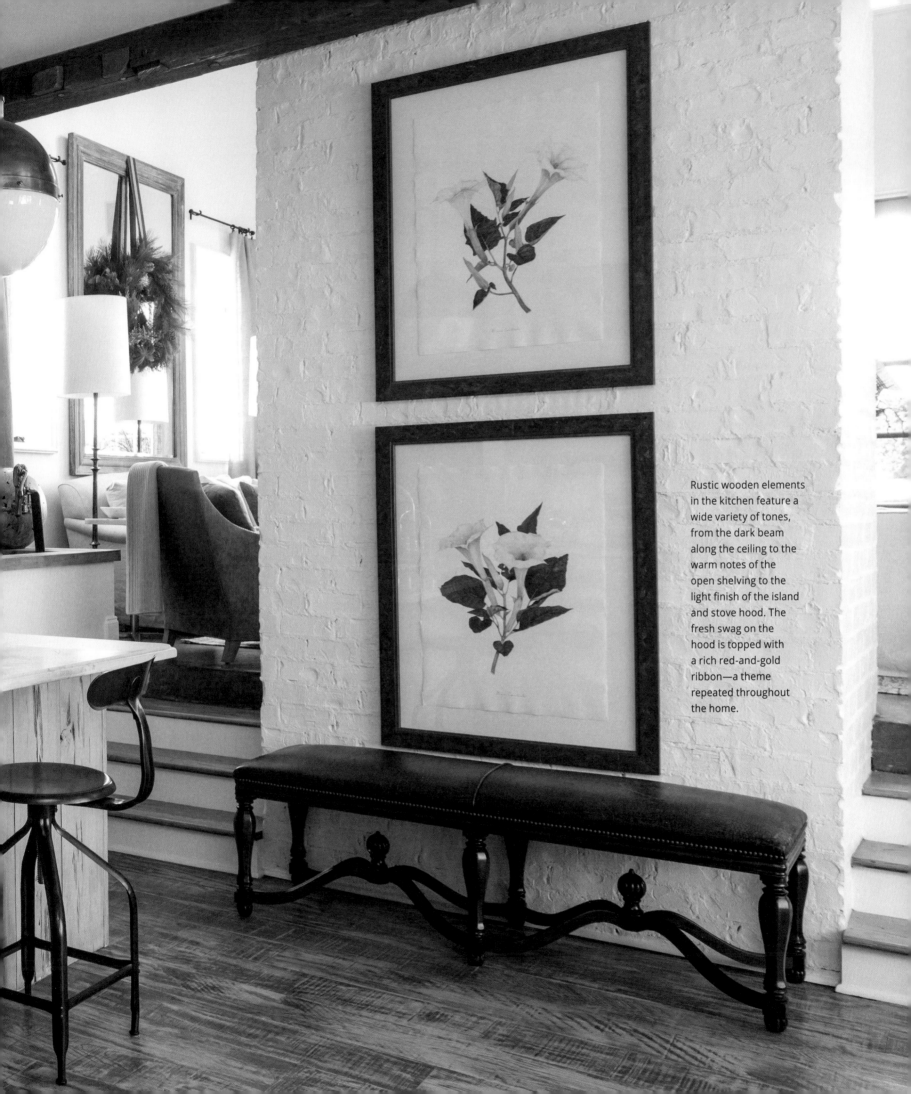

Rustic wooden elements in the kitchen feature a wide variety of tones, from the dark beam along the ceiling to the warm notes of the open shelving to the light finish of the island and stove hood. The fresh swag on the hood is topped with a rich red-and-gold ribbon—a theme repeated throughout the home.

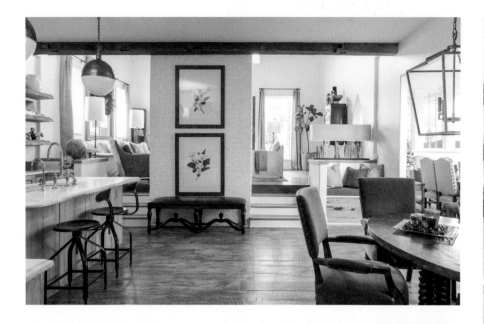

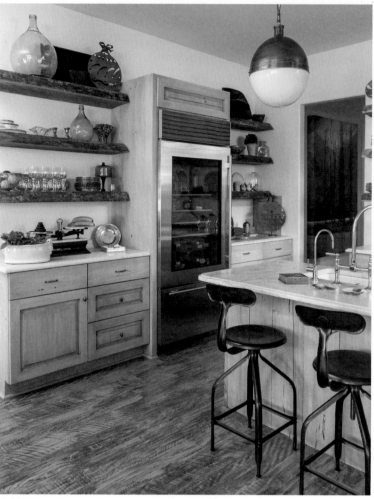

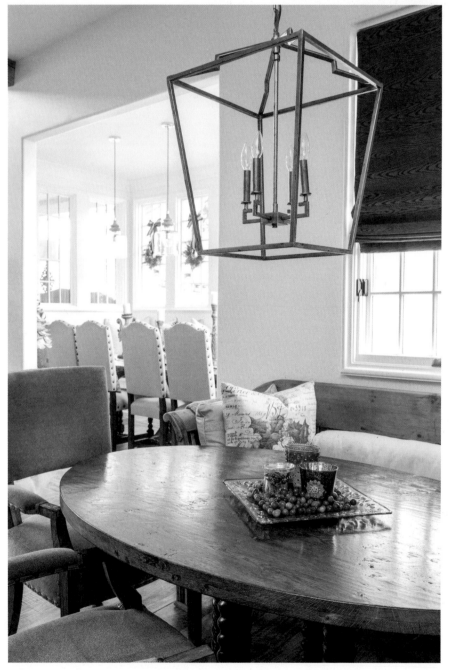

Judy notes that her favorite part of holiday decorating is "getting it done" so she can relax, appreciate the festivities, and spend time with loved ones. "I like to get it done early so I can enjoy it," she says. "Because it's so pretty and it's such a short time span that, to me, it's almost like the most important thing is to get it finished so you're not stressed and can enjoy all the family elements."

Many of those "family elements" include the kitchen and dining areas, which happen to be Judy's favorite parts of the home. She notes that the open nature of the space lends itself to entertaining, which is perfect during the Christmas season. "For the holidays, we literally had our entire family around that table," she says. "Sometimes, your family's too big and you have to use a secondary table for the kids. But everybody fit, and it just felt really like the family experience you want."

A bit of Christmas cheer is easily injected into any centerpiece with a handful of decorative cranberries, and grouping together mismatched holiday candles can add warmth and interest to your table.

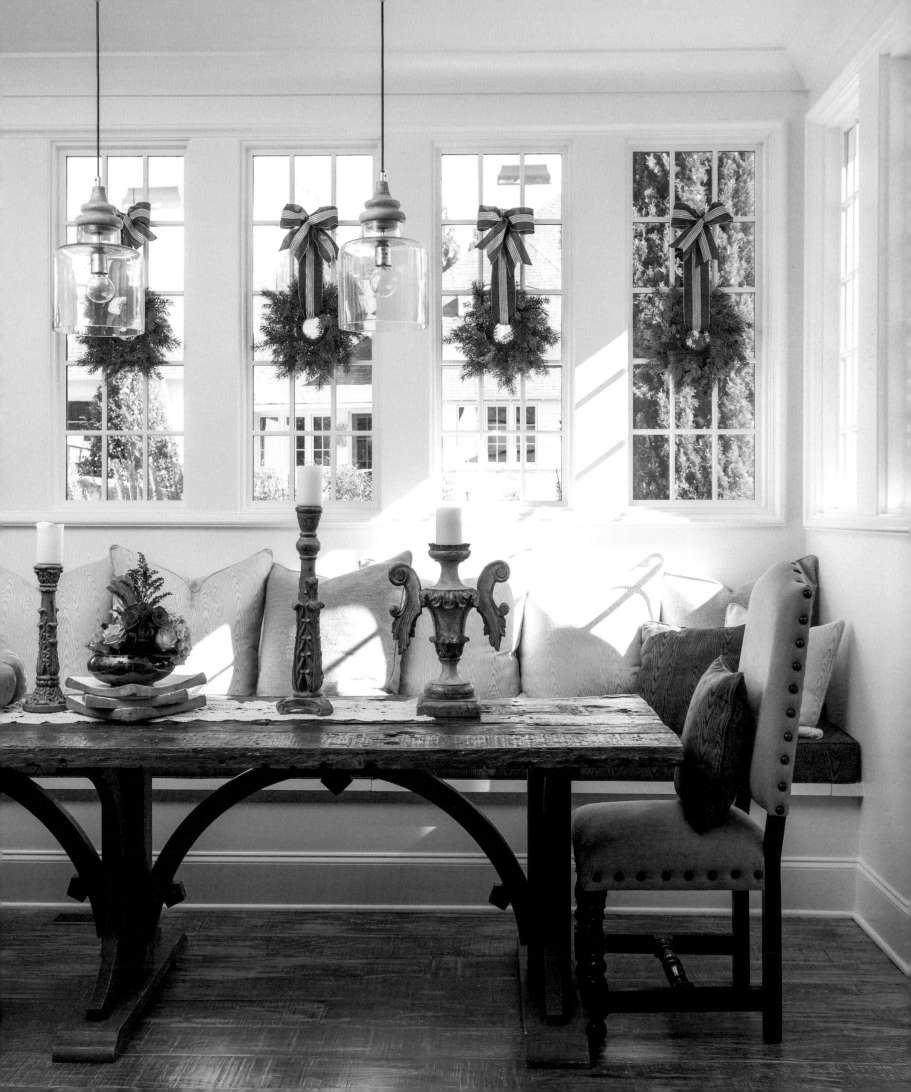

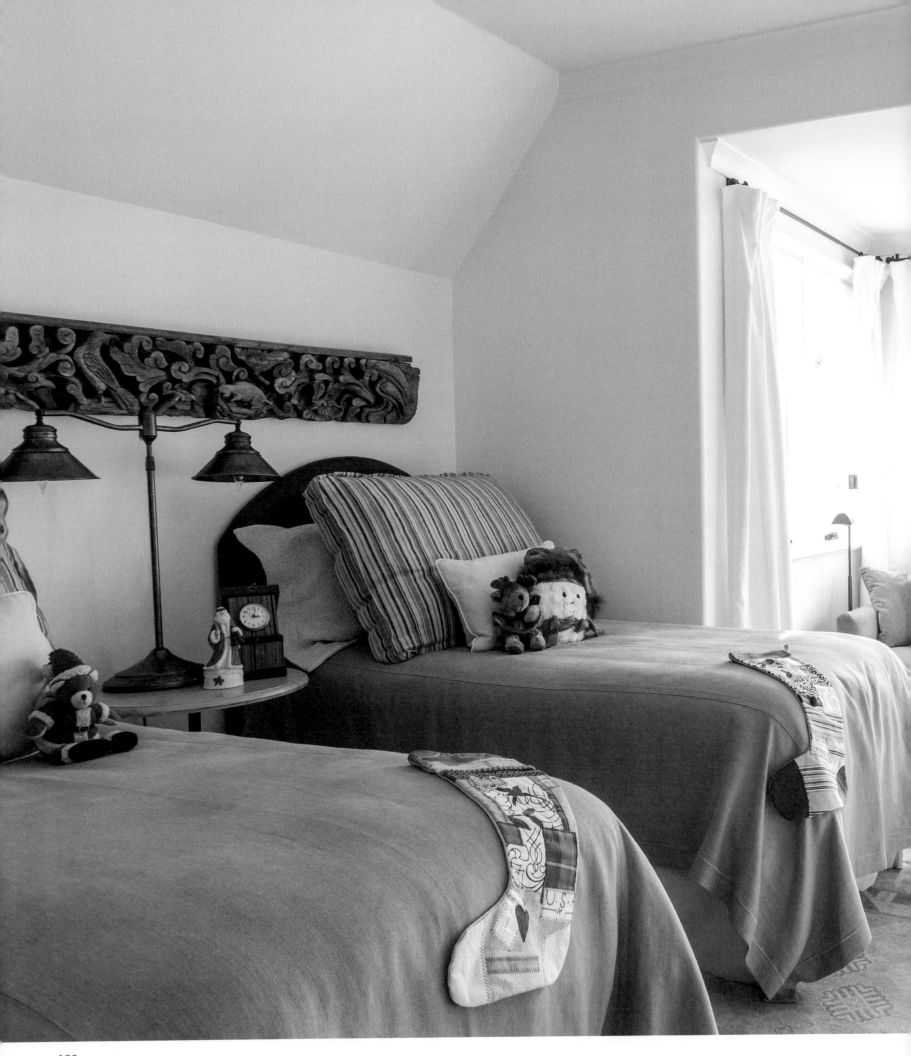

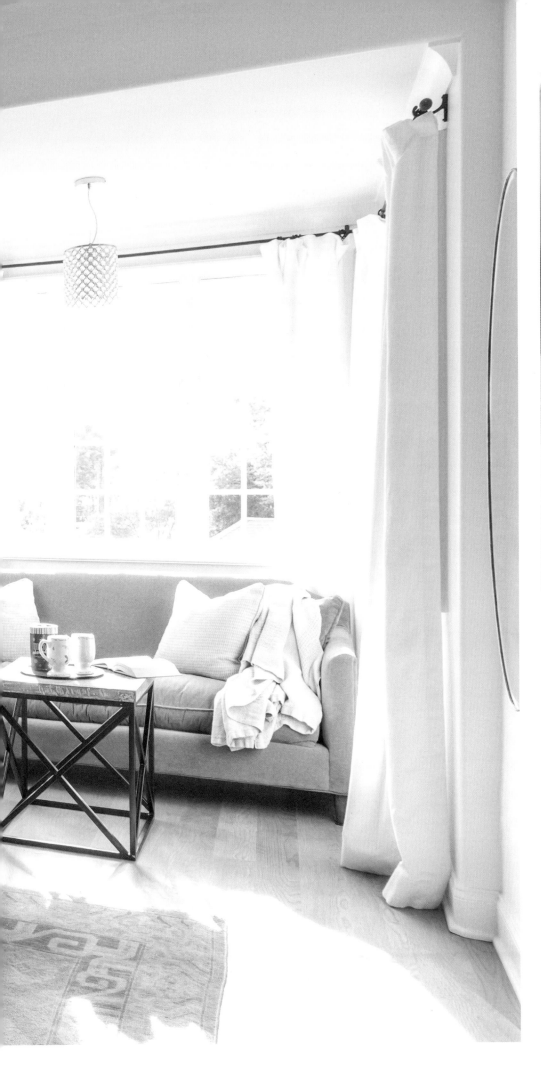

The Christmas cheer spills into the bedrooms, where the muted tones of the children's space are brightened by more of the throw pillows that are seen in other parts of the home. Noting the neutral style of the interior, Judy says that collecting the pillows is a festive way to add a little color, and pairing them with stuffed animals and stockings injects even more Christmas spirit. By the seating area tucked into the window, a pair of cheery mugs encourages cozying up in the window with family and some steaming hot cocoa.

It's just one more way that the home's timelessly festive décor facilitates making new Christmas memories with loved ones throughout the season. "I'll have a party with my Bunco group or my book club, or sometimes we have our company party at our home," Judy says. And, of course, the season isn't complete without getting together with family and enjoying the beauty on every side.

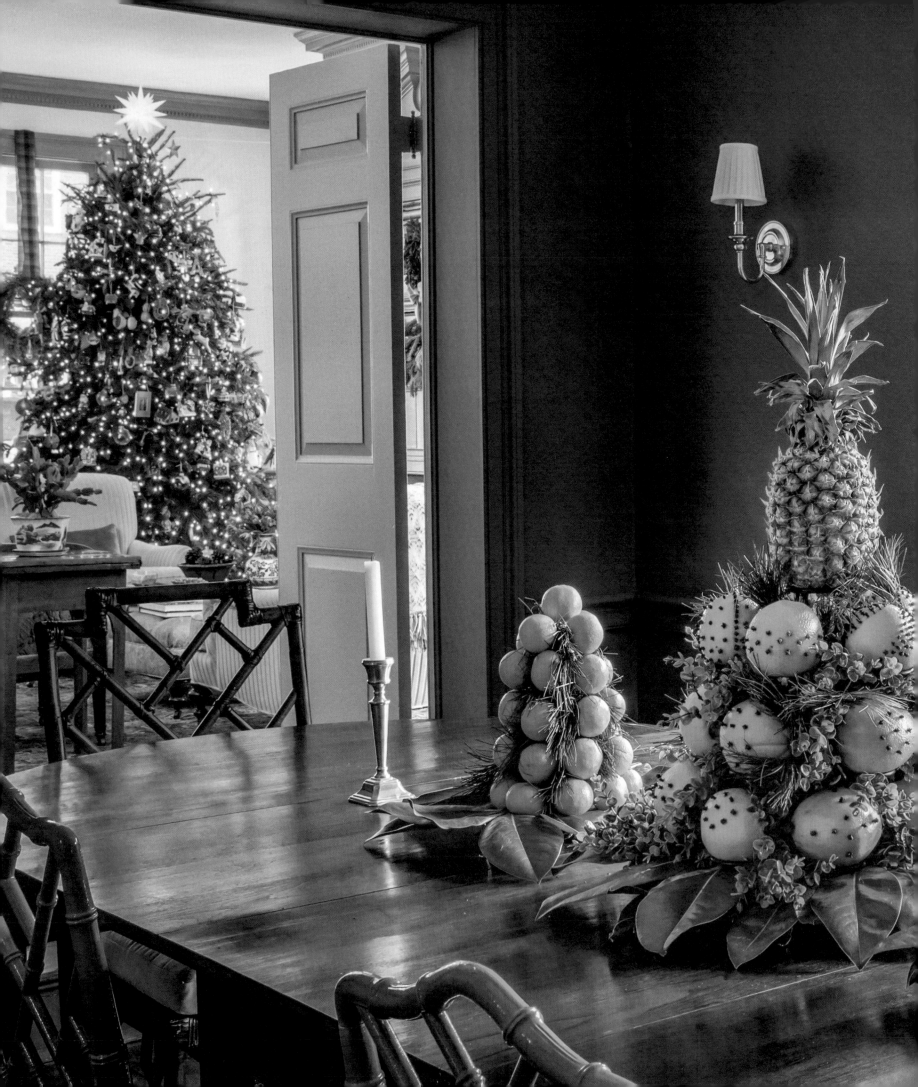

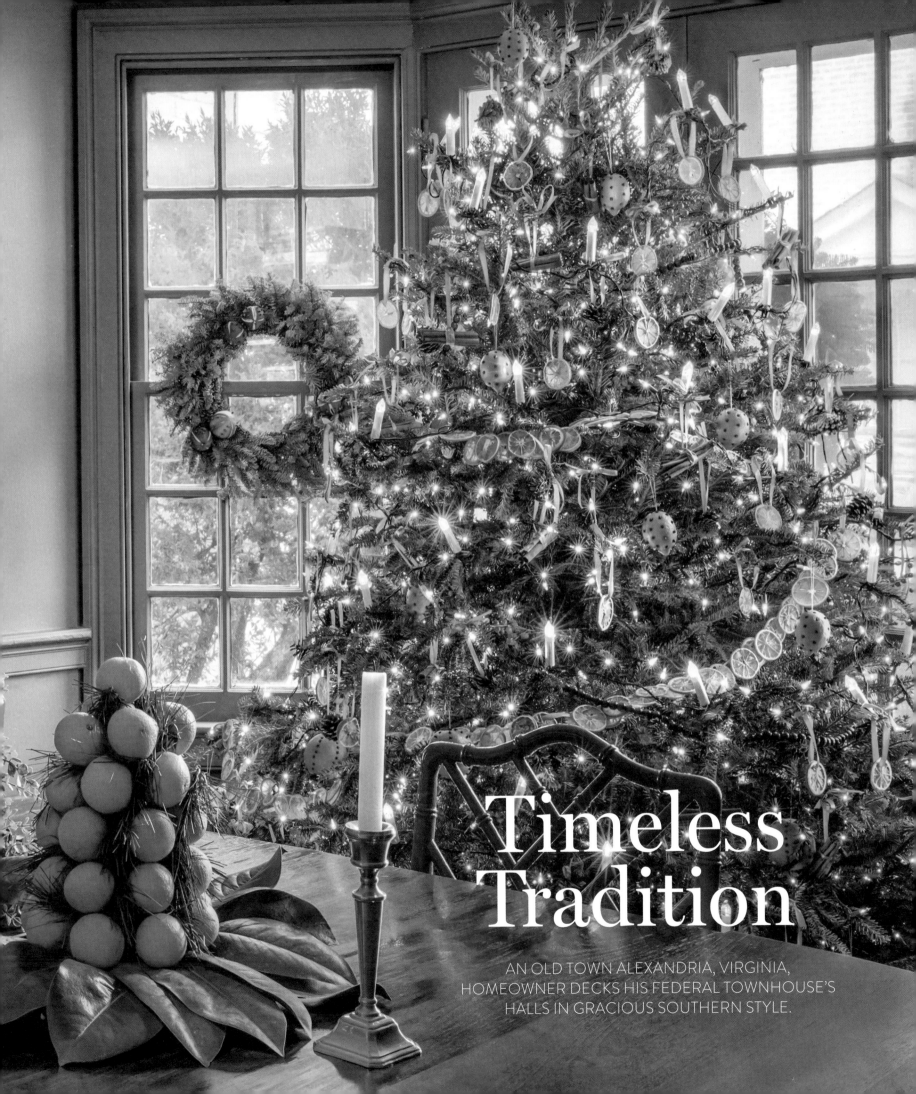

Timeless Tradition

AN OLD TOWN ALEXANDRIA, VIRGINIA, HOMEOWNER DECKS HIS FEDERAL TOWNHOUSE'S HALLS IN GRACIOUS SOUTHERN STYLE.

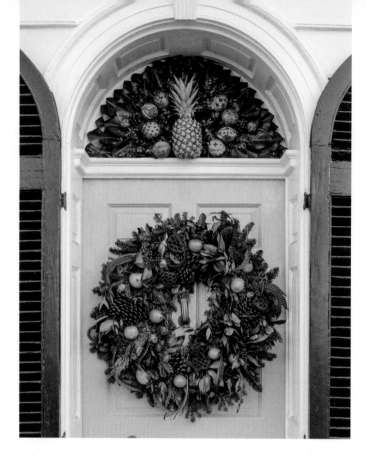

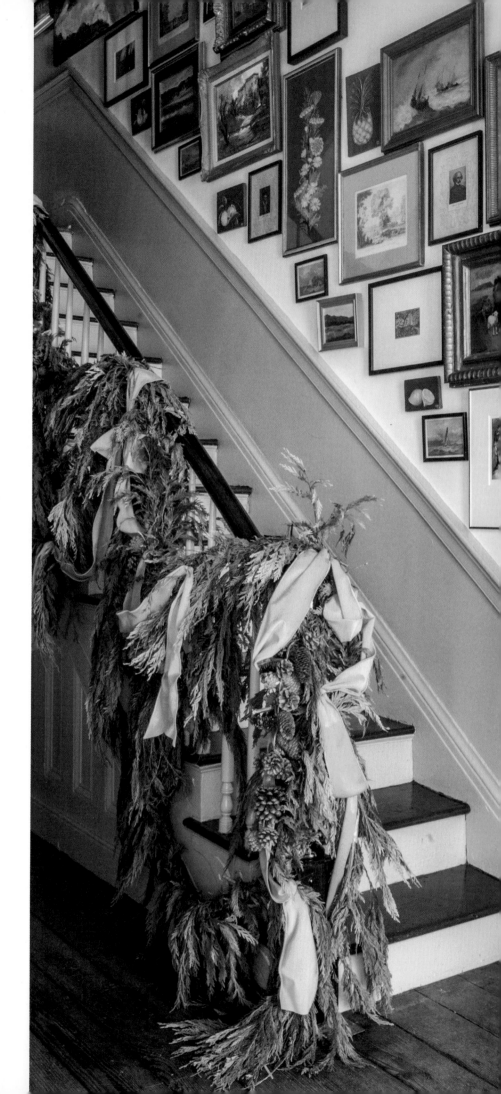

When it comes to Christmas décor, the holiday design of this Federal townhouse in Old Town Alexandria, Virginia, celebrates the season by keeping with timeless tradition. "Our home is 200 years old, so I stick with that as my holiday decorating inspiration," says homeowner Brian Branton, who shares the 2,400-square-foot house with his partner, Adam Podbielski. "I want the décor to be traditional but also fitting for a much lived-in and beloved home, so that resonates throughout."

Not only is the house filled with family antiques and priceless heirlooms, but its warm color palette of rich, earthy tones—with shades of green, yellow, and blue layered in—lends itself to a traditional Southern Christmas decorating style. "I've always loved Christmas," says Brian, whose own heritage hearkens generations back from North Carolina. "My approach is traditional, traditional, traditional, with sprinkles of Southern thrown in. I am heavily influenced by my family and the décor of Christmases past, so I use that for my own home."

To achieve the right look, Brian starts early and sets himself an end goal of cohosting an annual Christmas party. By then, the entire first floor, from the entry hall to the double parlor and dining room, is fully decked out, with trimmed Christmas trees, boxwood wreaths in every window, mantel evergreens, and so much more.

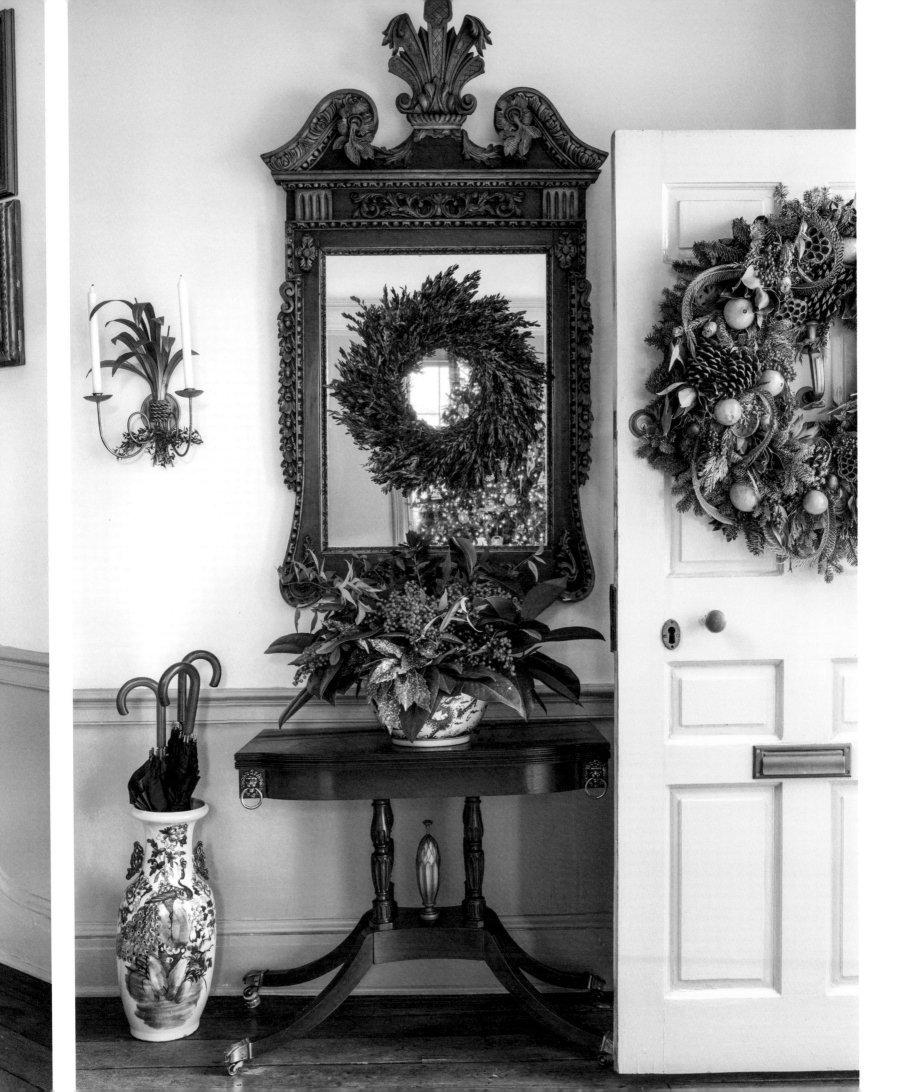

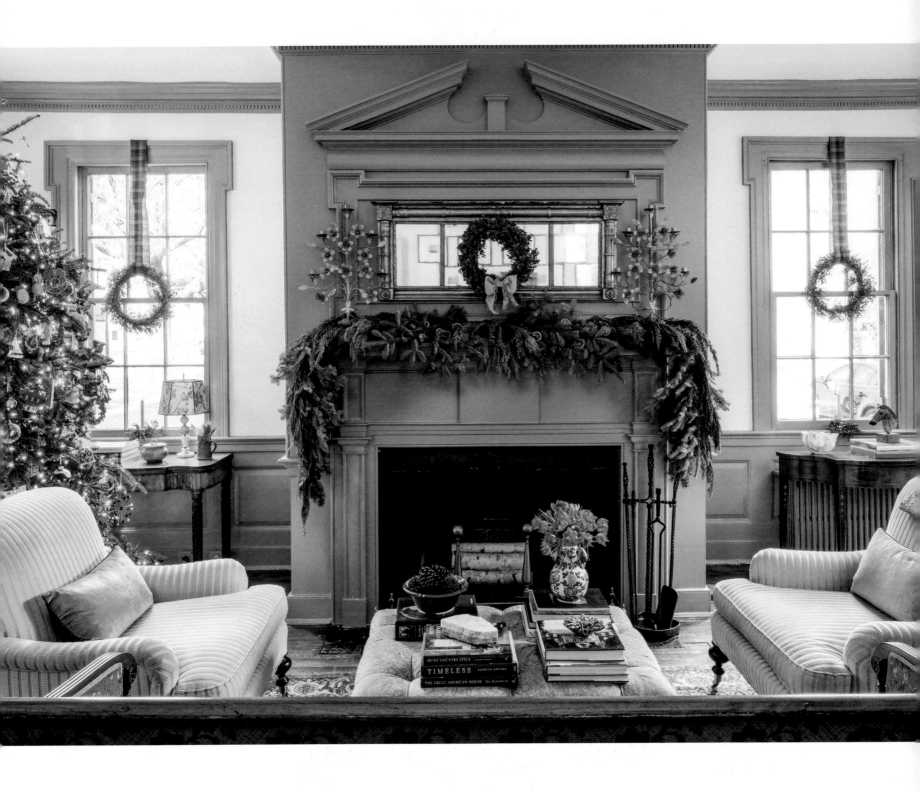

"The day after Thanksgiving is when I begin decorating, and I spread the chores out over time," Brian says. "I always do three trees: two downstairs and one in the master bedroom suite. I also put a ton of lights on all my trees by wrapping every branch—and that takes time," he says, noting that he dedicates a whole day to this cumbersome but transformative task.

Once the sparkly lights are up, each tree has its own theme. The main tree in the parlor holds collected, heirloom, and family ornaments, and the one in the dining room is decked entirely in dried fruit and spiced pomanders, all of which Brian makes himself. Fresh greenery abounds throughout. The resulting holiday décor is spectacular yet approachable in that classic Christmas way.

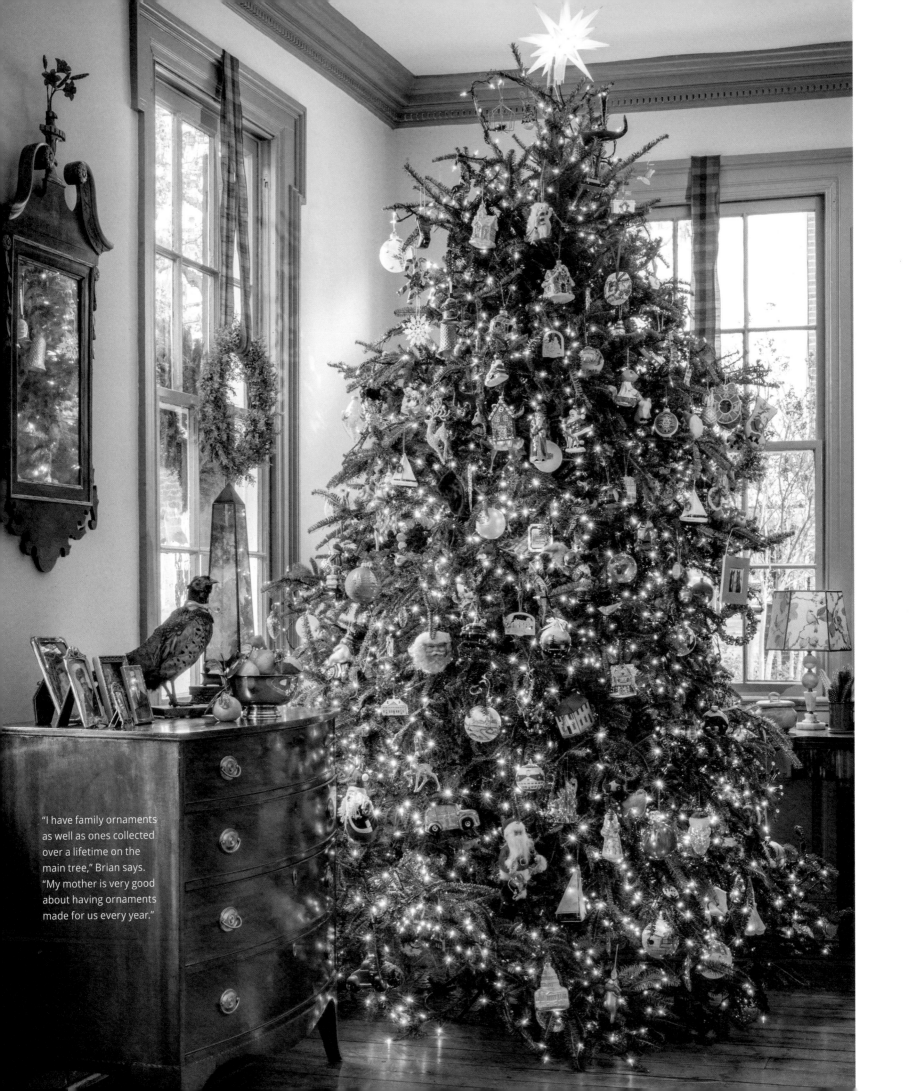

"I have family ornaments as well as ones collected over a lifetime on the main tree," Brian says. "My mother is very good about having ornaments made for us every year."

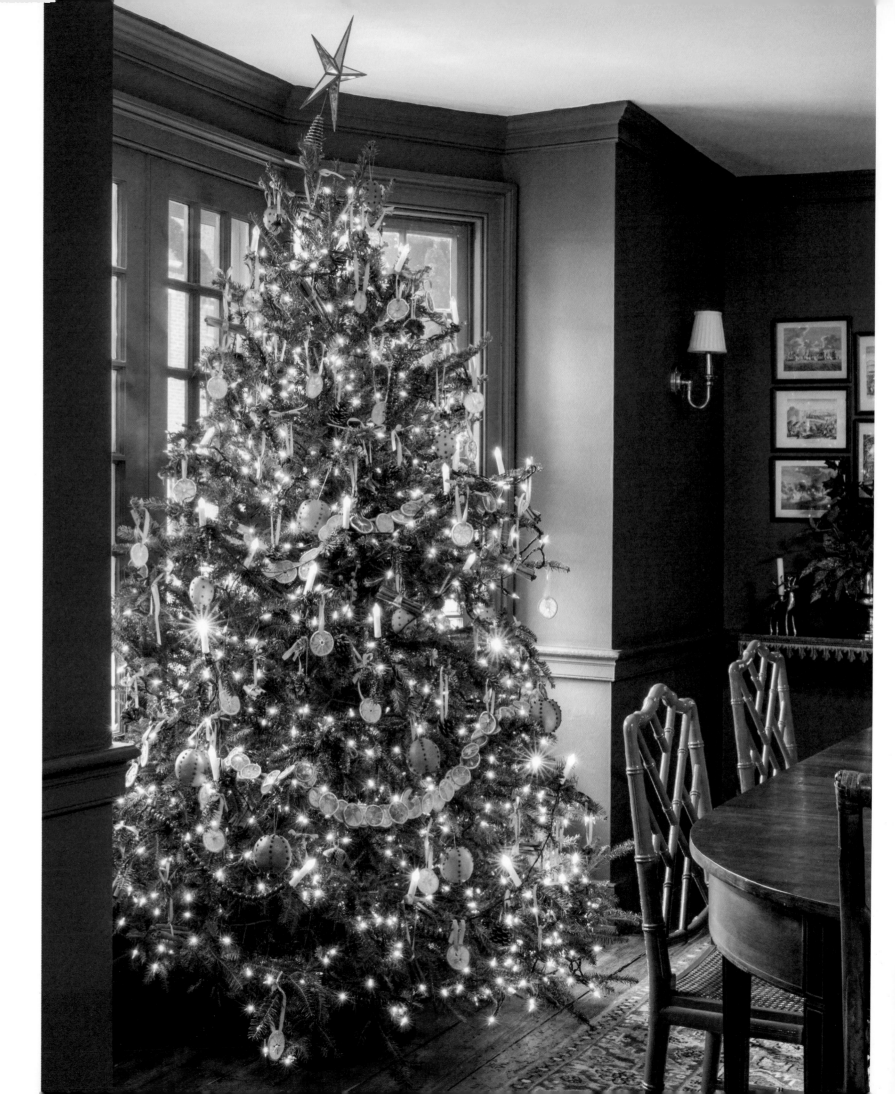

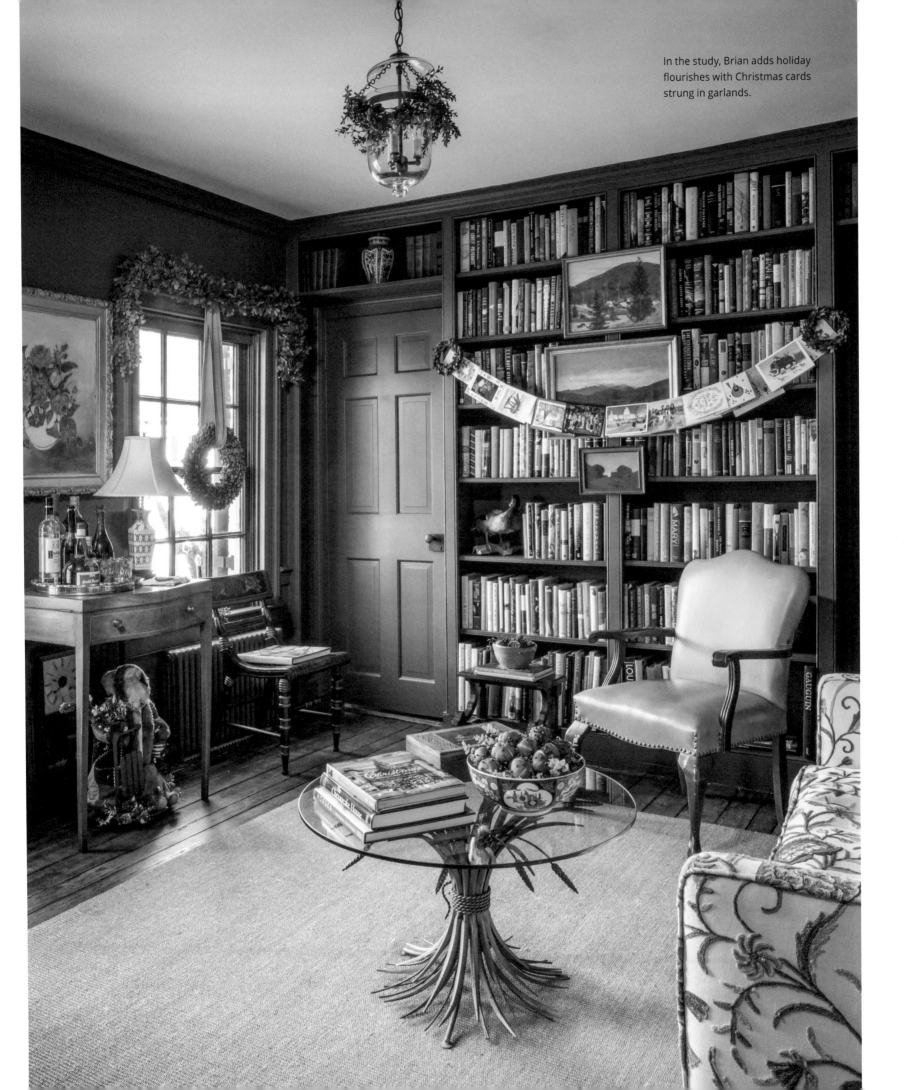

In the study, Brian adds holiday flourishes with Christmas cards strung in garlands.

"During our holiday party, we like our guests to spread out through the entire house instead of crowding in one room, so I decorate all the rooms. I'm amazed at the number of people who love to hang out in our bedroom during the party! But we have decked it up for just that purpose," Brian says of the space, which features its own holiday tree, adjacent sitting room, and four-poster bed canopied in evergreen swags.

From the 1800s yellow front door, with its traditional wreath centerpiece of fresh fruit, pine cones, and evergreens that Brian commissions each year from his friend and neighbor Ashley Greer, to the splendid indoors that he decks on his own, this Federal house comes to life with the celebration of Christmases gone by.

"I just love how the light shines on all our trees and throughout the home, and the fruit and evergreens just make everything smell divine," he says.

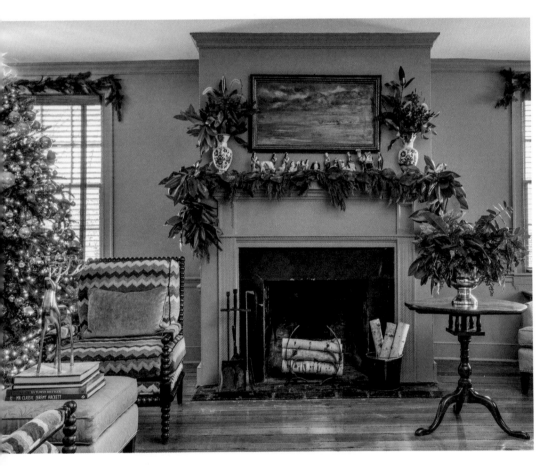

"I like to do smaller touches of greenery on lights and in brackets," says Brian, who also adds evergreen garlands to the four-poster bed canopy in the main bedroom. "It's the smaller things that most people don't do that make a home so warm and cozy at Christmas." On the bedroom mantel, amid greenery, is an antique blue-and-white china nativity scene. The tree to the left is decorated more simply with new ice-blue glass balls.

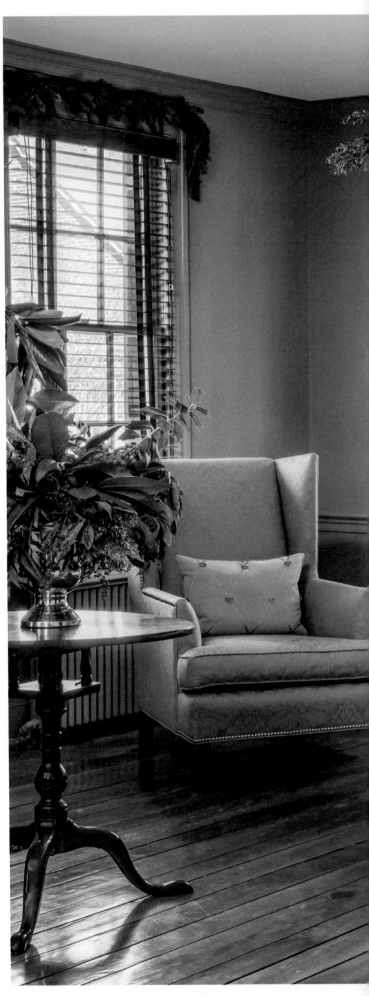

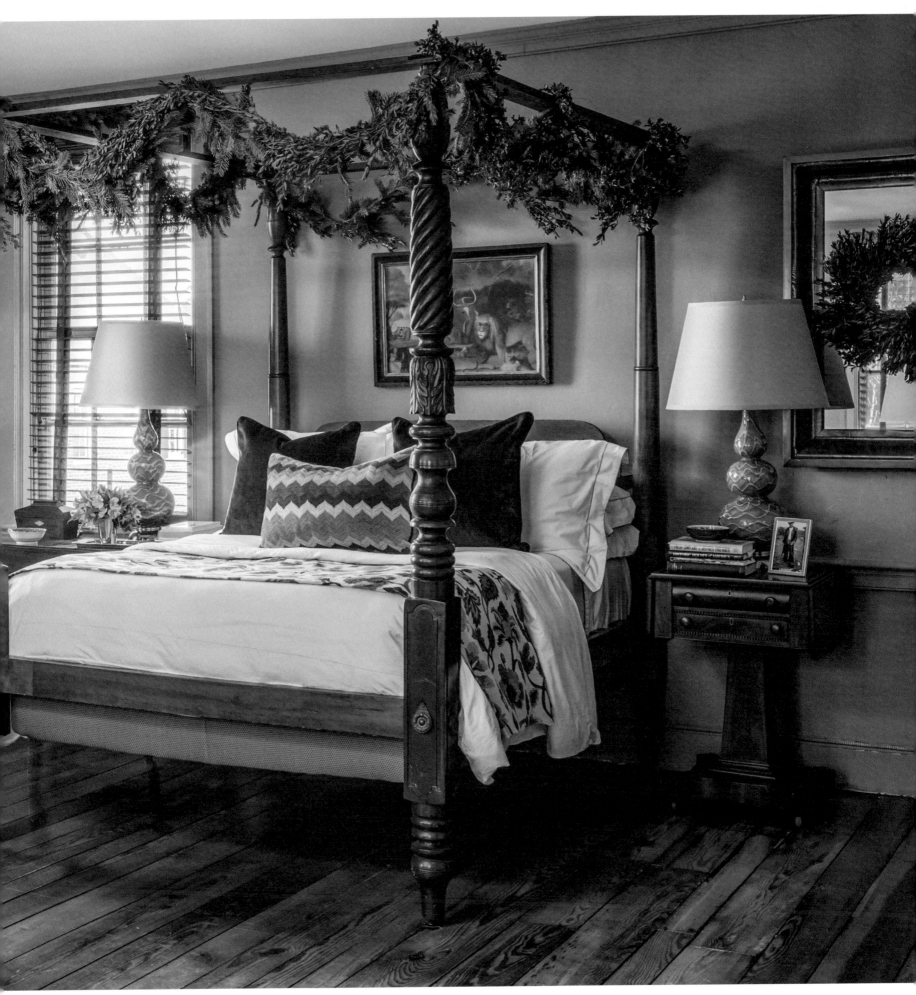

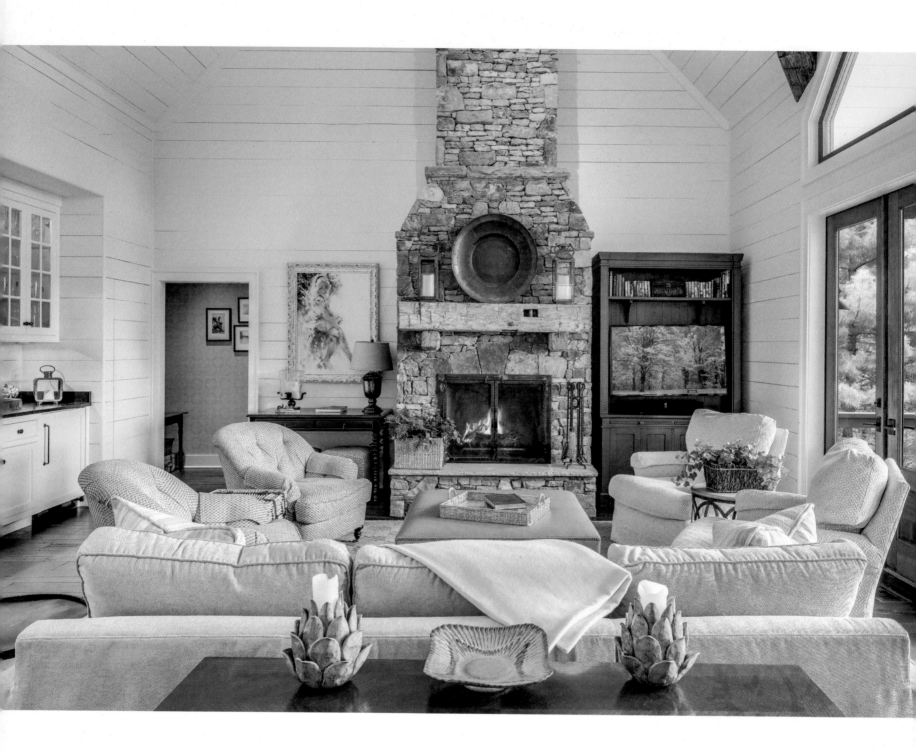

Capturing the View

WHEN LOOKING FOR A PLACE TO PUT DOWN ROOTS IN THE MOUNTAINS,
LYNN AND ED CASSADY RETURNED TO THE REGION THAT STARTED IT ALL.

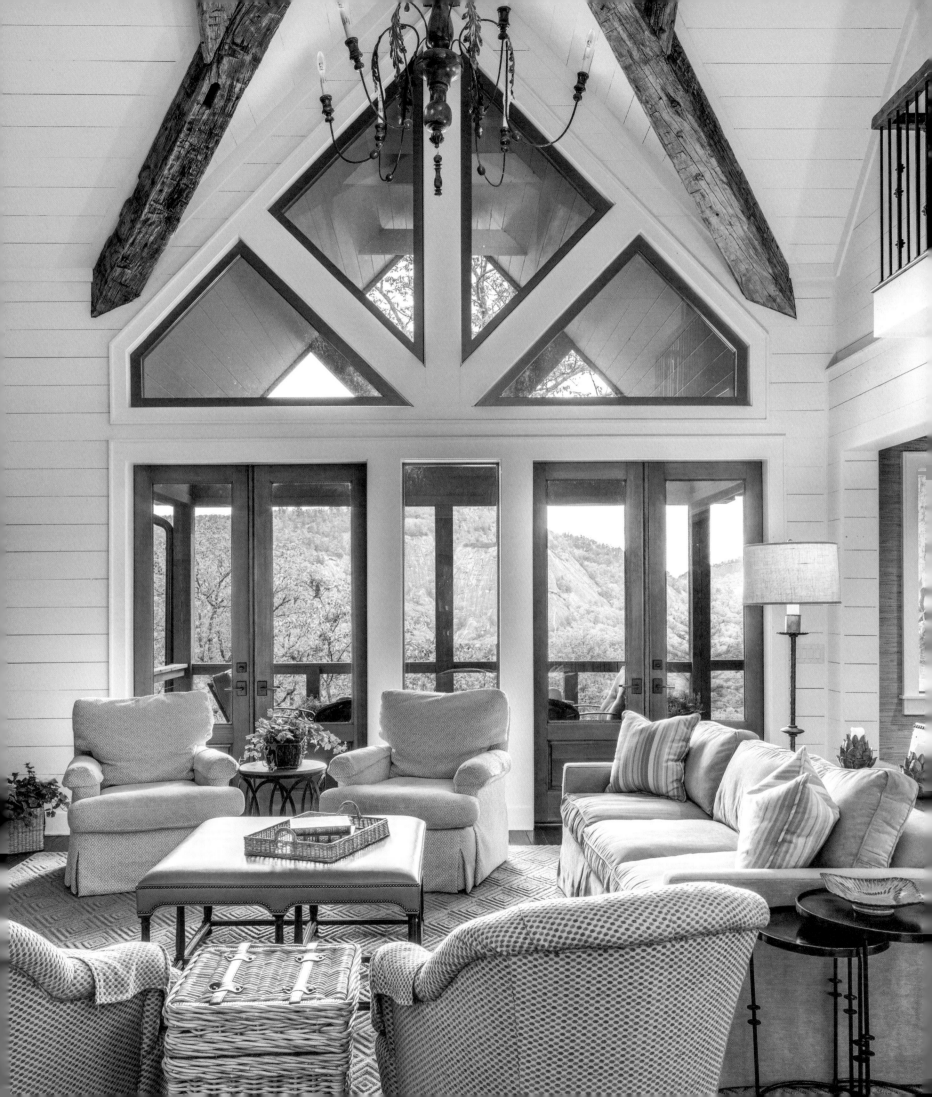

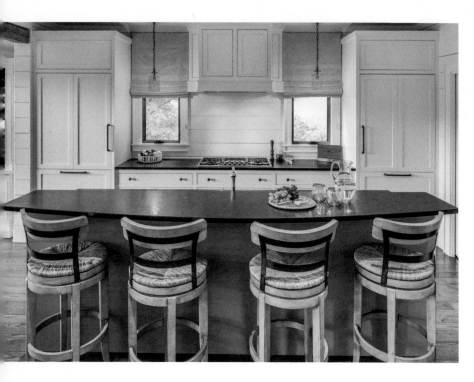

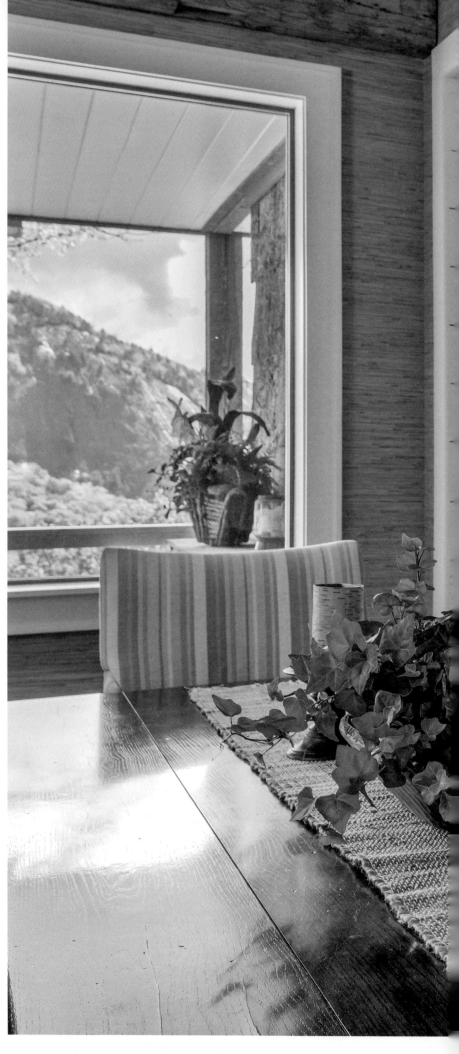

Ten years after a visit to Cashiers, North Carolina, Lynn and Ed Cassady decided it was time to have their own place in the mountains. They spent three summers touring various North Carolina and Georgia communities but kept coming back to one problem.

"We kept comparing everything to Cashiers," Lynn says. "And we finally said, 'Well, instead of comparing all of these to Cashiers, why don't we go to Cashiers?'" They landed in the High Hampton community, where they purchased a lot that gave them both stunning mountain views and access to nearby amenities.

The next step was to plan their dream vacation cabin, and for that, they turned to Jim Robinson of Design South Builders. "We absolutely wanted to capture the view," Lynn says of their plans for the space, pointing out the home's proximity to Rock Mountain and Chimney Top, two of Cashiers's most recognizable landmarks.

To accomplish that, they centered the house on Rock Mountain and included plenty of carefully placed windows. "You can see the mountains in the background, regardless of which window you're looking at," says Jim.

And with the surroundings playing such a crucial part in the experience, it was important to create an interior that reflected the character of the mountains. Toward that end, Jim incorporated materials like antique hand-hewn barn beams and reclaimed oak flooring throughout the main level. "Everything about this house is very authentic," he says.

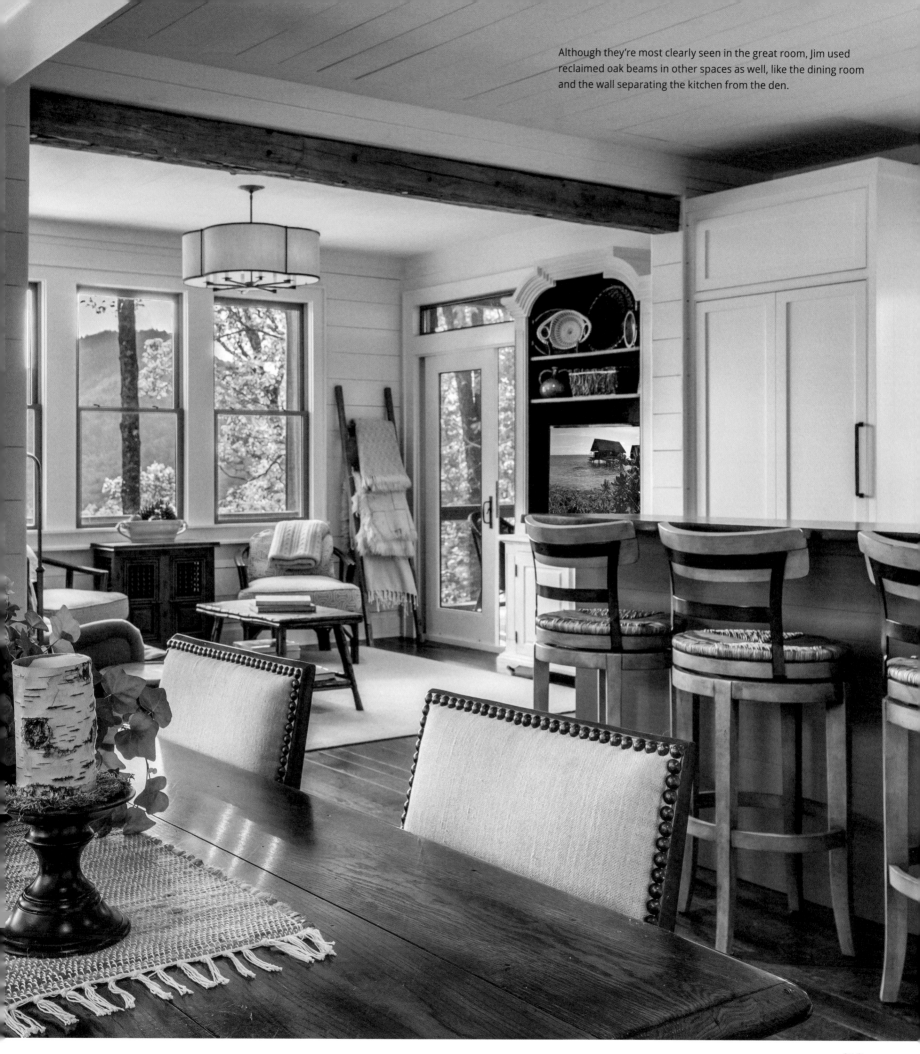

Although they're most clearly seen in the great room, Jim used reclaimed oak beams in other spaces as well, like the dining room and the wall separating the kitchen from the den.

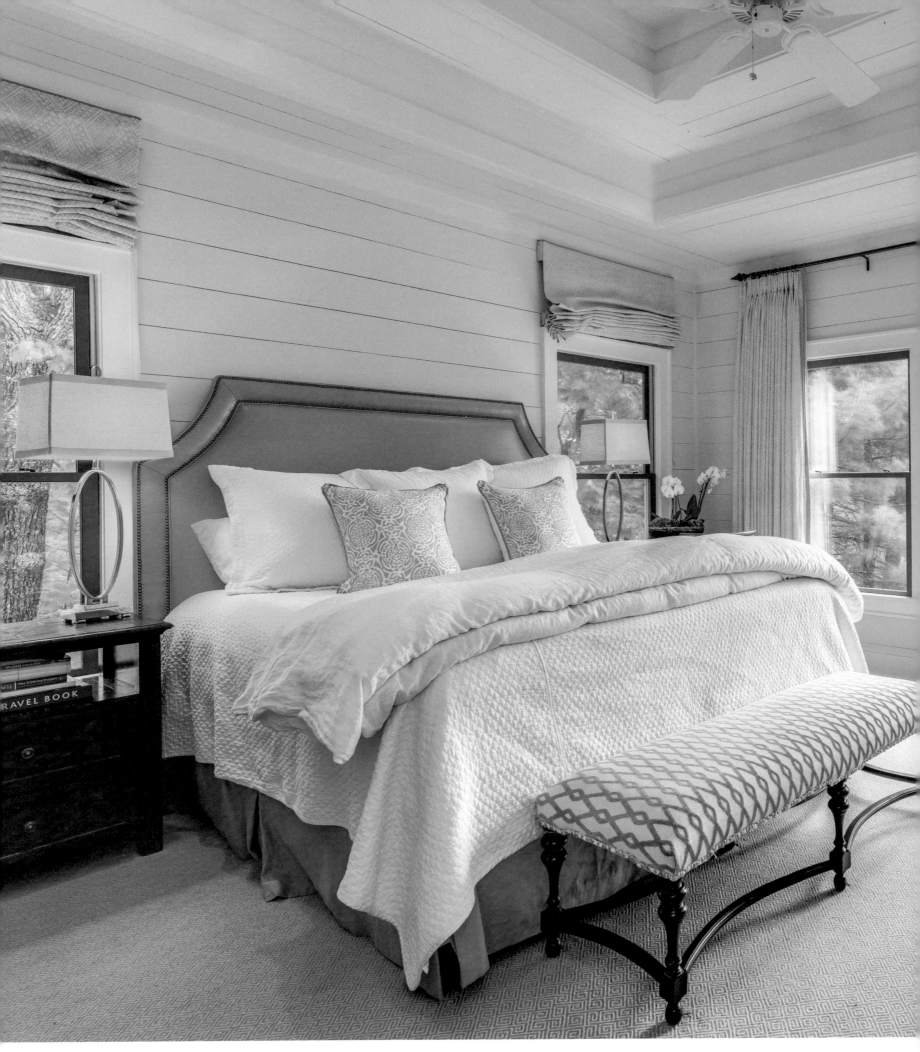

The more rustic elements are balanced by the clean, uncluttered atmosphere that Lynn wanted to create in the design. "The backdrop is all cream and white, all the shiplap and all the casing, and that keeps it really light," Lynn says, noting rich browns throughout the design that pull in the warmth of the mountains outside.

With three children in high school and college and plenty of out-of-town friends and family, the Cassadys wanted the home to have plenty of room, as well as space for gathering, which led to a layout that centered on the great room. "The loft has a great relationship to it looking down, and the kitchen and dining room certainly have a wonderful relationship and closeness to it," says Jim, describing the space as a "hub."

Located on the main floor away from the upstairs bedrooms, the master bedroom was created to give Lynn and Ed privacy—along with a stunning view. The tray ceiling and walls covered in white shiplap glow with a serene light, making the room the perfect place to curl up under a pile of cozy linens and watch the mist in the valley.

But it's the screened porch, where a swing bed waits next to a warm fire, that really seems to bring people together. "That is by far everyone's favorite [place]," Lynn says. "We spend 90 percent of our time out there." Whether it's watching the sun rise in the early morning with a cup of coffee or gathering around the fire in the evening, the family loves coming together and enjoying the mountain view.

"The really pretty thing about having our view against Rock Mountain and Chimney Top, where you have the bald face of the mountain, is that the colors change on the rock face of the mountain all day long," Lynn says of the view outside the master bedroom.

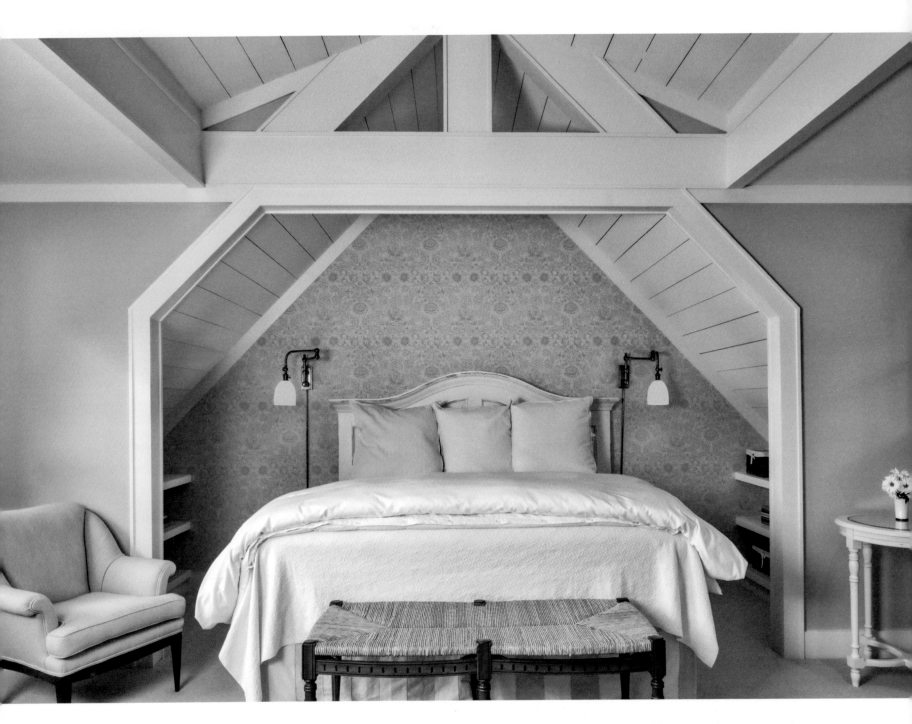

One of the bedrooms, while originally designed to hold two queen beds, became the object of some quick thinking during the building process. "Originally, there was no niche—it was going to go straight down," Lynn says of the back wall. Instead, she and Jim agreed to expand the room and swap the two queens out for a king, flanking the bed with built-in bookshelves and backing it with a cheerful patterned wallpaper. Now, the room is the favorite of the family's children. Opposite: A favorite spot of the whole family, the swing bed on the screened porch was the first purchase for the new house. "We had a lot of our existing furniture, and then I found that and fell in love with it, and Jim changed the dimensions of the porch so it would work for the sitting area," Lynn says.

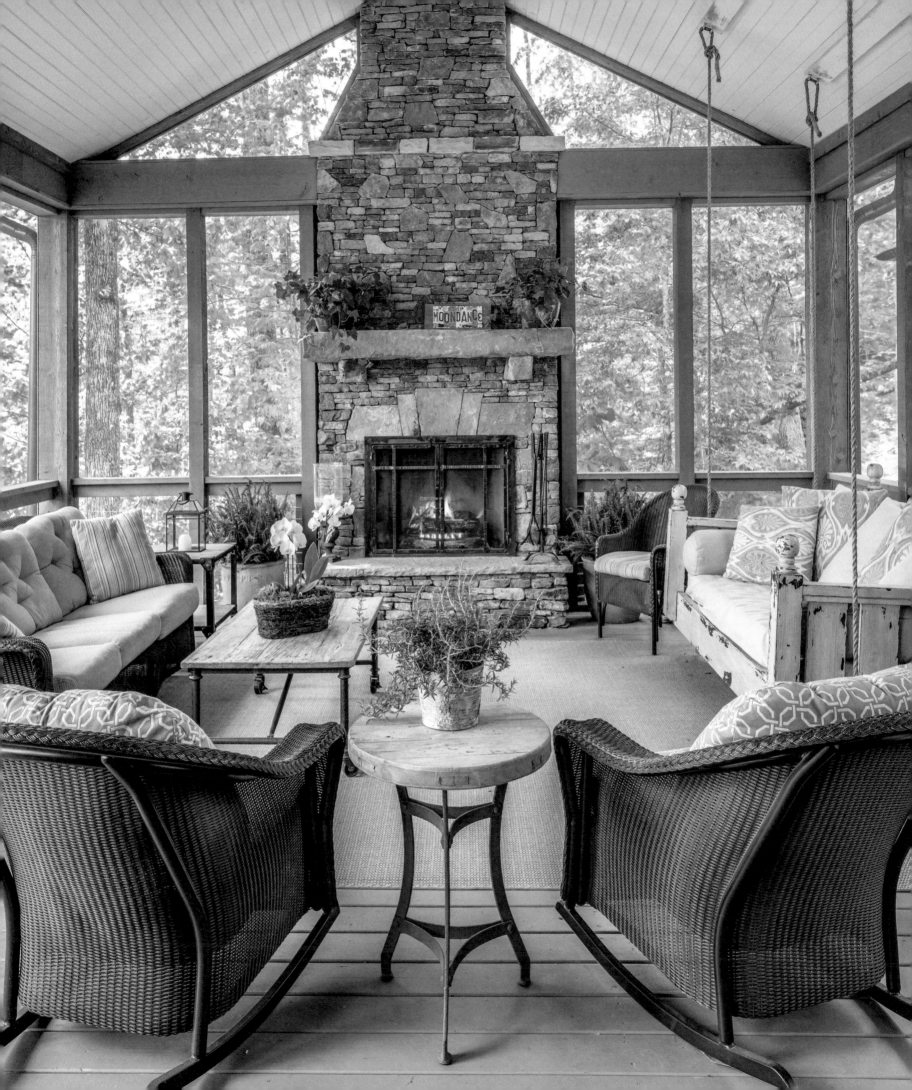

RESOURCES

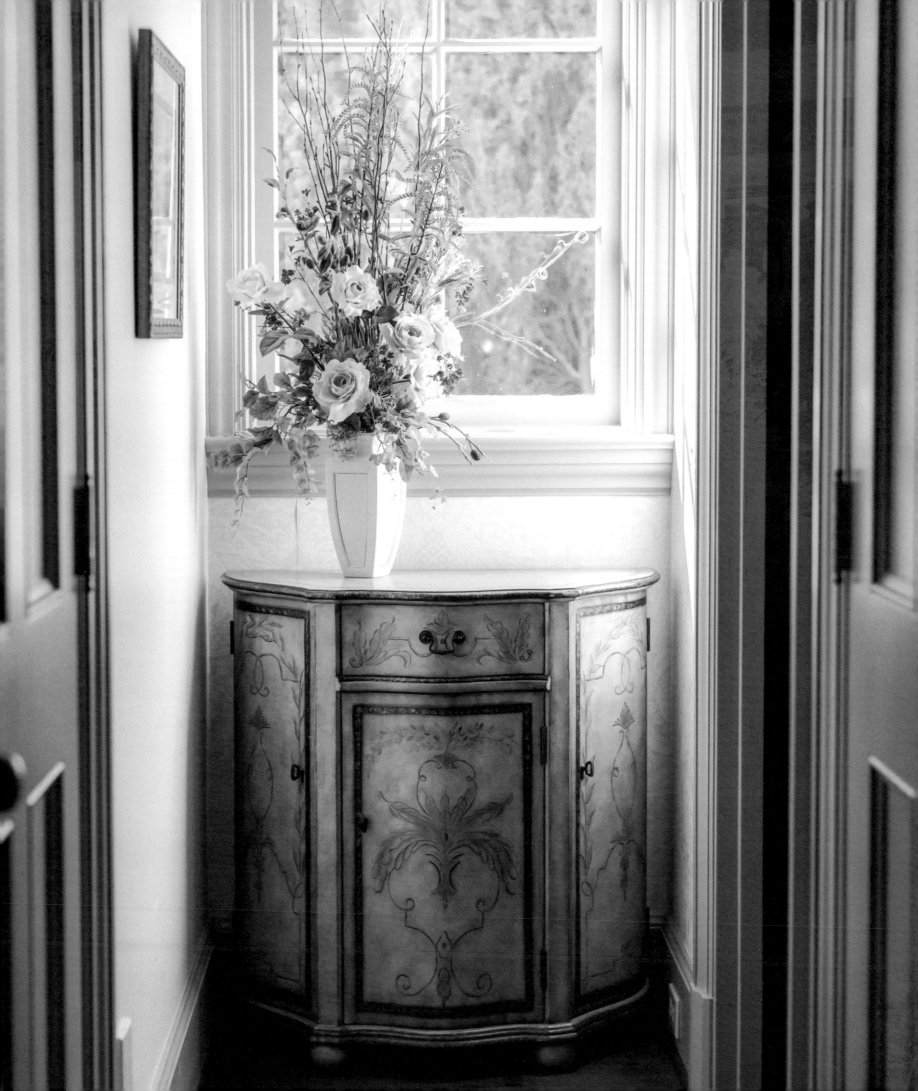

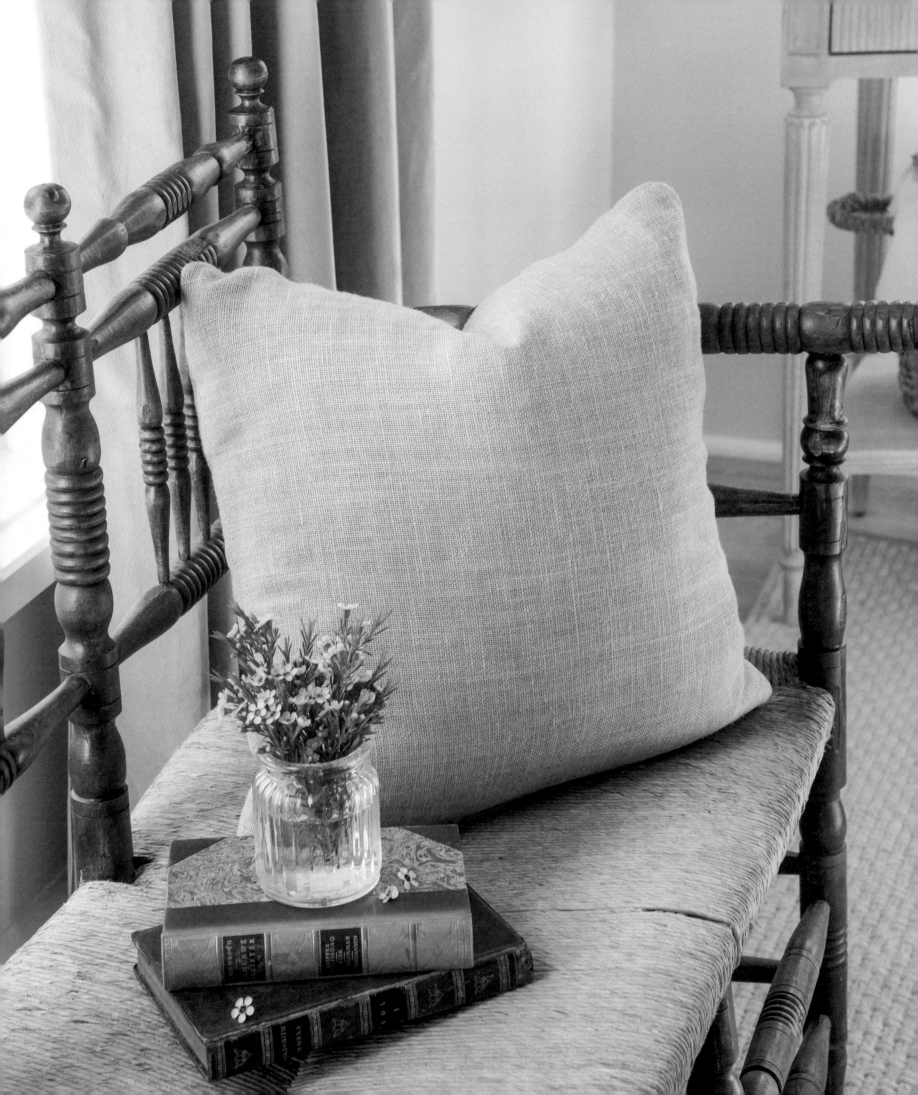

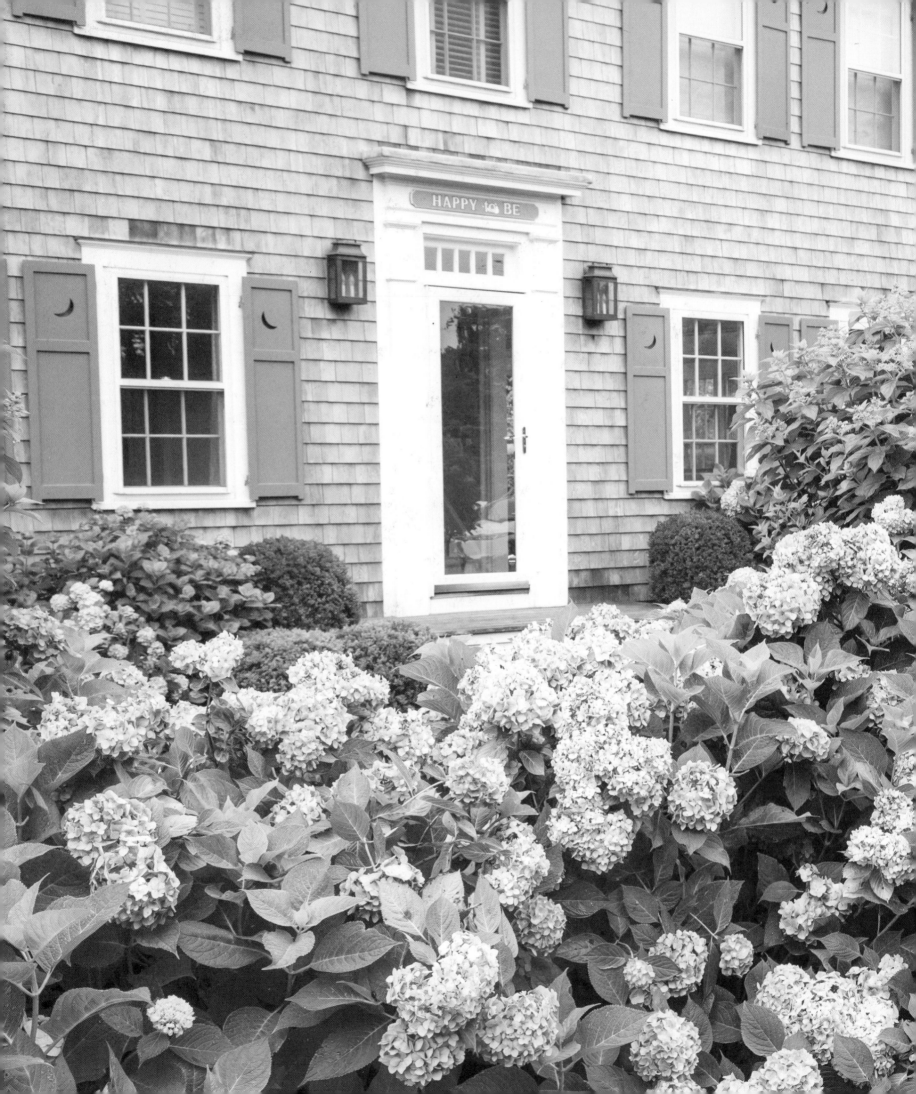